THE BLACK WOMAN

SAGE FOCUS EDITIONS

THE BLACK WOMAN

edited by
La Frances Rodgers-Rose

 SAGE PUBLICATIONS Beverly Hills London

To the ever-continuing life forces of Fannie Lou Hamer, a true African-American women. We hear you.

For information address:

SAGE Publications, Inc.
275 South Beverly Drive
Beverly Hills, California 90212

SAGE Publications, Ltd
28 Banner Street
London EC1Y 8QE, England

Printed in the United States of America

Library of Congress Cataloging in Publication Data
Main entry under title:

The Black woman.

 (Sage focus editions; v. 24)
 Bibliography: p.
 1. Afro-American women—Addresses, essays, lectures. I. Rodgers-Rose, La Frances.
II. Series.
E185.86.B54 305.4′8 79-28712
ISBN 0-8039-1311-7
ISBN 0-8039-1312-5 pbk.

FIRST PRINTING

CONTENTS

ACKNOWLEDGMENTS

There are many people who have been both directly and indirectly responsible for my completing this major effort. For the most part, their names will not be called, since that would take the length of a major chapter. Most of these people exist under the collective group identity of the Hill-Williams family from Scotland Neck, North Carolina. They be my extended family, my support, my reasons for doing what I have to do.

My father, Rev. Carroll M. Rodgers, Sr., keeps on doing what he has to do for my survival and the survival of our people. Brothers James and Carroll, Jr., we did it. Cynthia will always be my special sister. Thank you. Without my mother, Mrs. Beulah Smith Rodgers, I could never have started or completed this project. She knows!

I am also indebted to Jennifer Hill, my former student and friend, who under very short notice was asked to edit all of the papers. We owe her tremendous gratitude. She has the ability to correct your "stuff" without changing or disturbing the flow of your thoughts. Mrs. Mildred Joseph typed the entire manuscript. Her hours were long and the pay was little. We indeed became extended sisters doing the whole endeavor. Thanks, Mil.

Again, I would like to publicly thank all of the women who contributed to the volume. Their intellectual depth gives us a new perspective on what it means to be a Black woman. Although it has taken us five years to pull it all together, it was worth every minute of it. I give you all a standing ovation.

I would like to thank Sage Publications for agreeing to publish this book at a time when Black ain't in. Our deep appreciation is given to you.

Finally, I would like to give homage to my children, Henry and Valija, for being the spirits that they are. You let me know that what I am about is the continued survival of all Black children.

—La Frances Rodgers-Rose

PREFACE

New Bones

we will wear
new bones again.
we will leave
these rainy days,
break out through
another mouth
into sun and honey times.
worlds buzz over us like bees,
we be splendid in new bones.
other people think they know
how long life is
how strong life is.
we know.

Lucille Clifton:
An Ordinary Woman

Who is this woman of Blackness? This daughter of Africa? Where has she been? Where is she going? Lucille Clifton tells us that she will wear new bonds and will break out "into sun and honey times." This seminal poem captures the essence and existence of the African-American woman in the new world. Her existence has been characterized by three hundred—no, nearly four hundred—years of struggle, a struggle to exist, to be her own person, not only for herself but for her family. We will understand the Black woman to the extent that we are able to concretize her general experiences. We must know not only her contemporary experiences, but also the historical collective experiences of all Black women. The Black woman has emerged out of a history of oppression. She survived the long middle passage from Africa to America, bringing with her many of the diverse characteristics of her African mothers—not only did she bring with her the ability

to raise strong sons and daughters, but she also brought with her a sense of independence, a knowledge of warfare, and a commitment to the survival of her race.

She survived the wanton misuse and abuse of her body—raped by white men, forced to conceive babies to increase his economic wealth. She delivered babies so rapidly that her body became old before its time, or she died in childbirth. She somehow survived the pain of seeing her children die in infancy, and for those who survived, she suffered the pain of seeing some of them sold away from her. For those who remained with her, she still lived with the thought that her master might sell them away. Through it all, the Black woman managed to keep on keeping on. She gave her children love, cooked for them, protected them, told them about life, about slavery, about freedom, about survival, about loving, about pain, about joy, and about Africa.

The knowledge of the history of Black women tells us that they continue to live in an oppressive society. The Black woman moved from slavery into the system of sharecropping with her family. And, as the "new" history of slavery is being written, we are amazed to find the number of Black families that existed as viable structures immediately after the end of slavery. No, the system of slavery was not able to destroy the African concept of the family. As the need for farm labor decreased in America, the Black family was pushed into the city. There the Black woman was only permitted to do the dirty work of the society. She worked in the homes of white families, doing the housework of her white mistress. She raised white children, and she raised her own children. Again, somehow she managed to survive. She managed to see that her children learned to read and write, although in many cases she could do neither herself. She worked long hours to make sure that they had food to eat. She continued to teach her children the ways of her African and African-American ancestors.

As we move into the 1980s, we find that Black women must continue to remember, to be, and to relive the slave and peasant existence of their ancestors. To do so means that the African-American woman will never be separated from her reality. The task is not easy, since her history has not been readily available to her. This has become particularly true as Black people have moved away from their rural way of life into the concrete cities and vertical housing structures. It is not easy because of the assault on Black identity by the mass media. With nearly one television set in every Black home, we find a growing dependence on this form of media to tell us who we are, where we have been, and where we are going. It becomes difficult to see the reality of Black life in such television shows as "Good Times," "What's Happenin'," "Sanford and Son," or "The Jeffersons."

It is also not easy to hold on to the reality of the Black woman's history in

America because of the unfavorable research conducted by social scientists on her. For the most part, these social scientists have been white, they have not lived the experience of Black womanhood, nor have they made an earnest effort to be introspective learners and observers. Thus, in trying to grasp the understanding of Black women and their history, we are left with one-sided characterizations of them as matriarchal, domineering, aggressive, permissive, superstrong, overly religious. Very rarely have we seen research or theory that presents a balanced picture of the Black woman. It has only been in the past ten years or so that the negative perceptions of Black women have seriously been challenged. The works of Bell and Parker, Billingsley, Cade, Crutchfield, Davis, Gutman, Harley and Terborg-Penn, Hill, Johnson and Green, Ladner, Lerner, Mossell, Noble, Staples, and Walker are all part of the growing social scientific literature that questions the validity of the prevailing characterizations of Black women.

However, none of these authors has had the impact on the general public that Michele Wallace created with her book *Black Macho and the Myth of the Superwoman*. It could indeed be real that this book, published in 1979 by a major publishing house, is destroying the revisional work that the previously mentioned scholars have done on Black women and the Black family. One must ask, Why this book at this particular time? Why have people paid more attention to what Wallace had to say than to Ladner or Cade? Could it be that just as Black women were beginning to consider, reflect, and evaluate (see Wilson's article) their existence in this country from a perspective of their African past and slave history, those "forces" that would have them ignorant of that past saw fit to confuse them, to negate what they were beginning to see as their purpose or mission in this country? June Jordan, in her review of Wallace's book (*New York Times Book Review*, April 8, 1979), gives us some insight into the significance of this book. She says that *Ms. Magazine* departed from its routine policies and published a photograph of Wallace on the front cover and proclaimed, "The book that will shape the 1980's." However, in Jordan's assessment, the book consists of a series of overgeneralizations. Jordan states that there is not one direct quote from an interview that Wallace conducted with a living Black man or woman in the entire book. The overall opinion of the book is that it is shallow and devoid of any knowledge of what it has meant to be a Black woman or man in American society. Why this book at this time? We may not be absolutely sure of the reason, but the book serves to negate not only our past and the struggles of our ancestors, but it also calls into question the ability of Black men and women to continue to struggle together for the survival of their children.

It can only be hoped that the purpose of Wallace's divisive book will not be realized. Indeed, this is not the first time that negative evaluations of

Black men and women have been made. We can also hope that those who are correcting false definitions of the realities of Black people in general and Black women specifically will continue to research the question of what it means to be a Black woman in America. This volume of original research and theory papers by Black women about Black women seeks to continue the process of correcting the history of Black women. It aims to go beyond the debunking of the prevailing ideology, although we realize that debunking is an important process in the effort to correct Black women's history. We have endeavored to understand the relationship between ideology and utopian thought as that relationship impinges on the Black woman. We have, therefore, attempted to escape the distortions of reality that grow out of defending particular positions. The underlying purpose in each of the essays is the quest for the reality of the situation. That reality becomes clear to the extent that we have been able to adhere to the actual situation. In both the research papers and the theoretical essays, there is the continued effort to grasp the situation from the perspective of Black women. There is also the effort to understand the everyday lives of Black women, recognizing that there are or there may be differences based on variations in age, socioeconomic status, marital status, occupation, region, values, beliefs, and goals. We take the position that the whole can only be comprehended to the extent that we are aware of the limited scope of every point of view (Mannheim, 1936). Throughout the volume, there is the continued effort to identify the specific point of view.

This volume represents the most comprehensive analysis of the everyday life of Black women in print. The volume brings together for the first time the original works of sixteen Black women trained in the fields of sociology, social psychology, political science, demography, and history. The congruence in our ideas is revealed throughout the volume. Whether analyzing the changes in fertility patterns or the perceptions of Black women in literature and sociology, the conclusions are the same—much of the theory and data applied to Black women have not been appropriate. Each of the scholars suggests the need to rethink the definitions of Black women from her own perspective. They are concerned with how Black women handle various problems that confront them. What values guide their lives? Are there variations in the support mechanisms of the extended family by class and marital status? What kinds of relationships exist between Black men and women? What attitudes do Black women have toward the women's liberation movement? What roles do Black women play in the family?

In seeking to answer these questions, the authors stress the point that the history and lives of Black women cannot be separated from the history and lives of Black men and their children. Therefore, this volume presents new ways of looking at not only the everyday life of Black women but also the

everyday life of all Black people. The Black woman is but one part of the total picture. Her day-to-day struggle is played out in a scene that includes Black men and Black children.

The volume is organized into four sections. The first section looks at the social demographic characteristics of Black women. Topics of discussion include the consistent historical undercount of the Black male population; changes in the educational level of Black women; and the changing fertility patterns of Black women. The second section focuses on the Black woman and her family. Consideration is given to the role of the extended family in the stability of Black families; to the child-rearing goals and strategies among Black domestic servants; and marital interaction goals in Black families. This section includes a diverse group of Black women who differ by region, occupation, and marital status. The impact of the political, educational, and economic institutions on the Black women are delineated in Part 3. The dilemma of Black women leaders in managerial positions is viewed. The concept of the so-called added benefit of being a Black professional woman is handled in another chapter. The misconceptions of the political behavior of Black women is analyzed, and professional female community leaders and organizers are studied in depth. The final section of the volume gives a social psychological analysis of the behaviors of Black women. Issues dealing with male/female relationships, the alarm over the alleged drastic increases in Black female suicide, and the attitude of Black women toward the women's liberation movement, are all included in this final section. The volume ends with a discussion on the self/group actualization of Black women.

We hope that this volume will shed light on what it has meant and continues to mean to be a Black woman in America. We recognize that one volume cannot address all aspects of the Black woman, nor can it correct all the misperceptions of her. We have endeavored, however, to be as thorough as possible with the aspects we studied. If we have caused the reader to consider, reflect, and evaluate in any way the Black woman in America, our efforts were not in vain.

—La Frances Rodgers-Rose

REFERENCES

Jordan, J. (1979) Book Review: Black Macho and the Myth of the Superwoman, by Michele Wallace. New York Times Book Review, April 8.

Mannheim, K. (1936) Ideology and Utopia. New York: Harcourt Brace Jovanovich.

INTRODUCTION

THE BLACK WOMAN
A Historical Overview

La Frances Rodgers-Rose

THE BLACK WOMAN:
HER AFRICAN BACKGROUND

It is generally agreed that the majority of Black people brought to America came from West African societies (Blassingame, 1972: Billingsley, 1968; Franklin, 1974; Gutman, 1976; Herskovits, 1941; Noble, 1978). Therefore, what I have to say in this section holds true for traditional West African societies, but similar patterns can be seen throughout African societies. We are concerned with West African societies in the late seventeenth, eighteenth, and early nineteenth centuries. It was during these centuries that Black African women were brought to America. The assumption is that these women also brought with them the culture of their people—the ideas and beliefs of their people were part and parcel of these women's lives.

No one would deny that the role of the woman in West African traditional societies differed from the roles of the Black woman in American society during slavery. However, it would seem that in order to fully understand the Black woman during slavery and even certain behavioral aspects of the Black woman today, we need to know about her female African forbears.

When the Black African woman was introduced into American society, she was an adult with set role behaviors and expectations. She had certain styles of behavior and belief patterns that spoke of her African past. We tend to forget just how recent some of our foremothers came to this country. As Cedric Clark suggests, "'long in the past' and 'recent' are highly misleading terms when we recognize that space and time are not absolute but relative" (Clark, 1972: 8). Clark goes on to say that in terms of a relative universe, the

occurrence of slavery might be as near as yesterday; for slavery only ended in 1863—my great grandmother was born a slave, and until as late as 1850 new slaves were still being imported illegally into America. Further, we know that these women and men did not come to this country without a vivid past: They had been socialized into the ways and beliefs of their people. We also know that once individuals have been socialized, their basic personalities are established. Their way of looking at things, defining situations, has been set. Although the middle passage to America was inhuman and difficult, it could not erase the memory of the slaves, nor stop them from thinking about their homeland and families.

Only humans have the ability to think and record things in great detail, to remember the past, and to contemplate the future. The Africans brought to this country had those same human abilities. It was this ability to remember that makes it possible to suggest that Africans were able to retain parts of their cultures, although over the years the culture has been modified to fit the environment. What, then, were some of the values, ideas, beliefs, and behavioral patterns of African women in traditional African societies?

We know that the woman in West African societies played roles that were vital to the survival of the group. Her role as mother was her most important function. It is through her that the future of the nation is assured. Kasbury (1952) tells us that women were viewed like gods because they bear children. Without her, there would be no future. Because of this crucial role, we find that Africa is defined as the motherland. In African mythology, the universe was conceived and delivered by a woman. No other person has that ability—the ability to give birth, to ensure the ever-increasing number of ancestors, to link the past with the present.

The African woman was more than a mother, however. She was instrumental in the economic marketplace. She controlled certain industries—the making and selling of cloth, pottery, spinning, and the sale of goods of various kinds. The economic position of the African woman was high. The women were traders, and what they earned belonged to them. Some women became independently wealthy. The West African woman was also responsible for raising the food for her family—she planted the crops and maintained them.

The African woman was also a wife, and she was expected to prepare her husband's meals. In many families, the role of wife was made somewhat easy since her husband would more than likely have more than one wife. The more wives the husband had, the fewer physical obligations each wife had to him. Thus, her role as mother was always more important than her role as wife or trader in the marketplace, although what she earned in the marketplace added to her ability to care for her children. The African woman performed her duties as wife on a rotating basis. Once she became pregnant,

she left her husband's house and returned to her father's house until the baby was born, and did not return to her husband's house until the baby was weaned, around the age of three (Jahn, 1961). Therefore, for all practical purposes, the West African woman lived as an independent person with her children, only returning to her husband after the weaning of the baby, and leaving again when the next child was conceived. In West African societies, it is believed that the survival and care of children are the most important functions men and women can perform. A man cannot interfere with a woman carrying out the function of raising children. The mother should give her complete attention and love to the child. She should not be tied down to role obligations to the husband, and she should not run the risk of conceiving another child before the first child is weaned. We find, then, that children are very close to their mothers. From birth, the child goes everywhere with the mother—tied to her back. The child is not on a strict feeding schedule, but eats whenever he or she wants. The needs and desires of the child are paramount. The African child would be characterized in the western sense as spoiled. But, from the African perspective, there is no other way to raise children: Happy children make for happy ancestors.

As suggested earlier, the role of the woman in West African society extends beyond the role of mother and wife. She has a certain degree of independence because she is a member of an extended family. Not only does she have her extended family of birth, but also her extended family by marriage. Before reaching maturity, the African woman is raised in a society of women her own age. These women are called sisters, and the women her mother's age are called mothers. It is in the peer group that the female learns about life in general, about her different roles, and she gains a sense of independence. In some West African societies, particularly in Yorubaland, there is a woman chief, Iyalole, who looks after the women's interests in their dealings with the men and the king (Jahn, 1961). Women have their own organizations which men cannot attend. One must recognize that African women spend more time with each other than they do with their husbands. Each woman has her own house that she lives in with her children. She only visits her husband's house when it is her time to perform wifely duties. Jahn says that a true Yoruba woman cannot let her husband take care of her. She must earn her own way.

In summary, the African woman, when she came to America, had the following attitudes, beliefs, and expected role behavior: She was raised in an environment that stressed the importance of motherhood. The survival of children was paramount in the culture. The raising of children was more important than the role of wife. Usually the African woman was part of a polygamous family, taking her turn in the routine to perform the function of a wife. When she became pregnant, she left her husband and returned to her

father. Quite often the separation was at least three years long, and each subsequent pregnancy followed the same process. The West African woman was independent. She controlled the economic marketplace, often becoming wealthy. What she earned belonged to her, and, further, she felt that her husband should not take care of her, rather, she must earn her own way.

THE BLACK WOMAN DURING SLAVERY

To some extent, the African woman was thrown into a situation during slavery that was familiar to her. She was accustomed to hard work, since she raised crops for her family in Africa. She was accustomed to children being in her care most of the time.

Slavery in American society has been characterized as the cruelest ever known to man. Not only were people captured and forcibly taken from their homeland, but in order to maintain the economic position of white men, the slave was defined as less than human, deserving to be treated as chattel. Slaves were often sold at the slave auction without clothing, indicating to the public that these were not humans who had feelings and pride, but rather subhumans. Women were not treated differently than men. They too were exposed to the public—they were poked, rudely examined, and dehumanized. One can imagine the dread this kind of behavior caused the African woman, who was raised to expect privacy. Some slaves imagined that whites were savages and planned to eat them (Blassingame, 1972).

The slave woman was defined in terms of her breeding capacity. The concept of motherhood and the care of her children was minimized. The younger the slave woman, the better. In this way, slave owners were assured that the woman was at the beginning of her childbearing age and would have many children. Each new child increased the wealth of the owner: He could either sell the child for a profit when the child reached a certain age, or he could see that within a few years the child would become a part of his labor force, producing cotton or tobacco. The sacredness of motherhood and the raising of healthy, happy children was denied the slave woman. She lived in the constant fear that her children would be sold away from her. In many instances, they were. No longer could the African woman space her children three years apart. She was forced to give birth as often as once a year. Her body was misused, and quite often she was old before her time. Not only was she forced to have children rapidly, but she was given very little time to regain her own strength and only two weeks to care for her children. After that time, the slave woman had to return to work. Her child was brought to the field with her, and she was given breaks during the day to nurse the child. After the child reached the age of one, he or she was left in the care of an elderly woman or an older sibling.

Perhaps the most difficult aspect of slavery to the Black woman was the change that was forced on her in mother-child relationships. However, we know from slave autobiographies and letters that the strongest bond in slavery was that between mother and child. It is interesting to see this duality, which at first sight appears to be contradictory but which, after a close look at the situation, suggests that just as slavery drastically changed the primary relationship between mother and child (changed the spacing of children and changed the amount of time that mothers could spend with their children), it also was not strong enough to destroy that relationship. Mothers still managed to care for their children; they still managed to show love for their children, and they still sacrificed for their children. One must ask how this was possible. Blassingame (1972) tells us that the slaves developed their own community, which existed separate from that of the master.

Quite often we are given the impression that the master was forever present in the slave's life. However, we know that on several of the large plantations the owner was an absentee owner (Gutman, 1976). The running of the plantation was left to an overseer whose position in the structure differed significantly from the owner. Likewise, on the large plantations the slaves were physically removed from the owner. Life can be viewed from the perspective of an army camp: One has certain roles and obligations, but at the same time one has a life of one's own that is played out in the camp. The large plantations had this structure. The slaves worked from sunup to sundown, but after that they had lives of their own separate from their white owners. This life must account for the strong bond that developed between mother and child. It was after work that mothers cared for their children, cooked for them, made clothes for them, told them stories of their motherland and of their ancestors, discussed the meaning of slavery, and how they felt about slavery.

What I am suggesting is that the bond that existed between mother and child in African society continued in slavery; although the structure of that relationship had changed, the crucial process of care, love, and devotion continued. The Black slave woman was not respected by the white slave owners the way she was in Africa, but she was respected by her children and by her spouse.

We are often given the picture that few intimate relationships existed between slave men and women. However, with the initial work of Gutman (1976) and Blassingame (1972), a different picture is emerging. Gutman suggests that the Black family in slavery was more stable than past historians have suggested, although he admits that nearly one-third of all slave families were dissolved by force by the white owners. For example, in looking at the length of marriages in Nelson County, Virginia, in 1866, Gutman found that 55 percent had been married for more than ten years and, of this percentage,

15 percent had been married for more than 30 years (Gutman, 1976: 12) These were not exceptional statistics. The same held true in counties in North Carolina, South Carolina, Louisiana, and Mississippi. From Gutman's research, one can begin to see that Black women were not alone in their struggle; they had spouses who helped them. Particularly, from Gutman's data, it would appear that no more than 25 percent of all black households two years after emancipation were headed by females. This is a far cry from the perception of the Black household during slavery as headed by a female. The exception has been viewed and defined as the rule. It is true that the percentage of female-headed households at this time was much greater for blacks than for whites; but whites were not forcibly put into slavery, nor were they forcibly separated from their spouses. At the same time, we do not know what the household composition of Black families would look like had it not been for slavery. At the same time, we can see that slavery was not able to destroy the bonds that existed among mothers, fathers, children, husbands, and wives. The autobiographies of Martha Browne, William Craft, Harriet Brent Jacobs, Elizabeth Hobbs Keckley, and Amanda Berry Smith tell of mothers searching for their children, of the love of mothers for their children, and wives and husbands for each other. Nowhere do we get a more vivid picture of the pain and agony of slavery, nor of the bonds that bind families together, than in these personal accounts.

In addition to being mother and wife, the slave woman was a worker. She worked in the cotton, rice, and tobacco fields from early morning to late evening. If the overseer felt that she was not working hard enough, she was subject to the same kinds of beating the men received. After working in the field all day, the Black woman returned to her cabin to cook the evening meal in addition to preparing the breakfast for the next day, since she was not given time to do so in the morning. She had to wash, sew, and clean up before retiring for the evening. Indeed, her life was very difficult.

In addition to this heavy burden, the Black woman had to withstand the sexual abuses of the white master, his sons, and the overseer. A young woman was not safe. Before reaching maturity, many Black woman had suffered the sexual advances of the white male. If she refused to succumb to his advances, she was beaten and in some cases tortured to death. Some white men took Black women as their concubines. Out of these relationships and less stable ones children were born. These children took on the status of the mother: They were slaves and treated as slaves. In some instances, the wife of the white slave owner took out her jealousy on the Black woman. Gerda Lerner writes about the slave, Patsy, who had the misfortune of being the slave of a "licentious master and a jealous mistress" who would have her beaten for little cause and would throw heavy objects at her (Northrop, 1853: 256–259). Her life was miserable, but she had no recourse but to survive the

best she could. The story of Patsy as told by Solomon Northrop could be repeated many times. Gerda Lerner's volume on the Black woman discusses many incidents of the sexual abuse of Black women during and after slavery (Lerner, 1973: chaps. 1, 3). The Black women most subjected to the sexual abuse of the master were the house servants, who were forced to confront him on a daily basis.

In some cases, writers make a clear-cut distinction between the house servant and the field hand. But a close look at historical records shows that Black women in both situations suffered. The ultimate power, in either case, was in the hands of the master. He decided how long a woman would work, whether or not he would sell away her children and husband, how much food her family would have, and whether he would take her for his concubine or give her to his son or sons. Although masters had this power, they did not use it unilaterally. One need not sell *everyone's* child or husband away. Quite often, then, masters used their power capriciously to keep slaves in check. Further, we know that the power of the master was held somewhat in check by the ever-present potential revolts or uprisings on the plantations (Aptheker, 1943; Genovese, 1974). Consequently, the slave master had to weigh the pros and cons of the overall situation before making use of his power. It is for these reasons, along with differences in the personalities of masters, that we see the kind of variations in the behavior of slave masters to their slaves. Thus, we can find situations like the slaves of Good Hope Plantation (Gutman, 1976) who, in 1865, could count five generations born on that plantation. It is for these reasons that we see a certain degree of stability in the slave family, in the role of motherhood, and in the longevity of male-female relationships.

To summarize, during slavery Black women were forced to bear many children in rapid succession, which led to a high maternal death rate because of the poor health care mothers received. Wives were forcibly separated from their children and spouses. White men raped Black women, and many children were born out of these encounters. Black women worked long hours in the field, returning home to cook, clean, sew, and prepare for the next day. Life was difficult, but Black women survived. They even appear to have gotten stronger as they were forced to cope with situations brought on by slavery. As we leave slavery, we find that motherhood is still an important component of Black womanhood, a strong work orientation, and an independence that originally came from Africa but that changed somewhat as a consequence of slavery. Black women took care of themselves because they were originally socialized to do so, and the circumstances of slavery forced them to do so. They continued to work along with their men, struggling the best they could to assure the survival of their children.

THE BLACK WOMAN AFTER SLAVERY[1]

At the time of emancipation and up until World War I, roughly 90 percent of all Black people lived in the South. Blacks made up 30 percent of the South's population. In addition, more than 50 percent of the Black population lived in counties that were 50 percent or more Black. The role of the Black woman as mother, wife, and worker did not change significantly. Her children still died more often than did white children. She no longer had the trauma of living with the thought that her children would be sold away.

During slavery, Black women had an average of seven children. For example, women born in the cohort 1835–1839 had an average of 6.9 children; 35 percent of them had had ten or more children. However, for those women born in 1865–1869, the average number of children was down to 4.9, and only 13.8 percent had had more than ten children. From these data one can begin to see the impact of slavery on the child-bearing process of Black women. For those women born in 1895–1899, the average number of children born was 3.1, and only 6.5 percent had had ten or more children. Women born between 1920 and 1924 had an average of 3.4 children, and 5.8 percent had ten or more children. Even as late as 1900, the life expectancy was 33.5 years for Black women. The low life expectancy was due to the high infant mortality rate. The differences between Black and white infant mortality rates can be seen in the 1940 rate of 39.7 versus 27.2 per 1,000 live births. As late as 1973, the Black infant mortality rate of 26.2 was very close to the rate that whites reached in 1940. In 1973, the infant mortality rate for whites was 15.8 per 1,000. Thus, one can begin to see that Black mothers more often than white mothers had to face the real possibility of their children dying in infancy.

Black women also had to cope with the economic hardship of life in America after slavery and even up to the present. For the first 70 years after slavery, the Black woman remained on the farm and worked the land with her husband and children. In cases where she was without a husband, she worked the land alone. Powdermaker (1967) interviewed women in Mississippi who still had the ability to work their land alone, although they were in their sixties by that time. However, many Black families raised their children together under the system of sharecropping. The sharecropping system tied Black families to one piece of land for as long as four generations. Families were not free to move from one area to another because the landowner systematically kept families in perpetual debt from one season to another. As each harvesting season ended, the Black family found itself still in debt. Crops were underweighed. Therefore, families received less than the money due them. Black families were also cheated out of their money if they did not know how to count. Even in cases where someone in the family

could count, the white man could not be challenged: to do so, in many cases, meant death or a severe beating.

In 1870, more than 80 percent of all Black female workers were in agriculture. For the most part, they, along with their husbands and children, were a part of the sharecropping system described above. By 1910, the percentage of Black women in agriculture had dropped to 52, but over 90 percent of all Black female workers were in agriculture or working as servants (21 percent), or laundresses (18 percent) not in laundries. Out of 2,013,981 Black female workers, the above three categories accounted for 1,828,104 workers. There were only 22,450 Black teachers in the labor force, a little over one percent of all Black female workers. There were only 13 Black female bankers, but 122 Black male bankers in the entire country. In 1910, there were only two Black female lawyers in the country, but 796 Black male lawyers; and 333 Black female physicians out of 3,077 Black physicians. One can begin to see that the Black woman in America was very restricted in the kinds of occupations she could enter.

Prior to 1930, Black women could not expect to see their children go far in school. Most did not attend school beyond the fifth grade, and many children did not go that far in school since Black children were forced to work the land with their mothers and fathers. In the South, white children went to school for nine months during the year, while Black children went to school until it was time to harvest the crops. Even when they attended school, Black children learned under inadequate conditions: Buildings were substandard; schools were overcrowded and inadequately staffed.

In terms of family structure, most Black women were married and living with their husbands. It would seem that from the time of slavery through 1960, the number of Black women heading households never exceeded 25 percent on a national level (Gutman, 1976), although the urban areas have always had a higher number of women-headed households than the rural areas. For example, in 1896, 30 percent of all Black females over 15 years of age were listed as single; another 54.6 percent were listed as married. The married category did not specify whether these women were living with their spouses. As late as 1920, the married category had not been divided by the Bureau of the Census. Seen in another way, up until 1960, 80 percent of all Black children lived with both parents. By 1977, we find that less than half of all Black children live with both parents. One can begin to see the significant changes taking place in the Black family in the past 17 years. These changes can be accounted for by the economic structure and how that structure affects the Black family. More and more Black women are being forced to raise their children without the official presence of a spouse, as the welfare state requires that "support" can only be given to dependent children and not to intact but struggling families.

NOTES

1. Data cited in this section were taken from U.S. Dept. of Commerce (1970).

REFERENCES

Aptheker, H. (1943) American Negro Slave Revolts. New York: Columbia University Press.

Blassingame, J. W. (1972) The Slave Community: Plantation Life in the Antebellum South. New York: Oxford University Press.

Billingsley, A. (1968) Black Families in White America. Englewood Cliffs, N.J.: Prentice-Hall.

Blumer, H. (1962) "Society as symbolic interaction," in A. M. Rose, (ed.) Human Behavior and Social Processes. New York: Houghton Mifflin.

————(1969) Symbolic Interactionism. Englewood Cliffs, N.J.:Prentice-Hall.

Boykin, P. A. [ed.] (1945) Lay My Burden Down: A Folk History of Slavery. Chicago: University of Chicago Press.

Brown, W. W. (1847) Narrative of William Wells Brown, A Fugitive Slave. Boston: The Anti-Slavery Office.

Browne, M. (1857) Autobiography of a Female Slave. New York: Redfield.

Clark, C. (1972) "Black studies or the study of Black people," in S. Jones, Black Psychology. New York: Harper & Row.

Clarke, J. H. (1971) "The Black woman: a figure in world history." Essence (June): 36–44.

Craft, W. (1860) Running a Thousand Miles for Freedom, or the Escape of William and Ellen Craft from Slavery. London: W. Tweedie.

DuBois, W. E. B. (1903) The Souls of Black Folk. Chicago: A. C. McClury.

Equiano, O. (1829) The Life and Adventures of Olaudah Equiano or Gustavus Vassa, The African. New York: S. Wood & Sons.

Franklin, J. H. (1974) From Slavery to Freedom. New York: Alfred Knopf.

Frazier, E. F. (1939) The Negro Family in the United States. Chicago: University of Chicago Press.

Genovese, E. D. (1974) Roll, Jordan, Roll: The World the Slaves Made. New York: Pantheon.

Gutman, H. G. (1976) The Black Family in Slavery and Freedom, 1750–1925. New York: Pantheon.

Herskovits, M. J. (1941) The Myth of the Negro Past. New York: Harper & Row.

Hill, R. B. (1972) The Strength of Black Families. New York: Emerson-Hall.

Jacobs, H. B. (1973) Incidents in the Life of a Slave Girl, Written by Herself. New York: Harcourt Brace Jovanovich.

Jahn, J. (1961) Muntu: An Outline of the Neo-African Culture. New York: Grove Press.

Kusbury, P. (1952) Women of the Grassland. London: Colonial Research Publications.

Keckley, E. H. (1868) Behind the Scenes: Thirty Years a Slave and Four Years in the White House. New York: G. W. Carleton.

Ladner, G. (1972) Tomorrow's Tomorrow: The Black Woman. New York: Doubleday.

Lerner, G. (1973) Black Women in White America. New York: Vintage Books.

Masuoka, J. and C. S. Johnson (1945) "Unwritten history of slavery: autobiographical accounts of Negro ex-slaves." Social Science Document, No. 1. Nashville, TN: Fisk University.

Moynihan, D. P. (1967) The Negro Family: The Case for National Action. Washington, DC: U. S. Government Printing Office.

Noble, J. (1978) Beautiful, Also, are the Souls of My Black Sisters. Englewood Cliffs, NJ: Prentice-Hall.

Nobles, W. W. (1974) "African root and American fruit: the Black family." Journal of Social and Behavioral Scientists (Spring): 52–64.

Northrup, S. (1853) Narrative of Solomon Northrup, Twelve Years a Slave. Auburn, NY: Duby and Miller.

Powdermaker, H. (1967) After Freedom. New York: Atheneum.

Smith, A. B. (1893) An Autobiography. Chicago: Meyer and Brother.

Staples, R. (1977) The Black Woman in America. Chicago: Nelson-Hall.

Thomas, W. and D. Swaine, (1928) The Child in America. New York: Alfred A. Knopf.

U.S. Department of Commerce, Bureau of the Census (1973) Historical Statistics of the United States: Colonial Times to 1970. House Document No. 83–78. Washington, DC: U.S. Government Printing Office.

Walker, M. (1971) Jubilee. New York: Houghton Mifflin.

Wrong, D. (1961) "The oversocialized conception of man in modern sociology." American Sociological Review 26 (April): 183–193.

PART I
SOCIAL DEMOGRAPHIC CHARACTERISTICS

Using the most recent government statistics, La Frances Rodgers-Rose analyzes the sociodemographic characteristics of the Black woman from 1940 to 1975. She finds that the undercount of the Black male population has led to a belief in the drastic shortage of Black males. Instead of the supposed count of 857 males per 1,000 listed in the 1970 census, Rose reveals that the adjusted count was 958 per 1,000 females. Further, she says that this adjusted count was very similar to the 1940 sex ratio of the Black population. Changes in the educational and occupational levels of Black women are described. The author notes that Black women still earn less than Black men, white men, and white women.

Christina Carter examines the effects of six variables on the total and unwanted marital fertility of Black women, ages 35–44, with intact first marriages as of 1970. Age at marriage was influenced by respondents' education, particularly the completion of high school. Education explained a higher proportion of the variation in age at first birth than age at marriage. Generally, the higher the education, the older the age at marriage and first birth. Carter says it would appear that Black women define a relatively lengthy child-bearing span with no particular enforced notions of the number of children wanted. The findings indicate strongly the importance of delaying marriage and first births if unwanted fertility is to be minimized. She maintains that the number of children desired can be reached quite readily with ages at first marriage of 22 to 28. What is suggested is that older ages at marriage or first birth add to the ability to exercise fertility options and quality of life options, which is not the case with young ages at marriage and first birth.

1

SOME DEMOGRAPHIC CHARACTERISTICS
OF THE BLACK WOMAN:
1940 to 1975

La Frances Rodgers-Rose

Many myths exist about the overall status of the Black woman in American society. Some scholars would suggest that the Black woman has reaped benefits from society while the Black male fell further behind her socially and economically. One way we can begin to piece together the recent history and conditions of the Black woman is to analyze her status through the use of government statistics, recognizing that statistics are imperfect. One can see the imperfection of government statistics by analyzing the sex ratio of the Black population. For example, the Census Bureau recognized as early as 1861 that there was an undercount of the Black population in the 1860 census. They also admit that the undercount existed in the 1870 and 1880 censuses, but no corrections were ever made of these statistics. It is the male population that is undercounted more often than the female population. In viewing the data from Table 2, the reader must keep in mind the general undercount of the Black population.

Taking the last official census, 1970, we find that 1.88 million Blacks were not counted in that census. This accounted for 7.7 percent of the total Black population. For whites, 1.9 percent of the population was missed. It is suggested that one out of every eight Black males 20 years and older was missed in both 1970 and 1960. This means that the sex ratio is not as drastic as it might at first appear. Jacob Siegel of the Bureau of the Census, writing in 1973, suggested 627,000 Black men between the ages of 20 and 44 were missed by the census in comparison to only 214,000 Black women (Siegel,

1973). It is in this age group that the greatest discrepancy exists in the male-female ratio. It was data from the 1970 census that led Jacquelyne Jackson to ask the question, "But Where Are the Men?" Our answer to that question is that many men were never counted. Table 1 shows Siegel's midrange corrections of the 20- to 44-year age group.

TABLE 1 Undercount of the Black Population, 1970, Ages 20–40 (in thousands)

Age Group	Census Count		Midrange Correction	
	Male	Female	Male	Female
20–24	1,045	1,160	116	54
25–34	1,423	1,673	278	105
35–44	1,106	1,336	233	55
Totals	3,574	4,169	627	214

In that age group, rather than a count of 3,574, the midadjusted count based on the birth and death specific rates for each subgroup, the count would be 4,201 for males. For the female population the adjustments are not as great, showing that Black males are missed nearly three times as often as Black women. The 1970 census showed 4,169 females in the above age group, and the adjusted count is 4,383.

TABLE 2 Black Population by Sex and Sex Ratio, 1820–1974*

Year	Male	Female	Sex Ratio
1820	900,796	870,860	1,034
1840	1,432,988	1,440,660	995
1860	2,216,744	2,225,086	996
1890	3,735,603	3,753,073	995
1910	4,885,881	4,941,882	989
1930	5,855,669	6,035,474	970
1940	6,269,038	6,596,480	950
1950	7,269,170	7,757,505	937
1960	9,097,704	9,750,915	933
1970	10,748,316	11,831,973	908
1974	11,452,000	12,592,000	909

*All statistical tables are from the U.S. Department of Commerce, Bureau of the Census, *Historical Statistics of the United States: Colonial Times to 1970*, House Document, No. 93-78; and Current Population Reports, Special Studies Series P-23, No. 54, *The Social and Economic Status of the Black Population in the United States, 1970, 1973, and 1974.*

Therefore, instead of the sex ratio of 857 for this age group, which says that for every 1,000 Black women in the age group of 20–44, there are only 857 males in the same age group. The adjusted rate, based on Siegel's data is 958. This sex ratio is significantly different from the official 1970 census count.

Analyzing the male-female sex ratio is very important to the survival of Black people in general, and the Black female specifically. For some people would have us believe that there is a drastic shortage of Black males. It is indeed true that there is a difference in the sex ratio, but the difference is not

as great as we have been led to believe. Siegel's data also suggest that the sex ratio has not changed significantly since 1940. One should note in Table 2 the significant drop in the sex ratio between 1910 and 1930 and again between 1930 and 1940. Part of the undercount for these censuses must be explained by the changing distribution of the Black population. As men and women began the mass migration from the south to the north, many were "lost" in the great exodus north. However, there has been no systematic attempt on the part of the Bureau of the Census to correct these past statistics. Given the data in Table 2, we must be very cautious in accepting census data without careful analysis.

One of the things we can see from the census count of the population is that Black females live longer than Black males. In part, the differences in life expectancy account for the uneven sex ratio. That is, although more males are born, women live longer than men. The differences in the life expectancy of Black men and women can be seen in Table 3. This table also shows the progress Blacks have made in the past 70 years in increasing their life expectancy. Specifically, we can see that the Black female has gone from a life expectancy of 33.5 years in 1900 to 69.4 years in 1970. On the average, Black women are living eight years longer than Black men. The white woman is also living nearly eight years longer than the white man. The lowest life expectancy rate is for the Black man, who is expected to live a little over 61 years. His life expectancy is seven years less than that of the white male.

TABLE 3 Expectation of Life at Birth by Race and Sex, 1900–1970

Year	Male		Female	
	White	Black	White	Black
1970	68.0	61.3	75.6	69.4
1960	67.4	61.1	74.1	66.3
1950	66.5	59.1	72.2	62.9
1940	62.1	51.5	66.6	54.9
1930	59.7	47.3	63.5	49.2
1920	54.4	45.5	55.6	45.2
1910	48.6	33.8	52.0	37.5
1900	46.6	32.5	48.7	33.5

Most of the increase in the life expectancy of Blacks can be accounted for by the tremendous drop in the infant mortality rate that whites reached more than 25 years ago (see Table 4). In 1973, the infant mortality rate was 26.2 for Blacks. Whites had a rate of 15.8, and in 1950 the rate was 26.8 for whites. Blacks still fall behind whites in these vital statistics. The poor economic conditions of Blacks account for these differences. Without economic resources, Blacks cannot afford the doctors needed to maintain health, nor can they buy the kinds of food that would ensure their physical health.

TABLE 4 Infant Mortality Rates by Race, 1940–1973 (per 1,000)

Year	Black	White
1973	26.2	15.8
1970	30.9	17.8
1965	40.3	21.5
1960	43.2	22.9
1950	44.5	26.8
1940	73.8	43.2

Education is a key factor in determining the economic resources of Black people, and whites continue to outdistance Blacks in education. Rather than the question of whether Black women receive more education than Black men, the crucial question is to what extent Blacks have been able to close the educational gap between Blacks and whites. In viewing Table 5, we find that in 1850, more than half of the white population was enrolled in school, compared with less than two percent of the Black population. By 1970, an equal number of Blacks and whites were enrolled in school. However, this does not mean that an equal number of Blacks and whites finish high school, or that the average number of years of school completed is the same. As late as 1940, the Black female had completed an average of 6.1 years of school, and the Black male had completed 5.4 years. By 1970, the Black female had completed 10.2 years of school; the Black male, 9.6 years. This represents an increase of four years for both sexes since 1940. But, by 1970, the white male and female had graduated from high school, averaging over twelve years of schooling. We can further see that the educational attainment of Black women did not nor does it differ from Black males significantly. That is, what difference does it make, economically or socially, if the Black woman finished an average of 10.2 years of school and the Black male finished 9.6 years?

TABLE 5 School Enrollment Rates Per 100 Population by Sex and Race, 1850–1970

Year	Male		Female	
	White	Black	White	Black
1970	91.9	89.6	89.7	89.1
1960	90.6	86.6	87.3	85.7
1950	79.7	74.7	78.9	74.9
1940	75.9	67.5	75.4	69.2
1930	71.4	59.7	70.9	60.8
1920	65.6	52.5	65.8	54.5
1910	61.4	43.1	61.3	46.6
1900	53.4	29.4	53.9	32.8
1890	58.5	31.8	57.2	33.9
1880	63.5	34.1	60.5	33.5
1870	56.0	9.6	52.7	10.0
1860	62.0	1.9	57.2	1.8
1850	59.0	2.0	53.3	1.8

TABLE 6 Median Years of School Completed by Sex and Race, 1940–1970

Year	Male		Female	
	White	Black	White	Black
1970	12.2	9.6	12.2	10.2
1960	10.6	7.9	11.0	8.5
1950	9.3	6.4	10.0	7.2
1940	8.7	5.4	8.8	6.1

If one looks at those persons over 25 years of age who graduated from college (Table 7), there is very little difference between males and females. In none of these figures do we see such drastic differences that would call for the kind of theorizing that exists about why Black women are more "educated" than Black males. Nor do we see the kind of data that suggest that Black daughters have been preferred over Black sons in terms of education. The fact is that both Black men and women have very similar educational levels compared with white men and women. For example, in 1940, 4.0 percent of the white females and 5.8 percent of the white males had graduated from college. This was true for only 1.2 percent of the Black females and 1.4 percent of the Black males. By 1970, the number of Black women graduating from college had increased, but so had the number of whites, and the differences by race were still larger than the differences by sex; 5.6 percent Black females and 6.8 percent Black males had completed four years of college. This was true for 8.6 percent of the white females and 15.0 percent of the white males. What we note in these statistics is the great difference

TABLE 7 Percentage of the Black Population Over 25 with at Least Some High School by Sex, 1940–1970

Year	1–3 Years High School		Graduated High School		1-3 Years College		4+ Years College	
	Male	Female	Male	Female	Male	Female	Male	Female
1970	20.6	23.5	22.4	24.6	6.2	6.4	6.8	5.6
1966	20.1	24.0	17.4	21.2	5.3	5.4	5.0	4.4
1959	14.7	19.6	11.5	14.7	3.7	3.5	3.6	2.9
1950	11.6	14.4	7.2	8.9	2.8	3.1	2.0	2.3
1940	7.3	9.8	3.8	5.0	1.6	2.1	1.4	1.2

TABLE 8 Percentage of the Population Over 25 Who Completed Four or More Years of College by Race and Sex, 1940–1974

Year	Black		White	
	Male	Female	Male	Female
1974	8.8	7.6	24.9	17.2
1970	6.8	5.6	15.0	8.6
1966	5.0	4.4	13.3	7.7
1960	3.5	3.6	10.3	6.0
1947	2.0	2.6	6.5	4.8
1940	1.4	1.2	5.8	4.0

between the white male and female. There has been a tendency for white social scientists to look at near parity in the college education of Blacks and see that as a disadvantage for Black males, since white females do not graduate from college nearly as often as white males. Whatever disagreements might exist between Black males and females cannot be blamed on the excessive educational advantage of Black women.

One must ask what the educational advancement of Black women has meant to them. In looking at Table 9, we can see the significant changes that have taken place in the occupational structure of Black women. In 1964, more than half of all employed Black women were service workers, and 33

TABLE 9 Occupation of Employed Men and Women by Race, 1964, 1970, and 1974 (in percentages)*

	1964		1970		1974	
	Black	White	Black	White	Black	White
WOMEN						
White-collar workers	23	61	38	64	42	63
Professional & tech.	8	14	11	15	12	15
Teachers, except college	5	6	5	6	5	6
Mgrs. & admin.	2	5	3	5	2	5
Sales workers	2	8	3	8	3	7
Clerical workers	11	34	21	36	25	36
Blue-collar workers	15	17	19	16	20	15
Service workers	56	19	43	19	37	19
Private household	33	5	18	3	11	3
Farm workers	6	3	2	2	1	2
Total	100	100	100	100	100	100
MEN						
White-collar workers	16	41	22	43	24	42
Professional & tech.	6	13	8	15	9	15
Teachers, except college	1	1	1	2	2	2
Mgrs. & admin.	3	15	5	15	5	15
Sales workers	2	6	2	6	2	6
Clerical workers	5	7	7	7	7	6
Blue-collar workers	58	46	60	46	57	46
Service workers	16	6	13	6	15	7
Farm workers	10	7	6	5	4	5
Total	100	100	100	100	100	100

*Percentages may not equal 100 due to rounding.

percent of them were in private household work. By 1974, the number of service workers had decreased to 37 percent, and 11 percent of all Black women were in private household work. Over the 10-year period there has been little change in the number of white women in service work—19 percent—or the number in private household service—from 5 to 3 percent. The number of Black women in professional or technical fields rose from 8 percent in 1964 to 12 percent in 1974. For white women, the percentage has remained the same; 15. Very few women, Black or white, are found in

managerial jobs—2 percent for Blacks and 5 percent for whites. There has been an increase of over 100 percent in the number of Black women in clerical jobs: The percentage has gone from 11 in 1964 to 25 in 1974; whereas, again, the percentage for white women over the 10-year period has remained about the same, a little over one-third of all employed white women. What we see from Table 9 is that the Black woman has seen significant changes in her employment pattern over the past 10 years: She has left the field of service workers in significant numbers and gone into the clerical field. However, the largest number of Black women is still found in service work. From Table 9, we also note that more Black women than men are in professional and technical fields. What one must remember is that of the 12 percent of Black women who are professional, 42 percent of these were teachers (excluding college). This was true for only 22 percent of the Black males.

Although the employment pattern of the Black woman has changed, she is still more often unemployed than the Black male, white female, or white male. Table 10 shows the unemployment rates from 1948 to 1970 by race and sex. First, one can see that the unemployment rate of Blacks is much

TABLE 10 Unemployment Rates by Race and Sex, 1948–1974

| Year | Male | | Female | |
	Black	White	Black	White
1974	8.4	4.3	10.1	5.9
1970	7.3	4.0	9.3	5.4
1965	7.4	3.6	9.2	5.0
1960	10.7	4.8	9.4	5.3
1955	8.8	3.7	8.4	4.3
1950	9.4	4.7	8.4	5.3
1948	5.8	3.4	6.1	5.9

higher than the rate for whites. Further, Black women, on the whole, have a higher unemployment rate than Black men. Whereas the unemployment rate for whites is about 4.5 percent, it is almost 8.0 percent for Blacks. This rate does not reflect the underemployment of Black men and women. We know that gains have been made in the occupational and educational fields, but Blacks are more often hired in jobs for which they are overqualified.

The underemployment of Black women and men can be seen in the median income of year-round full-time workers. What one notes in Table 11 is that Black women have consistently earned less than white men, Black men, and white women. Therefore, it is unfair to suggest that Black women have somehow managed to outdistance Black men in earnings; this has never been the case. Not only does the Black woman earn less than any other group, but, as noted above, she is more often unemployed. For example, in 1975, the white male earned an average of $12,961 per year; the Black male earned $10,000. The Black female was earning only $7,486 while the white

TABLE 11 Median Money Wage or Salary Income of Year-Round Full-Time Workers, by Sex and Race, 1939–1975

Year	Male		Female	
	Black	White	Black	White
1975	$10,000	$12,961	$7,486	$7,617
1973	7,953	11,800	5,595	6,598
1970	6,598	9,373	4,674	5,490
1965	4,367	6,814	2,713	3,960
1960	3,789	5,662	2,372	3,410
1955	2,831	4,458	1,637	2,870
1939	639	1,419	327	863

female earned $7,617. Although the earning power of Black and white females is near equal, one must keep in mind that Black women stay in the economic marketplace longer. Unlike white women, they tend to remain in the job market until their children start school. They must work for low wages, even if they do not want to. The economic institution has greater impact on Black people in general and the Black woman specifically.

Another area of interest to Blacks is political participation (see Table 12). Again, the impression might be that Black women are more active in politics than are Black men. However, the data collected by the Joint Center for Political Studies show this is far from the truth. In 1975, only 13.1 of all Blacks elected officially were female, and the majority of them were in the

TABLE 12 Black Elected Officials by Sex and Type of Office, May 1975*

	Total 4,033	Male 3,503 (84.9%)	Female 530 (13.1%)
U.S. Senators and Representatives		18 (81.8%)	4 (18.2%)
State legislators and executives		281	35 (11.1%)
Mayors		135	9 (6.2%)
Others		3,069	482 (13.6%)
County		305	31 (9.2%)
Municipal		1,438	203 (12.4%)
Law enforcement		387	34 (8.1%)
Education		939	214 (18.6%)

*SOURCE: Joint Center for Political Studies

field of education. Of the 530 Black females elected officials, 214 of them were in education. There is a tendency to pay undue attention to Black females who hold high elected positions and to assume they represent what Black women are doing nationally. For example, we fail to see that of the 18 U.S. Representatives only four are female. Black women are participating in the political process, but not at the same rate as men. Blacks in general make up less than five percent of all U.S. Senators and Representatives. Therefore, we can begin to see that Blacks are severely underrepresented given their population size, and Black women are the minority in the elected group that does exist.

What kind of impact has the above data had on the Black family? We find that for the most part, the impact has been negative. Table 13 shows that, since 1950, the number of husband-wife families has dropped from 77.7 percent to 60.9 percent in 1975—a percentage change of nearly 17 points in 25 years. Conversely, the number of Black women heading households has

TABLE 13 Percentage Distribution of Black and White Families by Type, 1950–1975

| Year | Husband-Wife | | Female Headed | | Other Male | |
	Black	White	Black	White	Black	White
1950	77.7	88.0	17.6	8.5	4.7	3.5
1955	75.3	87.9	20.7	9.0	4.0	3.0
1960	73.6	88.7	22.4	8.7	4.0	2.6
1965	73.1	88.6	23.7	9.0	3.2	2.4
1970	68.1	88.7	28.3	9.1	3.7	2.3
1971	65.6	88.3	30.6	9.4	3.8	2.3
1972	63.8	88.2	31.8	9.4	4.4	2.3
1973	61.4	87.8	34.6	9.6	4.0	2.5
1974	61.8	87.7	34.0	9.9	4.2	2.4
1975	60.9	86.9	35.3	10.5	3.9	2.6

TABLE 14 Marital Status of Black Female Heads of Families, 1960, 1967, 1970, and 1973 (in percentages)

Marital Status	1960	1967	1970	1973
Single (never married)	12	12	16	20
Separated or divorced	40	47	48	49
Separated	29	33	34	33
Divorced	11	13	14	16
Husband temporarily absent	6	7	7	4
Armed forces	—	2	2	1
Other reasons	6	5	4	3
Widowed	42	35	30	28
Percentage	100	100	100	100

increased from 17.6 percent in 1950 to 35.3 percent in 1975. For whites, the change has been only two percentage points—from 8.5 percent in 1950 to 10.5 percent in 1975. When one views the increase in the number of female-headed households, the assumption is, quite often, that the increase is due to the break-up of already existing relationships. Table 14 reveals that the greatest change has come about in the single, never-married category, where percentage has gone from 12 in 1960 to 20 in 1973. Over this 13-year period there was a change of 66 percent. The category of separated or divorced accounted for a 25-percent change, going from 40 percent in 1960 to 49 percent in 1973. That is, marital discord does not account for 50 percent of the female-headed households. We can see other changes taking place in Black families by looking at Table 14, which shows the percentage of ever-married women not living with husbands because of marital discord. In

1950, 14 percent of ever-married Black women were not living with husbands because of marital discord. By 1960, the percentage had risen to 16 and by 1970 it was 19 percent. It took 20 years to show a percentage point difference of four in this category. However, it took only three years to go from 19 percent in 1970 to 23 percent in 1973.

It is obvious from these data that something is happening in the society which accounts for the drastic changes in the number of married Black women not living with their husbands because of marital discord. Likewise, we need to study the causes for the large increase in single, never-married Black women. We know that a large number of single female-headed households include children: In 1974, 70 percent of all such households included children, and these households accounted for 39 percent of all black children under 18 years of age. Further, in 1960, 75 percent of all Black children lived with both parents; by 1970, the percentage was down to 64; and for the first time in 1976, less than half of all Black children lived with both parents. Whites have also seen a change in the number of children living with both parents. In 1960, 92 percent of all white children under 18 lived with both parents; in 1970 it was 90 percent, and by 1977 it was down to 79 percent—a percentage drop of 11 points in seven years. Some authorities suggest that the changes in the white family are due to the changes in women's status

TABLE 15 Percentage of Ever-Married Women Not Living with Spouse Because of Marital Discord, 1950–1973

Year	Separated		Divorced	
	Black	White	Black	White
1950	11	2	3	3
1951	9	2	3	3
1952	10	1	3	3
1953	8	2	4	3
1954	14	1	4	3
1955	12	2	3	3
1956	11	2	4	3
1957	10	1	4	4
1958	12	2	3	3
1959	14	2	4	3
1960	11	2	5	3
1961	11	2	5	3
1962	11	2	5	3
1963	11	2	6	3
1964	12	2	5	4
1965	12	2	5	4
1966	11	2	5	4
1967	11	2	5	4
1968	12	2	6	4
1969	12	2	6	5
1970	13	2	6	4
1973	15	2	8	5

brought on by the women's liberation movement. The same line of reasoning has not been suggested to explain the changes in Black families and the lives of Black children. Rather, the changes have been viewed as indications of family disorganization without looking for the causes other than the acting individuals. However, we know that the one factor which accounts for the greatest variance in the number of Black children living with both parents is income. In Table 16, we can readily see the difference income makes in the number of Black children living with both parents; a perfect correlation exists between income and presence of parents. The higher the family income, the higher the percentage of children living with both parents. For families with incomes under $4,000, only 18 percent of the children live with both parents; and for incomes over $15,000, 90 percent of all Black children live with both parents. Since slightly more than half of all Black

TABLE 16 Own Children Under 18 by Presence of Parents and Family Income, 1974

Income	Black		White	
	Both Parents	One Parent	Both Parents	One Parent
Under $4,000	18	82	39	61
4,000– 5,999	35	65	66	34
6,000– 7,999	53	47	77	23
8,000– 9,999	78	22	88	12
10,000–14,999	86	14	94	6
15,000 and over	90	10	97	3

children live with one parent, we can be sure that the vast majority of these children are in households below the poverty level. For example, the median family income for a Black male-headed household was $7,766 in 1974, while a Black female-headed household had an income level of $3,576. In 1974, 52.8 percent of all Black female-headed households were below the poverty level. This was true for only 24.9 percent of all white female-headed households and 14.2 percent for all Black male-headed households. What these data show is that Black women who are heading households are living in or near poverty and raising children who do not have the basic necessities of life. Rather than malign these women, we need to systematically study their needs and their coping strategies, and help develop ways to give them the income they need to live decent lives.

The data in this chapter show that significant changes have taken place in the lives of Black women on a national demographic level. Most of these changes can be tied to the urbanization process. Although poor and living in an oppressive economic system, it would seem that Black women and their families were able to maintain certain stabilities within the family. More wives and husbands stayed together and worked to maintain a family. The urban move has meant that Black women are still poor, but, unlike their forebears they no longer have the land on which to raise their food. The

urban environment has imposed a structure which tends to separate wives from their husbands. The welfare state will not "support" struggling families; aid is only given to dependent children. Therefore, from 1940 to 1975, we have witnessed a drastic decrease in the number of children living with both parents. In 1976, less than 50 percent of all Black children lived with both parents. We know that in the vast majority of cases these are poor Black children, living with poor Black mothers. For example, we see that only 18 percent of all Black children living in families with less than $4,000 per year were with both parents, whereas 90 percent of all Black children who were in families with incomes over $15,000 were living with both parents in 1974. The economic system is destroying the poor Black family.

We have also seen that the life expectancy of Black women has changed significantly over the past 40 years. She can expect to live on an average of 70 years. If the Black female can survive the first year of life, her life expectancy does not differ significantly from the white female. Also, we noted that there is a difference in the Black male-female sex ratio, with more women than men present. However, we saw that in every census the Black male population is undercounted more often than the female population. When we correct for the undercount, the sex ratio is not as drastic as it might first appear.

Finally, it was noted that significant changes can be seen in the educational levels of Black women. From 1940 to 1970, the average number of years of school completed increased by four. However, the Black had still only completed 10.2 years of school in 1970.

Additionally, changes occurred in the kinds of jobs held by Black women. They are no longer exclusively in service occupations. In fact, from 1964 to 1974, the number of women in service employment dropped from 56 to 37 percent, and private household jobs declined to 11 percent in 1974. A larger number of Black women are now in the clerical field. Only 12 percent of all Black female workers are in professional and technical occupations, and nearly 50 percent of them are teachers below the college level. Black women continue to earn less money than Black or white men and, although they work more frequently and remain in the labor force longer, they still earn less than white females.

It is very difficult to justify the concept of the positive-negative force of being Black and female from these data. One cannot see the positive advantages. The data show that Black women still comprise the most destitute group—educationally, economically, and politically. These institutions are affecting Black women in such a way that the very survival of the Black family is being threatened, and the survival of Black children is becoming more and more doubtful. Unless our children can survive both physically and mentally, we as a people can no longer survive.

REFERENCES

Farley, R. (1970) Growth of the Black Population: A Study of Demographic Trends. Chicago: Markham.

U.S. Dept. of Commerce, Bureau of the Census (1976) Historical Statistics of the United States: Colonial Times to 1970. House Document No. 93–78. Washington, DC: U.S. Government Printing Office.

————(1979) Current Population Reports, Special Studies Series P-23, No. 54, The Social and Economic Status of the Black Population in the United States. Washington DC: U.S. Government Printing Office.

Siegal, J. S. (1973) "Estimates of coverage of the population by sex, race, and age in the 1970 Census." Presented at the annual meeting of the Population Association of America, New Orleans, Louisiana, April 26.

2

BLACK FERTILITY
Recent Demographic and Sociological Influences

Christina Brinkley-Carter

The number of children a woman has is determined biologically by the length of her reproductive lifespan and the *pace* of childbearing within this span. The length is the difference between the age at which the risk of childbearing begins and the age at which there is no longer any possibility that she will bear additional children. The pace of childbearing is determined by social, cultural, and economic factors. Much of fertility analyses have focused on Black-white differentials, and the structural and aggregated individual characteristics that appear to influence such differentials. This analysis focuses on Black marital fertility and within-group differences rather than between-group differentials. It was directed toward two questions: (1) How important is the beginning of reproductive life in determining the level of marital fertility among Afro-American women? (2) What demographic and sociological factors appear most significant in affecting unwanted and total fertility?

Based upon a review of prior research (the review of prior research included all fertility studies, regardless of the race or ethnicity of sample respondents—Afro-American women were not included in major fertility studies until 1960) and exploratory analysis, a model of causal relations was postulated which combined demographic and socio-economic measures as the principal influences on total and unwanted fertility. The model was evaluated for Black Protestant women who were interviewed in 1970 as part of the National Fertility Survey (NFS), all of whom were ages 35–44 with intact first marriages at the time of interview.

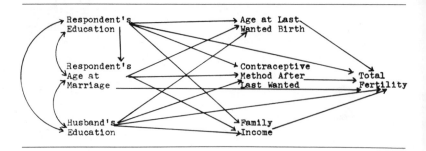

FIGURE 1 Proposed Model of Principal Determinants of Total Fertility

The following linear causal model was proposed (Figure 1) for this study based on the most recent research studies dealing with fertility. Education, income, employment, social status, age at marriage, contraceptive usage and efficacy, and birth intervals have all been investigated as factors influencing fertility.

The system in Figure 1 postulates causal relations among seven variables, six of which are assumed to affect total fertility directly and/or indirectly. Our inquiry focused upon evaluating the adequacy of the system, the direct and indirect effects of the variables indicated, and the implications of findings for policy formulation. The model was examined utilizing path analysis and contingency table analysis. In addition, similar systems were evaluated substituting unwanted for total fertility and substituting age at first birth for age at marriage.

DATA SOURCE AND METHODOLOGY

The data presented are from the 1970 National Fertility Survey (NFS), which was a national probability sample of 6,752 ever-married women under 45 years of age in the continental United States. The sample for this study was selected on the basis of age and marital status, and was confined to one cohort so as not to confound period and cohort fertility. The analysis was confined to women in the 1926–1935 fiscal birth cohorts; that is, women who were born between July 1, 1925 and June 30, 1935, and who had reached the ages of 35–44 as of July 1, 1970 with intact first marriages. The 35–44 age group is well within reproductive age boundaries, where both short- and long-term variable effects can be examined. Simultaneously, approximately 97 percent of their fertility has been completed, implying that our results should be more meaningful than applying the model to younger age groups where a much lower proportion of women have completed fertility. Of the 449 Black respondents ages 35–44, 220 or 49 percent met the age and marital status criteria. This sample was reduced further to 203

due to the exclusion of Black Catholic women. Past fertility research provides no basis for assuming that racial identification is more important than religious, or the reverse.

Marital duration, the total lapse of time between date of marriage and date of interview, has an effect on wanted and unwanted fertility. Younger marriage durations are high in childbearing activity regardless of age or income, because the vast majority of couples desire at least one child and few can state specifically when childbearing activity will end. At that time, also, it is difficult to distinguish between wanted and unwanted fertility, let alone measure these components (Ryder and Westoff, 1971; Westoff and Ryder, 1977). With marriage durations of 15 or more years total fertility is more easily ascertained, and wanted and unwanted fertility can be measured. The majority of sample participants, 82.7 percent of Black Protestant women, were married for 15 or more years. Restrictions on marital duration were introduced by confining our research to ages 35–44, rather than utilizing marital duration as a control variable. Any age-at-marriage bias has been minimized, since very few first marriages occur after age 35.

Path analysis was used to test and evaluate the structure of the proposed relationships. Path analysis is a multivariate regression technique aimed at finding the degree to which variation in a given dependent variable(s) can be explained by a postulated set of relationships as well as the direct and indirect roles of each structural component. We applied path analysis using unstandardized (metric) rather than standardized coefficients. This allows for the possibility that populations may differ with respect to variation in each variable, and provides a stronger basis for program and policy responses based on group-specific needs. Statistical analysis can rarely rely on a single statistical technique; therefore, the core analysis was supplemented with contingency table analysis and analysis of variance (ANOVA).

A MODEL FOR ANALYZING
DETERMINANTS OF TOTAL FERTILITY

The principal determinants of total fertility consist of four types of variables: control, background, intervening, and dependent. The control variables are race and religion. Respondent's education and age at marriage (AAM) and husband's total education are background variables. There are three intervening variables: age at last wanted birth (AALW), contraceptive method after the last wanted birth, and family income. The dependent variable is total fertility. In separate analysis, age at first birth (AAB) is substituted for age at marriage (AAM), and the number of unwanted births is substituted for total fertility. Timing failures—that is, when the birth was wanted but generally later—were not examined.

Race and religion were selected as control variables, because both are

social selection factors representing major sources of diversity which occur prior to all other model components. Recent fertility research shows that differentials by race and religion, particularly the latter, have been decreasing, but such findings refer principally to age groups younger than 35–44 in 1970, and they carry no implications that our proposed structural components are less significant in their effect on overall fertility patterns.

The dependent variable is total fertility, which equals the total number of wanted births *plus* the number of unwanted births. Among Black women ages 35–44 in 1970, the mean total fertility was 4.6 (median = 3.9, SD = 3.3) and the mean number of unwanted births equalled 1.4 (SD = 2.4). It is hypothesized that each demographic and sociological variable is inversely related to total fertility and unwanted births. Generally, the higher the value of an exogenous (independent) variable, the lower total fertility and the number of unwanted births. Table 1 presents the correlation coefficients between constituents of the model.

TABLE 1 Correlation Coefficients Between Variables Affecting Fertility and Unwanted Births for Black Women 35–44 with Intact First Marriages: NFS 1970 (1)

Variable	Correlation with								
	X_1	X_2	X_3	X_{3a}	X_4	X_5	X_6	X_7	X_{7a}
Black	Prot								
X_1	—	.54	.22	.30	.19	.20	.40	−.25	−.27
X_2	—	—	.06	.17	.02	.22	.43	−.31	−.24
X_3	—	—	—	.63	.22	.01	.05	−.36	−.21
X_{3a}	—	—	—	—	.51	.13	.16	−.43	−.29
X_4	—	—	—	—	—	.18	−.03	.06	−.40
X_5	—	—	—	—	—	—	.13	−.11	−.16
X_6	—	—	—	—	—	—	—	−.25	−.22
X_7	—	—	—	—	—	—	—	—	−.69
X_{7a}	—	—	—	—	—	—	—	—	—

NOTE: The symbols X_1 through X_7 represent the following variables: X_1 = respondent's education; X_2 = husband's total education; X_3 = age at marriage; X_{3a} = age at first birth; X_4 = age at last wanted birth; X_5 = probability of success with post-wanted contraception; X_6 = family income; X_7 = total fertility; X_{7a} = number of unwanted births.

BACKGROUND VARIABLES

There are three background variables: respondent's education and age at marriage and husband's total education. Each variable represents a significant juncture in the lifecycle which generally occurs prior, or represents a forman initiation, to the family formation process.

Respondent's education is an exogenous variable measured by the number of grades completed prior to marriage. Of additional significance is its capacity to be a socioeconomic index of the past, present, and future. It is strongly indicative of socio-economic background; it is also a powerful direct and indirect determinant of future demographic and sociological events such as age at marriage, age at first birth, children ever born, and

family income (Bumpass, 1969; Sweet, 1973, 1974; Ryder and Westoff, 1971; U.S. Bureau of the Census, 1973). Demographically, education is important as an indicator of reproductive rationality and the ability to implement such. The relationships between education and ages at marriage and first birth are positive, while the relationship between education and children ever born is negative. Women with more than 12 years of education tend to use contraceptive methods at early parities to limit family size. Also, the higher a wife's education, the higher the family income, due either to the addition of her earnings to the family income or the propensity of college-educated women to have husbands whose earnings are above the national median. In summary, education completed prior to marriage is a quantitative node indicative of socio-economic background, reproductive rationality, and the limits of educational and occupational options in the immediate present and future. In this sample, 63 percent of the women had completed less than four years of high school, 27 percent completed high school, and 10 percent had 1 or more years of college.

Prolonging education or obtaining employment may increase the probability of family planning knowledge and practice, as well as functioning to delay the family formation process. Of the women sampled, 53.7% reported that they had held a full-time job before marriage. The percentage of women employed between marriage and the birth of the first child was 38.4. One of the earliest effects of education is on the timing of marriage, which is dependent partially upon developing alternatives to marriage and parental roles that function as delay mechanisms. The younger the age at marriage, the lower the probability of obtaining a full-time position prior to marriage or between marriage and the birth of the first child.

The effects of education can be perceived also in terms of the timing of the initiation of contraceptive use and the type of method selected; both somewhat indicative of the desire and ability to implement reproductive plans. The model includes a measure of the probability of preventing an unwanted birth by contraceptive method used after the birth of the last wanted child. It is postulated that the higher the education, the higher the probability of preventing an unwanted birth after the last wanted birth. In summary, it is expected that respondents' education directly affects age at marriage, the initiation and modernity of contraception, family income, total fertility, and the ability to minimize unwanted fertility. Although respondents' and husbands' education are highly correlated, no causal relationship between them is hypothesized.

Husband's education is an exogenous variable equal to the sum of husband's completed education at the time of marriage and education completed since marriage. Overall, the distribution of husband's total education was as follows: 33 percent completed one or more years of college, 30

percent completed high school, and 36 percent completed less than four years of high school.

It is expected that husband's education directly affects contraceptive method, family income, total fertility, and the number of unwanted births. Its largest direct, positive effect is expected to be on family income. Although it may exert an independent effect upon total fertility and the number of unwanted births, its indirect effect on these variables acting through age at last wanted birth and contraceptive method after the last wanted child may be more significant. Part of the rationale for postulating a larger indirect than direct effect lies in the role of the wife for contraceptive responsibility. The relationship between husband's total education and total fertility and the unwanted births is expected to be a moderately inverse one with, perhaps, the indirect effects being equally, if not more, important than the direct effects.

Age at marriage (AAM) is a woman's age in completed years at the time of marriage. It is influenced by education completed prior to marriage, and is therefore an endogenous backgorund variable.

Age at marriage represents demographically an estimate of the beginning of exposure to the probability of pregnancy. More importantly, marriage is a phenomenon that ends one set of statuses, roles, and opportunities and begins another, tending to affect in some way nearly every subsequent experience of whatever nature. Combined with information on the respondent's education and economic position prior to marriage, AAM can be a significant predictor of future socioeconomic and demographic events. It influences the probability and timing of contraceptive usage within marriage, wanted and unwanted fertility, and the probability and level of a wife's future occupation. In our analysis, it is expected that the younger the age at marriage, the less effective is contraception after the last wanted birth. This relationship would result from a lack of contraceptive knowledge, accessibility, and less firm intentions. We would expect also a higher number of reportedly "wanted" children, resulting from individual rationalization and the "collective conscience" that places supreme nonmonetary value on children at whatever costs.

Among Black women the pace of entry into marriage is skewed toward the younger ages. Fifty-one percent of sample participants had married prior to age 20. In the 20 to 24 age range, an additional 34.5 percent married. The mean AAM was 20.1 (median = 19,4, SD = 4.5).

INTERVENING VARIABLES

There are three intervening variables: age at last wanted birth (AALW), the probability of success in preventing an unwanted pregnancy by contraceptive method (post-wanted contraception), and family income.

Age at last wanted birth (AALW) is defined as the age of the woman in

years at the time of her last wanted birth. It is at least partially dependent upon AAM and AAB. It is a major intervening variable because it is a pivotal point in relation to at least three periods: (1) the span of child-bearing activity; (2) the decision to have no additional children; and (3) the remaining years of fecundity when additional children generally are no longer desired. Within the sample, 2 of 10 women were ages 21 or younger at the time of their last wanted birth; 4 of 10 were ages 22–27; 3 of 10 were 28–34; and 1 of 10 was age 35 or older. If AALW is subtracted from respondent's age at the time of interview, the difference indicates the exposure period to the risk of unwanted pregnancy. Age at last wanted birth does not exceed 30 for the majority of women, and indeed for many it was considerably less. This added to the significance of AALW and post-wanted contraception as factors affecting unwanted births and total fertility.

Contraceptive method after birth of the last wanted child represents the action taken to *prevent* any additional pregnancies, reflecting a couple's intentions to end family growth. The measure of *post-wanted contraception* was the probability of success in preventing an unwanted pregnancy within the first year of contraceptive use by age and method. It is equal to one minus the probability of failure (Ryder, 1973; Vaughn et al., 1977). The method-specific probabilities of success were assigned based upon the mean number of wanted births (3.2) and the mean age at last wanted birth (26.7) among sample participants.

To some degree, the method selected indicates also the seriousness of the decision—for example, sterilization as compared with douche—as well as the effect of contraceptive information, knowledge, and practice. Presumably, a method is chosen on the basis of both high use-effectiveness and to minimize potential injurious effects to the user. Because it comes after the last wanted birth, as defined by those involved, there is little question of motivation. Past experience and, for an unknown number, past timing or number failure imply strongly that motivation would be high. In addition, efficacy generally increases with age. For these reasons, this measure of contraception was considered appropriate for the age of and corresponding marital duration group being studied. In addition, such families are becoming or are settled occupationally, have reached given levels of income and parity, and are most likely seeking to improve their resources and statuses for both themselves and/or their children. On these bases, it was expected that the distribution of methods would be skewed towards those with the highest probabilities of success. The data showed this assumption to be incorrect. Post-wanted contraception was "no method" for 61 percent of the women; condom, foam, cream or jelly for 16 percent; diaphragm for 9 percent; and pill or IUD for 4 percent.

In regard to the proposed model, it is expected that post-wanted contra-

ceptive methods are influenced principally by respondent's education and AAM, with a small independent effect exerted by husband's total education. However, from Table 1, it appears that husband's total education ($r_{25} = .22$) is as important as wife's education ($r_{15} = .20$), and age at marriage ($r_{35} = .01$) appears to be of little consequence. Also, it is expected that contraceptive method has a positive influence on family income and tends to depress total and unwanted fertility.

Family income is an endogenous variable defined as the reported 1970 total income from all sources. It is an ordinal variable with categories ranging from 1 to 12, with 1 = under \$2,000; 2 through 9 are \$1,000 intervals corresponding to the coded interger; 10 = \$10,000–11,999; 11 = \$12,000–14,999; and 12 = \$15,000 or more. Principally family income is based upon the wages of spouses. Among husbands, 90.6 percent were wage earners; the remainder were retired, unemployed, or fell into a residual "other" category. Also, 65.5 percent of wives were employed and contributing to the family income. In part, the percentage of wives employed can be attributed to the age group under investigation and the corresponding decrease in child-rearing and household responsibilities. Another major factor may be simply economic necessity.

We hypothesize that family income is affected independently by three measures: husband's total education and respondent's education and age at marriage, with husband's total education having the largest direct effect. Family income serves also as a proxy for occupation, given the resultant collinearity if education and occupation were part of the same model. It is expected that family income is inversely related to both total and unwanted fertility.

In our analysis, age at first birth will be substituted for age at marriage in order to examine the importance of the beginning of reproductive life in determining marital fertility. In addition, in examining the distributions of ages at marriage and first birth for Black women, the two curves crossed each other at several points. This implies that AAM alone is unstable in explaining a subsequent event. This analytical instability can be resolved by either using AAB *or* AAB minus AAM. We have selected the former. Age at first birth (AAB) is assumed to be a function principally of respondent's education. The number of unwanted births, a dependent variable, was substituted for total fertility. The results of our analysis follow.

FINDINGS AND DISCUSSION

We examined the effect of six factors on the total and unwanted marital fertility of Black women. The hypothesized factors influencing each instrumental variable were examined also. The latter results will be summarized before we present the findings in regard to total and unwanted marital

fertility. While reviewing these results, bear in mind that the 1970 NFS lacked a fair representation from low-income urban areas. Thus, although the direction of our coefficients may be correct, generally the level of effect may have been underestimated.[3]

EFFECT OF EDUCATION ON AGE AT MARRIAGE

Age at marriage (AAM) was our earliest endogenous variable and was regressed on the respondent's education. For each year of education, the average AAM increased four months. Generally, successfully completing major phases of the educational process increases the propensity toward higher ages at marriage. Based on aggregated data, however, Black women completing high school and those with one to three years of high school had the same mean AAM, 20.6 years. In each college category, "college one to three years" and "college completed," the observed mean AAM was one year higher than the estimated, indicating that education beyond high school had a greater effect on AAM than predicted from the regression equation.

ZERO-ORDER EFFECT OF AAM ON
AGE AT LAST WANTED FERTILITY (AALW)

Young ages at first birth and marriage imply that women might desire to end their childbearing periods at correspondingly younger ages. Conversely, as AAM increased, AALW would increase. The importance of AALW is that it indicates the end of bearing children in terms of both the number borne and the span of time women allocate to childbearing activity regardless of fecundity. Among Black women, the pattern of mean AALW was found to be irregular, with little relationship to AAM. AALW were far less variable for each AAB category. The mean difference between AAB and AALW was approximately seven years for women who experienced a first birth before age 20; six years for AAB of 20–21; five years for ages 20–24 at the time of first birth; and a two-year difference for women whose first birth occurred at ages 25 or older. Among Black women, AAB is a stronger predictor of AALW than AAM.

Black women marrying at ages less than 18 averaged six children; those marrying at ages 18–21 averaged five children; ages at marriage of 22–24 averaged three; and ages at marriage of 25+ averaged two. The mean number of unwanted births by ages at marriage and first birth is shown in Table 2. The younger the AAM or AAB, the higher was the number of unwanted births. The mean number unwanted was always larger for an AAB category than the corresponding AAM category. The highest number of unwanted births coincided with ages less than 22 at the time of marriage and first birth; the same ages where a significant proportion of births either preceded marriage or were premaritally conceived.

TABLE 2 Mean Number of Unwanted Births by AAM and AAB, and ANOVA Results for Black
Women 35–44 with Intact First Marriages: NFS 1970

Age at Marriage	Unwanted Births			Age at 1st Birth[a]	Unwanted Births		
	Mean	S.D.	N		Mean	S.D.	N
<18	2.14	2.72	28.6	<18	2.37	3.15	26.3
18–19	1.50	2.41	22.7	18–19	2.26	2.71	17.5
20–21	1.54	2.71	20.2	20–21	1.59	2.35	20.1
22–24	.66	1.45	14.3	22–24	.52	1.35	14.9
25+	.55	1.94	14.3	25+	.39	1.16	21.1
Total	1.43	2.40	203	Total	1.50	2.36	194
	$F=3.02$,	$p<.02$			$F=6.17$,	$p=.001$	

[a]Excludes respondents who have not experienced a first birth.

DETERMINANTS OF AGE AT LAST WANTED BIRTH (AALW)

Respondent's age at the time of the last wanted birth (AALW) is theoreti-
cally the principal intervening variable affecting fertility, because it is a
pivotal point in relation to at least three periods: (1) the span of childbearing
activity; (2) the decision to have no additional children; and (3) the remain-
ing years of fecundity when additional children are no longer wanted. We
have hypothesized that it is dependent upon three factors: respondent's edu-
cation, husband's total education, and age at marriage (AAM). The net effect
of a one-year increase in respondent's education, husband's total education,
and age at marriage was to increase AALW by approximately seven and one-
half months. The variance (R^2) in AALW explained by these factors was
only 7.6 percent, and two-thirds of this was attributable to AAM.
Respondent's education had the strongest direct, linear effect on AALW.
Controlling for AAM and husband's total education, an additional year of the
respondent's education increased AALW by an average of six and one-half
months, an effect on AALW twice as large as that of AAM.

DETERMINANTS OF POST-WANTED CONTRACEPTION

We hypothesized that success with post-wanted contraception is depen-
dent upon four factors: respondent's education, husband's total education,
age at marriage, and age at last wanted birth. We found that these factors
were not strongly related to use-effectiveness. The sum of all effect variables
does not explain more than four percent of the variation in use-
effectivesness, and this percentage could easily be attributed to random and
measurement errors. Further, we found the assumption of linearity to be
inappropriate for examining relationships between these factors and use-
effectiveness.

DETERMINANTS OF TOTAL FERTILITY

We have proposed six demographic and sociological factors as the princi-

pal determinants of total fertility (see figure 1). Using multiple regression, the model explains 25.5 percent of the variance in total fertility among Black women. Table 3 summarizes the effects of the independent variables on total fertility. The statistically significant variables affecting total fertility were AAM, husband's total education, family income, and AALW, in that order. For these factors except family income, the reconstructed and observed regression coefficients were fairly close in value and in the same direction, indicating that AAM, AALW, and husband's total education were interrelated causes of total fertility. Seven-eighths of the explained variation resulted from the effects of AAM and husband's total education. The independent effect of AAM was to reduce total fertility by .28 of a child. The effect coefficient[4] does not reflect the strength of the independent effect of AAM, because the latter is added to the indirect effect of AAM through AALW which is opposite in sign.

TABLE 3 Significant, Independent Effects on the Total Fertility of Black Women 35–44 with Intact First Marriages: NFS 1970[a]

Variable/Measure	Results of Multiple Regression	Variable/Measure	Results of Multiple Regression
R^2 (Adjusted R^2)	25.5% (22.8)		
Age at Marriage			
Signifance of F	.001		
Addition to RSQ	13.7		
b'_{73}	−.260		
b_{73}	−.272		
Direct Effect	−.280		
Indirect Effect	−.019		
Age at Last Wanted			
Signifance of F	.001		
Addition to RSQ	0.4		
b'_{74}	.087	*Husband's Total Education*	
b_{74}	.033	Signifance of F	.001
Direct Effect	.087	Addition to RSQ	8.8
Indirect Effect	−.001	b'_{72}	−.255
		b_{72}	−.287
		Direct Effect	−.201
		Indirect Effect	−.053
		Family Income	
		Significance of F	.05
		Addition to RSQ	1.1
		b'_{76}	−.131
		b	−.293

[a] b prime coefficients are the reconstructed coefficients; b coefficients represent observed correlation coefficients.

Table 4 summarizes the bivariate relationships between ages at marriages and first birth and mean total fertility. Ages at marriage and first birth of *less than 22* tended to produce significantly higher total fertility than ages equal to or greater than 22. Although a proportion of total fertility was "wanted" fertility, these same ages tended also to produce a significant proportion of unwanted childbearing. The highest mean total fertility corresponded to a low mean AAM and first birth, but not to particularly low means on the education variables.

TABLE 4 Mean Total Fertility by Ages at Marriage and First Birth and ANOVA Results for Black Women 35–44 with Intact First Marriages: NFS 1970

| Age at Marriage | Total Fertility | | | Age at 1st Birth[a] | Total Fertility | | |
	Mean	S.D.	N		Mean	S.D.	N
<18	5.93	3.20	28.6	<18	6.27	3.66	26.3
18–19	4.98	2.81	22.7	18–19	6.12	2.59	17.5
20–21	5.22	3.77	20.2	20–21	5.26	2.94	20.1
22–24	2.79	2.21	14.3	22–24	3.45	2.59	14.9
25+	2.17	2.38	14.3	25+	2.39	1.84	21.1
Total	4.59	3.03	203	Total	4.80	2.86	194
	$F=10.62$, $p<.001$				$F=14.36$, $p<.001$		

[a]Excludes respondents where AAB is inapplicable.

AALW

A one-year increase in AALW increased total fertility .09; that is, if 100 women experienced a one-year increase in AALW, on the average nine would bear additional children. Although the effect of AALW was statistically significant, its contribution toward explaining the variation in total fertility was miniscule, due in part to two factors: (1) the younger ages at marriage and first birth among Black women and (2) the generally higher parity levels reached by Black women (in contrast to national averages) regardless of age at the time of the last wanted birth (AALW).

RESPONDENT'S EDUCATION

Among 35 to 44-year-old women, the indirect effects of respondent's education through the demographic variables (and family income) reflected major and apparently long-term effects. In addition, husband's total education constituted one-fourth of the explained variance in total fertility. On the average, a one-year increase in husband's total education reduced total fertility by .25 of a child.

SUBSTITUTING AGE AT FIRST BIRTH (AAB) FOR AGE AT MARRIAGE (AAM)

The proportion of explained variation in total fertility increased to 34.7 percent when AAB was substituted for AAM and virtually all of the increase

can be attributed to AAB. The average independent effect of AAB on total fertility was a reduction of .36 of a child, in contrast to the independent effect of AAM of $-.25$. The indirect effect through AALW increased from .01 to 10. Thus, for every year younger at AAB, the self-defined reproductive span was slightly lengthened and total fertility increased by one-third of a child.

Among Black women, AAB affected total fertility more significantly than did AAM, because of the substantially increased direct effect of AAB in contrast to AAM and the indirect effect of AAB through AALW.

DETERMINANTS OF UNWANTED BIRTH

Our model explained 24.8 percent of the variance in unwanted births, with AALW being the most influential variable. The results have been summarized in Table 5. Husband's total education and family income were both important determinants of, and inversely related to, the number of unwanted births. The overall effect of AALW, husband's education, and family income was an average reduction in the number unwanted by .38 of a child. Age at marriage reflected no significant effect.

TABLE 5 Significant, Independent Effects on the Number of unwanted Births for Black Women 35 44 with Intact First Marriages: NFS 1970[a]

Variable/Measure	Multiple Regression Results[a]	Variable/Measure	Multiple Regression Results[a]
R^2 (adjusted R^2)	24.8% (22.1)		
Age at Last Wanted (AALW)			
Significance of F	.001		
Addition to RSQ	15.9		
b'_{74}	$-.144$	*Husband's Total Education*	
b_{74}	$-.166$	Significance of F	.05
		Addition to RSQ	4.7
		b'_{72}	$-.099$
Direct Effect	$-.147$		
Indirect Effect	.003	b_{72}	$-.162$
		Direct Effect	$-.087$
		Indirect Effect	$-.012$
		Family Income	
		Significance of F	.001
		Addition to RSQ	2.2
		b'_{76}	$-.135$
		b_{76}	$-.196$
		Direct Effect	$-.135$

[a] b prime coefficients are reconstructed coefficients; b coefficients represent observed correlation coefficient.

AALW equaled three-fifths of R^2, family income equaled nearly one-tenth, and husband's total education equaled nearly one-fifth. In contrast, the effect of AALW on total fertility was trivial, though statistically significant. Such a drastic change in the effect of AALW birth emphasizes the importance of achieving younger ages at last wanted birth and lower related parities, when early marriage and childbearing, a faster pace of childbearing, and unwanted fertility affect significant proportions of a population. The major effect of repondent's education was indirect through AAM, AALW, both AAM and AALW, and family income. In summary, all of the variables affected inversely the number of unwanted births among Black women.

The results changed little when AAB was substituted for AAM. The squared multiple correlation coefficient decreased slightly to 23.9 percent. When the model was used to explore influences on total fertility, AAB exhibited always more affect on total fertility than AAM.

Use-effectiveness was not related to either total fertility or the number of unwanted births. Table 6 gives the mean total fertility and mean number of unwanted births by post-wanted use-effectiveness.

TABLE 6 Mean Total Fertility and Number Unwanted by Effectiveness and Results of ANOVA for Black Women 35–44 with Intact First Marriages: NFS 1970

Post-Wanted Contraception (Use-Effectiveness)	Percent of N (181)	(a) Total Fertility		(b) Number Unwanted		(c) Difference (a) − (b)
		Mean	S.D.	Mean	S.D.	
No method (.72)	61.3	5.3	3.6	1.9	2.7	3.4
Rhythm (.86)	0.6*	—	—	—	—	—
Diaphragm (.89)	8.8	3.9	2.5	1.2	2.6	2.7
Foam, jelly (.92)	8.8	4.4	1.9	1.1	1.5	3.3
Condom (.93)	7.7	4.0	1.9	0.9	1.6	3.1
Pill (.97)	2.8	5.6	5.1	0.0	0.0	5.6
IUD (.98)	1.1	5.5	0.0	0.0	0.0	5.5
Other (.99)	8.8	4.9	3.2	1.6	3.1	3.3
Total	99.9	5.0	3.3	1.6	2.5	3.4

*Too small for calculations.

For a small proportion of the sample (12.7 percent), the most effective contraceptive methods were being utilized by those with the highest mean total fertility. The "no method" group (61 percent of N) had a mean total fertility of 5.3 and the highest mean number unwanted of 1.9. Highest mean numbers unwanted corresponded also with categories where the method in use was dependent on the intervention of factors at or near the time of coitus. The prevention of unwanted births would have reduced mean total fertility by nearly one-third, from 5.0 to 3.4.

SUMMARY

We have examined the effects of six variables on the total and unwanted marital fertility of Black women, ages 35–44, with intact first marriages as of 1970. Age at first birth was substituted for age at marriage in all analyses.

Age at marriage was our initial and earliest endogenous variable. It was influenced by respondent's education, particularly the completion of high school and one or more years of college. Education explained a higher proportion of the variation in AAB than in age at marriage. Generally, the higher the education, the older the ages at marriage and first birth.

We examined also the effect of AAM on age at last wanted birth (AALW). One might expect that as AAM increases, AALW would increase also; however, the pattern of mean AALW was irregular and thus related less than anticipated to AAM or AAB. This was somewhat surprising, considering the young AAM and AAB distributions among Black women and assuming that if ages at first birth are young, the desire to terminate childbearing activity would likewise occur at somewhat youthful ages. Mean ages at last wanted birth were not correspondingly lower. Generally, the difference between the mean ages at first birth and last wanted was six years. Thus, it appears that Black women define a relatively lengthy childbearing span with no particular enforced notions of the number wanted except among persons who had completed high school or more and ages at marriage older than 22 years. Older ages at marriage were strongly related to low fertility.

We found that post-wanted contraceptive use-effectiveness was nonlinearly related to age at marriage. This supports two propositions. (1) Regular and correct usage of contraception leads to effectiveness and not simply a particular method. (2) What appears as a higher level of use-effectiveness may well be a consequence of past unwanted births rationalized as wanted births or timing failures. As a result of the latter, higher use-effectiveness would reflect a greater effort to terminate childbearing. This line of reasoning receives some support from the increasing usage of contraceptive sterilization operations to terminate childbearing.

The data and discussion of the post-wanted exposure period and use-effectiveness provided further evidence that early ages at marriage and first birth tended to produce a significant number of unwanted births among two related aggregates: (1) those with less than a high school education who tended to marry and/or experience a first birth at ages less than 20; and (2) younger ages at marriage and/or first birth did not necessarily lead to younger ages at the time of the last wanted birth. The findings imply that the childbearing and child-rearing experience of those who marry at ages less than twenty does not compensate for information gleaned formally and informally through alternative involvements (such as education and employment) by those marrying at older ages.

Whether there is greater wanted or unwanted fertility, total fertility is increased by ages at marriage of less than 22. In addition, the highest number of unwanted births (Table 2) occurred in those age-at-marriage and first-birth categories of less than 22 years, and where a significant proportion of births either preceded marriage or were premaritally conceived. More specifically, the mean number unwanted for ages at first birth less than 22 was greater than the aggregated mean number unwanted. The mean AAB was less than the mean AAM among respondents with one to three years of high school, implying that the completion of an educational process was important in delaying the family formation process.

Concerning Black fertility generally, AAB was a better explanatory variable than AAM. This finding contributed not only to the explanation of total and unwanted fertility, but was useful methodologically and programmatically. Methodologically, one hopes always to use the most reliable and valid measures of a phenomenon in relation to any social group. In addition, empirical generalizations can only be valid within the limitations of the measurements utilized as well as the logic surrounding them. Programmatically, the implication goes beyond simply access to selected contraceptive methods and focusing on "clearly defined" five-year age groups, as many family planners tend to do. In particular, when ages at first birth and/or marriage are less than 22, a comprehensive family planning program which includes education and day care components may be necessary if unwanted fertility is to decline. Or more directly, birth-spacing and day care components should be included as part of education programs.

In examining the influences on total fertility, the model explained 25.5 percent of the variance. AAM composed seven-eighths of the explained variation. Indirect influences on fertility were marginal. The model explained 24.8 percent of the variation in unwanted fertility. The principal factors influencing unwanted fertility were AALW and family income. Given that the proportions of explained variation in unwanted and total fertility were quite close, it may be hypothesized that the vast majority of Black fertility may have been unwanted, more so than previous findings may have indicated. Or, this may reflect a problem with the definitions of wanted and unwanted fertility, as applied to the Black population.

The findings of this study reveal the following six factors.

(1) Early marriages and/or early births tend to produce higher parities of wanted fertility and larger numbers of unwanted births. The data imply strongly that a significant proportion of the former may have been unwanted births also.

(2) The most important causal relationships affecting the fertility of Black women are the effect of respondent's education on AAB and age at first birth on fertility.

(3) Among Black women the beginning of the family formation process is indicated more validly by AAB than AAM. The importance of these findings contributes not only to explaining total and unwanted fertility, but also to obtaining the most reliable and valid measures of a phenomenon in relation to any social group.

(4) Age at last wanted birth is a part of the AAM, AAB triangle. It is the only intervening variable affecting both total and unwanted fertility; in turn, it is affected largely by AAM or AAB.

(5) Post-wanted contraceptive use-effectiveness and non-linearly related to the demographic and sociological variables that preceded it. Its effect was not statistically significant in relation to fertility. It was associated with higher parities of wanted fertility, and thus may have resulted where the control of future fertility was problematic.

(6) The findings imply the normative orientations of Black women concerning the childbearing span and the number to be reached within that span. There does not appear to be any particular number wanted. Whatever child-bearing occurs within a given age span is the fertility. More specifically, the upper limit of this age span appears to be close to age 29, and the lower boundary is extremely dependent on attainable education and age at first birth. Other variables not included in this analysis may also significantly affect fertility (for example, employment).

The findings indicate strongly the importance of delaying marriage and first births if unwanted fertility is to be minimized. Barring extremes, the number of children desired can be reached quite readily with ages at marriage of 22 to 28. What is important *individually* is the number desired, rather than age at marriage as an inhibitor of the number desired. The number wanted, including zero, is a choice, and can be a choice regardless of AAM. Another way of viewing this choice is that older ages at marriage or first birth do add to the ability to exercise fertility options and quality of life options, which apparently is not the case with young ages at marriage and first birth.

NOTES

1. Hereafter Black Protestant women will be referred to as Black women.

2. Path analysis was developed by Sewall Wright in a series of five essays spanning 1921–1960. Recent descriptions and discussions of it can be found in Heise (1975), Land (1969), and Namboodiri et al. (1975).

3. A critique of the 1970 NFS has been provided by Ryder (1973).

4. "Reconstructed partial regression coefficients" are referred to as "reconstructed coefficients." Such coefficients are interpreted as "effect coefficients" in path analysis.

REFERENCES

Bartz, K. W. and F. I. Nye (1970) "Early marriage: a propositional formulation." Journal of Marriage and the Family 32: 258–268.

Bonham, G. S. and P. J. Placek (1975) "The impact of social and demographic, maternal health and infant health factors on expected family size: preliminary findings from the 1973 National Survey of Family Growth and the 1972 National Natality Survey." Presented at the April 1975 Meetings of the Population Association of America.

Bumpass, L. (1969) "Age at marriage as a variable in socio-economic differentials in fertility." Demography 6: 45–54.

———— and C. F. Westoff (1969) "The prediction of completed fertility." Demography 6: 445–454.

Busfield, J. (1972) "Age at marriage and family size: social causation and social selection hypotheses." Journal of Biosocial Science 4: 117–134.

Cutright, P. (1973) "Timing the first birth: does it matter?" Journal of Marriage and the Family 35: 585–595.

Farley, R. (1970) Growth of the Black Population: A Study of Demographic Trends. Chicago: Markham.

Freedman, R. and L. Coombs (1966) "Economic considerations in family growth decisions." Population Studies 20: 204–219.

Heise, D. R. (1975) Causal Analysis. New York: Wiley-Interscience.

Kramer, M. J. (1975) "Legal abortion among New York City residents: an analysis according to socioeconomic and demographic characteristics." Family Planning Perspectives 7: 128–137.

Land, K. C. (1969) "Principles of path analysis," p. 3–37 in E. F. Borgatta (ed.) Sociological Methodology. San Francisco: Jossey-Bass.

Loewenthal, N. H. and A. S. David (1972) Social and Economic Correlates of Family Fertility: An Updated Survey of the Evidence. Prepared as RTI Project SU-507-9 for the Asia Bureau/Office of Population Programs under U.S. Agency for International Development, Contract NESA/460.

Namboodiri, N. K. et al. (1974) "Which couples at given parities expect to have additional births? an exercise in discriminant analysis." Demography 11: 45–56.

Presser, H. B. (1971) "The timing of the first birth, female roles and Black fertility." The Milbank Memorial Fund Quarterly 49: 329–361.

Preston, S. H. and A. T. Richards (1975) "The influence of women's work opportunities on marriage rates." Demography 12: 209–222.

Rindfuss, R. and C. F. Westoff (1974) "The initiation of contraception." Demography 11: 75–87.

Ryder, N. E. (1973a) "A critique of the National Fertility Study." Demography 10: 495–506.

———— (1973b) "Contraceptive failure in the United States." Family Planning Perspectives 5: 113–142.

———— and C. F. Westoff (1971) Reproduction in the United States: 1965. Princeton: Princeton University Press.

Sweet, J. A. (1974) "Recent fertility change among high fertility minorities in the United States." Working paper No. 74–11. University of Wisconsin, Center for Demography and Ecology.

———— (1973) Women in the Labor Force. New York: Seminar Press.

U.S. Bureau of the Census (1973) Census of Population, 1970 Subject Reports, Final Report PC(2)-3A, Women by Number of Children Ever Born. Washington: U.S. Government Printing Office.

Vaughan, B., J. Trussell, J. Menken, and E. P. Jones (1977) "Contraceptive failure among married women in the United States 1970–1973." Family Planning Perspectives 9: 251–258.

Waite, L. J. and R. M. Stolzenberg (1976) "Intended child-bearing and labor force participation of young women: insights from nonrecursive models." American Sociological Review 41: 235–252.

Waldman, E. (1975) "Children of working mothers, March 1974." Special Labor Force Report 174, Reprinted with Supplementary Tables from the January 1975 Monthly Labor Review. U.S. Dept. of Labor, Bureau of Labor Statistics. Washington, DC: U.S. Government Printing Office.

Weller, R. H. (1973) "Female labor force participation, fertility, and population policy." presented at the General Conference of the International Union for the Scientific Study of Population, Liege, Belgium.

Westoff, C. F. and N. B. Ryder (1977) The Contraceptive Revolution. Princeton: Princeton University Press.

PART II
THE BLACK WOMAN AND HER FAMILY

In the introductory essay to the Black woman and her family, Carrie Allen McCray argues for a more balanced and unbiased perspective on the Black woman. She states that there is a need for research that neither denigrates the Black woman because of the very functional roles she has had to play, nor idealizes her in the process of Black family survival and stability almost to the exclusion of the Black man. McCray discusses the importance of the extended caring role of children, which dates back to slavery. Caring for other people's children, whether kin or not, continues to be a significant role of Black women today. McCray writes, "The sense of caring and social responsibility in the Black community, plus strong kinship bonds and other reinforcements, kept families together and strengthened their functioning." It is this extended caring for children that the author says will determine the continued survival of the Black family, and therefore all Black people.

Janice Hale, in her article "The Black Woman and Child Rearing," suggests that the Black mother has the task of interpreting the culture to Black children. The author discusses child-rearing practices that are adaptations to racism and oppression, and those practices of Black child-rearing that are derived from African culture. Black women, she goes on to say, have had to ignore white child-rearing norms which are irrelevant to the existential situation of their children. Hale avers that there is further need for research on mother-child relationships among Black Americans. This research should have strong implications for educating Black children. There is a need for greater continuity between the behavior of the mother and the behavior of the teacher. The author concludes that cultural dissonance occurs for Black children when authority figures behave differently from the way Black children expect them to behave. The educational system must move toward eliminating cultural dissonance for Black children.

Gloria Wade-Gayles, in "She Who Is Black and Mother," seeks to study the interrelations between art and science in the analysis of the

role of Black mothers. Specifically, Gayles draws an in-depth portrait of the Black mother in America as she is presented in selected novels and sociological studies published between 1940 and 1970. Gayles demonstrates that the studies by sociologists emphasize the Black mother's fatalistic attitude toward life, while fiction emphasizes frustration and struggle, but not fatalism. She further maintains that sociologists' perception of the Black mother is not so much the reality of their lives as it is the narrowness of their understanding of that reality. She concludes that we need to use both art and science to produce knowledge that is not impoverished.

Bonnie Thornton Dill, in her study on the child-rearing goals and strategies among Black domestic servants, demonstrates what sociology can do when knowledge is not impoverished. Dill studied in depth the life histories of 26 women living in the northeastern United States who were household workers while raising their own children. The women, when interviewed, were between the ages of 60 and 80. Dill found that the relationship between the Black woman's family life and her work was shaped by four basic factors: (a) the structure of the work; (b) tasks and duties assigned her; (c) degree of employer-employee intimacy; and (d) goals for her children. Those women who did not share much of their own lives with their employers appeared to minimize the interaction of work and family.

Harriette Pipes-McAdoo explores the differential involvement and support given Black mothers who are single parents and those mothers who have husbands. The author's sample was 175 mothers; 26% were single and 74% were married. The mothers in the sample were involved extensively in the kin-help exchange network. The kin exchange took the form of child care, financial assistance, and emotional support. All the mothers were middle class. Single mothers received more help than married mothers. However, both groups of mothers felt obligated to help poorer members of the family and they, in turn, expected someone in the family who was substantially better off than they were to help them. The data support the importance of the extended family system in maintaining economic and emotional stability. The study, then, adds empirical validity to the theoretical chapter by McCray.

Essie Manuel Rutledge investigates marital interaction goals. The purpose of the study is to interpret marital "strengths" on the basis of marital interaction goals. The study is based on a sample of 256 Black women. The findings indicate that the most valued interaction goals were being a good wife, understanding how the husband thinks, and helping to make big decisions. Rutledge states that these findings are

quite contrary to the notion of Black female dominance which has traditionally saturated the family literature. Further, she says, the least valued among the goals was having the kind of sex life desired. The one variable which was most consistent in its impact on marital interaction goals was the chance for extrafamilial activities. The author concludes that the marital relations of the Black women in her study are much more characteristic of "strengths" than of weaknesses.

Lena Wright Myers, in "Perceptions of Black Women on Marital Relations," gives an account of the social interaction among Black couples as perceived by 400 Black women. Half the sample was from Michigan and half from Mississippi. The women ranged in age from 20 to 81 years; they were either presently married for at least five years or they were separated or divorced. The author looked at the perceptions of cathectic affection, the opportunity to relate to their husbands, and perceived degree of satisfaction with companionship. As one might expect, the women still married were more satisfied with the cathectic aspect of their marriages than the separated or divorced women. Also, the married women felt freer than the separated or divorced women to communicate with their spouses. Myers' chapter relates directly to Rutledge's. Both address the importance of affect in marital relations, and both suggest that marital success is based on the ability to define marital interaction goals and to establish opportunities to carry out these goals in an environment that is flexible without negating the positive aspects of conflict.

3

THE BLACK WOMAN AND FAMILY ROLES

Carrie Allen McCray

In much of the social science and popular literature, the Black women has either been depicted as the dominating, castrating female under whose hand the Black family and the Black community are falling apart, or as the romanticized, strong, self-sufficient female responsible for the survival of the Black family and of Black people. Neither of these two opposing views gives the true picture. There must be a balance somewhere, and the search for the truth has become a commitment for some of the researchers doing recent work in this area of study.

This article will examine the roles of the Black woman in the family against the above views with a plea for continued research from a more balanced and unbiased perspective; one that neither denigrates the Black woman because of the very functional roles she has had to play nor idealizes her in the process of Black family survival and stability almost to the exclusion of the Black man. This will in no way diminish the recognition of the very significant contribution of the Black woman in this process. However, it is difficult to believe that Black families could have survived if it were not for some strengths attributable to the Black male, the Black female, and to that combination.

Social scientists, through lack of understanding of some of the more subtle and intricate patterns of Black family life, have developed the "pathology" and "deviance" themes well-known in the literature. We raise some questions in relation to this.

"DEVIANT" OR "VARIANT"?

Changes in various family forms, beliefs, values, behaviors, as well as

adaptations of roles have been necessary for Black people in light of harsh social realities. That these family forms and roles within the family have varied from the white middle-class norm should have been no surprise to the social scientists with their knowledge of the influence of social forces on the development of social institutions and of roles within these institutions. That Black families have developed as they have and that roles within these families varied as they have should be understood within the context of that knowledge.

Billingsley (1968) set a theoretical framework for studying Black families. His use of the social systems approach emphasizes the interdependence of Black families with other levels of society—the variability of Black family forms, the subsystems of the larger society that affect family life (values, political, economic, etc.), the subsystems of the Black community, and the subsystems of the Black family. This significant work, more than any other, has helped a number of perceptive social scientists in their new look at the Black family and roles within that system.

If, as Sarbin (1954: 224) says, "a role is a pattern of attitudes and actions which a person takes in a social situation," then one would expect a general acceptance of variance in role within Black families. The social situation of Black people in America has been of such a nature as to demand role variability for the sake of stability and survival. We were not in the same social situation as the definers of the norm. Although variability of role is regarded as legitimate in our society (Parsons and Shils, 1954: 24), early and some current writings of social scientists, historians, and social workers reflect little understanding of this fact in relation to the Black family and more specifically in relation to the role of the Black woman within that system. As Ladner (1973: xxiii) says, "Blacks have always been measured against an alien set of norms. As a result, they have been considered to be a deviation from the ambiguous white middle-class model, which itself has not always been clearly defined."

The Black family and the Black woman have too often been discussed in terms of pathology and deviance. It is extremely interesting, however, that, after years of labeling the Black family as "deviant" because its structures varied from the norm, now that mainstream families are moving in some of these same directions, terms are changing and becoming more respectable. Says Alice S. Rossi, sociologist at the University of Massachusetts, "What was defined a decade ago as 'deviant' is today labeled 'variant' in order to suggest that there is a healthy, experimental quality to current social explorations 'beyond monogamy' or beyond the nuclear family" (Newsweek, May 15, 1978: 67). I am afraid it will be a long time, however, before the negative connotations attached to the Black family and the Black woman will be completely dispelled. The images created in scientific and popular literature

have left an imprint on the minds of many.

In relation to the first view expressed, that of the Black woman as the "dominating," castrating female, no other group of women in our society has been so maligned. Bond and Peery (1971) puncture the emasculation theory, as does Ladner (1972: 41–49). If the wealth of literature on this country's historic past contains a shred of truth, the behavior, attitudes, and actions of the pioneer woman moving westward were as different as day and night from those of the southern mistress on the plantation during slavery, yet neither group was considered "deviant" by social scientists. As Dr. Jeanne Morrison, Chairman of the Psychology Department at Talladega College, said in discussion,

> Each of them behaved appropriately to get the results for survival of the woman and her family. The pioneer woman had to be strong, often self-sufficient, as a coping and survival mechanism to deal with her reality. The southern woman had to play the passive, helpless female role because she was controlled by her husband.

At points in time in our history and in special social situations, both the pioneer woman and the Black woman had to be strong. However, no one describes the pioneer woman's strength in terms of dominance. Then, too, as Jackson(1975: 63) reminds us in relation to the "strong, self-reliant image of Black women, some were and some were not."

Only in recent years have more concerned and more sensitive researchers committed themselves to destroying the myths and stereotypes of the Black woman and her roles in the family. It is refreshing to read the works of some of the revisionists and corrective social scientists such as Billingsley (1968), Ladner (1972), Staples (1971), Genovese (1974), Blassingame (1972), Gutman (1976), Rawick (1972), Stack (1974), Willie (1970), and others.

That Black people have survived at all throughout years of oppression is cause for wonder; and perhaps we were not expected to. Dr. Herman Hodge Long, former President of Talladega College, opened each year's faculty orientation with a quote from an early twentieth-century sociologist whose name eludes me but whose thought remains. In essence, he stated that the problem of the Negro would disappear in time because of the high mortality rate, with a prediction that by mid-century we would not be here in any numbers to cause concern. Dr. Long called it "willing us away." We have proved that prediction false, and this, in itself, should indicate that there had to be some strength factors worth exploring involved in that survival; medical advances and the blessings of procreativity could not do this alone. One avenue is to explore roles within the Black family with special emphasis on the Black woman. If social role includes the values, attitudes, and behaviors within a social situation, let us look at some of these in relation to the Black woman first from a historical perspective.

THE HISTORIC "EXTENDED CARING" ROLE

I want to spend some time on what I have come to call the historic extended caring role, alluded to in much of the research and described profusely throughout the literature of this country, albeit too often romanticized. However, I am not certain that those early researchers and labelers of Black woman have given this role enough thought, especially in relation to positive values, attitudes, and behaviors that are resulting factors. Nor have planners and social interventionists approached solutions to problems from the positive perspective of recognizing and using this valuable asset.

Perhaps one of the most significant aspects of our survival has been a deep resource of humanistic values. Do not misunderstand me; suggestion is not being made that all Black people have all these humanistic values to the exclusion of others. Our cultural heritage, our historic roles in this society, and the experience of oppression and strong religious beliefs have combined to develop, generally, within our people a special set of humanistic values. That the Revolution of the 1960s, led by Martin Luther King, espoused a philosophy of love should have been no surprise to anyone.

The development of these values could possibly be traced to the several sources mentioned above: (1) our African cultural heritage, (2) our strong religious beliefs, (3) the "caring roles" into which we were placed because of social and economic situations, and (4) recognition of the need for mutual aids in order to survive the oppressive societal forces we know so well.

It has been established that, contrary to the thoughts of earlier writers, we were not cut off completely from our African heritage. Throught examination of Negro societies throughout the New World, Herskovits, in *The Myth of the Negro Past* (1968), was one of the first to advance evidence of links to this heritage. Before this, as Herskovits suggests, Woodson (1936) and W. E. B. Dubois (1939) had refuted the claim that Black people in America had no vestiges of their cultural past. We had to come to these shores with certain behaviors, attitudes, and values which become so much a part of a people that they are not so easily dispelled. That some of these behaviors and values were transmitted from generation to generation seems apparent through more empirical research.

Africans placed great value on marriage, family unity, kinship bonds, and responsibility to the extended family and the broader society. There was a strong sense of social responsibility. The revisionists such as Rawick, Gutman, Genovese, Bayliss, and Blassingame have given sufficient evidence to indicate that these values and practices remained during slavery and beyond. Rawick cites case after case from narratives of slaves describing their marriages; perhaps not the typical legal marriage as we know it, but an adaptive form of marriage which served the same function. Earlier writers gave little evidence of slaves valuing this institution.

Some emphasis, too, was placed on the value of caring for others, implicit in the extended family and entrenched in African culture. This value served a special purpose within the institution of slavery. Since slaves could be sold away from the family, others—mainly the Black woman whether kin or not—would care for the children who were left. This role is apparent throughout the slave narratives. In *The American Slave: A Composite Autobiography,* Rawick cites this example:

> "When Mrs. King was five, she was sold along with her grandmother, mother, two aunts and an uncle. She was sold with her grandmother, an aunt and an uncle, while her mother went elsewhere—she lived in the slave quarters with a few slaves owned by the master, nearly all of whom were her kinfolk." Until she joined her mother after the war, her kinfolk cared for her [Rawick, 1972: 83].

In another narrative, included in *Black Slave Narratives* by Bayliss (1970: 114), we read, "My grandmother could not avoid seeing things which excited her suspicions. She was uneasy about me and tried various ways to buy me." This and numerous other accounts support the fact that there was also a special value placed on children. Although many slave children were born not out of love but under adverse circumstances, slave mothers were found to be "fiercely maternal" (Bernard, 1966: 103). Even today, valuing children is an important aspect of Black culture, and extension of the caring role is evident, as will be discussed later. Billingsley (1972) states that during the period after slavery, when the Freedmen's Bureau disbanded, social resources were not provided by the larger society, and the Black community, through "informal neighbor to neighbor" systems had to provide resources for the care of children (1972: 46).

The sense of caring and social responsibility in the Black community, plus strong kinship bonds and other reinforcements, kept families together and strengthened their functioning. Gutman (1976: 213–214), in *The Black Family in Slavery and Freedom,* discusses the strong kinship networks among Black families, and in relation to the literature on the Black family he says that the excessive attention given to "pathology" in the Black family obscured the adaptive capacities revealed in the extended kinship networks among the slaves, their free children, and grandchildren.

Not only did the Black slave woman come from a culture in which the family structure expected some responsibility for others, but history placed her in a social situation which demanded extending her caring role to her children and children of other slaves, as well as children of the master. This role did not end with slavery, but continued to be a major one in the economic history of the Black woman.

Contemporary studies support the existence of the extended caring role within the Black community today as well as a continued strong familism.

Carol Stack (1974), a young white woman who conducted studies of Black urban poor families, found much sharing of goods, services, and the care of children. She viewed this mutual aid as an "adaptive strategy to cope with poverty and racism" (1974: 28). In *Living Poor,* Camille Jeffers, who lived in a low-income housing project for a number of months as a participant-observer, was struck with the frequency and common mutual aid in child care and household management. "The unspoken theme of this kind of aid [from one mother to another]," she says, "was: 'you take care of mine and I'll take care of yours'" (Jeffers, 1967: 21).

When crises arise in many low-income families, the above code is often seen in operation. Jeffers found it "impressive to see how quickly some mothers could parcel out their children and just as impressive to see the way neighbors would rise to the occasion when such demands were made" (1967: 21). Billingsley, in his penetrating article "Family Functioning in the Low Income Black Community," reports on Carson's sensitive study of the role of Black women today. Carson found a strong attachment to familism and extended caring roles in Black communities. Billingsley (1964: 566) cites incidents from her report which support this, such as "my mother keeps him while I work—my granddaddy bought my grandma—the children stops by my Aunt's place till I comes home."

Historically, extended family relationships have been greater in Black families than in white families, and, although this pattern has declined in both, there still exists within the Black community a strong kinship bond and a willingness to absorb children (Hill, 1972: 36). Hill estimates that "more than 160,000 out of wedlock Black babies were absorbed in 1969 by already existing Black families," which, he states, "helps to minimize the number of new Black families headed by single women" (1972: 36). Caring for other people's children, whether kin or not, has been a significant role of the Black woman and continues to be so today.

The willingness on the part of Black families to absorb children other than their own is remarkable especially when one realizes that many of these families already have a number of children and are in no way economically privileged. Working in child welfare for a number of years, I observed the extended caring role as a common practice and as a natural expression of human concern and mutual support even under circumstances as described above. As one mother of ten said to me when her sister died, leaving three little children in her care: "I got 10 heads of children—3 more don' make no difference and dey so little and pitiful. I love 'em jes' like I birthed 'em."

When the Black mother in these families is head of the household, as this mother was, she has to fill the role that carries out the instrumental as well as the expressive function of the family. Under the most favorable circumstances this can often be very demanding; with eight, ten, or more children

to care for, it would seem a monumental task. However, the Black mother in these circumstances is much more likely to absorb other children than her white counterpart; as is indicated in Hill's studies, in two-parent families only three percent of white families compared with 13 percent of Black families absorbed children under 18. In female-headed families, 41 percent of Black families had relatives under 18 living with them, compared with seven percent of white families in comparable situations (Hill, 1972: 5).

One need only talk a few moments with a group in a Black community, especially the low-income community, and the extended caring role becomes very clear. One hears such statements as, "My Auntie raised me," "I lived with my grandmother growing up," "My older sister raised me." Hill, in his book *Informal Adoption Among Black Families* (1977), points out the functional role that this pattern has played in Black families.

It would serve future social scientists well to examine some of the historic roles of the Black woman from a more positive perspective and within the context of the entirely different set of social circumstances and norms than is found in mainstream families. More sensitive and less biased research would have to emerge from this.

TOWARD A MORE BALANCED APPROACH

One cannot discuss the role of the Black woman in the family without discussing the role of the Black man. The approach to this section of the chapter is not one which elevates the Black woman to some superhuman position, while granting a lesser status to the Black man; that, unfortunately, has too often been the damaging theme within social sciences and popular literature.

The emphasis here will be a plea for a more balanced look at the role of the Black woman within the family, the flexibility of Black family roles, the functionality of this for survival and stability, and a suggestion for the need for more unbiased research in the area of the roles of the Black woman and the Black man in the family.

For functional purposes, roles within Black families have always been more flexible and open than those within mainstream families. Black women have often had to share the roles designated by society as male roles, just as Black men have had to share some of the traditionally designated female roles (Hill, 1972: 17). Whatever was functional for the survival of the family had to be done, and whoever was available and able had to do it.

Staples (1973: 16) says that Black men who, because of illness or disability, are unable to work suffer less emotional damage if the wife has to take on the role of provider of the family than do white men operating within a rigid norm. Harsh social realities have made flexibility of role a necessity for Black families. We could not live with the unrealistic societally determined

rigid role prescriptions, which were not always applicable to us. For family survival in crises, the Black woman has often had to take on the role that carries out the instrumental function of the family. Staples even goes so far as to speculate that "the Black woman's adaptability to several other roles may increase the male's appreciation of her and bind them closer together" (1973: 16). This does not mean that there are no conflicts in relation to male-female role performance; certainly, as we take on mainstream society's middle-class beliefs in relation to male role performance, conflicts arise. However, especially for the low-income Black family, interchanging of roles as well as assumption of dual roles (in single-parent families) has been an accepted pattern of life. It is suggested that even within higher income Black families there is more acceptance on the part of the husband for his wife to work. Fichter's (1969) findings on racial comparisons by sex indicated that Black wives expect to work and Black husbands accept this more easily than do white husbands; and that "attitudes on marriage, child rearing and wife's occupational role are more dissimilar between male and female whites and more similar between male and female Negroes" (1969: 83).

In some groups in our society, male-female roles traditionally have been more distinct. The father has been the provider, protector, and disciplinarian; the mother's role has been that of a homemaker, taking care of the children and providing the emotional-expressive functions. However, historically, for most Black families this clear-cut distinction never existed. One could assume that this pattern of role sharing was one of the sources of survival and stability within the Black family.

The ability of the Black woman to adapt to roles traditionally thought of in this society as male roles should have been viewed by social scientists as a positive strength necessary for survival; instead, it had led to negative labeling. Ladner (1972), in *Tomorrow's Tomorrow,* states that "the highly functional role that the Black female has historically played has caused her to be erroneously stereotyped as a matriarch, and this label has been quite injurious to Black women and men" (p. 41).

The adaptability of the Black woman in assuming the role of provider when necessary has been a positive factor in Black families. Since the Black male's unemployment and underemployment rates are higher and his life expectancy lower than those of the white male, it follows that the Black woman has had to share or assume the role of provider when the situation so demanded. In female-headed households, the assumption has been that most of these families are dependent upon welfare or some other source of support. Hill's (1972: 38) data puncture this, citing recent census data which indicate that three-fifths of these women work, most of them full-time.

It is also suggested by Beckett (1976: 465) that the Black woman is more likely to work whether or not this is necessary than her white counterpart,

and that Black husbands are more accepting of this. In this same article, which examined nine survey research studies, evidence indicated that

> Black men are more willing than white men to make tentative, temporary, or long-range accommodations to the special needs of working wives—for instance, more willing to stay home with a sick child—or to be amenable to the wife's absence from home overnight because of work requirements [1976: 465–466].

There needs to be a better balance in discussion of male-female roles in the Black family and much more documented evidence of the role of the male as provider and protector. Social scientists have denigrated the role the Black man has played in relation to provider and protector of his family, and some have almost glorified the strong Black woman who has "done everything." One area that needs more research is that of the Black man's role as provider and protector. Literature is full of references to the Black female's lack of protection by the Black male. Certainly, slavery, just by its nature, made this many times an almost impossible task given the risks involved. However, it would take much more documentation than I have seen to convince me that there were not more instances of protection, whether through physical force or through some more subtle strategy than is evident in the literature up to now. One does not confront a tank with a small-calibre shotgun and expect to live; but there may be some strategic way of circumventing it.

Genovese (1974), in discussing the "no protection" thesis, gives instances of slaves protecting their women at the risk of death. He writes that "even short of death the price of assertive manliness could reach fearful proportions" (p. 485). Further, he cites instances of this from narratives with the astute assessment that "In view of the risks, the wonder is not that more Black men did not defend their women but that so many did." He believes that sometimes submission to outrage revealed "a far greater strength than most men and women are ever asked—or ever should be asked to display" (1974: 485). The protective father's role was evident, too, in many ways throughout slave narratives as expressed in lullabies slave mothers sang to their children (1974: 492).

John H. McCray, for many years editor-publisher of *The Lighthouse and Informer,* a newspaper in South Carolina which spoke out against injustices, and one of the spearheading forces of the NAACP in that state, speaks of numerous instances of men protecting their families at the risk of their lives, knowing that justice was an alien term in the courts when it applied to Black men. A case in point was that of Sammy Osborne of Barnwell County who in 1939 killed a white man who forced his way into the home of Osborne's aunt. In a familiar scene of miscarriage of justice, the courts found Osborne guilty of murder, saying that Osborne lured the man into the home. Osborne was

electrocuted. In a justice system geared to protect white society, self-defense was unlikely to be ruled in cases of this kind.

I am not denying the Black man had to carry out this role against the greatest of odds, but much of the literature would have us believe the Black woman had no protection from the Black male at all. Since protection is a natural response of all living creatures, the conclusion would be that this strong Black woman had to stand alone in protecting herself from the ravages of the white society. It makes her super-human and the Black male less than a man, and grants to her alone the reward for our survival. This kind of thesis is divisive. I believe more research in this area would prove that this role in the family, more times than is indicated thus far, was carried out by the Black man.

Time was spent on this subject to raise a question about the position much of the literature has taken in relation to the Black male's role as protector. This question is in no way an attempt to underestimate the dehumanizing experiences of Black women well documented in the history of this country. Rather, the question is raised with the hope that further research will give a better balance to the subject.

Another area of study in relation to Black male-female roles is that of spouse dominance. A further examination of some of the beliefs in relation to the matriarchal image of the Black woman is punctured by Hill (1972: 20) and others, as evidence has indicated that the "typical" pattern within Black families, whether low-income or not, is more equalitarian; neither spouse dominates, and decision making is shared. Further research on all areas of Black male-female roles needs to be done to clear up the maze of distorted social science findings.

I want to end with an emphasis on one of the most valuable resources that we have and its potential for further strengthening the Black family. Hill (1977: 78) says that the "extended family and the informal absorption of families and individuals by relatives is still one of the most viable institutions for survival of Black people." The Black woman has been a strong force here and should be recognized as such; but here, again, not to the exclusion of the Black man. In Hill's *Informal Adoption Among Black Families,* evidence is given that two-parent families are as likely to adopt children (46 per cent) as are one-parent families; and although slightly over one-half (54 per cent) live in one-parent families and a high proportion of these are female-headed (45 per cent), a small percentage lives in one-parent, male-headed homes (9 per cent) (Hill, 1977: 51). Grandmothers are, however, still the most significant force in the absorption of Black children (1977: 54–55).

This role of the Black woman in the family, almost more than any other, along with the strong kinship bonds and mutual aid networks need to be recognized for their functional value and implications for child welfare.

Child welfare policy makers, planners, and deliverers of service should use these assets within the Black family which have been a significant source of survival. For Black families and Black people, there is but one danger; if these informal adaptive coping mechanisms are pulled into the bureaucratic structure, the informal nature of the network and the network itself could be destroyed. A careful use of the network would have to be devised to avoid this loss.

CONCLUSION

The old myths and stereotypes attached to the Black woman and her roles in the family continue to plague us. Perceptive social scientists are moving in the right direction, but more research, more popular literature, and the media need to reflect a truer picture of the intricate nature of Black culture. Black families and roles within this system have to be understood in light of their development out of harsh social circumstances, and the validity of the variance from the norm has to be respected as necessary coping strategies. Resources within the Black family and the role of the Black woman need to be recognized by social welfare policy makers and used in a productive, creative way. A final plea is for more balanced and unbiased research in the area of Black male-female roles and relationships.

REFERENCES

Bayliss, J. E. (1970) Black Slave Narratives. New York: Macmillan.

Beckett, J. (1976) "Working wives: a racial comparison." Social Work (November).

Bernard, J. (1966) Marriage and Family Among Negroes. Englewood Cliffs, NJ: Prentice-Hall.

Billingsley, A. (1968) Black Families in White America. Englewood Cliffs, NJ: Prentice-Hall.

——— (1969) "Family functioning in the low income Black community." Social Casework (December).

——— (1972) Children of the Storm: Black Children and American Child Welfare. New York: Harcourt Brace Jovanovich.

Blassingame, J. W. (1972) The Slave Community: Plantation Life in the Antebellum South. New York: Oxford University Press.

Bond, J. C. and P. Peery (1971) "Has the Black man been castrated?" in R. Stack (ed.) The Black Family. Belmont, CA: Wadsworth.

Cade, T. [ed.] (1970) The Black Woman: An Anthology. New York: Signet Press.

DuBois, W. E. B. (1961) Souls of Black Folk. New York: Fawcett.

Ellison, R. (1967) "A very stern discipline." Interview with Ralph Ellison, Harper's Magazine (March).

Fichter, J. (1969) Graduates from Predominantly Negro Colleges: Class of 1964. Washington, DC: U.S. Government Printing Office.

Frazier, E. F. (1969) The Negro Family in the United States. Chicago: University of Chicago Press.

Genovese, E. (1974) Roll, Jordan, Roll: The World the Slaves Made. New York: Pantheon.

Gutman, H. (1976) The Black Family in Slavery and Freedom: 1750–1925. New York: Vintage.

Hannerz, U. (1969) Soulside. New York: Columbia University Press.

Herskovits, M.J. (1968) The Myth of the Negro Past. Boston: Beacon.

Herzog, E. (1966) "Is there a 'breakdown' of the Negro family?" Social Work (January).

Hill, R. (1972) The Strengths of Black Families. New York: National Urban League.

———— (1977) Informal Adoption Among Black Families. Washington DC: National Urban League Research Department.

———— (1978) The Illusion of Progress. Washington, DC: National Urban League Research Department.

Jackson, J. (1975) "A critique of Lerner's work on Black women." Journal of Social and Behavioral Sciences.

Jeffers, C. (1967) Living Poor. Ann Arbor: Ann Arbor Publishers.

Kadushin, A. (1974) Child Welfare Services. New York: Macmillan.

Ladner, J. (1972) Tomorrow's Tomorrow: The Black Woman. Garden City, NY: Doubleday.

———— (1973) Death of White Sociology. New York: Random House.

Lewis, H. (1965) "The family: resources for change." Agenda Paper No. 5, Planning Session of the White House Conference "To Fulfill these Rights," November.

Parsons, T. and E. Shils [eds.] (1954) Toward a General Theory of Action. Cambridge, MA: Harvard University Press.

Rainwater, L. and W. Yancy (1967) The Moynihan Report and the Politics of Controversy. Cambridge, MA: MIT Press.

Rawick, G. (1972) The American Slave: A Composite Autobiography—Sunup to Sundown. Westport, CT: Greenwood Publishing.

Ross, E.L. [ed] (1978) Black Heritage in Social Welfare, 1860–1930. Metuchen, NJ: Scarecrow Press.

Sarbin, T. (1954) "Role theory," in G. Lindzey (ed.) Handbook of Social Psychology. Reading, MA: Addison-Wesley.

Schultz, D. (1969) Coming Up Black: Patterns of Ghetto Socialization. Englewood Cliffs, NJ: Prentice-Hall.

Stack, C. (1974) All Our Kin: Strategies for Survival in a Black Community. New York: Harper & Row.

Staples, R. [ed.] (1971) The Black Family. Belmont, CA: Wadworth.

———— (1973) The Black Woman in America. Chicago: Nelson-Hall.

Willie, C.V. (1970) The Family Life of Black People. Columbus, OH: Charles E. Merrill.

Woodson, C. (1936) The African Background Outlined. Washington, DC: Negro Universities Press.

4

THE BLACK WOMAN AND CHILD REARING

Janice Hale

Now there rose up a king over Egypt which knew not Joseph.

Exodus 1:8

Pharaoh became alarmed at the rapid increases in the numbers of Hebrew slaves. He issued a decree that all male Hebrew babies were to be cast into the water at birth. There was a man in the tribe of Levi who took a wife who bore a child during this time. She hid the child for three months. Then, unable to conceal him any longer, she made a basket and lets him to float by the side of the river. His sister, Miriam, watched the child and ensured his safety.

Each day, the daughter of Pharaoh came down to wash herself by the side of this river. When she saw the basket, she asked her maidens to fetch it. She opened it, and saw the child, and the baby wept. She said with compassion, "This is one of the Hebrews'children." At that moment, Miriam, his sister, emerged from the bulrushes and said, "Shall I go and call a nurse of the Hebrew women so that she may nurse the child for you?" And Pharaoh's daughter said to her, "Go." And Miriam went and called the child's mother. And Pharaoh's daughter said to her, "Take this child away, and nurse it for me, and I will give you wages." And the woman took the child and nursed it.

And the child grew, and she brought him unto Pharaoh's daughter, and he became her son. And she called him Moses.

But even though Moses grew up in the house of Pharaoh and became his son, there was a difference between Moses and the other sons of Pharaoh. Pharaoh's sons grew up to become oppressors and Moses grew up to become a liberator. The difference between Moses and Pharaoh's sons was the differ-

ence made by Moses' nurse, who was his mother. Not only did she nurse him with the milk of her breast, but she also imbued her child with a clear understanding of who he was, who the enemy was, and what he must do. She provided Moses with an identity, a god, and a heritage such that when his moment in history arrived, when he saw an Egyptian overseer striking a Hebrew slave, he didn't experience an identity crisis. He immediately knew whose side he was on and what had to be done. Without Hannah, there would have been no Moses.

Nobles has pointed out that the task of the Black family has been to prepare its children to live among white people without *becoming* white people (1975). There existed no formal "Black studies" program in this country wherein Black people were taught who they were. But just as Moses' mother, Hannah, taught him who Joseph was as well as Abraham, Isaac, and Jacob, my mother taught me who Booker T. Washington was and Phyllis Wheatley, Harriet Tubman, W. E. B. DuBois, and Marian Anderson. When the news media projected Martin Luther King in a dubious light during the early civil rights movement and questioned his tactics and leadership, it was Black mothers who turned off the television sets and explained to their children who Martin Luther King was and what he was struggling for.

It is appropriate that we devote special attention to the relationship between the Black woman and her child because of the strong bond that exists between them. As Nobles has pointed out, the special bond cannot be attributed merely to the fact that slavery legally defined the family as mother and child, but is "deeply rooted in our African heritage and philosophical orientation which . . . places a special value on children because they represent the continuity of life." Robert Bell has suggested that motherhood has historically been an important role for Black women and possibly even more important than the role of wife. It is also imperative that our consideration of the Black woman proceed within the context of our Africanism and from the perspective of our African heritage.

Historically, research on the Black woman has paralleled or been a part of research on the Black family, which has defined her as domineering, pathological, and matriarchal. We must join the scholars who interpret the Black woman in terms of Black (African) social reality. Ladner (1972), for example, has pointed out that it is more appropriate to describe the Black woman as *strong* rather than domineering. This strength has contributed immeasurably to our survival, for she has had to maintain the dual role of working for wages and shouldering the primary responsibility for the household.

During slavery, women were often forced to work as hard as men, even during pregnancy. After childbirth, when they suffered from full breasts because their infants could not join them in the fields to nurse, they were

beaten raw by the overseer when they did not keep up with the men (Davis, 1971). But even though childbirth has imposed varying degrees of hardship on them, women have struggled through infant mortality, forced abortions, forced sterilizations, informal adoptions, and planned parenthood propaganda to produce children for the survival of the group.

Hill (1972) suggests that "the preoccupation with pathology in most research on Black families has obscured some fruitful avenues of investigation." It is his contention that examining the strengths of Black families can contribute as much toward understanding and ameliorating social problems as examining weaknesses. He suggests further: "If, as most scholars agree, there is a need to strengthen Black families, then a first-order priority should be the identification of presently-existing strengths and resources." Hill identifies and analyzes five such strengths: strong kinship bonds, adaptability of family roles, strong religious orientation, strong work orientation, and strong achievement orientation. He maintains that these five characteristics have been functional for the survival, advancements, and stability of Black families.

This discussion of child rearing will be divided into two categories. This is not to suggest that these categories are inclusive; rather, they are an effort to tie together some trends that may otherwise seem fragmented.

The two categories are: (1) those characteristics of Black child rearing that are an adaptation to the racism and oppression Black people have experienced in America; and (2) those characteristics of Black child rearing that are derived from our African culture.

Let us consider specific child-rearing practices that are adaptations. Nobles (1975) suggests that although the child-rearing practices in African-American families can be described in terms of African influences, they are also shaped by Black parents' conceptions of the realities they and their children face in America: white racism and economic oppression. The Black mother must prepare her child to take on

> the appropriate sex and age roles (which by historical and philosophical definition are flexible, interchangeable and fluid) as well as the racial role (which by social and political definition are ones of resistance, suspicion and caution).

Black child rearing must resolve a basic conflict that exists between the European world view and the African world view. Nobles (1975) describes these orientations as each possessing a "set of guiding principles, dominant values and customs and . . . behavioral and mental dispositions of a particular people." He describes the African ethos as being "survival of the tribe" and "oneness with nature." The cultural values associated with this world view are cooperation, interdependence, and collective responsibility. In contrast, the Euro-American ethos emphasizes the "survival of the fittest"

and "control over nature." The cultural values associated with this world view are "competition," "individualism," and "independence." Nobles states that the role of the Black family has been to mediate these two opposing world views.

An interesting example comes to mind that highlights the role of Black women in reconciling opposing world views. As Girl Scouts, we were taught service-oriented courtesies such as helping the elderly across streets and giving up our seats to people who were our seniors on an overcrowded bus. I recall being on a bus trip downtown with a girlfriend and her mother, who was our Girl Scout leader. We were seated together and hit upon the idea that we should give some white ladies our seats since they were our elders. My girlfriend's mother sharply reprimanded us and instructed us to sit in the next available seat and remain there. Even though this was Columbus, Ohio, and we were not struggling over segregated buses, I'm sure that the bus was symbolic of the struggle over segregated transportation in the South and that accounted for her strong reaction. However, the sharp distinction that this mother drew, without explanation, was that those Girl Scout principles were nice, but they were not to be implemented in a situation where they conflicted with racial folkways and make it appear that we were deferring to white people.

There is a duality of socialization required for Black people. Black children have to be prepared to imitate the behavior of the culture in which they live and at the same time take on those behaviors that are needed in order to be upwardly mobile. Levine (1977) has offered an explanation for the persistence of Black language in the face of the strong pressure to conform to standard English.

> Living in the midst of a hostile and repressive white society, Black people found in language an important means of promoting and maintaining a sense of group unity and cohesion. Thus, while the appropriateness and usefulness of speaking Standard English in certain situations was understood, within the group, there were frequently pressures to speak the vernacular [1977: 133].

Black women, in many cases, have had to ignore white child-rearing norms which are irrelevant to the existential situation of their children. White teachers never cease to be amazed while teaching children not to fight and to tell the teacher if someone hits them when a Black child reports that his parents told him to hit anybody back immediately who hits him. The white teacher has no conception of the kind of reality a Black child has to face: If there is no one around to tell when a child is hit, he must be able to defend himself from attack.

The Black woman has made her home a sanctuary in which she has taken some of the sting out of many of the painful realities of the Black experience. She has ministered to the needs of her man, her children, other women's

children, and the community. It is to "my woman" and "my momma" men and children turn to have mended the wounds inflicted by this society.

Black women have been challenged to foster positive self-concept development in their children. Black mothers have kept many a child going with, "you're just as good as anybody else." It is Black parents who have soothed the anxieties that arise in Black children when they engage in competition or social comparison with white children.

Another important area to investigate is the strong motivation to achieve that is transmitted to Black children. Black parents have always stressed to their children the importance of excelling white children in behavior and performance because falling short would reflect unfavorably upon the group. As a child, I can recall being given very strict guidelines for behavior on the bus or in public because for me to be loud and boisterous would make white people feel that all Blacks were that way.

Hill has identified a strong achievement orientation as a strength of Black families (1972). He cites as evidence the fact that most of the Black youths in college come from families who were not college educated. This suggests that many Black parents sacrifice to provide the college education for their children they never had.

A study was conducted by Temple University to determine what life looks like for an elementary school child. An interesting finding was that more than 75 percent of the Black children and 66 percent of the whites said that their mothers wanted them to be "one of the best students in the class."

The second category of child-rearing practices is traceable to an African heritage.

Let us turn our attention to the strong religious orientation of Black child rearing. Akbar (1975) observed that Black women "didn't know nothin' 'bout Dr. Spock, but they did know the Bible—'raise up a child in the way he should go and when he is old he will not depart from it.' "

As Hill points out, even though the strong religious orientation of Black families is widely discussed, it has almost never been empirically documented. Furthermore, Hill's and other discussions of the Black church focus primarily upon the political role of the church during slavery and the civil rights movement (1972). The church's economic leadership is demonstrated by the leadership of Rev. Leon Sullivan and Rev. Jesse Jackson.

Other studies of the Black church focus on the emotional quality of the services and the spiritual release the parishioners receive as they dream of "pie in the sky by and by." However, very little attention has been given to the role of the Black church as a socializing institution. W.E.B. DuBois (1899) has produced one of the most significant works that examines that role.

DuBois states that the Black church is a center of social intercourse to a degree unknown in white churches. He describes the life of an individual or family closely involved in the church as being somehow different than those who do not have that involvement. Church membership is not limited to Sunday morning contact at worship services. It provides children and adults with a peer group. The organizations and activities of the church give Black people an opportunity to provide leadership and exhibit and develop competencies that are not available in the broader society. Thus, a woman who is a domestic worker all week is the president of the missionary society at her church. A man who is a janitor all week is a member of the church trustee board and obtains experience in handling a budget and develops expertise in financial matters.

Comparable experiences are provided for children growing up in the church. Entertainment and athletics are two of the means by which Black youths have been able to achieve wealth and enhanced status. However, little recognition is given to the fact that the church is the training ground for Black musicians. Children gain experience and training singing in church choirs. Some move into semisecular groups such as gospel groups; others move directly into rhythm and blues. A case in point is Aretha Franklin (who is a preacher's daughter), Isaac Hayes, The Staple Singers, and countless others.

So, the church is the hub of social life for those involved. Clearly, Black women participate in the largest numbers in church worship and activities. Often the question is raised of how Black women who are single can manage so well in raising their children alone. The answer is that they are not *alone*. The church becomes a kind of extended family fellowship; it provides other significant adults to relate to the children, as well as material and human resources to the family.

The realms of feeling and effect and the cognitive processes arising from interpersonal relations may have important implications for Black people. Research suggests that Blacks are a very emotional people. Some scholars have suggested that the emotion-charged, people-oriented quality of Black expression is part of an African heritage:

> Knowledge in Western societies is largely derived from such propositions as "I think, therefore, I am." The non-Western heritage of Afro-Americans suggests that knowledge stems from the proposition that, "I feel, therefore, I think, therefore I am" [Dixon and Foster, 1971: 18].

> The uniqueness of Black culture can be explained in that it is a culture whose emphasis is on the nonverbal. . . . In Black culture, it is the experience that counts, not what is said [Lester, 1969: 87].

This does not mean that Black people don't think or conceptualize their experiences symbolically; rather, these scholars suggest that intellectual

analysis disconnected from feelings leads to incomplete knowledge of the world (Haskins and Butts, 1973).

Many research studies have found Black children to be more feeling-oriented, more people-oriented, and more proficient at nonverbal communication than white children.

The work of Young (1970: 276) is notable in providing evidence about child-rearing practices that influence this "people orientation."

> Even though household composition varies widely in the Black community, each is almost certain to contain many different types of people of all ages to hold and play with the baby. In many cases, the physical closeness between infants and adults is reinforced by the fact that they are often observed to sleep with their parents or either parent alone. There is a kind of rhythm found between eating and napping with short periods of each activity found with frequent repetition. This rhythm is very different from the disciplined long span of attention cultivated in middle-class child-rearing and expected in schools.

Because the babies are held so much of the time, there is a direct response to urination and bowel movements. Hence, from an early age, there is an association in the infant's mind between these functions and a response from the mother. Consequently, when the mother seeks to toilet-train the child (in the early and stringent manner that has been observed in the Black community), the child is accustomed to her direct involvement in this process. In contrast, the transition is more startling for middle-class American infants whose functions have typically occurred alone. The mother begins to interfere with the bowel and bladder functions after many months of paying no attention to them. There is greater continuity in the behavior of Black mothers (Young, 1970: 278).

Young contrasts the highly personal interaction with the low object orientation found in the Black families. She noticed that few objects were given to the babies. The only type observed were some plastic toys that the mother may have picked up in the supermarket while shopping. Also, when babies reached to grasp an object or feel a surface, they were often redirected to feeling the holder's face or engaged in a game of "rubbing faces" as a substitute. This inhibition of exploration is possible because

> there are always eyes on the baby and idle hands to take away the forbidden objects and then distract the frustrated baby. The personal is thus often substituted for the impersonal [Young, 1970: 279–280].

It has been reported that there is a minimal amount of verbal exchange in lower-class families. Young observes that this is because of the abundance of communication in other forms. She observed the people to look deeply into each other's eyes, not speaking, but seeming to communicate fully. She

suggests that parents use this to impress a point on a child. It has been noted that Black people avoid meeting the eyes of whites and this has been interpreted as a gesture of inequality. However, Young suggests that it may, instead, be a gesture of unwillingness to communicate. Other forms of nonverbal communication are the mother's caressing of the baby and children sitting in a circle rubbing bare feet. Young also notes what she calls a "mutuality" in family relations exhibited in remarks that pass between mothers and children:

> "I'm tired," the three-year-old girl complains. "I'm tired, too," her mother responds. "I want some ice cream," the eight-year-old says wistfully as the ice cream truck passes. "I want some, too," is the mother's way of saying no. This echoing of words and tone of voice is a common speech pattern. One does not see mother and children clash and contend [Young, 1970: 286].

Young concludes that there are distinctive cultural styles that provide the milieu for the personality formation of Black children. This cultural style needs to be carried over into the learning environment of the school.

Leichter (1973: 244) develops the concept of educative style. She uses the term educative style to include school and nonschool institutions. There should be an exploration of the "cultural distance" in educational values between parents and teachers. To what extent does the school reinforce, complement, contradict, or inhibit the efforts of the family and community; and to what extent does the family and community reinforce, complement, contradict or inhibit the efforts of the school? In Leichter's opinion, note should be taken of the fact that children learn from many persons as well as school teachers. Educators should gain an understanding of how the child moves through and utilizes diverse educative experiences over a lifetime. (1973: 239).

Leichter warns against the current trend of determining educational policy by considering singly variables and treating aspects of education in isolation. The concept of educative style encompasses the total social (cultural) situation of the individual. She describes the confusion that has resulted in these disjointed considerations of the influences of the culture on education. An example is that one group of policy makers in early childhood education will advocate removing the lower income child from the home and providing compensatory experiences; and others will advocate subsidizing the mothers to *remain at home* with their children instead of working. Some of the extremes of this kind of debate could be averted if a theoretical perspective could postulate the best combination of family, community, and school effort.

Leichter observes:

In designing programs and considering questions of the most effective points for education intervention, the issue of how individuals combine educative experiences and the styles by which they educate *themselves,* both in early childhood and later in life, is clearly fundamental [1973: 249].

There is a need for further investigation of the mother-child relationship among Black Americans. This research should have strong implications for educating Black children, particularly in early childhood settings. There is a need for greater continuity between the behavior of the mother and the behavior of the teacher. Through careful study of the child rearing of Black mothers and the resultant learnings styles of Black children, we may obtain important information on how to achieve continuity among the home, school, and community in educating our children.

REFERENCES

Akbar, N. (1975) Address before the Black Child Development Institute Annual Meeting, October, San Francisco, California.

Bell, R. (1971) "The relative importance of mother and wife roles among Negro lower class women," in R. Staples (ed.) The Black Family: Essays and Studies. Belmont, CA: Wadsworth.

Davis, A. (1971) "Reflections on the Black woman's role in the community of slaves." The Black Scholar.

Dixon, V. J. and B. G. Foster (1971) Beyond Black or White. Boston: Little, Brown.

DuBois, W. E. B. (1973) The Philadelphia Negro. Millwood, NY : Kraus Reprint.

Gitter, A. G., H. Black and D. I. Mostofsky (1972) "Race and sex in perception of emotion." Journal of Social Issues 28.

Hale, J. E. (1974) "A comparative study of the racial attitudes of Black children who attended a Pan-African and non-Pan-African preschool." Doctoral dissertation. (unpublished)

Haskins, J. and H. F. Butts, (1973) The Psychology of Black Language. New York: Barnes and Noble.

Hill, R. (1972) The Strengths of Black Families. New York: National Urban League.

Kochman , T. (1970) "Toward an ethnography of Black American speech behavior," in N. E. Whitten, Jr. and J. F. Szwed (eds.) Afro-American Anthropology. New York: Free Press.

Ladner, J. (1972) Tomorrow's Tomorrow: The Black Woman. Garden City, NY: Doubleday.

Leichter, H. J. (1973) "The concept of educative style." Teachers College Record 75.

Lester, J. (1969) Look Out Whitey! Black Powers Gon' Get Your Mama! N.Y.: Grove Press.

Levine, L. W. (1977) Black Culture and Black Consciousness. New York: Oxford University Press.

Nobles, W. W. (1975) "Africanity in Black families." The Black Scholar (June).

Time Magazine (1977) "Polling the children." March 14.

Young, V. A. (1970) "Family and childhood in a southern Georgia community." American Anthropologist 72.

5

SHE WHO IS BLACK AND MOTHER:
In Sociology and Fiction, 1940-1970

Gloria Wade-Gayles

Using different tools and guided by different perspectives, the novelist and the sociologist come to their finished products via distinctly different routes. The novelist begins with an artistic vision and, guided by creative inspiration, shapes that vision into a fully drawn *synthetic* picture of life. Freely he uses personal, vicarious, and imaginative experiences that support and illustrate his understanding of the cultural matrix in which he lives. By contrast, the sociologist is guided by the directives of scientific investigation. He begins with a hypothesis, not an artistic vision, and he tests that hypothesis through analysis of real people in real situations in real places. Whereas the novelist offers an individualized, personal view of reality, the sociologist renders a theory on real life, or reaffirms or refutes existing theories.

Unquestionably, these are divergent paths, but they intersect and converge. Both lead to a statement on people and the dynamics of social processes, or the "qualitative life." This, precisely, is the thesis of Wright's introduction to *Black Metropolis: A Study of Negro Life in a Northern City* (Cayton and Drake, 1948). Wright spoke of a common subject painted on different canvases in different tones and arrangements and with different strokes of different brushes. His own art, Wright claims, was greatly enriched, if not guided by, scientific studies of Black life conducted by the then-famous Department of Sociology at the University of Chicago. Throughout the lengthy and classic essay, Wright so carefully pulls sociology and fiction together that his thesis seems beyond challenge: "Sincere art and honest science are not far apart, each [can] enrich the other" (Cayton and Drake, 1948: II, 17).

This weighty thesis was written more than 30 years ago, and yet there have been few, if any, serious attempts to test its validity and examine its limitations. This chapter seeks to do both by drawing an in-depth portrait of the Black mother in America as she is presented in selected novels and in selected sociological studies published between 1940 and 1970. The portrait highlights three features: (1) child-rearing posture, (2) maternal aspirations, and (3) maternal fulfillment.

Imaginative features for the portraits are extracted from five novels over four decades. All five novels place the Black mother at the center of development of plot and theme. All five are significant works, having received critical attention in such reputable journals as *CLAJ, Black World, Phylon, Freedomways,* and others. Further, as a group, the novels reflect artistic visions of both sexes.

Historically, sociology has been dominated by white scholars, most of whom are men. Consequently, sociological works in this study cannot be juxtaposed to the novels according to the sexual or racial identities of the scientists. Nor can the studies and the novels be chronologically juxtaposed. As Billingsley explains in *Black Families in White America* (1966), not until the 1930s did sociology "discover" the Black family, and when the '50s began, the "discovery" was virtually abandoned (1966: 205).

These unalterable facts about sociology as it has treated the Black experience in America dictate a special set of criteria for the selection of sociological works in this study. Those works are chosen for two reasons, and two reasons only: (1) They are relevant to the subject of this chapter and (2) they are considered reputable to the studies in the discipline. The articles are found in scholarly journals such as *The Journal of Social and Behavioral Studies, Journal of Marriage and the Family, The American Journal of Sociology, Social Forces,* and others that are major in sociological research. All the articles and the nine book-length studies are frequently cited in various scientific examinations of the Black family in America.

The scope and objectives of this study necessitate examination of a great body of material—eight novels, seven articles, nine book-length sociological studies, not to mention numerous works read but not cited here. In a brief paper, detailed discussion of these sources is simply not possible. Consequently, only the *sharp* lines of the fictional portraits and the *major* conclusions of the sociological studies will be discussed. Analysis of extractions from the works rather than discussion of the works themselves best serves the objectives of this present study. While these objectives involve discussion of similarities and differences between fiction and sociology, they go beyond mere comparison and contrast. Primarily, they seek to make "data" from fiction and data from sociology interpenetrate. Proof of interpenetra-

tion will document the existence of an enriching relationship between "honest science" and "sincere art."

For the 1940s, the first decade of this study, Richard Wright's Mrs. Thomas in *Native Son* (1940) is a classic mother in "sincere art." Of special importance is the fact that she is the mother of Bigger Thomas, the most celebrated antihero in Black American fiction. Without the assistance of a male provider, Mrs. Thomas rears Bigger and his teenage brother and sister in the narrow confines of a one-room kitchenette in Southside Chicago. When the novel begins, she is a severe voice awakening her children to the bleak reality of their lives, and throughout the novel her voice remains severe. Indeed, the sharpest line of Wright's portrait of the mother is the negative role she plays in Bigger's struggle toward healthy manhood.

Wright is emphatic about Mrs. Thomas' child-rearing posture: It is stern, cold, distant, and unsympathetic. Instead of affection, she gives ridicule: "You're just a plumb Black crazy fool!" (1940: 12–13). Instead of praise, she offers prophecies of doom: If Bigger does not reform, she tells him, he will end up "regretting the way you live," for his future shows only the thick shadow of the gallows (1940: 14).

Sewing lessons at the Y for Vera are stepping-stones to Mrs. Thomas' definition of success for the young girl. A chauffeur's job for Bigger is, from her perspective, a deterrent to his involvement with street gangs and a sure path toward maintaining the family's welfare status. Destitute of hope and vision, Mrs. Thomas cannot aspire beyond niches marked

> for poor blacks: in bold and indelible print. Understandably, then, maternal
> joy and fulfillment are anathemas to her reality. Thus is Wright's portrait of
> Mrs. Thomas inseparable from her maternal moan: "Bigger, sometimes I
> wonder why I birthed you" [Wright, 1940: 15].

The portrait of Elizabeth Grimes in James Baldwin's *Go Tell It on the Mountain* (1953) is drawn from a new perspective.

Elizabeth Grimes is not a welfare mother and she does not hold the family together in the absence of a male provider. Her husband, Rev. Gabriel Grimes, a storefront preacher, is very present in the family. In fact, he is a thorn in Elizabeth's existence. Hypocritical in his Christian posture and domineering in the role of father/husband, Gabriel shows preference for the two children of his union with Elizabeth and hostilely rejects Elizabeth's bastard son, twelve-year-old Johnny. Because Elizabeth must defend Johnny against his stepfather's rage, her child-rearing posture toward him in particular is one of warmth, affection, and sympathy. She is the boy's protector and friend. Baldwin writes, "The avowal of her love . . . lent to John's bewilderment a dignity that consoled him" (1953: 11–12).

As the title of the novel suggests, the story of Elizabeth Grimes takes its metaphors and symbols from Black religion. The storefront church, the

singing and praying church mothers, the fast/gentle moving of tambourines add color and rhythm to the spiritual suffering of Elizabeth Grimes. Her maternal aspirations reflect this emphasis on religion. More than anything else, Elizabeth wants the "Lord to have mercy on her son, and spare him the sin-born anguish of his father and his mother" (1953: 175). As a "saint," Elizabeth carries well the "cross" of motherhood, believing that if she can succeed as Johnny's mother, she will atone for the sin of giving birth to an illegitimate child. Like all "saints," Elizabeth will know "glory" only in heaven, she believes. Baldwin's description of her outlines "a sad" face that carries "hard lines" and a "deep perpetual scowl" (1953: 22).

Of all the novels that will be discussed in this chapter, John Williams' *Sissie* (1969) is undoubtedly the most provocative study of the Black mother. In his introduction to the work, Williams places the novel among the many substantive responses to Daniel P. Moynihan's controversial work, *The Negro Family: The Case for National Action* (1967). He writes that his character, Sissie Joplin, is not the image of the Black matriarchy Moynihan discusses. She could "not be such a stern, sexless, humorless creature" (1969: 9). In light of these comments, it is interesting that *Sissie* is often used as a fictional illustration of some of the very problems Moynihan addresses in his work.

Written in flashbacks provided by Sissie's children, Ralph and Iris, the story is Sissie's journey from marriage through motherhood to death. The journey begins with the sensuous sounds of Sissie's marriage to Big Ralph. In the beginning, they had few material things, but they had each other and a joyous mixture of passionate nights and carefree days anxious for the nights. "Then one day Sissie discovered that she was pregnant . . . and the condition came as a shock to her. Soon she would not be able to work. They would have difficulty sustaining on what Ralph made. Their life would suddenly be different" (Williams, 1969: 157).

Within months after the birth of the child, Ralph loses his job and is unable to find employment of any kind. Their life becomes "suddenly different." Poverty sets in like a plague and spreads as rapidly and as devastatingly. Overnight, it seems, Sissie Joplin, the sensuous woman with a "gypsy soul," becomes a hardened shell of bitterness and despair. In the role of mother, she becomes a study in extreme disillusionment. She is psychologically abusive toward her daughter Iris, and for the smallest infraction of her rules, she physically abuses her son Ralph. She brandishes a "leather belt," sometimes "losing all sense of time and reality" (Williams, 1969: 186). After each expression of maternal abuse, Sissie attempts to make amends, but the abuses return and return until Sissie submits to her own dissipation. Neither maternal aspirations nor maternal joys are possible for Sissie Joplin.

On her deathbed, Sissie faces her two surviving children, now successful adults, and seeks their forgiveness for her maternal errors. She pleads that they understand: "I couldn't have a single dream so you could have a little teeny one" (1969: 190). Their response is an indictment of Sissie's failure as mother: "Ah, Sissie, it cost too much—pain, guilt, hate, rage, and much too little love" (1969: 227).

Kristin Hunter's *The Soul Brothers and Sister Lou* (1968) is also a novel from the 1960s, but it is a welcomed contrast to Williams' story of tragedy and defeat. It is the joyful sound of beauty and strength in the Black experience, and an all-too-obvious attempt to capture in fiction the meaning of the Afro and the rhythm of soul music. Its setting is Harlem, but Hunter's Harlem has a heroine who makes the ghetto experience a song to sing about. Fourteen-year-old Lauretta Hawkins, imbued with an all-Black-people-can-sing talent, soul-sings herself, her large family, and her peers to a heightened level of racial consciousness.

The Harlem family Hunter sings about is the Hawkins family, composed of Momma, her eight children (ages nine to 21), and one illegitimate grandchild. It is a single-parent family, but it is *not* a welfare family. The post-office salary of Momm'a oldest son, William, and Momma's careful stretching of the dollar have kept the family proud that they never had to go on welfare after the father's mysterious desertion.

As a symbol of Black motherhood, Momma Hawkins is refreshing: She delights in "being Momma." Old-fashioned, religious, and strict, Momma sets the rules and insists (using the rod when necessary) that they be obeyed. The beauty of Momma is her ability to mix firmness with affection and a religious posture with love for soul music. Using this music as a symbol of family warmth and cohesiveness, Hunter writes:

> The whole family loved to dance, but Momma was the best dancer of them all . . . shuffling in her slippers so that her feet barely seemed to move. Momma's maternal joy explains why the poor family of nine children "had more fun than any other family in town" [1968: 22] Hunter.

Unfortunately, Momma's song has one dissonant note: She places a low ceiling on her children's dreams for the future. She wants for them a decent, Christian life, a good name, and a good job. Nothing more is included. Education in particular is not included. Lauretta speaks of a college education, and Momma comments on Black folk trying to "rise too high." William wants to attend night school and Momma preaches, "You have a good job already. What you need school for?" Born and reared in a volatilely racist South and confronting each day the bleak exigencies of Black life in Harlem, Momma believes that, as Blacks, her children should "stay in your place even if it's a miserable corner, and hang on to what you have" (1968: 39).

The Coffin family in Louise Meriwether's *Daddy Was a Number Runner* (1970) is not drawn in humorous or satiric lines. Tragedy and irony dominate the novel. Told from the point of view of fourteen-year-old Francie Coffin, the novel dramatizes the struggle of a strong Black family to remain strong and intact during the difficult years of the Depression. Survival does not come easy for the Coffin family because the father, a number runner, cannot earn enough to sustain his wife and their three teenage children. And then there is the additional problem of pervasive crime in Harlem!

The uniqueness of Meriwether's portrait of the Coffin family is her reversal of traditional images of the Black father and the Black mother. Here the father, a number runner, is the favored parent, a symbol of laughter and warmth. The mother, on the other hand, a study in extreme anxiety, lacks laughter and warmth. "Beautiful" Daddy "curses and kisses," Francie explains. "Mama didn't curse you, but she didn't kiss you either" (1970: 18). Even at the critical time when Francie enters puberty, Henrietta Coffin is unable to offer maternal warmth. She gives the girl three orders in a tone of seeming detachment: "Shut up that screaming." "Don't mess with boys." "Change this pad every couple of hours" (1970: 102).

In spite of her distance, Henrietta Coffin is a devoted mother. Indeed, her distance is a reflection of her devotion to her family and, more importantly, of her prayer that the children experience a future totally different from the present that holds them on the edge of survival. Whereas "Beautiful" Daddy talks of Black pride and wishes for his children's education, "Ugly" Mama plans for education and, in the process, insists that character and pride shape her children's reputations. Repeatedly, Meriwether pushes Mrs. Coffin's maternal aspirations to the very center of the novel: Her children will get a college education. Even when the Depression and the welfare system in America succeed in pushing Daddy from the Harlem tenement, even when Daddy is no longer stroking the family with his love and laughter, even when potted meat can no longer be "stretched from here to yonder with mayonnaise," Mrs. Coffin remains committed to her maternal aspirations. Even when her sons have dropped out of school, she continues to believe that perhaps Francie will succeed. And so she preaches to the girl the only sermon she has ever known: "You don't be no fool, you hear? You finish school and go on to college . . . You hear?" (1970: 173).

From *Native Son,* published in 1940, to *Daddy Was a Number Runner,* published in 1970, all five novels testify that there is no monolithic Black mother in Black American fiction. In each of the novels examined, child-rearing posture is of pivotal importance to the tone of the portrait, often enhancing the artist's theme of hope and despair. And in each, child-rearing posture is uniquely handled. The alienating blindness of Mrs. Thomas, the intimate understanding of Elizabeth Grimes, the cruelty of Sissie Joplin—

these postures and others point to the rich variety of the fictional portraits.

Maternal aspirations are equally important and, like child-rearing postures, they are expressed in different ways. Mrs. Thomas' and Momma Hawkins' rough skidmarks on rich dreams contrast sharply with Henrietta Coffin's sermons on the importance of a college education. Aspirations in the portraits run the spectrum from high goals to acceptance of traditional perimeters of Black life. While it can be argued that all five mothers want their children's future to be improvements over their present realities, the present realities, and the extent and shape of those individual improvements differ from novel to novel.

Though often less concrete than maternal goals and child-rearing postures, maternal joy or despair is nevertheless central in the portraits. Indeed, this feature is a major detail, since it alone gives the mothers' assessment of their own realities. Again, there is no one maternal point of view. Mrs. Thomas wonders why she "birthed" Bigger. And while Sissie Joplin is "circumscribed by children," Momma Hawkins is moved by the sounds of motherhood—and she dances.

When we move from fiction to sociology, we move from portraits of individual mothers who are named, physically described, and spiritually and psychologically analyzed, to analyses of groups of mothers who are not named, not described, not presented in full portraits as they interact with their children. We move essentially to analyses of representative groups and to examinations of the impact that class, family structure, lifestyles, and other factors have on maternal functioning. To be sure, these factors are present in fiction, as this discussion has already documented. In fact, they are the needed frames in which portraits of the mothers are placed. However, once they are presented as details in the reality of individual mothers, they yield to artistic emphasis on character delineation. In sociology, on the other hand, these factors determine the who, what, where, and often the how of the study. Consequently, scientific examination of the three maternal features of this study is enmeshed in sociology's interest in group behavior identified according to class, family size, family structure, and other delimiting factors.

The first step of our move to sociology does not yield the kind of works this present study needs. As Billingsley explains in *Black Families in White America* (1966), not until the 1930s did sociology "discover" the Black family, and the discovery was data-oriented and preoccupied with a consuming interest in "problems." Two major, if not definitive, studies that resulted from this "discovery" are Frazier's *The Negro Family in the United States* (revised in 1948) and Cayton and Drake's *Black Metropolis: A Study of Negro Life in a Northern City* (1948). Frazier's study is a historical examination of the Black family from slavery to the 1940s which analyzes family

"problems" as they were created by slavery and racism. Cayton and Drake's work is an analytical map depicting various lifestyles in Bronzeville, Chicago's large Black community. Neither work pays particular attention to the three features of this present study. Although Frazier's study is a tribute to the strength of the Black mother (a tribute that unwittingly helped create the myth of the Black matriarchy), the tribute does not offer specifics on child-rearing postures, maternal aspirations, and maternal fulfillment or joy.

Interfacing novels from the '40s with the two sociological studies is possible, though limited. Frazier's work, for example, complements *Native Son* in significant ways. Its rich data on poverty, crime, poor housing, welfare, family desertion, and juvenile delinquency make Mrs. Thomas' maternal burdens not simply realistic, but real. The same point is true of Cayton and Drake's data on Black life in Chicago. In the case of both sociological studies, one finds specifics from real life that add weight to and enlarge the imaginative realities in *Native Son* and Ann Petry's *The Street* (1972).

Likewise, the novels add to sociological data. When readers respond to that data, they speculate on intangibles in the Black mother's reality: How does the mother function in a ghetto environment? What does she teach her children about life and what does she plan for her children's future? How does she respond to them and how does she respond to the role? Fiction gives answers to these questions and, in so doing, adds distinct shapes to specula-tions about intangibles often omitted from sociological studies.

The brilliance of the works by Frazier and Cayton and Drake should have been sufficient reason for sociology to continue its interest in the Black family, but, as noted earlier, the discipline all but ignored the Black family for a full decade. When it once again showed interest in its "discovery," it did so with a new orientation. Influenced by "the new psychoanalytic revolu-tion, a new and growing prosperity, social class considerations, mental health, and large interest in childrearing practices," sociology began to examine the three features of this study's portrait of the Black mother in America (Billingsley, 1966: 206). It is possible, therefore, for subsequent discussion of sociological works herein examined to be organized according to theories on child-rearing postures, maternal aspirations, and maternal joy or despair.

Under child-rearing posture, Bernard's *Marriage and Family Among Negroes* (1966) is a major work. It is guided by Bernard's respect for Black women, "One of the most remarkable phenomena in American history" (1966: 68). Surprisingly, Bernard's theories on the Black mother criticize rather than praise this phenomenon. Those theories include maternal indul-gence and overprotectiveness, but they emphasize maternal cruelty and neglect. "Hospitals are hosts to hundreds of mothers who disappear once

they have delivered," writes Bernard, "and there is no count of the number of infants suffering from the battered [child] syndrome (1966: 105).

It should be pointed out that these conclusions are based on Bernard's conversations with a group of Howard University students, conversations with various colleagues, and a collection of substantive theories from reputable sociological studies, both published and unpublished. Methodology is one problem in Bernard's study; scope is another problem altogether. Bernard studies the Black woman in various classes as she functions in the roles of husband and father. The study's periodicity is extensive: from slavery up to and through the early 1960s. A major undertaking for a slim work of 150 pages; Bernard's one-paragraph, unsupported, and sweeping generalizations on child-rearing postures can be seen as reflections of a fragmented methodology and a "large bite."[2]

Bernard presents data on extreme "effects" with virtually no discussion of "causes." In fiction, cause and effect are inseparable. Indeed, the fact that the mother in fiction is forced to be the kind of mother she does not wish to be makes the imaginative statement on cause as important as the dramatic illustration of effect.

Jeffers' *Living Poor* (1967) is very different from Bernard's data-oriented study. It is based on Jeffers' experiences in a public housing project in the National Capitol area, where Jeffers lived for fifteen months as a working mother, a household head, and a participant-observer. It is singularly absent of quantitative data because it is a narrative written by a social worker; a journal, a casebook, an intimately drawn portrait of individual mothers who were Jeffers' neighbors and friends. Since it is, like fiction, a *narrative* work and since Jeffers, like all eight novelists in this study, is Black, *Living Poor* is particularly unique among the sociological works examined in this chapter. It identifies three mothers by name, describes them, comments on them as they interact with their children, and gives voice to their feelings about motherhood.

Of all the sociological works examined here, only *Living Poor* adds to our understanding of the Black mother a dimension that is not present in ficiton——at least not in sharp focus in any of the novels discussed earlier. That dimension shows mothers interacting with other mothers and explaining how they see themselves in the role, how they evaluate the functioning of others in the role, and how they confront various problems that define the role. Jeffers shares with her readers the sound and mood of a society of Black mothers in the project. This angle of vision produces a multidimensional portrait of the Black mothers. It reveals them as mothers functioning *in the home* and as individuals who participate in experiences *outside the home,* always keeping motherhood central to their conversations and peer-group interactions. When we interface this kind of seeing with fiction's emphasis

on the individual mother who is drawn apart from supportive group relationships, we come in touch with a more sensitive understanding of the role that group interaction must play in the mother's ongoing response to and assessment of her identity.

In "Tracktown Children" (1970), Goodman and Beman comment on the child-rearing postures of Black mothers in "Tracktown," Houston's Watts or Harlem. From interviews with 30 school-age children, Goodman and Beman drew conclusions on the mothers' child-rearing postures. Since the conclusions are based on the children's assessments, no illustrations of the mothers interacting with children are given. As seen by the children, "Tracktown" mothers are "nice." "She don't be yelling at us all the time," or "She gives me money and food." The consensus of the children is that the mothers, loved and respected, are anchors of the home. They assign chores, see homework, mete out punishment, and warn against hazards. In these chores and others they treat their children with firmness, but with love and understanding (Goodman and Beman, 1970: 203).

In light of the disproportionate amount of emphasis sociology places on "Tracktown" families, Scanzoni writes in the preface to his work, *The Modern Black Family in America* (1971), that "as a corrective— theoretically, substantively, and practically"—his own study will deal exclusively with families that are "conjugally stable and economically secure (1971: 8). He conducted extensive interviews with husbands/fathers and wives/mothers who were heads of 400 households in a middle-class community in Indianapolis. Like the mothers in fiction, the mothers in Scanzoni's work do not represent one child-rearing posture.

Although we have interfaced individual sociological works with individual novels, it is possible to interface the works and the novels as they constitute groups of portraits. Several interesting observations result from this group interfacing. We note, for example, that in all four sociological studies—*Living Poor,* "Tracktown Children," *The Modern Black Family in America,* and *Marriage and Family Among Negroes*— essentially two factors were considered in the interpretation of child-rearing postures: family structure and class. Fiction suggests that other factors affect the way the Black mother treats her children. In the case of Elizabeth Grimes, Johnny's bastard birth and Gabriel's rejection of the boy determine how Elizabeth responds to Johnny. In each case, a unique mother-child relationship, created by circumstances other than social class and family structure, produces not *one* child-rearing posture, but *two*. These kinds of mother-child relationships and others that determine child-rearing postures are not major concerns in sociology. Interfacing fiction with sociology gives us, then, a mixture of them and variations on them, or the "rule and exceptions to the rule." It makes possible interesting speculations on the reality of

individual mothers who constitute a clearly-defined group on the other hand and a minority within the group on the other hand.

In *Marriage and Family* (1966), Bernard posits that motherhood is more highly valued than wifehood, but she adds, "Given their social class and its related problems, some lower-class Black mothers actually reject the adult female roles of both spouse and *mother*" (1966: 106) italics added). Bernard uses "some" in her statement, but she gives no data on percentages. As in her comments on maternal cruelty, she focuses here on maternal rejection. Rejection explains the countless number of abandoned children to which we referred earlier. And rejection means, of course, the absence of fulfillment. Because motherhood does not fulfill the Black woman, writes Bernard, her "poor performance in the role" is inevitable (1966: 103).

Of all the interpretations in Bernard's study, none is more surprising than her conclusion that the Black mother does not find motherhood a significant status, and performs poorly in the role. The insignificance of motherhood is like an anomaly in sociological works read for this study. Altogether different from the question of fulfillment, of course, the significance of the role for lower-class Black women is a strength in the Black family. That is the conclusion of a large number of sociological studies. Interestingly, it is the conclusion in works by Bell, on whom Bernard relied for much of her data. In "The Relative Importance of Mother and Wife Roles Among Lower Class Women" (1967), Bell posits that although the Black woman is often wife, mother, and part-time provider, she "seems to find handling the family on her own to her liking." He continues, "The lower-class Black woman has a strong commitment to the mother role" (1970: 221). Historically, Black women have always accepted their children, Bell writes, and have found rearing them, even without the assistance of the male, an experience of worth and dignity.

Jeffers writes of "the bitterness, despair and futility" often associated with motherhood in the National Capitol area. And yet, she does not suggest that the mothers, thus burdened, reject the role or find no joy in mothering. Instead, she suggests that being a mother is often a source of identity and meaning. It is that experience, like none other in their lives, which gives them immediate and frequent rewards.

In *The Sociology of the Black Experience* (1964), Thompson discusses motherhood as it is experienced by Black women in a very poor housing project in New Orleans. Using students from Dillard University as interviewers, Thompson studied some 789 mothers, most of whom were on welfare. The single characteristic those mothers had in common was their love for their children and their sense of fulfillment as mothers. For them, writes Thompson, motherhood "is the only honorable status they can reasonably expect to have" (1964: 81–82).

What needs to be underscored here is the difference between sociological theory on maternal fulfillment and fictional presentation of that fulfillment. In the former, the feature is often considered apart from other features. In fiction, child-rearing posture and fulfillment are integrated. Mrs. Thomas' bitter attacks on Bigger are manifestations of her maternal moan, and Momma Hawkins' warm involvement with her children could not exist without expressions of maternal joy. Child-rearing posture is inseparable from the question of joy or despair in maternal fulfillment. Trying to decide which comes first—despair or distance, joy or warmth—is like the unanswerable question on the chicken and the egg. It really does not matter which comes first. What matters, and in an essential way, is that one cannot exist without the other. When one is excluded, any comment on the other is incomplete; and being incomplete, it could very well be misleading, if not distorted. It follows that when some sociological works, though not all, theorize on child-rearing postures to the exclusion of maternal fulfillment or dissipation, or vice versa, the picture is incomplete. In this regard, fiction can complete and complement sociological data.

Of the three features with which this study is concerned, maternal aspirations receive the most consistent and thorough attention in sociology. If we begin with works published in the 1940s, however, we find, once again, limited comment on maternal aspirations. Frazier (1948), for example, writes that the Black mother desires a different future for her children, but he does not express in concrete terms what she envisions that future to be. Cayton and and Drake (1948), on the other hand, because they are interested in lifestyles, pay particular attention to Black aspirations. They write of upward mobility, education, respectable jobs, and Christian character, among other goals. However, they do not attribute any of these goals exclusively to the Black mother; rather, they treat them as goals of a particular class of Black families. To suggest that it is the mother in the family who determines goals would be tantamount to saying that Cayton and Drake (like Bernard and her theory of the "unnatural superiority of Black women") believe that the father is an ancillary figure in the Black family.[3]

Interestingly, one of those rare works from the 1950s comments very explicitly on aspirations, giving major attention to the mother's impact on aspirations. In "Race, Ethnicity and the Achievement Syndrome" (1959), Rosen contends that slavery taught Black people to believe in their helplessness. "The Negro life situation," he writes, "does not encourage the belief that one can manipulate his environment or the conviction that one can improve his condition very much by planning and hard work" (1959: 55). It is understandable, then, concludes Rosen, that the Black mother cannot teach her children to strive for success of any kind.

For the 1960s, Bernard's *Marriage and Family* (1966) is once again

relevant to this study. The reader will recall that Bernard wrote of lower-class Black women who criminally abuse their children and who reject the role of mother. Surprisingly, these same mothers have incredibly high aspirations for their children's futures. Bernard writes,

Even in the lowest income classes, despite the recurring characterization of the Negro family as apathetic, no research result is more consistently reported than the salience of high—some say unrealistically high—educational goals [Black mothers] have for their children [1966: 105].

Black mothers have another goal, writes Bernard, and that is to teach their children how to cope with their blackness in a white environment. Mothers teach their children "How To Be Negroes," Bernard writes, "focusing on prohibition and restrictions, the snubs, slights, insults, derision of racism." The lesson taught is the wisdom of "obsequious and subservient behavior" (1966: 147). One wonders how such behavior can be consonant with high educational goals, but Bernard does not explain the seeming discrepancy.

Lessons on "How To Be Negroes" are present in other studies of the Black experience. Indeed, the lessons and the focus on subservient behavior seem to be a given in scholarly judgments on blackness. In "The Concept of Identity in Race Relations: Notes and Queries," published in the same year as Bernard's work, Erikson, a psychoanalyst, writes that the Black mother (in sharp contrast to the Jewish mother, he carefully points out) neither desires nor stresses high achievement for her children. She attempts to "keep her children, and especially the gifted and questioning ones, away from futile and dangerous competition, imposing on them 'a surrendered identity'" (Erikson, 1965: 200).[4]

Rainwater, a noted sociologist, seems to take his cue from Erikson's thesis. In "The Crucible of Identity: The Lower-Class Negro Family" (1969), Rainwater writes of the Black mother's sense of "importance in the face of the street system. Once the children go to school and become involved in peer-group activities, the mother gives up, feeling that . . . there is little she can do to continue to control and direct their development" (Rainwater, 1965: 310).[5] In part, this submission to the street is produced by a negative attitude toward human nature, explains Rainwater. The Black mother believes "human nature is essentially bad, destructive, immoral." Her children, then, are cursed with "inherent badness" that can be suppressed only if she can isolate them from the outside world. Thus, explains Rainwater, the Black mother fails to teach her children "to embark on any course of action that might make things better" (1965: 310).

In "Lower Class Negro Mothers' Aspirations for Their Children," an empirical study of 194 lower class mothers in Philadelphia, Bell (1965) writes that the mothers were not enthusiastic or optimistic about the future.

"The general ideal for educational success is determined by what the lower-class mother sees as the reality situation." In the poor Black neighborhood, the "reality situation" is unmistakably grim. Thus, concludes Bell, the Black mother has little reason to encourage her children to pursue educational goals. She simply "does not believe in success" (1965: 449).

Coming Up Black: Patterns of Ghetto Socialization (Schultz, 1969) is an equally grim statement of achievement orientation and the Black mother. The study is a sociological narrative of Schultz' experience with 10 lower class Black families in an urban housing project. Because the environment in which the ten mothers lived was so starkly harsh, there were no high maternal aspirations. Schultz writes, "Education [as ghetto people] experience it is a handicap, not a help." Since Blacks can "earn more illegitimately without it than they can earn legitimately with it," mothers see little reason to stress education for their children. They are, in fact, so lukewarm on education, Schultz writes, that they accept from their children any old excuse for "staying home from school" (Schultz, 1969: 160–162).

The distance from celebration of maternal aspirations in the study by Bernard to the deflated importance of education in the works by Rainwater, Bell, Rosen, and Schultz is like a wide chasm that suggests difficult crossing. Nevertheless, both high and low aspirations are illustrated in fiction.

There is tremendous tension between the tone and emphasis in fiction and the tone and emphasis in these sociological studies. For Rainwater, Bell, Rosen, and Schultz, there is the explicit statement that nothing alters or raises the Black mother's aspirations for the future. It is as if being Black and being a mother means being in constant touch with low ceilings against which there is no pushing, no struggle. Their studies emphasize the Black mother's fatalistic attitude toward life. On the other hand, fiction emphasizes frustration and struggle, but not fatalism. To be sure, in the end several imaginative mothers resign themselves to bleak futures, but they do so only after a fierce struggle for survival and success ends in unalterable defeat. In fact, *all* five imaginative mothers, in unique ways, struggle for success and *all* instruct their children in moral values. Whether their struggles end in defeat or success is not the point in this interfacing. Rather, it is that struggles *are* waged.

Perhaps the sociologists emphasize fatalism because "the reality situation" they studied was far harsher than the poverty and economic deprivation presented in fiction. The point is valid, but proving it (if proof is possible) involves more space than this present study has. But even if the point *is* proved, we would still have reason to call the scientists' perspective "deviant" and their methodologies inadequate. Rainwater's article, for example, (published in *Daedalus*!) mentions no methodology and includes no data. He seems to be one of those many "experts" who can theorize about

Black life simply on the basis of their scholarly stature. Schultz studied only 10 families out of a total of 1,632 in the housing project, and yet he writes of willful surrender to "illegitimate"means of earning money. Bell concludes that the Black mother (lowerclass mother, that is) does not believe in success, and yet he studied 194 mothers only through interview. And finally, Rosen based his research on the assumption that "the Negro life situation" does not encourage belief in success or hard work. For him, Black people are victims who are "manipulated" by their environment. In effect, all four researchers suggest that there has been no success in the Black experience, that Black people know no heroes, no models of success or decency. They can be considered outsiders who went inside armed with preconceived and negative notions of the Black experience. As such, they were as crippled as the people they studied were victimized.

Quickly, and emphatically, we must add that not all white sociologists study the Black family from a deviant perspective. In several instances, they openly challenge that perspective. Kandel, in "Race, Maternal Authority and Adolescent Aspiration" (1967), is a significant case in point. She speaks directly to the deviant school when she documents that the ghetto is often a stimulant for high goals, not a deterrent. In interviews of Black mothers and students in a working-class community, in which Blacks represented 20 percent of a total population of 1,638, she observed that maternal aspirations were so high that they were "clearly unrealistic and may reflect an element of wishful thinking" (Kandel, 1967: 999). Kriesberg, another white scientist, adds a thick statistical coating to Kandel's thesis. In a study of 1,274 *father-less* families, which involved both interviews and observations, Kriesberg (1967) found that Black mothers "want their children to acquire an education even if it results in estrangement from the family" (Kriesberg, 1967: 229–230).

The most forceful statement on high material aspirations is Hill's *The Strengths of Black Families* (1972). This study raises to a new level of interpretation and strength those families that bear the brunt of the Moynihan prophecy of doom for Black America. "One of the unheralded strengths of Blacks," writes Hill, "is the strong achievement orientation of low-income families" (1972: 27). Of 75 pages in the book, 36 are devoted to charts, graphs, tables, and other quantitative particulars that reflect a national picture rather than a regional picture. All challenge the assumption that high goals are "excessively high" (enter Kandel and Kriesberg!) or "unrealistic, reflecting wishful thinking" (enter Kandel and Bernard *and* others!). They document that poor, one-parent families are far less unstable and unsuccessful than the myth implies. Hill proves that the "overwhelming majority of Black college students come from lower-income homes," and, further, that "the heads of those homes have had no college education" (Hill, 1972: 29).

Since the data in the work correspond to the reality of female-headed homes, Hill's thesis on high aspirations can be interpreted as conclusions on maternal aspirations.

This analysis of fiction and sociology published from 1940 to 1970 offers substantive proof of the validity of Wright's thesis. As we moved from *Native Son* to *Daddy Was A Number Runner* and from *The Negro Family in the United States* to *The Strengths of Black Families,* we discussed specific ways in which the selected examples of "sincere art" enriched the selected examples of "honest science," and vice versa. What is needed at this point is to pull together "data" and conclusions into a theoretical statement on the nature of the enriching relationship to which Wright paid tribute.

One trouble spot in this interplay between sociology and fiction is the disproportionate number of data-oriented and so-called deviant studies in the body of scientific material. This complexion of the material has created a large group of critics of sociology. Artists and sociologists alike belong to this group. Ellison (in Hill, 1972: 13) expresses the views of many artists when he argues that "sociological formulas, while reliable do not define the complexity of Black life." They are not in touch, he insists, with a "something else" which defines and sustains Black culture.

Contributors to Ladner's *The Death of White Sociology* (1973) express the attitudes of Black scientists toward this problem. They call for "the death" of the discipline as it has historically examined the Black experience. Clark (1963), for example, challenges sociology to "move beyond data . . . beyond facts that are quantifiable and are computable, and that distort the actual lives of individual human beings into rigid statistics" (Clark, 1964: 28).

White sociologists, too, are concerned about what they consider excessive emphasis on data in the discipline. Taking the problem beyond racial concerns, they argue that sociology must be returned to its rightful place in the humanistic tradition of intellectual thought. Toward that end, Coser (1963) advises that "Nothing human ought to be alien to the social scientist." He continues, "The sociologist who ignores literature is bound to be not merely a much impoverished man, but a worse social scientist" (1963: 4).

To suggest ways by which novelists can learn from sociology or ways by which sociologists can learn from fiction also falls beyond the confines of this study. Points of new departures for both art and science were implicitly offered in this discussion, but the validity of the total study lies elsewhere. Wright himself made reference to that validity when he commented on how much one gains from reading fiction and sociology in a sensitive and in-depth understanding of the Black experience in America. By implication, he was suggesting that the task of those of us who are neither novelists nor scientists is to use both art and science to produce knowledge that is not, to use Coser's word, "impoverished."

NOTES

1. "Child-rearing posture," a term borrowed from sociology, means the way the mother treats her children and the way she responds to their needs. "Maternal aspirations" means the plans she has for her children's future, as distinct from the plans she has for her own future. "Maternal fulfillment" means the mother's expression of joy that is rewarding as opposed to frustration that is debilitating.

2. Space does not permit a detailed discussion of the tone, emphasis, and hypotheses of Bernard's (1966) work. Some mention should be made, however, of the broad scope of the work and the rather complex and labyrinthine categories which define Black women as wives/mothers and Black men as husbands/fathers. Bernard is so overly ambitious in the work that she offers conclusions that sometimes have the weight of only footnotes. Nevertheless, her book is significant and should be included in any serious examiniation of sociological interpretations of the Black family in America.

3. Particularly in reference to *Black Metropolis* would such an assumption be a severe distortion of the author's perspective. Among works published during the forties, this work stands out as singularly positive in its approach.

4. This article is not a sociological study. However, it is frequently referred to by Black sociologists who challenge deviant interpretations of the Black experience and by white sociologists who support their conclusions on low aspirations with material from other fields. It is a major article in the *Daedalus* special issue on the Black experience.

5. As the citation shows, this article appeared in the same issue of *Daedalus* as the article by Erikson. What is interesting about the two articles is that they read the same on several points in spite of the fact that Erikson is a psychoanalyst and Rainwater is a sociologist. This kind of consistently negative conclusions in scholarly studies of the Black experience, regardless of disciplines, is a reflection of the problems Black sociologists in the 1960s are attacking as a group. See later pages in this chapter for comment on this concern.

REFERENCES

Fiction

Baldwin, J. (1953) Go Tell It on the Mountain. New York: Dial Press.

Hunter, K. (1968) The Soul Brothers and Sister Lou. New York: Scribners.

Killens, J.O. (1971) The Cotillion, or One Good Bull Is Half the Herd. New York: Trident Press.

Marshall, P. (1959) Brown Girl, Brownstones. New York: Random House.

Meriwether, L. (1970) Daddy Was a Number Runner. New York: Doubleday.

Petry, A. (1972) The Street. New York: Houghton Mifflin.

Williams, J. (1969) Sissie. New York: Doubleday.

Wright, R. (1940) Native Son. New York: Harper & Row.

Sociology

Bell, R. (1965) "Lower class Negro mothers' aspirations for their children." Social Forces 43: 130–138.

————(1970) "The relative importance of mother and wife roles among lower class women," in C. Willie (ed.) The Family Life of Black People. Columbus, OH: Charles E. Merrill.

Bernard, J. (1966) Marriage and Family Among Negroes. Englewood Cliffs, NJ: Prentice-Hall.

Billingsley, A. (1966) Black Families in White America. Englewood Cliffs, NJ: Prentice-Hall

Blau, Z. (1964) "Exposure to child-rearing experts: a structural interpretation of class color differences." American Journal of Sociology 69.

Bracey, J. et al. (1971) Black Matriarchy: Myth or Reality. Belmont, CA: Wadsworth.

Cayton, H. and S. C. Drake (1948) Black Metropolis: A Study of Negro Life in a Northern City, Vols. I and II. New York: Harcourt Brace Jovanovich.

Clark, K. (1963) Dark Ghetto: Dilemmas of Social Power. New York: Harper & Row.

Coser, L. [ed.] (1963) Sociology Through Literature. Englewood Cliffs, NJ: Prentice-Hall.

Erickson E. (1965) "The concept of identity in race relations: notes and queries." Daedalus 95: 200–215.

Frazier, F. (1948) The Negro Family in the United States. Chicago: University of Chicago Press.

Goodman, M. and A. Beman (1970) "Tracktown children," in C. Willie (ed.) The Family Life of Black People. Columbus, OH: Charles E. Merrill.

Herzog, E. (1966) "Is there a breakdown of the Negro family?" Social Work (January): 1–8.

Hill, R. (1972) The Strengths of Black Families. New York: Emerson Hall.

Jeffers, C. (1967) Living Poor. Ann Arbor: University of Michigan Press.

Kamii, C. and N. Radin (1967) "Class differences in the socialization of Negro mothers." Journal of Marriage and the Family 29: 302–310.

Kandel, D. (1967) "Race, maternal authority and adolescent aspiration." American Journal of Sociology 76: 999–1008.

King, K. (1967) "A comparison of the Negro and white family power structure in low-income families." Child and Family (Spring): 65–74.

Kriesberg, L. (1967) "Rearing children in fatherless families." Journal of Marriage and the Family 39: 229–234.

Ladner, J. (1972) Tomorrow's Tomorrow: The Black Woman. Garden City, NY: Doubleday.

————(1973) The Death of White Sociology. New York: Random House.

Moynihan, D. P. (1967) The Negro Family: The Case for National Action. Washington, DC: U.S. Government Printing Office.

Parker, S. and R. Kleiner (1967) "Social and psychological dimensions of the family role." Journal of Marriage and the Family 31: 500–506.

Quinn, E. et al. [eds.] (1972) Interdiscipline. New York: Free Press.

Rainwater, L. (1966) "The crucible of identity: the lower-class Negro family." Daedalus 95: 258–264.

Rodman, H. (1971) Lower Class Families. New York: Oxford University Press.

Rosen, B. (1959) "Race, ethnicity and the achievement syndrome." American Sociological Review 24: 55–66.

Scanzoni, J. (1966) "Family organization and the probability of disorganization." Journal of Marriage and the Family 28: 403–410.

————(1971) The Black Family in Modern Society. Boston: Allyn & Bacon.

Schultz, D. (1969) Coming Up Black: Patterns of Ghetto Socialization. Englewood Cliffs, NJ: Prentice-Hall.

Staples, R. (1971) "The myth of the Black matriarch." The Black Scholar (June): 2–9.

————(1972) "The matricentric family: a cross-cultural examination." Journal of Marriage and the Family 34: 156–165.

————(1973) The Black Women in America: Sex, Marriage and the Family. Chicago: Nelson Hall.

————[ed.] (1978) The Black Family: Essays and Studies. Belmont, CA: Wadsworth.

Thompson, D. (1974) Sociology of the Black Experience. Westport, CT: Greenwood Press.

Willie, C. [ed.] (1970) The Family Life of Black People. Columbus, OH: Charles E. Merrill.

6

"THE MEANS TO PUT MY CHILDREN THROUGH"
Child-Rearing Goals and Strategies Among
Black Female Domestic Servants

Bonnie Thornton Dill

This essay explores the family and child-rearing strategies presented by a small group of Afro-American women who held jobs as household workers while raising their children. The data are drawn from a study of the relationship of work and family among American-born women of African descent who were private household workers (domestic servants) for most of their working lives.

The primary method of data collection was life histories, collected through open-ended, in-depth interviews with 26 women living in the northeastern United States. All participants were between 60 and 80 years old. A word of caution in reading this essay: The conclusions are not meant to apply to all Black female domestic servants, but represent only my interpretation of the experiences of these 26 women.

The life history method is particularly useful in studying Black female domestic workers whose stories and experiences have largely been distorted or ignored in the social science literature.[1] According to Denzin (1970: 220), the method "presents the experiences and definitions held by one person, group or organization as that person, group or organization interprets those experiences." As such, it provides a means of exploring the processes whereby people construct, endure, and create meaning in both the interac-

AUTHOR'S NOTE: This chapter is drawn from an unpublished Ph.D. dissertation entitled, "Across the Boundaries of Race and Class: An Exploration of the Relationship Between Work and Family Among Black Female Domestic Servants" (New York University, 1979).

tional and structural aspects of their lives. It aids in the identification and definition of concepts appropriate to a sociological understanding of the subject's experience, and moves toward building theory that is grounded in imagery and meanings relevant to the subject. Collected through in-depth interviews, life histories are active processes of rendering meaning to one's life—its conflicts, ambiguities, crises, successes, and significant interpersonal relationships. Subjects are not merely asked to "report" but rather to reconstruct and interpret their choices, situations and experiences.[2] The study of Black Americans cries out for such a sensitized approach to their lives.

The child-rearing goals and strategies adopted by the women who participated in this study are particularly revealing of the relationship of work and family. As working mothers, they were concerned with providing safe and secure care for their children while they were away from home. As working-class people, seeking to advance their children beyond their own occupational achievements, they confronted the problem of guiding them toward goals that were outside of their own personal experience. These issues, as well as others, take on a particular form for women who were household workers primarily because of the nature of their work.

Unlike many other occupations, domestic work brings together, in a closed and intimate sphere of human interaction, people whose paths would never cross were they to conduct their lives within the socioeconomic boundaries to which they were ascribed. These intimate interactions across the barriers of income, ethnicity, religion, and race occur within a sphere of life that is private and has little public exposure—the family.

As household workers, these women often became vital participants in the daily lives of two separate families: their employer's and their own. In fact, they have often been described as being "like one of the family" (Childress, 1956), and yet the barriers between them and their employers are real and immutable ones. In addition, working-class Black women employed by middle- and upper-class white families observe and experience vast differences in the material quality of life in the two homes. With regard to child-rearing, employers could provide luxuries and experiences for their children that were well beyond the financial means of the employee.

This essay, therefore, presents some of the ways in which the women talked about their reactions and responses to the discrepancies in life chances between those of their children and those of their employers. To some extent, these discrepancies became the lens through which we viewed their goals for their children and their child-rearing practices. At the same time, the contrast in objective conditions provides a background against which the women's perceptions of similarities between themselves and their employers are made more interesting.

The data from this study indicate that the relationship between the employee's family life and her work was shaped by four basic factors. First, there was the structure of the work. Whether she worked full-time or part-time and lived-in, lived-out, or did day work determined the extent to which she became involved in the employer's day-to-day life. It also determined the amount of time she had to share with her own family. Second were the tasks and duties she was assigned. With regard to her own child-rearing goals and strategies, the intermingling of employer and employee lifestyles occurred most frequently among those women who took care of the employer's children. It is through their discussion of these activities that the similarities and differences between the two families are most sharply revealed. A third factor is the degree of employer-employee intimacy. An employee who cared for the employer's children was more likely to have an intimate relationship with her employing family, but not always. Though the employer-employee relationship in domestic service is characterized as a personalized one when compared with other work relationships, this does not presume intimacy between the two parties; that is, a reciprocal exchange of interests and concerns. Among the women who participated in this study, those who did not share much of their own life with their employers appeared to minimize the interaction of work and family. Finally were the employee's goals for her children. Those women who felt that their employers could aid them in achieving the educational or other goals they had set for their children were more likely to encourage an intermingling of these two parts of their lives.

On domestic work and upward mobility:
Strangely enough, I never intended for my children to have to work for anybody in the capacity that I worked. Never. And I never allowed my children to do any babysitting or anything of the sort. I figured it's enough for the mother to do it and in this day and time you don't have to do that. . . . So they never knew anything about going out to work or anything. They went to school.

Given the low social status of the occupation, the ambivalent and defensive feelings many of the women expressed about their work and the eagerness with which women left the occupation when other opportunities were opened to them, it is not at all surprising that most of the women in this study said they did not want their children to work in domestic service. Their hopes were centered upon "better" jobs for their children: jobs with more status, income, security, and comfort. Pearl Runner[3] recalled her goals for her children:

My main goal was I didn't want them to follow in my footsteps as far as working. I always wanted them to please go to school and get a good job because it's important. That was really my main object.

Lena Hudson explained her own similar feelings this way:

> They had a better chance that I had, and they shouldn't look back at what I was
> doing. They had a better chance and a better education than I had, so look out
> for something better than I was doing. And they did. I haven't had a one that
> had to do any housework or anything like that. So I think that's good.

The notion of a better chance was a dominant one in the women's discussions
of their goals for their children. They portray themselves as struggling to
give their children the skills and training they did not have; and as praying
that opportunities which had not been open to them would be open to their
children. In their life histories, the women describe many of the obstacles
they encountered in this quest. Nevertheless, there are dilemmas which,
though not discussed explicitly, are implicit in their narratives and a natural
outgrowth of their aspirations.

First of these is the task of guiding children toward a future over which
they had little control and toward occupational objectives with which they
had no direct experience. Closely tied to this problem was their need to
communicate the undesirability of household work and at the same time
maintain their personal dignity despite the occupation. While these two
problems are not exceptional for working-class parents in an upwardly
mobile society, they were mediated for Black domestic workers through the
attitudes toward household work held by members of the Black communities
in which the women lived and raised their children.

Had domestic work not been the primary occupation of Black women and
had racial and sexual barriers not been so clearly identifiable as the reason
for their concentration in this field of employment, these problems might
have been viewed more personally and the women's histories might have
been more self-deprecating than in fact they were. This particular set of
circumstances would suggest that the women at least had the option of
directing their anger and frustration about their situation outward upon the
society rather than turning it inward upon themselves. Drake and Cayton (p.
45) confirm this argument in their analysis of domestic work, saying that
"colored girls are often bitter in their comments about a society which
condemns them to the 'white folks' kitchen" (p. 246). In addition, attitudes
in the Black community toward domestic service work mediated some of the
more negative attitudes which were prevalent in the wider society. Thus, the
community could potentially become an important support in the child-
rearing process, reinforcing the idea that while domestic service was low-
status work, the people who did it were not necessarily low-status people.

The data in this study do not include the attitudes of the children of
domestic servants toward their mothers' occupation. To my knowledge,
there has been no systematic study of this issue. However, some biographies
and community studies have provided insight into the range of feelings

children express. Drake and Cayton (1945), for example, cite one woman who described her daughter as being "bitter against what she calls the American social system." DuBois talks about feeling an instinctive hatred toward the occupation (1920: 110). I have had employers tell me that their domestics' children hated their children because the employer's kids got the best of their mother's time. I have also heard Black professionals speak with a mixture of pride, anger, and embarrassment about the fact that their mother worked "in the white folk's kitchen" so that they could get an education. Clearly, these issues deserve further study.

Throughout these histories, the women identified education as the primary means through which mobility could be achieved. As with many working-class people, education was seen as a primary strategy for upward mobility; a means to a better-paying and more prestigious job. Most of the women who participated in this study had not completed high school (the mean years of schooling completed for the group was 9.2 years). They reasoned that their limited education in combination with racial discrimination had hindered their own chances for upward mobility. Zenobia King explained her attitudes toward education in this way:

> In my home in Virginia, education, I don't think, was stressed. The best you could do was be a school teacher. It wasn't something people impressed upon you you could get. I had an Aunt and cousin who were trained nurses and the best they could do was nursing somebody at home or something. They couldn't get a job in a hospital. . . . I didn't pay education any mind really until I came to New York. I'd gotten to a certain stage in domestic work in the country and I didn't see the need for it. When I came, I could see opportunities that I could have had if I had a degree. People said it's too bad I didn't have a diploma.

From Mrs. King's perspective and from those of some of the other women, education for a Black woman in the South before World War II did not seem to offer any tangible rewards. She communicates the idea that an education was not only unnecessary but could perhaps have been a source of even greater frustration and dissatisfaction. This idea was reemphasized by other women who talked about college-educated women they knew who could find no work other that domestic work. In fact, both Queenie Watkins and Corrinne Raines discussed their experiences as trained teachers who could not find suitable jobs and thus took work in domestic service. Nevertheless, Corrinne Raines maintained her belief in education as a means of upward mobility, a belief that was rooted in her family of orientation. She said:

> I am the 12th child [and was] born on a farm. My father was—at that day, you would call him a successful farmer. He was a man who was eager for his children to get an education. Some of the older ones had gotten out of school and were working and they were able to help the younger ones. That's how he was able to give his children as much education as he gave them, because the older ones helped him out.

Given this mixed experience with education and social mobility, it might be expected that many of the women would have expressed reservations about the value of an education for their children's mobility. However, this was not the case. Most of them, reflecting on their goals for their children, expressed sentiments similar to Pearl Runner's:

> This is the reason why I told them to get an education. . . . If they want to go to college it was fine because the higher you go the better jobs you get. They understood that because I always taught that into them. Please try to get an education so you can get a good job 'cause it was hard for colored girls to get jobs, period. They had to have an education.

Mrs. Runner's statement is important because it contains the rudiments of an explanation for why she and other women stressed education in the face of discriminatory practices that frequently discounted even their best efforts. Opallou Tucker elaborates on this theme and provides a somewhat more detailed explanation:

> It's [domestic work] all right if you want to do it and if you can't do anything else, but it's not necessary now. If you prepare yourself for something that's better, the doors are open now. I know years ago there was no such thing as a Black typist. I remember girls who were taking typing when I was going to school. They were never able to get a job at it. So it really [was] for their own personal use. My third child, and a niece, after they got up some size, started taking typing. And things began to open up after she got grown up. But in my day and time you could have been the greatest typist in the world, but you would never have gotten a job. It's fine to prepare yourself so that when opportunity knocks, you'll be able to catch up.

In these statements, Mrs. Runner and Mrs. Tucker convey a complex and subtle understanding of the interaction of racism and opportunity. They recognize the former as a real and tangible barrier, but they do not give in to it. They describe themselves as having taught their children to be prepared: Education was seen as a means of equipping oneself for whatever breaks might occur in the nation's patterns of racial exclusion. Thus, key to their aspirations for their children was the hope and belief that opportunities would eventually open and permit their children to make full use of the skills and knowledge they encouraged them to attain.

Nevertheless, maintaining these hopes could not have been as easy and unproblematic as hindsight makes it seem. The fact that many of the women who expressed this strong commitment to education at the time of the interview had seen their children complete a number of years of schooling and enter jobs which would never have been open to them when they were young was clearly a source of pride and satisfaction which could only have strengthened their beliefs. Thus, as they recalled their goals and aspirations for their children, they tended to speak with a sense of self-affirmation about

their choices; confidence that may not have been present years earlier. As Mrs. Runner expressed,

> I tell you I feel really proud and I really feel that with all the struggling that I went through, I feel happy and proud that I was able to keep helping my children, that they listened and that they all went to high school. So when I look back, I really feel proud, even though at times the work was very hard and I came home very tired. But now, I feel proud about it. They all got their education.

Perhaps reflective of their understanding of the complex interaction of racism and opportunity, most of the women described limited and general educational objectives for their children. Although a few women said they had wanted their children to go to college and one sent her son to a private high school with the help of scholarships, most women saw high school graduation as the concrete, realizable objective which they could help their children attain. Willie Lee Murray's story brings out a theme that was recurrent in several other histories:

> My children did not go to college. I could not afford to send them to college. And they told me, my younger one especially, he said: Mommy, I don't want to go to college at your expense. When I go to college, I'll go on my own. I would not think of you workin' all your days—sometimes you go sick and I don't know how you gonna get back. You put us through school and you gave us a beautiful life. We'll get to college on our own.

Mrs. Murray seems to indicate that while she would have liked for her children to go to college, she limited her goals and concentrated her energies upon their completing high school.

In addition to limited educational objectives, most of the women did not describe themselves as having had a specific career objective in mind for their children. They encouraged the children to get an education in order to get a better job. Precisely what those jobs would be was left open, to be resolved through the interaction of their son or daughter's own luck, skill, perseverance, and the overall position of the job market vis-à-vis Black entrants.

Closely related to the goals the women expressed about their children's future position in society were their goals relative to their child's development as a person. Concern that their children grow up to be good, decent, law-abiding citizens was a dominant theme in these discussions. Most of the women in the study described their employers as having very specific career goals for their children, usually goals that would have the children following their parents' professional footsteps. In characterizing the differences between their goals and those of their employers, the women stressed the differences in economic resources. Johnnie Boatwright was quite explicit on this point:

There was a lot of things they [employers] did that I wanted to do for mine, but I just couldn't afford it. . . . Like sending them to school. Then they could hire somebody; child slow, they could hire a tutor for the child. I wish I could have been able to do what they done. And then too, they sent them to camps, nice camps, not any camp but one they'd pick out. . . . So that's what I wished I could had did for him [her son]. . . . See, whether it was right or wrong, mines I couldn't do it because I didn't have the money to do it. I wasn't able to do it. So that's the way it was. I did what I could and that was better than nothing.

In light of these discrepancies in resources, personal development was an important and realizable goal which may have been an adaptive response to the barriers which constricted the women's range of choices. This was an area over which the women had greater influence and potential control. It was also an area in which they probably received considerable community support, since values in the Black community, as pointed out above, attribute status to success along personal and family dimensions in addition to the basic ones of occupation, education, and income.

While Mrs. Boatwright conveys a sense of resignation and defeat in discussing her inability to do for her son what the employers did for theirs, Pearl Runner is more optimistic and positive about what she was able to do for her children.

Their money may be a little more, but I felt my goal was just as important as long as they [the children] got their education. They [the employers] had the money to do lots more than I did, but I felt that if I kept working, my goals was just as important. I felt my children were just as important.

Feelings like those expressed by both Mrs. Runner and Mrs. Boatwright are reflected throughout the data in the women's comparisons of their aspirations and expectations for their children's future with those of their employers. However, it also seems apparent that their intimate participation in families in which the husbands were doctors, lawyers, stockbrokers, college professors, writers, and housewives provided considerable support for their more limited educational objectives. While not everyone had the specific experience of Lena Hudson, whose employer provided an allowance for her daughter which permitted the girl to stay in high school, the model of the employer's life with regard to the kinds of things they were able to give their children was a forceful one and is repeatedly reflected in the women's discussions of their child-rearing goals.

When asked: "What do you think were the goals that the Wallises (her employers) had for their children? What did they want for their children? What did they want them to become in life?" Lena Hudson replied:

Well, for *their* children, I imagine they wanted them to become like they were, educators or something that-like. What they had in mind for *my* children, they

saw in me that I wasn't able to make all of that mark. But raised my children in the best method I could. Because I wouldn't have the means to put *my* children through like they could for *their* children. And they see I wasn't the worst person in the world, and they saw I meant *some* good to my family, you see, so I think that was the standard with them and my family.

Her answers provide insight into the personal and social relationship between the two families and into her recognition of the points of connectedness and distance between them. The way in which she chose to answer the question reflects her feelings about working for the Wallis family and how that helped her accomplish the goals which she had set for her own family.

MRS. HUDSON: And in the meantime, they owned a big place up in Connecticut. And they would take my children, and she, the madam, would do for my children just what she did for theirs.

INTERVIEWER: What kinds of things do you think your children learned from that, from the time that they spent with them?

MRS. HUDSON: Well, I think what they learnt from them, to try to live a decent life themselves, and try to make the best out of their life and the best out of the education they had. So I think that's what they got from them.

INTERVIEWER: What would you say you liked most about the work that you did?

MRS. HUDSON: Well, what I liked most about it, the things that I weren't able to go to school to do for my children, I could kinda pattern from the families that I worked for, that I could give my children the best of my abilities. And I think that's the thing I got from them, though they [her children] couldn't become professors, but they could be good in whatever they did.

The warm personal relationship between the two families was based not only on the direct assistance which the Wallises gave Mrs. Hudson, but also on the ways in which she was able to utilize her position in their family to support and sustain her personal goals. Thus, we can understand why she saw work as an ability rather than a burden. Work was a means for attaining her goals; it provided her with the money she needed to be an independent person, and it exposed her and her children to "good" things—values and a style of life which she considered important. To some extent, Lena Hudson found the same things in her work that she found in her church; reinforcement for the standards which she held for her children and for herself.

The women who stressed education for their children and saw their children attain it were most frequently women like Mrs. Hudson who were closely tied to one or two employing families for a long period of time. For

the most part, they were the women who had careers in domestic service. However, ties with employers were not crucial even within this small group, because some women said they had received very little support from their employers along these lines. Several women, as indicated above, pointed to a strong emphasis upon education in their families of orientation. Additionally, education as a means of upward mobility is a fundamental element in American social ideology. It appears, therefore, that the importance of the employer-employee relationship was in the support and reinforcement these middle-class families' goals, aspirations, and style of life provided the women. The amount of support varied, of course, with the particular relationship the employee had with her employer's family and the degree of the employer's interest in and commitment to the employee's personal life. On the spectrum presented by the women in this study, Mrs. Hudson's relationship with the Wallis family would be at one end; the relationship between Georgia Sims and the family for whom she worked longest at the other. The following segment of the interview with Mrs. Sims is a good example of a minimally interactive employer-employee relationship:

INTERVIEWER: What were your goals for your children?

MRS. SIMS: Well, to be decent, law-abiding men. That's all.

INTERVIEWER: Do you think there were any similarities between your goals for your children and the goals your employers, the Peters, had for their children?

MRS. SIMS: Oh, sure! Oh, yes, because I mean you must remember, they had the money; now I didn't have it. Oh, definitely there was different goals between us. [NOTE: Mrs. Sims obviously understood the question to be about *differences* rather than similarities, so the question was asked again.]

INTERVIEWER: Do you think there were any things that were alike in terms of your goals for your children and their goals for their children?

MRS. SIMS: No. Nothing.

INTERVIEWER: Nothing at all?

MRS. SIMS: No.

INTERVIEWER: What kinds of goals did they have for their children?

MRS. SIMS: Oh, I mean education, going on to be, you know, upstanding citizens, and they had the jobs—My children couldn't get up, I mean when they become 20, 21, they couldn't get up and go out and say, well, I'm gonna get an office job. I'm gonna get this kind of job. No. The best thing they could do is go and be a porter in the subway.

Mrs. Sims was very detached from her occupation. She was not a career household worker. In fact, she described herself as having had very limited contact with her employers; arriving when they were all on their way to work and school and often departing before they returned home. She said that she had no specific child care duties. Thus, her description of the employer's goals for their children is probably more of a projection on her part than it is based on discussion or direct participation in the employer's life.

Two types of child-rearing goals have been identified thus far: goals regarding the child's future position in the society and goals regarding his or her personal development. In addition to these two types of goals, the women aspired to provide their children with some accoutrements of a middle-class lifestyle. Their discussion of these desires often reflects the discrepancies between their lives and those of their employers'. Jewell Prieleau describes her employer's children as follows:

> Her children always dress nice. Whenever her daughter was going to music school or anyplace, I had to take her in a taxi. Whenever she finish, she had to be picked up. I had to go get her.

In describing her own grandchildren, she said:

> I went to three nice department stores and I opened up credit for them so I could send them to school looking nice. I got up early in the morning and sent them off to school. After school I would pick them up in a taxi and bring them here [the job].

Mrs. Prieleau is not the only woman in this study who talked about going into debt to give her children some of the material things that she never had and that were part of her image of a "better life" for her children. Willa Murray told the following story:

> I remember when my sons wanted that record player. I said I'm gonna get a record player; I'm gonna do days work. But I had to get AC current for this record player. I called up this lady [her employer] and I said, I'm goin' to Household Finance this morning. If they call you for a reference would you give me some reference. She said, sure. I sat down and the man said come in. He said, Miz Murray, do you have a co-signer. I said, no. He said, well what's your collateral? I said something about the furniture. He said, do you work? I said, yeah, I do days work. He said, days work? You don't have a steady job? I said yes sir, days work. He said, who do you work for? I told him. He said, we'll see what we can do. He gave the hundred and fifty dollars. I came home, phone the electric company, told them they could send the man to put the current in.

In these statements and some of the ones quoted earlier, we begin to see how the employer's style of life influenced these women. However, it cannot be assumed that the women's desires were merely an outgrowth of the em-

ployer-employee relationship. The material products which they sought are so widely available in the culture that they are considered general symbols of upward mobility. Upward mobility for their children was the basic goal of most of the women who participated in this study. It was a goal which seems to have existed prior to and apart from their work situation and the values of their employers. Nevertheless, in some cases the women found reinforcement for and regeneration of these goals within the work situation, just as they found supports within their community and family lives.

RAISING THE "WHITE FOLKS'" CHILDREN

The women's discussion of child-rearing strategies, particularly such issues as discipline, exemplify both the class and cultural differences between employer and employee. For private household workers, these differences are expressed within a relationship of inequality. The data collected in this study permitted an examination of employer parent-child interactions as it was perceived and constructed by the household workers. This has benefits as well as liabilities. As outsiders whose child-rearing practices and lifestyle differed from those of the employers, the women in this study provide a particularly revealing picture of parent-child relationships in the employing family. However, they were not mere observers of the process; they participated in it and thereby restructured it. The women's insights, therefore, offer a unique critical perspective that is only found in subordinate's characterizations of their superiors. However, as participants in the process, their observations are limited to the time frame in which they were present and make it virtually impossible to assess the women's impact on the process. Nevertheless, their stories about their own role in rearing the employer's children provide considerable understanding of how they saw their work and, more importantly, how their work affected their own style of parenting. Willa Murray's comments illuminate this:

> Throughout, the people that I worked for taught their children that they can talk back. They would let them [the children] say anything they wanted to say to them. I noticed a lot of times they [the children] would talk back or something and they [the parents] would be hurt. They would say to me, I wish they [the children] wouldn't. I wish they were more like your children. They allowed them to do so much. But they taught them a lot of things. I know one thing, I think I got a lot of things from them. . . . I think I've learnt a lot about [how to do] with my children by letting them do and telling them—like the whites would tell them—that I trust you. I think a lot of Black mothers when we come along, they didn't trust us. They were always telling us what we were gonna do. . . . But I think they [whites] talk to their children about what's in life, what's for them, what not to do. And they let them talk, they tell them all

the things that we didn't tell our children. We're beginning to tell our children. . . . The alternative is that I told my children straight, that if a boy and a girl have sexual intercourse—I learned that from the white people—and you don't have anything to protect it, that girl will get a baby. So my children were looking out for that. I learned that from my people. I listened to what they tell [their children].

Talk between parents and children is a dominant theme of Mrs. Murray's comments. She is critical of her employers for permitting their children to "talk back" to them; to question their instructions, to respond impertinently or otherwise mock or demean the parent's authority. Yet, talking *with* the children, reasoning with them, explaining things and hearing their thoughts and opinions on various matters, is behavior which she admired enough to try to emulate. Telling the children that you "trust them" places greater emphasis upon self-direction than upon following orders. Clearly, the line between letting the children talk and permitting them to "talk back" is a difficult one to draw, yet Mrs. Murray draws it in transferring her work-learned behavior to her own child-rearing circumstances.

It should not be surprising that there would be behavioral characteristics which employers would admire in employee children, just as there were traits which Mrs. Murray and others admired in their employer's interactions with their children. In fact, it is striking that each would admire aspects of the other and seek to incorporate them within their own lives while the circumstances that generated those particular patterns were quite different. Nevertheless, reorienting the parent-child relationship in the employer's family was frequently described as a regular part of the worker's child care activity. In fact, the women's discussion of their experiences in caring for their employer's children are variations upon the stories of resistance which characterized their establishing themselves in the employer-employee relationship. Queenie Watkins' description of the following child-care incident provides a good example:

One morning I was feeding Stevie oatmeal and I was eating oatmeal. His uncle, the little girl and I were all sitting at the table together eating. He said, I don't want this and I'm gonna spit it out. I said, you better not, Stevie. With that he just let it all come into my face. I took myself a big mouthful and let it go right back in his face. He screamed, and his uncle said, what did you do that for? I said, you fight fire with fire. My psychology is to let a child know he can't do to you what you can't do to him. The mother came running. I said, this ends my work here but she said, just wash Stevie's face. I said, I'm not gonna wash it; let him wash it himself—he wasn't two years old. Finally, I said, I'll take him and wash his face but who's gonna wash my face? His mother started to laugh and said, you're some character. And you know what, he never did that again. He ate his food and I never had to chastise Stevie about anything after that.

Zenobia King told a slightly different story about the way in which she inserted her values into the parent-child relationship of an employing family:

> One time the daughter went out and she stayed all day. She didn't tell her mother where she was. And when she came back, her mother jumped on her in a really bad way. She told her she wished she had died out there, etc., etc., and her daughter said if her mother had loved her she would have asked where she was going. So, I separated them. I sent the daughter to one room and the mother to the other and talked to both of them and I brought them back together.

In both of these stories, as in others in this genre, the women see themselves as the instructor of both the children and the parents. They characterize themselves as helping the parent learn how to parent while simultaneously setting rules and regulations as to the kind of treatment they should expect from the children. Queenie Watkins' philosophy of fighting fire with fire was reiterated by Oneida Harris in describing her relations with one of the children whom she cared for:

> He was nine years old and he rate me the worst maid they'd ever had because I wouldn't take any of his foolishness. If he kicked me in the shins, I'd kick him back. . . . I said he hasn't any bringing up, and if I stay here he's gonna listen. I said to his mother, if you don't want me, tell me tomorrow and I'll go. So anyway, the next day he would bring me up a little bit; she's the next-to-the-worst maid we ever had. Each week I came up till I was the best one.

As in the stories of resistance, both Queenis Watkins and Oneida Harris depict themselves as setting guidelines for respect from the children in the same way respect was established in the employer-employee relationship. The additional dimension of instructing parents in the ways of handling their children was another recurrent theme in the life histories.

Through these and other similar anecdotes which the women used to describe their participation in caring for their employers' children, they communicate a perception of their employers as uncomfortable in exercising the power associated with the parenting role. To a large degree, they depict their employers as either inconsistent and afraid of their children or ignorant of child-rearing strategies that would develop obedience and respect. The women see this as their forte; in many instances they describe themselves as exercising power on behalf of the parents and teaching the children to obey them and to respect their parents. In so doing, they also present themselves as teaching the parents. Willa Murray is keenly aware of the paradoxical nature of this situation when she says: "Now I'm the maid, not the mistress." In the maid-mistress relationship, the latter gives instructions which the former carries out. In a sense, Willa Murray's story presents a role reversal, one which she finds both surprising and amusing but also appropriate. It is

akin to the anecdote in which she described herself telling her employers that they had more education than she did but their behavior was not intelligent. These presentations suggest that despite stereotypic conceptions of the maid-mistress relationship, women in these roles could gain considerable power and influence within a family, particularly where they had worked for a number of years and had considerable responsibility.

The household worker's impact on the parent-child relationship is only one aspect of their child care role. The other, equally important, aspect of this role is their relationship with the children they cared for and the fact, implicit in our earlier discussion, that they describe themselves as surrogate mothers for these children:

> There's a long time she [the child] use to thought I was her mamma. She would ask me why is my skin white and yours brown, you my mamma? I tell her I'm not your mamma and I see the hurt coming in her eye. You know like she didn't want me to say that. I said there's your mamma in there, I'm just your nurse. She said no, you my mamma [Mattie Washington].

> I took care of the children. In fact, the children would call me when they had a problem or something, before they would call her [their mother—Zenobia King].

> He [the boy] looked at me as a mother. When he went away to school he just would not come home if I wasn't there. And even when he was at home, if he was out playing with the boys he'd come in, his mother, grandmother and father would be sitting around, he'd say, where is everybody? His mother would look around and say well if you mean Oneida, I think she's upstairs. Upstairs he'd come. And they couldn't get that. It was sad, you see. They give him everything in the world but love.]Oneida Harris].

> I was more like a mother to them, and you see she didn't have to take too much time as a mother should to know her children. They were more used to me because I put them to bed. The only time she would actually be with them was like when I'm off Thursday and on Sundays. They would go out sometime, but actually I was really the mother because I raised them from little [Pearl Runner].

Without exception, the women in this study who had child care responsibilities talked about themselves as being "like a mother" to their employer's children. Their explanations of the development of this kind of relationship tended to follow those of Oneida Harris and Pearl Runner; Their employers were frequently unavailable and spent less time with the children than they did. Because they interacted with the children on a daily basis and often had responsibility for their care, discipline, play, and meals, their role was a vital and important one in the eyes of both child and parent. This explains, in part, some of their power in affecting the parent-child relationship, as discussed above. The fact that the women had such an important and pivotal role in the

development of the employer's children and at the same time held a job in which they could be replaced gave the entire relationship of parent, child, and housekeeper a particularly intense quality. For the most part, workers developed their strongest emotional ties to the children in the employing family.

Because the women saw themselves as surrogate mothers, the children whom they cared for could easily become their surrogate children. This is particularly apparent when we compare their comments and discussion about their own and their employer's children. One of the most prevalent patterns was to talk with pride and satisfaction about the accomplishments of their surrogate children. In general, the women would talk about how frequently they heard from these children and whether they got cards, letters, or money at Mothers' Day or Christmas. In addition, they would describe the (now grown) children's occupation and family and, if they had pictures available, they would show them to me. This type of commentary provided an interesting parallel to their discussions of their own children. But even more important, it was designed to communicate the closeness that they felt existed between them and the children they had raised; closeness which was maintained over a number of years even after the children were grown.

Surrogate mothering, as pointed out in Opallou Tucker's case study, had the prospect of tying the worker into the emotional life of the employing family. For the women who lived outside the employer's household and were actively engaged in rearing their own children and caring for their own families, as were most of the women in this study, the prospect was minimized. However, for a woman like Mattie Washington who lived in for most of the 30 years that she worked for one family, the potential for becoming enveloped in their life, at the expense of her own, was much greater.

In most instances, the women described themselves as caretakers, playmates, disciplinarians, confidantes, and friends of the employer's children. Nevertheless, it is clear from their discussion that in most cases the real ties of affection between themselves and their employer came through the children.

The children, therefore, provided both the ties that bound the women to their employers as well as the mark of their difference. The role of surrogate mother allowed the women to cross these barriers and, for a fleeting moment, express their love and concern for a child without regard to the obstacles that lay ahead. Also, because most young children readily return love that is freely given and are open and accepting of people without regard to status factors that have meaning for their parents, the workers probably felt that they were treated with greater equality and more genuine acceptance by the children of the household.

NOTES

1. There is a very limited body of literature directly focused upon Black women in domestic service in the United States. Many of these studies are confined to the Southern experience. Among the most important containing data on Black women in northern cities are Haynes (1923), Eaton (1967), and Chaplin (1964). Some discussion of the subject was also found in community studies, particularly those conducted before World War II (Drake and Cayton, 1945; Ovington, 1969). Labor studies provided a third source of data (among these were Greene and Woodson, 1930, and Haynes, 1912).

2. This discussion is largely drawn from a paper by Dill and Joselin (1977).

3. The names used for the participants in the study are fictitious.

REFERENCES

Chaplin, D. (1964) "Domestic service and the Negro," in A. Shostak and W. Gamberg (eds.) Blue Collar World. Englewood Cliffs, NJ: Prentice-Hall.

Childress, A. (1956) Like One of the Family. Brooklyn: Independence Publishers.

Denzin, N. K. (1970) The Research Act. Chicago: AVC.

Dill, B. T. and D. Joselin (1977) "The limit of quantitative methods: the need of life histories." Presented at the Society for the Study of Social Problems Annual Meetings, Chicago, September.

Drake, S. C. and H. Cayton (1945) Black Metropolis. New York: Harper & Row.

DuBois, W. E. B. (1920) Darkwater. New York: Harcourt Brace Jovanovich.

Eaton, I. (1967) "Negro domestic service in Seventh Ward Philadelphia," in W. E. B. DuBois, The Philadelphia Negro. New York: Schocken Books.

Greene, L. J. and C. G. Woodson (1930) The Negro Wage Earner. Washington, DC: The Association for the Study of Negro Life and History, Inc.

Haynes, G. (1912) The Negro at Work in New York City: A Study in Economic Progress. New York: Longmans.

——————(1923) "Negroes in domestic service in the United States." Journal of Negro History 8: 384–442.

Ovington, M. W. (1969) Half a Man. New York: Schocken Books.

7

BLACK MOTHERS AND
THE EXTENDED FAMILY SUPPORT NETWORK

Harriette Pipes McAdoo

One of the strongest Black cultural patterns is that of extensive help systems. The family's effective environment is composed of a network of relatives, friends, and neighbors. The social network acts to provide emotional support, economic supplements, and, most important, to protect the family's integrity from assault by external forces. One of the segments within the Black community that has benefited the most has been the single-parent Black family in which the mother is the only parent present in the home. One purpose of this report was to explore the operation of the Black extended family within the present-day context. We explored the differential involvement and support given Black mothers who are single parents and those who have husbands. We were also concerned with the utilization of community support systems when family needs exhaust the family resources.

Hill (1972) pointed to the extended family among Blacks as a source of strength and a protection against isolation in the larger society. Hamilton (1971) stated that viewing the higher proportion of one-parent families as unstable ignores the extended family adaptation along kinship bonds.

Billingsley (1968) stated that Black families cope by banding together to form a network of intimate mutual aid and social interaction with neighbors and kin. In support of this, Gibson (1972) felt that while the household was the basic unit with married couples, those who were in more insecure settings of all classes and groups, the unmarried, divorced, and widowed, were

AUTHOR'S NOTE: This research was supported under Grant 90-0-631(1), Department of Health, Education, and Welfare, Office of Child Development.

intimately integrated into the extended kin network.

Extensive kin family systems are found with complicated matrices of aid and service activities that linked together the family units into a functioning network (Rainwater, 1966). The services provided fell into four categories:

(1) Care of children, advice given, shopping, counseling, ongoing activities;
(2) services to older persons;
(3) providing for kin on the move (finding homes, jobs, etc.);
(4) assistance on special occasions and times of crises.

The main flow of financial aid was along generational lines: parent to young married, and middle-aged to aged.

Stack (1974), in an anthropological study of poor Black families, found an extended cluster of kinsmen related through children, marriage, and friendship who ally to provide domestic functions. Stack found the ties between women often constitute the core of the network. Although household composition changed, members were selected largely from a single network that has continuity over time. A variety of structures were found. Brewington and Comerford (1974) found in their sample that the Black families gave family assistance in finances (79 percent), help on important decisions (63 percent), help on special occasions (65 percent), clothing, food and furniture (50 percent), and transportation (52 percent).

Billingsley (1968), Ladner (1972), Stack (1974), and Heiss (1975) have all stated in their studies that the urban poor Black parents who are rearing children without fathers often exist within an extended family context of kin and fictive kin. The present structural forms that have evolved for Blacks are seen as the best ones from the alternatives that were possible (Gutman, 1976), which offset the detrimental strains that such families may experience. These earlier studies (Hill, 1972; Billingsley, 1968; Stack, 1974; and others) had documented the stabilizing influence of the extended family when it is in poverty. Stack noted that the extremely poor Black family has not developed along the nuclear pattern because there is a need to provide an alternative system of savings and insurance. The cooperative supports in the extended family sustain and help socialize the family members. McQueen (1971) also felt that the Black family would not be able to cope with poverty without this mutual assistance.

The involvement in the "kin-help insurance policy" has been the only means of survival. Many have come to look upon this as a successful coping mechanism. However, one must question the use of the term "coping mechanism" because it implies that this is a defense needed only when in poverty, to be abandoned once the poverty is no longer present. In other words, the Black who is able to become solidly working class, or even middle class, would no longer need the extended family and would enter the mainstream with only an individualistic orientation.

My own research (McAdoo, 1977) has indicated that this is not the situation. The Black family appears to have evolved a system of involvement within the wider extended family that has shown that the kin-help network is not a coping mechanism to be thrown away with the advent of increased income. It has become a viable part of our cultural patterns that has been found to be operational at all economic levels before, during, and after upward mobility, even into the third generation of middle-class status.

As my earlier work debunked the myth that middle-class Blacks are withdrawn from the extended family, I wanted to return to the data to see if the single mothers were more involved in the extended family and if mothers who had husbands who were reasonably financially secure had become less involved in the kin network. It was assumed that these parents were all involved within the kin system to an extent, but we wanted to document the mother's differential involvement within her wider family based on whether she was head of the household or if she was married.

METHOD

DATA COLLECTION AND ANALYSES

A questionnaire had been developed and field-tested twice in a larger research project (McAdoo, 1977) that looked at the impact of the extended family on upward mobility. For this study the data on the mothers only were extracted and were reanalyzed on 271 variables. The independent variables were: (1) Family type—single or married; (2) demography—urban, suburban; (3) socioeconomic status—working or middle class; and (4) mobility pattern—born working or middle class. Single mothers included those who were divorced, separated for a long period of time, never married, or widowed.

The instrument used was the Family Profile Scale that gathered data on (1) basic background information and the dependent variables; (2) extended familialism and kin-help scale; (3) educational and occupational mobility over four generations; (4) family structure, parental decision-making: (5) schedule of recent life experiences; (6) family size change; (7) comfort with child care; (8) satisfaction with life; and (9) preference for and utilization of family support systems.

In each family, the mother was interviewed for two and one-half hours by a Black female interviewer. Parents were then asked to fill in personal data sheets at their leisure (a 45-minute process) that provided background demographic information and three separate scales.

In single-parent homes, the mother was asked to fill out a background data sheet on herself and on the other parent. While there was some missing information on the nonresident or deceased parent, we were thus able to get some mobility data on both sides of all of our families. Comparisons were

made on both the paternal and maternal line to allow a more accurate analysis of the family's mobility over three generations. While data were obtained from or about both parents, the mother was the unit of analysis.

SAMPLE SELECTION

To test the impact of these family factors on the mother, only those already in the middle income were selected as the target group. Parents were selected from a mid-Atlantic metropolitan center to fit into the independent variables of demography and family type. One-half were in the District of Columbia and the other half were in the nearby suburban town of Columbia.

Columbia is a ten-year-old, planned new town located in Maryland, 15 miles outside of the District. While unique in the convenience of its urban planning, it typifies pleasant suburban sites across the country. A nearly complete list of all Black families was constructed from membership lists of every Black families organization, church rolls, and lists gathered from public and private preschools and elementary school rosters. These lists were then assembled into one master list from which the names were randomly selected with replacements. The suburban sample was selected first; then census tracts matching the suburban sample on income and education were selected in the urban center.

All of the mothers had to meet the following criteria: (1) Black; (2) a middle-income status (minimum income of $10,000 for one-parent, and $14,000 for two-parent homes); (3) had school-age children living in the home under the age of 18 years; and (4) were over the age of 25. The parental age cut-off was used because the period before age 25 is the time during which the prerequisites of socioeconomic status are developed: education, occupational, and income level. By age 25, the SES level begins to become apparent.

RESULTS

SAMPLE CHARACTERISTICS

Family type. Interviewers talked with 175 mothers; 26 percent were single and 74 percent were married, a distribution similar to the national census distribution in Black families. Fifty percent (88) were urban and 50 percent (87) were suburban. When broken down for family structure, 91 percent were in nuclear units of either one-parent (23 percent) or two-parent families (68 percent). Only 6 percent actually lived in extended families, 2 percent with one parent and 4 percent with two parents. The augmented form, in which a nonrelative lived in the home, only occurred with 3 percent of the mothers, 2 percent in one-parent, and 1 percent in two-parent units (see Table 1).

TABLE 1 Frequency Distribution of Sample by Family Type, Demography, Family Structure

Group	Total f	Total %	One-Parent f	One-Parent %	Two-Parent f	Two-Parent %
Demography						
Urban	88	50	18	40	69	55
Suburban	87	50	27	60	57	45
	175	100	45	100	126	100
Family Structure						
1-parent nuclear	40	23	39	91	—	—
2-parent nuclear	117	68	—	—	117	93
1-parent extended	3	2	3	7	—	—
2-parent extended	7	4	—	—	7	6
1-parent augmented	3	2	1	2	—	—
2-parent augmented	2	1	—	—	2	2
	172	100	43	101	126	101
Marital Status						
Single	5	3	5	1	—	—
Married	123	73	—	—	123	100
Common law	1	1	1	2	—	—
Separated	18	11	18	40	—	—
Divorced	17	10	17	38	—	—
Widowed	4	2	4	9	—	—
	175	100	45	100	123	100

By marital status, 73 percent were married, 11 percent were separated, 10 percent were divorced, 3 percent had never been married, 2 percent were widowed, and 1 percent was single in a common-law relationship.

Social class status. Three procedures of social class were used. The standard Hollingshead-Redlich procedure gave a higher factor loading to occupational than education. The H-R SES Modification gave a higher factor loading to education rther than occupation, because traditionally the Black female has not been able to obtain jobs commensurate to her education. This modification was considered to be a more sensitive and culturally fair procedure to use. In addition, each mother was asked to rate her own SES status and those of her parents, grandparents, and their neighbors.

Using the modified SES coding, mothers rated themselves into four groups: 43 percent put themselves in the upper class, 41 percent in upper-middle class, 14 percent in lower-middle class, and 2 percent in working class. The majority of both groups of mothers rated themselves as middle class, but one-third of the single mothers (36 percent versus 19 percent married) rated themselves as working class; this despite the fact that all had been screened as having met the minimum criteria for being considered middle class. When both groups rated their parents and grandparents, no

TABLE 2 Frequency Distribution and Chi-square of Mothers' Socioeconomic Status (Hollingshead and Redlich and Self-Rating) of Subjects and Ancestors by Family Type

Status Rating Class	Total		One-Parent		Two-Parent		X^2	df	p
	f	%	f	%	f	%			
Hollingshead-Redlich									
Class I	61	36	7	16	54	43	21.86	4	.0002
II	82	48	22	49	60	48			
III	24	14	13	29	11	9			
IV	3	2	2	4	1	1			
V	1	1	1	2	—	—			
	171	101	45	100	126	101			
Hollingshead-Redlich Modified									
Class I	73	43	9	20	64	51	22.04	3	.0001
II	70	41	20	44	50	40			
III	24	14	13	29	11	9			
IV	4	2	3	7	1	1			
	171	100	45	101	126	101			
Self-Rating: Self									
Upper class	8	5	3	7	5	4	6.39	2	.04
Middle class	122	72	26	58	96	77			
Working class	39	23	16	36	23	19			
	169	100	45	101	124	100			
Self-Rating: Parents									
Upper class	4	2	2	4	2	2	6.23	3	ns
Middle class	61	36	21	47	40	33			
Working class	96	57	19	42	77	63			
Lower class	7	4	3	7	4	3			
	168	99	45	100	123	101			

TABLE 2 Continued

Self-Rating: Grandparents									
Upper class	5	3	1	2	4	3			
Middle class	22	14	6	15	16	14			
Working class	112	71	26	63	86	74			
Lower class	18	12	8	20	10	9			
	157	100	41	100	116	100	3.73	3	ns
Self-Rating: Neighbors									
Upper class	7	4	2	5	5	4			
Middle class	126	76	27	61	99	81			
Working class	33	20	15	34	18	15			
	166	100	44	100	122	100	7.77	2	.02

differences were found; the majority of both were working class and one-third of the parents were rated as middle class.

Income. The total family incomes, including income of spouse or child support of nonresident fathers, ranged from $7,000–80,000, with a mean of $28,830 (SD = 14.50). A significant income difference was found between the single and married mothers' households. Half of the single mothers had incomes of between $7,000 and $15,000 (12 percent $5–10T; 38 percent $11–15T). Only 7 percent of the married women had a family income of less than $15,000, and 38 percent of them earned over $36,000. The single-parent unit was clearly economically more vulnerable.

Education. Thirty percent of the mothers had some college; 31 percent had completed college and 28 percent had some advanced graduate work. No differences were found between the educational level of single and married mothers, nor were there any differences in the actual earned degrees. Thirty-one percent of the total had earned a college degree, 8 percent had associated or two-year degrees, 31 percent had a high school diplomas, and only 2 percent had no degrees. Advanced masters degrees were earned by 22, and 6 percent had Ph.D. or Ed.D. degrees (see Table 3).

Occupations. No differences in jobs held were found between single and married mothers: 40 percent were administrative personnel or owners of small businesses, and 35 percent were managers or proprietors of medium-sized businesses. Twenty-two percent were top executives, 3 percent were semiskilled, and 1 percent did not work.

Subjects' fathers tended to be administrators or owners of small businesses (34 percent) or semi-skilled (28 percent). One-third of their mothers did not work outside of the home, 23 percent were managers of businesses, and 23 percent were semiskilled (see Table 4). Their paternal and maternal grandparents had very similar jobs. Half of the grandfathers were owners of small businesses and one-fourth were semiskilled. The majority of the grandmothers on both sides did not work outside of the family and one-fourth were semiskilled.

Maternal employment. The low employment of subjects' mothers (32 percent) and grandmothers (55 to 62 percent) was unexpected in light of the present statistics on high Black maternal employment. Each mother was asked if her own mother worked at certain points in her life. When the subjects were under five years, 47 percent of their mothers did not work, one-third worked full-time and 14 percent part-time (see Table 5). When they were of school age (between 6 and 10 years) 42 percent of their mothers still did not work, one-third worked part-time, and only 24 percent worked full-time.

Child care arrangements. In light of the present high maternal employment, the child care arrangements become important. The mothers in both

TABLE 3 Educational Level, Degrees Earned, of Mothers and Occupation by Family Type and for Total and Grandparents

| | One-Parent | | Two-Parent | | Total | | Maternal | | | |
| | | | | | | | Grandpa | | Grandma | |
	f	%	f	%	f	%	f	%	f	%
Educational Level										
Graduate	11	24	37	30	48	28	2	7	3	4
College	15	33	38	30	53	31	1	4	4	5
Some college	13	29	38	30	51	30	3	11	5	7
High school	4	9	11	9	15	9	8	29	22	29
Some high school	2	4	1	1	3	2	14	50	41	55
Junior high										
Grade school										
	45	99	125	100	170	100	28	101	75	100
Degrees Earned										
Ph.D., Ed.D	3	7	7	6	10	6	3	3	—	—
Med., Law	—	—	—	—	—	—	—	—	—	—
Masters	8	18	30	24	38	22	1	1	1	1
Bachelors	15	33	38	30	53	31	6	6	3	3
Assoc., RN, Bus.	3	7	11	9	14	8	1	1	1	1
High school	14	31	38	30	52	31	36	35	41	38
None	2	4	1	1	3	2	56	54	60	57
	45	100	125	100	170	100	103	100	106	100

groups tended to be satisfied (77 percent), while 9 percent were dissatisfied, and 6 percent felt their arrangements were workable but could be improved. While most were pleased, there was significantly more dissatisfaction in the single mothers (13 percent) than in the married (8 percent—$\chi^2(4) = 10.20$, $p<.04$).

TABLE 4 Occupation of Mothers and Ancestors over Three Generations/and Occupation by the Four Mobility Patterns of Subjects' Families plus Fathers of Subjects

Occupation	Subject %	Father %	Mother %	Paternal Grandpa %	Paternal Grandma %	Maternal Grandpa %	Maternal Grandma %
Executives	22	8	1	10	1	7	—
Managers	35	11	23	5	13	3	4
Administrative	40	34	17	45	10	56	9
Clerical	—	—	—	—	—	—	—
Skilled	—	19	6	16	10	10	3
Semiskilled	3	28	23	24	21	24	23
Unskilled	—	—	—	—	—	—	—
Not work	1	—	32	—	55	—	62
	101	99	100	100	100	99	101

TABLE 5 Occupation by the Four Mobility Patterns of the Subjects and of the Subjects' Fathers

Occupation	Upward in present generation f	Upward in present generation %	Upward in each generation f	Upward in each generation %	Upward in parents' generation f	Upward in parents' generation %	Middle class over three generations f	Middle class over three generations %
	Occupation of Subjects by Mobility Pattern							
Executives	25	37	3	27	9	41	5	29
Managers	31	46	7	64	10	46	6	35
Administrative	6	9	1	9	3	14	2	12
Clerical	2	3	—	—	—	—	2	12
Skilled	2	3	—	—	—	—	1	6
Semiskilled and Unskilled	1	2	—	—	—	—	1	6
	67	100	11	100	22	101	17	100
	Occupation of Subjects' Fathers by Mobility Pattern							
Executives	—	—	1	3	5	31	4	20
Managers	3	4	3	8	7	44	3	15
Administrative	7	10	4	11	1	6	4	20
Clerical	20	29	13	34	—	—	3	15
Skilled	14	20	10	26	2	13	3	15
Semiskilled	8	12	5	13	1	6	1	5
Unskilled	17	25	2	5	—	—	2	10
	69	100	38	100	16	100	20	100

TABLE 6 Employment of Subjects' Mothers at Different Periods of their Lives for Total
 and by Mobility Pattern

| Amount of | 1-5 years | | 6-10 years | |
Employment	f	%	f	%
Not work	78	47	70	42
Full time	55	33	39	24
Part time	23	14	52	31
Don't know	9	6	5	3
	165	100	166	100

When they worked, the children were cared for by paid sitters (31 percent) or were in school all day (30 percent) and did not need care. Many mentioned the need for after-school care. Eighteen percent were kept by relatives.

Because different arrangements may be made when the mother goes out for social occasions, we explored the arrangements made in these situations. The children were usually cared for by a friend (38 percent), relatives (29 percent), or paid sitters (23 percent).

The mothers did not use the kin network for child care during worktime but used sitters from outside the family. Friends helped during social outings. Informal care of related children was not widespread with this group.

Kin interaction patterns. The mothers were asked to evaluate their contact with relatives. Sixty-eight percent felt their interactions were about right and 28 percent wanted to have more contact with kin. Five percent felt a bit overwhelmed by the extensive contact; they indicated that they felt emotionally close to an average of 11.96 relatives.

The majority (50 percent) lived within 30 miles of relatives, and 40 percent lived farther than 150 miles away. They felt it was very easy (62 percent) for relatives to visit them and for them to visit (65 percent) kin. They saw all of their close kin several times a year, but the single mothers visited their kin significantly more ($\chi^2(5) = 12.27$, p<.03). More single mothers visited relatives daily (20 percent versus 9 percent married). Married mothers tended to see their kin on a weekly rather than daily basis.

When they were outside of visiting distances, the single mothers kept in closer contact with relatives by telephone or letter ($\chi^2(5) = 15.19$, p<.01). Forty-two percent of single mothers made such contacts daily, compared with only 18 percent of the married. Those with husbands tended to make long-distance contact weekly (39 percent) or monthly (34 percent).

Kin interaction in Black families often extends beyond the blood relatives into "fictive kin." Mothers were asked if, when they were growing up, there were people who were not related, but who were close to them and just like kin. Seventy percent said yes and only 29 percent said no. If they responded yes, they were asked to identify what particular relative they seemed to be

like. Fifty-three percent said the fictive kin were like aunts or uncles, while 24 percent felt they were like sisters or brothers.

The fictive kin patterns had been continued into the present, for 71 percent said they still had such relationships. These persons were viewed to be the same as their sisters (62 percent) and brothers (62 percent), or aunts or uncles (25 percent). The mothers developed fictive siblings who, in turn, become fictive aunts and uncles of their children, thus perpetuating the fictive kin relationships for the entire family. The incorporation of non-kin into the family meets their emotional needs, while also widening the extended family network.

Kin Help Exchange

The mothers were all involved to some extent in the kin help exchange, with no significant difference between single and married mothers in the type of help given or received. Both groups said that the family gave more (53 percent) than friends (29 percent—see Table 7).

They received the same type of help they gave. The most prevalent help exchanged was child care: 35 percent received and 33 percent gave such care. Financial assistance was rated second, with 28 percent receiving and 31 percent giving money to kin. The third most important help was emotional support: 24 percent received and 20 percent gave.

No differences were revealed in the type of help exchanged by demography or SES, but mobility pattern differences were found in the types received from kin ($\chi^2(8) = 16.10$, p<.04). Child care was at a similar level in all three patterns, but financial assistance was much higher in families born into the working class but which had moved up in each of three generations, from poverty to working to middle class (44 percent). Twenty-five percent of the newly mobile or 17 percent of those born middle class received financial aid. Yet, those who were born into middle-class families (39 percent) received more emotional support than the other two mobility pattern groups. The level of repairs and exchange of clothes was similar in all three groups (see Table 8).

The mothers appeared to be receiving more than they gave; 66 percent said that they received a great deal of help. Thirty-two percent received some help, and only 2 percent reported receiving no help. In contrast, only 32 percent helped their kin a great deal, while 56 percent gave some and 13 percent gave nothing. There were no quantitative differences between single and married mothers in the amount exchanged with kin.

All subjects reported that there was little change in the amount of help given to kin (62 percent), while 23 percent had increased and 16 percent had decreased in amount given kin. There was a significant family type difference in the change of help received from kin ($\chi^2(3) = 8.87$, p<.03). Mar-

TABLE 7 Frequency Distribution and Chi-Square of Amount of Help and Change in Help Exchanged between Kin and Friends

		Total		One Parent		Two Parent		X^2	df	p
		f	%	f	%	f	%			
Who gives most help	Family	89	53	29	66	60	49	3.86	3	ns
	Friends	45	27	9	21	36	29			
	Both Equal	16	10	3	7	13	11			
	None given	17	10	3	7	14	11			
		167	100	44	101	123	100			
Amount received from family	Great deal	110	66	29	66	81	66	.04	2	ns
	Some	53	32	15	34	38	32			
	None	3	2	0	0	3	3			
		166	100	44	100	122	101			

Kin Help

		Total		One Parent		Two Parent		X^2	df	p
		f	%	f	%	f	%			
Amount given to family	Great deal	53	32	18	40	35	29	3.31	2	ns
	Some	94	56	20	44	74	60			
	None	21	13	7	16	14	11			
		168	101	45	100	123	100			
Change in amount received	Increased	19	11	10	23	9	7	8.87	3	.03
	Same	113	69	24	55	89	74			
	Decreased	33	20	10	23	23	19			
		165	100	44	101	121	100			
Change in amount given	Increased	37	23	11	26	26	21	4.55	3	ns
	Same	101	62	23	53	78	64			
	Decreased	26	16	9	21	17	14			
		164	101	43	100	121	99			

Friends Help

		Total		One Parent		Two Parent		X^2	df	p
		f	%	f	%	f	%			
Amount received from friends	Great deal	38	23	17	38	21	17	8.20	2	.02
	Some	101	60	21	47	80	65			
	None	29	17	7	16	22	18			
		168	100	45	101	123	100			
Amount given to friends	Great deal	58	35	16	36	42	34	.33	2	ns
	Some	89	54	24	55	65	53			
	None	19	11	4	9	15	12			
		166	100	44	100	122	99			

TABLE 8 Frequency Distribution and Chi-Square of Type of Help Given and Received from Family and Friends

Direction of Help	Type of Help	Total f	Total %	One Parent f	One Parent %	Two Parent f	Two Parent %	X^2	df	p
Received from kin	Child care	48	35	15	39	33	34	7.84	4	ns
	Financial	38	28	15	39	23	24			
	Emotional	33	24	5	13	28	29			
	Repairs	12	9	4	10	8	8			
	Clothing	6	4	0	0	6	6			
		137	100	39	101	98	101			
Given to kin	Child care	48	33	18	47	30	28	7.62	4	ns
	Financial	45	31	12	32	33	30			
	Emotional	30	20	5	13	25	23			
	Repairs	6	4	0	0	6	6			
	Clothing	18	12	3	8	15	14			
		147	100	38	100	109	101			
Received from friends	Child care	41	29	10	26	31	30	15.73	5	.008
	Financial	24	17	13	34	11	11			
	Emotional	61	43	12	32	49	48			
	Repairs	10	7	1	3	9	9			
	Clothing	4	3	2	5	2	2			
		140	99	38	100	102	100			
Given to friends	Child care	38	26	9	23	29	27	9.32	4	.04
	Financial	35	24	16	40	19	18			
	Emotional	62	42	11	28	51	48			
	Repairs	9	6	3	7	6	6			
	Clothing	3	2	1	3	2	2			
		147	100	40	101	107	101			

ried mothers tended to continue at the same level of support. Over half of the single mothers and two-thirds of the married mothers had continued to receive about the same level of assistance. Another difference was that 23 percent of single mothers reported that they were receiving more help than before, compared with 7 percent of married subjects.

The 22 help-exchange questions were also analyzed by SES, demography, and mobility patterns; only one significant difference was found, with none found by SES. The only demographic difference was found in comparing who gave the most help ($\chi^2(8) = 16.10$, p<.04). While both urban and suburban mothers reported that the family gave more, urban mothers rated the family much higher (61 percent) than did suburban mothers (46 percent). Suburban mothers (36 percent) rated friends higher than did urban mothers (19 percent). It appeared that the needs were similar, but those in the city relied on family to a greater extent than those in the suburbs. However,

surprisingly, almost twice as many city (13 percent) versus suburban (7 percent) mothers reported that no one gave them help.

These mothers were actively involved in exchange networks with other family members, receiving almost twice as much help as they gave. The single mothers were now receiving more help than in the past, while all were giving their kin help at a similar rate as was done in the past. The strong kin-help patterns existed regardless of mobility pattern, for no association was found among involvement, source of greatest help, or the type of help given kin by mobility. All were similarly involved regardless of whether they were first-generation or third-generation middle class or if they had moved from poverty to middle class over three generations.

Reciprocal obligation of kin help. The majority of mothers (53 percent) appreciated the kin help and were glad to have it available. Eighteen percent appreciated the help and expected to have it available when they needed it, while 11 percent would appreciate it but would not take it for granted. Seventeen percent were not dependent on the family and 10 percent were hesitant to ask for assistance. No significant family type differences were found.

The mothers felt that they were receiving help at the level they were giving it in 50 percent of the families, 23 percent felt they received more than they gave, and 10 percent felt they gave more than received. Single and married mothers felt the same.

In response to the question, "Do you feel you owe a lot for the help given by kin?" 64 percent responded no and 35 percent said yes, they did feel this obligation. Again, both single and married mothers agreed.

We asked the mothers what they would expect if they went out of their way to help a close relative. Fifty-five percent expected nothing, 35 percent expected help only in an emergency, and 2 percent expected kin to always go out of their way to help. Single and married mothers held similar attitudes. Basically, they said they helped kin because it was needed and did not place a heavy obligation on the relatives to reciprocate. However, the expectation for repayment was stronger when help was in the form of money: 35 percent always expected to get it back, 30 percent usually got money back, while 23 percent rarely saw the money again.

Both singles and marrieds responded that over half usually felt obligated to help those who were less fortunate than they were, depending on the circumstances. One-third felt they must always help those who were less fortunate without fail or questions. This view was also supported when they were asked to respond to a hypothetical situation in which one person in the family "makes it" or "moves up." A great deal of sharing with the rest of the family would be *expected* in a situation for 67 percent of the family. Four-teen percent would expect some, and 15 percent would expect only a little

sharing. The obligations were strong to help those who had less, and those who were less fortunate expected this help. It would appear that the kin insurance policy dues are alive and running strong equally for single and married Black women.

FRIEND HELP EXCHANGE

The mothers evaluated the amount of their contact with close friends and 73 percent felt it was about right., 25 percent felt they did not see their friends often enough, and 2 percent saw too much of them. Almost all (89 percent) were involved in giving help to friends with no family type difference. Some help was given by 54 percent, a great deal by 35 percent, with only 11 percent not giving any help.

While they all gave help, the one-parent family received more from their friends ($\chi^2(2) = 8.20$, p<.02). Of the single mothers, 38 percent received a great deal of help, compared with only 17 percent of married ones. Sixty-five percent of the marrieds received some help, as did 47 percent of singles. Eighteen percent of marrieds and 16 percent of singles received no help.

Subjects felt they gave friends about as much help as they received (67 percent). Only 13 percent felt they gave more than they received, and 8 percent received more than they gave. When the mothers received help from friends, they all tended (75 percent) to feel that they were not placed under obligations to their friends. Only 24 percent felt that they owed something to their friends when given help.

While there were not many differences between single and married mothers on kin help, several significant differences were found in the type of help exchanged with friends. The same pattern of type of help was found for each family type in both the giving and receiving of assistance with friends. One-parent mothers received financial assistance from friends much more (33 percent) than did those who were in two-parent units (11 percent—$\chi^2(5) = 15.73$, p<.008). Emotional support was second for singles (31 percent) but highest for married mothers (48 percent). Child care was exchanged more for married (30 percent) than for single (26 percent) mothers. Single mothers needed more help because there was a significantly lower family income of the single-mother unit (F(3,143) = 34.38, p<.0000). They received proportionately more financial aid from friends than from family. In turn, the single mothers (40 percent) gave more financial help to their friends than marrieds (18 percent—$\chi^2(4) = 9.32$, <.04). The married mothers gave more emotional support (48 percent versus 28 percent single) and child care (27 percent versus 23 percent single).

Single mothers exchanged help more frequently, and the help was more concrete with friends; while those who were married exchanged emotional care, since their financial picture was more positive. There was an interac-

tion between marital status and financial stability; single mothers had fewer resources and therefore needed different kinds of help.

SATISFACTION WITH LIFE

The Standard Happiness Scale that had been repeatedly used in nation-wide surveys was used. There may be limitations in using such a small scale for these questions, and the modifications in reference to family situations are not as extensive as a longer scale and may not be sensitive enough to measure specific, sharply defined attitudes. However, the use of this scale to measure global constructs is based on the work of Gurin et al. (1960), NORC (1964), Bradburn (1969), Hill (1972) and Harrison (1976); it has been used repeatedly to measure very global attitudes such as marital happiness and life satisfaction in general. Physical satisfaction looked at how the families decided to live in the urban or suburban sites and the specific reasons.

No differences between family type were found on the physical or social satisfaction responses. These mothers were basically happy with their lives (63 percent). Many (30 percent) were very happy with life in general, while only 7 percent were not too happy (see Table 9). Subjects' satisfaction with their family life was much more positive than with life in general: 80 percent were satisfied with their family situation. Only 15 percent were neutral and 5 percent were dissatisfied. Similar responses were given by both married and single mothers.

They were asked to compare their present living situation with other places they had lived. Seventy percent felt they were now better off, 23 percent felt it was the same, and only 7 percent felt their situation was worse. When asked why they decided to live in this particular location, mothers gave a variety of responses. The most frequently mentioned reason (29 percent) was the good schools; this was consistent with the high value placed by mothers on the education of their children. Other reasons were sufficient space (16 percent); close to family (14 percent); and close to work (13 percent), recreation, and church (10 percent).

These mothers indicated that their lives were far from perfect but that overall they felt good about it. They made several references to how comfortable their situations were in relation to the situation in which most Blacks find themselves. Therefore, their lives became even more satisfying.

SUMMARY AND DISCUSSION

These mothers were involved extensively in the kin-help exchange network. They gave as well as received, appreciated this help, and generally expected it to be available when the need arose. They interacted frequently—specially the single mothers—with kin who lived nearby. When far away, they kept in close contact via letter and telephone, especially the

TABLE 9 Level of Physical and Social Satisfaction with Life of Mothers by Family Type

Level of Satisfaction	Total f	%	One-Parent f	%	Two-Parent f	%	X²	df	p
Satisfaction with life							4.58	2	ns
Very happy	49	30	8	18	41	34			
Pretty happy	104	63	31	71	73	60			
Not too happy	12	7	5	11	7	6			
	165	100	44	100	121	100			
Satisfaction with family life							3.17	2	ns
Satisfied	133	80	32	71	101	84			
Neutral	25	15	10	22	15	12			
Dissatisfied	8	5	3	7	5	4			
	166	100	45	100	121	100			
Physical satisfaction compared to other places							1.30	3	ns
Better	116	70	31	69	84	69			
Same	39	23	12	27	27	22			
Worse	12	7	2	4	10	8			
	167	100	45	100	121	99			
Why select location							8.90	7	ns
Good schools	39	29	15	39	24	25			
Large enough	22	16	4	10	18	18			
Close to family	19	14	4	10	15	15			
Close to work	18	13	6	15	12	12			
Recreation, church	13	10	3	8	10	10			
Close to friends	9	7	3	8	6	6			
Could afford it	5	4	3	8	2	2			
All combined	12	8	1	3	11	11			
	137	101	39	101	98	99			

single mothers. They had extended their family network to incorporate fictive kin who during at least two generations became as aunts and uncles for the children.

The kin exchange took the form of child care, financial assistance, and emotional support; however, mothers tended to use paid sitters while they worked. Their own mothers and grandmothers tended not to work.

Mothers appear to be receiving more than they give. Newly mobile mothers receive less assistance, probably because they may have more material resources than their working-class kin. Single mothers received more help than married ones. Mothers in the city were helped more by kin, and those in the suburbs received more help from friends.

Mothers did not feel that members of the family were under great obligations because of help given to them; they did, however, expect to have money returned to them. They also felt obligated to help poorer members of the family and in turn would expect to be helped by someone who was sustantially better off than they were. The kin insurance policy was highly active.

Friends were an important part of their supportive networks. Single parents received more help from friends, especially financial, but did not feel under great obligations for this help. Married mothers used friends more for emotional support.

These mothers had been able to become financially stable, and most experienced some upward mobility, while they were able to maintain their close involvement with their wider kin. The obligations from kin were not so great that they had to withdraw from the extended family to maintain stability and to meet their mobility goals. The Black extended family system was supportive of their emotional and financial stability that attributed to their high level of satisfaction with their family life. The supportive network was especially essential to the mother who was rearing her children alone. Her needs were extensive and went beyond her individual resources. These findings are further documentation of the crucial, continuing substance offered at all economic levels by the extended family system.

REFERENCES

Billingsley, A. (1968) Black Families in White America. Englewood Cliffs, NJ: Prentice-Hall.

Bradburn, N. and D. Caplovitz (1965) Reports on Happiness: A Pilot Study of Behavior Related to Mental Health. Chicago: AVC.

Brewington, D. and J. Comerford (1974) "A look at the kin family network of Black and white families." Master's research paper, Howard University, School of Social Work. (unpublished)

Gibson, J. (1972) "Kin family network: overheralded structure in past conceptualization of family functioning." Journal of Marriage and the Family 34.

Gurin, G., J. Veroff, and S. Feld (1960) Americans View Their Mental Health. New York: Basic Books.

Gutman, H. G. (1976) The Black Family in Slavery and Freedom: 1750–1925. New York: Pantheon.

Hamilton, C. (1971) "Just how unstable is the Black family?" New York Times, August l: E3.

Harrison, A. (1976) Components of Family Survival. Presented at symposium, "The Black Family: Survival Organization," annual meeting of Association of Black Psychologists, Chicago, August 14.

Heiss, J. (1975) The Case of the Black Family: A Social Inquiry. New York: Columbia University Press.

Hill, R. (1972) The Strengths of Black Families. Washington, DC: National Urban League.

Ladner, J. (1972) Tomorrow's Tomorrow: The Black Woman. Garden City, NY: Doubleday.

McAdoo, H. (1977) "The impact of extended family variables upon the upward mobility of Black families." Final Report under Contract No. 90-C-631(1). Washington, DC: U.S. Department of Health, Education and Welfare, HEW, Office of Child Development.

––––– (1978) "The impact of upward mobility of kin-help patterns and the reciprocal obligations in Black families." Journal of Marriage and the Family (Fall).

McQueen, A. (1971) "Incipient social mobility among poor black urban families." Presented at Howard University Research Seminar, Spring.

Rainwater, L. (1966) "Crucible of identity: the Negro lower-class family." Daedalus 95: 172–216.

Stack, C. B. (1974) All Our Kin. New York: Harper & Row.

8

MARITAL INTERACTION GOALS OF BLACK WOMEN:
Strengths and Effects

Essie Manuel Rutledge

Most studies of marital relations of Blacks, as well as of whites, have focused on marital happiness or marital satisfaction and decision-making. Furthermore, most of such studies have compared Blacks with whites, resulting in more negative images of Black marriages than of white marriages. Only a paucity of research has investigated Black marriages or families on their own merits with attempts at emphasizing the positives or testing the accusations made by critics (Scanzoni, 1971; Rutledge, 1974; Heiss, 1975). Other studies have emphasized or shown family strengths from the standpoint of structures and functions (Billingsley, 1969; Hill, 1972; Stack, 1974), but the emphases were on the family as a system. Thus, this chapter is an attempt to investigate marital relations based on the author's study of 1974 (a secondary data analysis). Hence, the focus here is on marital interaction goals (to be defined later), which are viewed as one aspect of the marital relation.

The assumption is that certain goals are a part of any normal marital relation. In other words, certain ends are sought in any marital relation—companionship, love, security, and the like. On the basis of this assumption several interaction goals are selected (the goals are limited by the data from which the analysis is drawn) as means of describing and analyzing the marital relations of Black women. The goals are categorized according to

importance, opportunities for fulfillment, and success at fulfillment, and are determined by the perceptions of wives only. Therefore, we do not assume anything about the husbands in regard to these goals.

The purpose of this study is twofold: (1) to interpret marital "strengths" on the basis of marital interaction goals and (2) to determine what factors seem to have the greatest impact or influence on marital interaction goals. Before proceeding further, three concepts critical to this research will be defined. The concepts are marital interaction, marital interaction goals, and marital "strengths." Marital interaction refers to the social exchange between spouses; it is an action-reaction process. For example, a husband asks a question of his wife and she responds by answering him. Marital interaction goals are viewed as ends toward which married couples strive within the marital interaction process—security, companionship, love, and so on. Marital "strength" is defined as the ability to maintain normal or healthy marital relations (defined on the basis of normative expectations) in spite of the stresses and strains experienced from within or without the family system. In other words, marital "strength" implies solidarity within the marital union even though it is met with both internal and external pressures. Some examples of marital "strengths" are keeping the marriage intact, handling marital disagreements successfully, and fulfilling the spouse's role successfully.

THE SAMPLE

The data reported here were collected in 1968 and 1969 by the Program for Urban Health Research, Department of Psychology, at the University of Michigan for a study which investigated the role of stress and heredity in Black and white blood pressure differences. The study was based on a sample of 1000 adults living in Detroit, Michigan. This study is based on a sample of 256 Black women selected from the above.

The sample selected by the Program for Urban Health Research was taken from residence areas which varied in extremes of high- and low-stress conditions relative to the city (Detroit). This was done by the use of a factor analysis technique, which resulted in the final selection of high- and low-stress areas. These areas were in the extreme quartiles of factor scores. The rates showed sharp differences between high and low stress across median income, median education, crime rates, and it was also revealed in rates such as school truancy, "dropouts," welfare registration, and more. Relative to this study, a high-stress area is a group of four census tracts which is low on socio-economic factors and high in rates of crime, marital instability, and residential instability. The reverse rates of these factors characterize a low-stress area.

INDICES OF MARITAL INTERACTION GOALS

The indices were generally constructed on the basis of Likert Scaling. An exception to this method was employed in constructing discrepancy indices; a subtraction technique, rather than a summation technique, was used. Below is a list of the indices, including index variables plus the questions, from which the variables were derived.

(1) Index of Importance of Marital Interaction Goals

 (a) Important to spend time with spouse: "How important is it to spend time with your husband and do things together?"

 (b) Important to help make decisions: "How important is it to you to help make big decisions for your family?"

 (c) Important to have good sex: "How important is it to you to have the kind of sex life you would like to have?"

 (d) Important to understand spouse: "How important is it to you to understand how your husband thinks and feels?"

 (e) Important to solve arguments with spouse: "How important is it to you to do well or be successful at handling any arguments with your husband?"

(2) Index of Opportunities for Fulfilling Marital Interaction Goals

 (a) Chance to spend time with spouse: "How much actual chance do you have to spend time with your husband and do things with him?"

 (b) Chance to make decisions: "How much actual chance do you have to help make the big decisions for your family?"

 (c) Chance for good sex: "How much actual chance do you have to have the kind of sex life you would like to have?"

(3) Index of Success at Fulfilling Marital Interaction Goals

 (a) Understood spouse: "In the last few years, how well have you understood how your husband thinks and feels?"

 (b) Handled disagreements with spouse: "In the last few years, how well have you done in handling disagreements with your husband?"

 (c) Good mate: "In the last few years, how well have you done at being a good wife to your husband?"

(4) Index of Discrepancy Between Importance and Opportunity of Marital Interaction Goals

 (a) Importance versus chance to spend time with spouse: "How important is it to you to spend time with your husband and do things together with him?" versus "How much actual chance do you have to spend time with your husband and do things with him?"

 (b) Importance versus chance to make decisions: "How important is it to you to help make big decisions for your family?" versus "How much actual chance do you have to help make big decisions for your family?"

 (c) Importance versus chance for good sex: "How important is it to you to have the kind of sexual life you would like to have?" versus "How much actual chance do you have to have the kind of sex life you would like to have?"

(5) Index of Discrepancy Between Importance and Success of Marital Interaction Goals

(a) Importance versus how well understood spouse: "How important is it to you to understand how your husband thinks and feels?" versus "In the last few years, how well have you understood how your husband thinks and feels?"

(b) Importance versus how well handled disagreements with spouse: "How important is it to you to do well or be successful at handling any disagreements with your husband?" versus "In the last few years, how well have you done at handling disagreements with your husband?"

(c) Importance versus how well done at being a good mate: "How important is it to you to be a good wife to your husband?" versus "In the last few years, how well have you done at being a good wife to your husband?"

FINDINGS

The descriptive data for the marital interaction goals are presented in Tables 1–4. The categorical aspects of the marital interaction goals include importance of marital interaction goals, opportunities for fulfilling marital interaction goals and discrepancies between these goals.

TABLE 1 Importance of Marital Interaction Goals

| Measures of Importance of Interaction | Rated Responses % | | | | |
	Highly Important	Moderately Important	Not Important	Total %	N
1. How important is it to spend time with husband and do things together?	82	17	1	100	(256)
2. How important is it to help make big decisions for your family?	89	11	0	100	(256)
3. How important is it to have the kind of sex life you desire?	78	20	2	100	(256)
4. How important is it to understand how your husband thinks and feels?	89	9	2	100	(256)
5. How important is it to do well or be successful at handling disagreements?	88	12	0	100	(256)
6. How important is it to be a good wife to your husband?	95	5	0	100	(256)

Table 1 represents a distribution of responses regarding the importance of marital interaction goals. This table is meant to show how important it is for women to interact with their husbands in varied ways. According to these data, all of the interaction goals are highly important for more than 75 percent of the respondents. In other words, these goals are highly valued. Of these goals, the most valued is being a good wife (95 percent), followed by

understanding how the husband thinks and feels and helping to make big decisions (89 percent). On the basis of these three most valued goals, it is suggested that these women (1) share with others in our society the normative expectation of being a good wife; (2) highly value the expressive goal of empathy which is sought after in modern marriage; and (3) highly value equalitarian decision-making which is indicated by the importance placed on helping to make big family decisions. This is quite contrary to the notion of Black female dominance which has traditionally saturated the family literature.

One of the most interesting, yet the least valued, among these goals is the importance of having the kind of sex life desired. In light of the widespread myth that Blacks are oversexed, this may come as a surprise. Many people are of the opinion that the most important aspect of the heterosexual relation is sex. That notion is not supported by these data.

Given these data, we may conclude that marital interaction, as represented by the varied interaction goals in Table 1, is highly important for a large majority of our respondents. This is in conformity with the normative expectations of a normal or healthy marriage in our society.

Since marital interaction seems highly important to the women of this sample, the concept is further explored by analyzing the opportunity for marital interaction. These results can be seen in Table 2. As we examine these data, it becomes rather obvious, when observing corresponding goals (Table 1) that opportunities for interaction do not coincide with the importance placed on the interaction. In other words, according to the data in Table 2, the women do not get as many chances to interact with their husbands as they desire, and the greatest opportunity for interaction is in making important decisions for the family (74 percent), followed by having the kind of sex life desired (63 percent) and spending time and doing things with spouse (43 percent). Since it has already been established that helping to make big decisions is more important to our respondents than any of the other interac-

TABLE 2 Opportunities for Fulfilling Marital Interaction Goals

Measures of Opportunities for Interaction	Very Good	Moderately Good	Not Good at All	Total %	N
1. How much actual chance to spend time with husband and do things together?	43	44	13	100	(256)
2. How much actual chance to help make big decisions for the family?	74	24	2	100	(256)
3. How much actual chance to have the kind of sex life you desire?	63	32	5	100	(256)

tion goals (see Table 1), one would assume that more time is made available for this than for the other goals. Thus, the assumption is confirmed.

These results suggest that opportunities for fulfilling marital interaction goals is an intervening variable which effects the fulfillment of these goals. This suggestion stems from the fact that Table 1 shows the marital interaction goals to be highly valued, and Table 2 shows the opportunities for fulfillment of the same goals to be considerably less. The diagrammatic representation of this relationship is as follows: Importance of marital interaction goals → opportunities for fulfilling marital interaction goals → success at fulfilling marital interaction goals. In other words, the opportunity or lack of opportunity in carrying out one's goal determines whether the goal is consummated.

The final aspect of interaction to be described is success at fulfilling interaction goals. Table 3 presents a distribution of responses in regard to certain interaction goals. The results show, of the goals listed, the one which the most respondents have been successful in fulfilling is being a good wife (77 percent). A further note regarding the fulfillment of this goal is that only 1 percent of the respondents consider themselves to have done poorly in fulfilling the goal. Since this goal is considered a measure of feelings of adequacy/inadequacy (Gurin et al., 1960), one might conjecture that for the vast majority of the respondents no such feeling exists, given that most of them indicate high success in being a good wife. In regard to the other two goals, a larger proportion of women have had high success in understanding how their husbands think and feel (46 percent) than in handling disagreements with their husbands (40 percent). The general conclusion drawn from Table 3 is that the majority of the women have experienced either high success or moderate success in the fulfillment of these marital interaction goals. Furthermore, it is speculated that opportunity is an intervening variable which has precluded the respondents from attaining the level of success that is congruent with the value they place on the goals (Table 1).

TABLE 3 Success at Fulfilling Marital Interaction Goals

| Measures of Success at Interaction | Rated Responses % | | | | |
	High Success	Moderate Success	Poor	Total %	N
1. How well have you understood how your husband thinks and feels?	46	44	10	100	(256)
2. How well have you done at handling disagreements with husband?	40	50	10	100	(256)
3. How well have you done at being a good wife for your husband?	78	21	1	100	(256)

In consideration of the marital interaction goals represented by the data in Tables 1–3 we get a positive image of marital interaction of Black women, which is expected of a normal or healthy marital relation. It is especially interesting to note that these women place high value (as measured by high importance of goals) upon marital interaction goals. Interacting with spouse may be especially important in light of the racial hostility faced by Blacks within the larger society. That is, interaction with spouse may serve as a buffer or coping mechanism for the stresses and strains encountered in the larger society. It may be even more important to note that the majority of these women are at least moderately successful in fulfilling certain marital interaction goals (Table 3), which is suggestive of interpersonal strengths and fortitude in overcoming the ordinary stresses and strains of marriage in addition to those of Black marriages. In sum, it is suggested that these marital interaction goals are indicative of marital "strengths" in light of the fact that these goals are valued and that a rather high level of success is obtained in spite of a lack of sufficient opportunity to do so.

A further analysis of these marital interaction goals has been done by measuring discrepancies between the different cognitions and behavior which were used for measuring marital interaction goals. Table 4 presents these data. The purpose of these data is to determine whether those respondents who consider certain interaction goals to be important have the opportunity to fulfill them or whether they actually consummate them. Hence, this led to a rating of the distribution of responses as positive inconsistency, consistency, and negative inconsistency.

Consistency exists when two cognitions or a cognition and a behavior match on the basis of response categories. When desire exceeds behavior or opportunity for behavior, positive inconsistency exists, but when behavior or opportunity for behavior exceeds desire, negative inconsistency exists. In other words, when a wife gets less than what she desires, the inconsistency is positive. An example is the woman who highly values spending time and doing things with her husband but has few chances to do so. When desire equals what one gets, then consistency exists. An example would be the woman who values being a good wife and is successful in doing do. Conversely, when a wife gets more than what she desires, the inconsistency is negative. An example of this is the woman who places little or no importance on spending time and doing things with her husband, yet she gets a lot of chances to do so.

From Table 4, we observe that that the largest proportion of respondents encounter inconsistency between "importance of spending time with spouse versus chance for spending time with spouse" (49 percent and 7 percent), followed by "importance of versus success in understanding how husband thinks and feels" (32 percent and 4 percent), and "importance of

TABLE 4 Discrepancy Between Cognitions and Cognitions and Behavior

| Measures of Cognitions and Behavior | Rated Responses % | | | Total | |
	Positive Inconsistency	Consistency	Negative Inconsistency	%	N
Cognitions					
1. Importance of vs. chance to spend time and do things with spouse	49	44	7	100	(256)
2. Importance of vs. chance to help make big family decisions	21	73	6	100	(256)
3. Importance of vs. chance to have the kind of sex life desired	24	67	9	100	(256)
4. Importance of vs. frequency by which spouse shows appreciation for things done for him and family	31	62	7	100	(256)
Cognitions and Behavior					
5. Importance of vs. success at handling disagreements	15	81	4	100	(256)
6. Importance of vs. success in understanding how spouse thinks and feels	32	64	4	100	(256)
7. Importance of vs. success at being a good wife	9	89	2	100	(256)

versus frequency by which husband shows appreciation" (31 percent versus 7 percent). As can be seen, the other inconsistencies are less than the three listed. An important note is that most of the women who experience inconsistencies experience them in a positive direction. That is, for these women, their desires exceed their opportunities and/or behavior, although this is as expected. However, there is a small proportion of women who experience negative inconsistencies. In other words, these respondents' opportunities and/or behavior exceed what they desire; they get more than they want. The prediction is that for women who experience either positive or negative inconsistencies some frustration or dissonance occurs initially. This prediction is based on the theoretical assumptions of cognitive dissonance.

In summarizing the results in Table 4, we find that an average of 69 percent of all the respondents experience consistencies, while 31 percent of

them experience some inconsistencies. Consistencies are interpreted as marital "strengths," since they represent either an opportunity for or the actual fulfillment of marital interaction goals which is suggestive of (1) the ability to overcome internal and external forces which might otherwise lead to cognitive inconsistencies and (2) less psychological tension or strain on the marital relation. Hence, we conclude that the marital relations of these women are more indicative of "strengths" than of weaknesses when using marital interaction goals as indicators of "strengths." On the other hand, we are fully aware that the goals presented here do not include all marital interaction goals, nor do they necessarily represent those that are most important to the respondents. Nevertheless, most of the respondents place high value on these goals; they have ranged from very good to moderately good opportunities for fulfilling goals; and they have ranged from high to moderate success in fulfilling these goals.

ANALYSIS OF EFFECTS
ON MARITAL INTERACTION GOALS

The purpose of this analysis is an attempt to determine the "best" set of variables for explaining the variation in marital relations as measured by marital interaction goals. In doing this, stepwise regression analysis is employed. The variables are selected on the basis of a t-statistics used in testing the significance level of the regression coefficients. A predetermined significance level of .05 was set for inclusion of all independent variables in the regression equations. Any variable with a significance level less than .05 is excluded; those with significance levels of .05 or greater are included. From the regression models we get some indication of the impact of each variable in producing change in the dependent variable (beta weights) as well as the percentage of explained variance (R^2). The dependent variables included in this analysis are all index variables, and the scales for the variables are based on scores of individual respondents.

Table 5 presents the data for the influence of selected independent variables on indices of marital interaction goals. In observing Table 5A we find that all of the variables have a certain amount of influence on importance of marital interaction goals, but the best predictor is degree of general happiness (.225): As the degree of general happiness increases, importance of marital interaction goals increases. Or, to put it differently, there is a positive relationship between the variables. The remaining variables, except for negative reaction to father's anger during childhood, are positively associated with the importance of marital interaction goals. The negative association suggests that this childhood experience might have been a motivating factor in helping the respondents to realize the importance of primary or

TABLE 5 Influence of Selected Independent Variables on Indices of Marital Interaction Goals

A. Index of Importance of Marital Interaction Goals

Selected Independent Variables	Correlation Coefficients (r)	Percent Variance Explained (R^2)	Standardized Regression Coefficients (b*)	N=255
Degree of General Happiness	.23	.05	.225	
Guilt feelings After Show of Anger Toward Mother	.18	.08	.162	
Family Income[a]	.15	.10	.161	
Negative Reaction to Father's Anger During Childhood	−.13	.12	−.135	
Spouse Age	.12	.14	.138	

B. Index of Opportunities for Fulfilling Marital Interaction Goals

Selected Independent Variables	Correlation Coefficients (r)	Percent Variance Explained (R^2)	Standardized Regression Coefficients (b*)	N=256
Index of Chances for Extra-Familial Activities[b]	.37	.14	.369	
Wife Occupational Status	.13	.15	.128	
Number of Children	.09	.17	.126	

C. Index of Success in Fulfilling Marital Interaction Goals

Selected Independent Variables	Correlation Coefficients (r)	Percent Variance Explained (R^2)	Standardized Regression Coefficients (b*)	N=256
Index of Chances for Extra-familial Activities	.26	.07	.249	
Safeness of Neighborhood	.16	.09	.159	
Education	−.12	.11	−.149	

[a]The family income variable consists of the following costs: $0–6,999, $7,000–14,999, and $15,000+.

[b]The items included in this index are chances for visiting relatives, going out for entertainment, for relaxing and doing what is desired, and visiting friends.

personal interaction. The table also shows that the total percentage of variance explained by these five variables is 14.

In regard to opportunities for fulfilling marital interaction goals, Table 5B shows that the Index of Chances for Extrafamilial Activities has a substantial impact (.369) on the dependent variable: As chances for extrafamilial activities become greater, it seems that opportunities (chances) for fulfilling marital interaction goals become greater. The other two variables in the model have an impact on the dependent variable that is equal to each other. The three variables included in this regression model explain 17 percent of the variation in opportunities for fulfilling marital interaction goals.

Furthermore, it might be of interest to point out that each of the variables

which seems to have some impact on the dependent variable is a factor which could be perceived as hampering opportunities for interaction. In other words, one might expect that the larger the number of children, the greater one's involvement in activities outside the family, and for the working wife there would be less opportunities for fulfilling marital interaction goals. In regard to the women of this study, no such evidence exists.

Table 5C indicates the influence of selected independent variables on the Index of Success in Fulfilling Marital Interaction Goals. The single best predictor among those included in this model is Index of Extrafamilial Activities: as chances for extrafamilial activities increase, so does success for fulfilling marital interaction goals. Both the other variables of this regression model are of interest because of what they suggest. The positive association between safeness of neighborhood and the dependent variables indicates that the less safe the neighborhood, less is the chance of success for fulfilling marital interaction goals or vice versa. The suggestion is that unsafe neighborhoods might induce significant fear or other psychological states and/or sociological conditions that inhibit the consummation of marital interaction goals. The negative association between education and success in fulfilling marital goals is meaningful, since it is consistent with a study by Gurin et al. (1960) and other findings from this study which show that on issues of self-criticism or evaluations the more educated persons appear to be more critical and more willing to admit to their inadequacies.

Even though the independent variables in this model (Table 5C) are significant and have some impact on the dependent variable, the total contribution of the variables in explaining the variation in success of fulfilling marital interaction goals is rather low (11 percent). Hence, most of the variation is unexplained by these variables.

Table 6 presents influence of selected independent variables on indices of discrepancies between marital interaction goals. Table 6A shows that of the two variables included in the regression model, the Index of Extrafamilial Activities is the best predictor of importance-opportunities of marital interaction goals. The relationship is inverse; put differently, as chances for extrafamilial activities increase, discrepancy between importance-opportunities decreases. The association between spouse occupation and the dependent variable is positive, indicating that there is less discrepancy between importance-opportunities of marital interaction goals for those wives whose husbands have white-collar occupations than for those wives whose husbands have blue-collar occupations. The data also show that these two variables contribute 12 percent to the explained variance.

Table 6B shows that education is the best predictor of discrepancy between importance-success of marital interaction goals (followed by Index of Extrafamilial Activities): as education increases, it appears that the discrep-

TABLE 6 Influence of Selected Independent Variables on Indices of Discrepancies Between Marital Interaction Goals[a]

A. Index of Discrepancy Between Importance-Opportunities of Marital Interaction Goals

Selected Independent Variables	Correlation Coefficients (r)	Percent Variance Explained (R^2)	Standardized Regression Coefficients (b*)	N=255
Index of Chances for Extra-familial Activities	−.32	.10	−.322	
Spouse Occupational Status	.13	.12	.133	

B. Index of Discrepancy Between Important-Success of Marital Interaction Goals

Selected Independent Variables	Correlation Coefficients (r)	Percent Variance Explained (R^2)	Standardized Regression Coefficients (b*)	N=255
Index of Chances for Extra-familial Activities	−.22	.05	−.237	
Education	.22	.10	.276	
Stress Areas	.02	.11	.166	
Spouse Work Status	.10	.13	.129	

[a]See text for items included in these discrepancy indices.

ancy increases; as education decreases, the discrepancy decreases; as extra-familial activities increase, the discrepancy decreases. It may be noted that the Index of Extrafamilial Activities is an important variable in determining both sets of discrepancies shown in Table 6, and in each instance it is negatively related to the discrepancy index. The four variables represented in this regression model explain a total of 13 percent of the variance in the discrepancies between importance-success of marital interaction goals.

The stepwise regression analysis resulted in five different regression models, but each model explains less than 20 percent of the variance. This tells us that even though the independent variables included in the models are statistically associated with the dependent variables (as determined by the regression coefficients), the strength of the relationships ranges from weak to moderate. Yet, the significance level (.05 or greater) of the variables tells us that the association between the variables is greater than what is expected by chance. Furthermore, the data tell us that a standardized change (beta standardized coefficients) in the independent variable leads to a standardized change in the dependent variable when all other variables are controlled. On the other hand, in that the variables are ordinal scales, we cannot determine the magnitude of change. Put another way, the measures do not possess the precision necessary for making precise conclusions. For example, we can say (based on the data) that degree of general happiness has a greater impact on importance of marital interaction goals than family income, but we cannot determine the magnitude of difference.

This analysis has provided us with a number of independent or explanatory variables that are significantly associated with marital interaction goals. Now, the major findings will be summarized:

(1) One of the most revealing findings is that of the association between marital interaction goals and chances for extrafamilial activities (Tables 5B and 5C). The relationships are positive. The Index of Chances for Extrafamilial Activities is also associated with discrepancies between marital interaction goals (Table 6), and the relationships are negative. For each of the associations, chances for extrafamilial activities has the greatest influence of any of the variables included in the regression models. The influence of this variable on marital interaction goals supports the theoretical notion of symbolic interactionism; namely, that interaction or relations outside the family unit aid in accounting for interaction within the family unit. These findings are suggestive of enhancement of marital interaction goals. This is inferred from the fact that the variable (Index of Chances for Extrafamilial Activities) increases both chances and success in fulfilling marital interaction goals.

(2) Degree of general happiness has a substantial influence on importance of marital interaction goals (Table 3). The influence is greater than that of any other variable in the model. The relationship is positive. Thus, the conclusion is that general happiness, too, enhances marital interaction goals.

(3) Education seems to be related to self-evaluation of role fulfillment. This is inferred from the association found between education and success in fulfilling marital interaction goals, as well as the association between education and discrepancy between importance-success of marital interaction goals. Both of the associations are positive (Tables 5C and 6B). These findings suggest that for the more educated women education may be a stabilizing force in marital relations, while the reverse might be the case for the less educated. Stated differently, since greater education appears to lead to self-criticism of role fulfillment, it is highly plausible to expect persons with higher education to attempt to remedy their inadequacies more than those with less education, since the latter is less likely to be critical of self.

SUMMARY AND CONCLUSION

This chapter has presented data for interpreting marital "strengths" as well as data for determining what variables seem to have the greatest impact in explaining the variation in the dependent variables (stepwise regression analysis). Hence, it was found that every aspect of marital interaction goals is indicative of marital "strengths." Such predominance of strength suggests that these women conform to both goal expectations and behavioral expectations of marriage. Furthermore, the data show that certain independent

variables have a significant impact on the dependent variables. The one variable which is most consistent in its impact on marital interaction goals is chances for extrafamilial activities, which seems to enhance them. In other words, to engage in activities outside the marriage seems to increase both opportunities for and success in fulfilling marital interaction goals.

It should be noted that the amount of explained variance in the regression models ranges from 11 to 17 percent. This leaves a large proportion of the variance unexplained. However, the amount of variance explained by these variables exceeds that which is usually explained by status variables (income, education, and occupation) in social science research. Even for this analysis, the status variables explained very little of the variance in any one regression model, although the prediction is that the amount of explained variance could be improved by using another technique. The suggested technique is to ask respondents to specify what enhances/hinders their opportunities and successes in fulfilling marital interaction goals. This technique could not be employed in the present study because it is a secondary analysis of data.

On the basis of the findings, three conclusions are made. The first is that the marital relations of the Black women of this study are much more characteristic of "strengths" than of weaknesses. To emphasize "strengths" is not a commission of the same sin committed by those social scientists who have emphasized weaknesses, because there is no attempt here to cover up or ignore weaknesses. The second conclusion is that extrafamilial activities or activities outside the marriage/family unit are sustaining for the marital relation. This conclusion is based on the fact that it has an impact on every aspect of marital interaction goals, except for the importance of goals, and the impact which it has on these goals is greater than the impact of any other variables. A third conclusion is that policy makers should focus on equality of opportunity and eliminating institutional racism and leave Black marriage and family to Black people. All other things being equal, it seems that Black people are quite capable of solving their marriage/family problems, at least as capable as are whites in solving their marriage/family problems.

The findings from this study contribute to a better understanding of Black marital relations, an understanding which is rooted in empiricism rather than speculation. It provides insight into some of the relevant variables which need to be further investigated. The other study, to my knowledge, which has tested some of these same variables, using Blacks as the unit of analysis, was done by Scanzoni (1971). Black family research is still in its embryonic stage, and continued research is needed in order to provide a more valid storehouse of knowledge about it. Speculation, opinions, and experiential knowledge are no substitutes for empirical research.

REFERENCES

Bernard, J. (1966) Marriage and Family Among Negroes. Englewood Cliffs, NJ: Prentice-Hall.

Billingsley, A. (1969) Black Families in White America. Englewood Cliffs, NJ: Prentice-Hall.

Blood, R. and D. Wolfe (1960) Husbands and Wives. New York: Free Press.

Christensen, H. [ed.] (1964) Handbook of Marriage and Family. Chicago: Rand McNally.

Gurin, G., J. Veroff, and S. Feld (1960) Americans View Their Mental Health. New York: Basic Books.

Heiss, J. (1975) The Case of the Black Family: A Sociological Inquiry. New York: Columbia University Press.

Hill, R. (1972) The Strengths of Black Families. New York: Emerson Hall.

Rutledge, E.M. (1974) Marital and Family Relations of Black Women. Ann Arbor, MI: University Microfilm.

Scanzoni, J. (1971) The Black Family in Modern Society. Boston: Allyn & Bacon.

Stack, C. (1974) All Our Kin. New York: Harper & Row.

9

ON MARITAL RELATIONS
Perceptions of Black Women

Lena Wright Myers

During the past few years, a number of books have been written about different aspects of human sexuality. "How-to-do" manuals have become best sellers, and books on sex roles and the psychology or social psychology of women (usually whites) have become household items. Recently, a few authors have started discussing the many supposedly profound and difficult dilemmas of intimate relationships and love that are evolving between men and women. And the latter term, love, has been claimed to be so subjective and so elusive that it defies definition. As a matter of fact, there are almost as many ways to love as there are people in the world to be loved or not loved. It is true that expressions of love vary from culture to culture, era to era, and person to person. In some centuries, "real love" had to be romantic and free of the "ugliness" of sex. In other periods of time, sexual expression was considered the most important ingredient of love.

Attitudes toward intimate expression in the western world have varied between the extreme of an almost total suppression of sexuality—at least on the surface—and a public tolerance of all varieties of intimate expression. The mass media have given emotional expressions with overtones of sexuality the hard sell, processing and packaging it in a variety of styles.

One may review magazine articles to see how the stars intimately express themselves. Another person may examine orthodox cases of intimacy by

AUTHOR'S NOTE: The research reported in this chapter was supported by a Ford Dissertation Fellowship in Ethnic Studies, 1972–1973, and a National Science Foundation Research Grant, 1974–1976.

various religious groups. Others may seek the norms of close friends or peers, or revert to parental norms regarding intimate expresssions. But all of us must set our own course for expressing ourselves in an intimate relationship.

Maybe some people are "on the fringes" in search of their own personal emotional expressions of sexuality (Masters and Johnson, 1974: 86)

This study is not an effort to define love among Black men and Black women, nor is it an attempt to provide a "how-to-do-it" (whatever it is that you are doing at a given time) manual. It is simply a descriptive account of social and/or symbolic interaction among Black couples as told by 400 Black women. Now, what is meant by social and/or symbolic interaction?

Developing and weaving related concepts, Mead (1934) noted that social interaction may be viewed as a conversation of gestures. He suggested that a conversation of gestures includes the mutual adjustment of behavior, where each participant uses the *first* gesture of the other participant's action as a cue for her or his own action. Thus, her or his response becomes a stimulus to the other participant, prompting either a shift in the other's attitude or the completion of the originally intended act. One person may unconsciously respond to the tone of voice or facial expression of the other person with whom he or she may be interacting and the other person may be unaware at a given time. This is called unconscious or nonsignificant conversation of gestures and consists of simple stimulus and response. But most human interaction through the process of socialization becomes symbolic depending upon shared understandings about the meanings of gestures. People respond creatively to the environment which they are a part of through the interpretive process. They do not respond mechanically to the intrinsic qualities of situations. Instead, they assign meanings to the given situations and respond in terms of those meanings (Blumer, 1966). The ability to assign meaning to given situations is learned by persons while interacting with other persons. Since each person will respond to events in terms of the meanings he or she assigns to them, each person's action is comprehensible and predictable to others only to the degree that the underlying meanings are *known* (Lauer and Handel, 1977).

Social and/or symbolic interaction is defined in this chapter as a social process which stresses communication through language and gestures (body talk) in the formation and maintenance of personality and social relationships among Black men and Black women. There are many things that are left *unsaid* among Black women and men; this may even complement the old cliché that "action speaks louder than words." Some things need to go *unsaid* and *unacted,* too, if there is not shared symbolic meaning among women and men in the form of language and gestures. However, if there are shared symbolic meanings, both verbally and nonverbally, more positive relation-

ships may exist between Black women and Black men.

Most Blacks do not marry in pursuit of a secure financial status, as do whites. However, when they do, they could end up as Ladner (1972) describes:

> It could be that when Blacks fall into the "trap" of using the dominant society's reasons for marriage, they become "ipso facto" prone to failure, because in this kind of environment, emotional love cannot counteract joblessness and the multitude of tensions which are frequently present.

For many Blacks the realities of the world cause frustrations that may affect their love lives. Therefore, it may be necessary to find alternatives for coping with the negative influences of society. Let us assume that a kind of symbolic or vicarious intimacy ensues which creates an unconscious desire for Black married couples to retain their marital relationships rather than resolve them. This form of symbolic intimacy may ensue in spite of negative environmental influences and traditional norms.

In an attempt to explore how Black women perceive their relationships with Black men in a marital situation, I used interview data which I collected from two separate, simple random samples, each of which included 200 Black women from Michigan and Mississippi (N = 400) in 1972–1973 and 1974, respectively. These were women who (1) had lived with their husbands for 5 years or more and (2) were divorced or separated. They were 20 to 81 years old. Their educational level ranged from third grade to masters degrees and above. These women had 1 to 15 children, with monthly *family* incomes ranging from $60 to $2,500. The length of residence in the respective areas ranged from 1 to 81 years.

This study describes how these Black women saw their social and/or symbolic relationships with their husbands or former husbands.

One of the expressive gratifications sought by married couples is cathectic affection. In order to examine how satisfied were Black women with their cathectic affection, the following question was asked:

> Cathectic affection has to do with feelings or emotions pertaining to the physical aspect of married life. These may range from the most innocent to the most intimate demonstrations of affection. Now, then, are you generally satisfied _____ or dissatisfied _____ with this aspect of your marriage or former marriage?

Table 1 shows the data obtained from the above question. For both samples, the married women appear more satisfied with the cathectic aspect of their marriages than do the women who are separated or divorced. The difference between the married women and the single women (separated or divorce) of the Mississippi sample is only slight (94 percent and 41 percent, respectively). But for the Michigan sample, the difference between the

married and single women is much greater. Ninety-six percent of the married women expressed general satisfaction with their cathectic affection, while 68 percent of the single women expressed the same.

TABLE 1 Perceived Satisfaction with Cathectic Affection

MICHIGAN	Generally Satisfied		Dissatisfied		Total	
	N	%	N	%	N	%
Married	80	96	3	4	83	100
Separated or divorced	48	68	23	32	71	100
MISSISSIPPI						
Married	103	94	7	6	110	100
Separated or divorced	68	91	7	9	75	100

A clearer understanding of cathectic affection may be found in the examples which follow.[1]

> Faye is a 47-year-old married woman with four children who lived in Mississippi. With a ray of self-confidence which even the most non-perceptive individual should be able to grasp seemingly, she had no problems with talking about her marital relationship with Melvin. She said, "Melvin has a way of looking at me that tells me that he wants to be *with* me, without having to say one word." She also said that he had another way of looking at her that let her know he did not want to be bothered at times.

> Somewhat similar is the example of Gerri, a native of Michigan, age 30, a divorcee, and the mother of one child. She talked about how "touchy-feely" both she and Paul (her former husband) were. Gerri made it very clear that the lack of cathectic affection was not the reason for their marriage ending in divorce. As a matter of fact, she stated, "that is one of the things that I miss the most about Paul and my relationship. . . . we could understand and feel each other."

Both cases indicate shared meanings and understandings of emotional expressions between Black women and their husbands or former husbands. Even though Faye may not have been very pleased about the way Melvin looked at her that told her he did not want to be bothered at the moment, she must have understood that nonverbal gesture and likely behaved accordingly. An understanding of such a gesture could also have aided her in not becoming a "clinging vine" in the marital relationship, as some women do and which some men resent.

For Gerri, the nonverbal communication between her and Paul appeared to have been of great importance to their relationship. Being "touchy-feely" toward each other seems to suggest shared meanings and understanding through and about touching.

The fact that Black women were satisfied with physical affection shown

by their mates is symbolic in that there must have been shared understanding about the meaning of gestures. Satisfaction received from expressions of physical affection has meaning and arouses meaning in the partners to whom these expressions are communicated. This sharing is essential to communication in the symbolic interactionist process. As one writer puts it:

> Each part of the body speaks a silent but intimate and revealing language. More than mere words—a wink, a shrug, or a handclasp can be the best clue you'll ever get to a person's innermost feelings [Callum, 1972].

The key to nonverbal communication of emotional expression is understanding the *clues,* and one need not be a sociologist or psychologist to do so. Black people are an expressive people. Data in Table 1 indicate that shared meanings and understandings about such clues did exist between Black women and their husbands or former husbands as perceived by the women.

The emergence of body language depends upon an already established form of interaction with the other in a marital situation. The other is the spouse. It is only to language that the individual using the gesture responds in the way the other individual does. In other words, the meaning of what one is saying includes the tendency for the other person to respond to it. As Black married couples speak, they are aware of the response which they hope to arouse. Each gesture or word serves as a stimulus to them as well as to their spouses. Now, let us examine the women's perception of freedom to communicate with their husbands or former husbands.

Assuming that the "significant other" within a marital situation, at a given time, is the spouse, the women of these samples were asked the following question:

> Do you feel very free _____ free _____ not so free _____ to confide, talk things over, or discuss anything with your husband or former husband?

TABLE 2 Perceived Satisfaction With "Freedom" to Communicate With Spouse

MICHIGAN	Very Free or Free N	%	Not so Free N	%	Total N	%
Married	75	89	9	11	84	100
Separated or divorced	40	55	33	45	73	100
MISSISSIPPI						
Married	82	74	28	26	110	100
Separated, divorced or widowed	37	49	38	51	75	100

In observing the data in Table 2, we find that the married women of both the Michigan and Mississippi samples felt freer than the separated or divorced women (when these women were married) to communicate with their spouses. Conversely, the separated or divorced women felt less free to

communicate with their spouses than did the married women. It is interesting to note that the married women of Mississippi felt less free than the married women of Michigan to communicate with their husbands. Could this difference be accounted for by region or social class? This question cannot be answered by this analysis, but it is an interesting question to be pursued in the future.

Examples of freedom or lack of freedom to verbally communicate with husbands or former husbands are as follows:

> Ellen is a 68-year-old mother of four from Mississippi who has been married to George for 47 years. She said, "I never believed in the old saying that a woman should be seen but not heard—like some people say about children . . . and George knows that."

> However, Annette, a 28-year-old mother of two from Michigan, offered an opposing view. She has been separated from Ray for almost three years. "He never wanted me to say much of anything unless he asked me something." Annette said. The lack of verbal communication between Annette and Ray is obvious in that Ray seemed to want Annette to do little or no talking to him. One-way verbal communication (as in this case) must have been extremely frustrating—especially for the listener. This alone could account for Annette having felt "not so free" to confide, talk things over, or discuss anything with her former husband.

What does this imply? It could be that a distinction between verbal and nonverbal communication did not occur among the separated or divorced women and their former spouses. Or, it may be that if distinctions were made, neither form of communication was utilized to its fullest, which may have accounted for their marital relationships having been resolved.

In an effort to assess the husbands' readiness to understand what their wives say to them during the process of interacting, data were obtained from the following question:

> Do you feel that your husband/former husband very readily _____ readily _____ not so readily _____ received or understands what you are trying to say?

From Table 3 one can observe that for both samples a greater proportion of the married women than the separated or divorced women said that their husbands very readily received or understood what they were trying to say to them. Conversely, a greater proportion of the separated or divorced women than the married women indicated that their former husbands did *not* so readily receive or understand what they were trying to say to them.

The difference between the married women and the separated or divorced women is much greater in the Michigan sample than in the Mississippi sample. In other words, the Mississippi women, married as well as separated

TABLE 3 Spouses' Readiness to Receive and Understand What Respondents Were
Saying

MICHIGAN	Very Readily or Readily		Not so Readily		Total	
	N	%	N	%	N	%
Married	71	85	13	15	84	100
Separated or divorced	32	42	44	58	76	100
MISSISSIPPI						
Married	50	49	52	51	102	100
Separated, divorced, or widowed	29	40	44	60	73	100

TABLE 4 Perceived Satisfaction With Companionship

MICHIGAN	Generally Satisfied		Dissatisfied		Total	
	N	%	N	%	N	%
Married	76	90	8	10	84	100
Separated or divorced	40	56	32	44	72	100
MISSISSIPPI						
Married	72	67	35	33	107	100
Separated, divorced, or widowed	37	49	38	51	75	100

or divorced, have more in common (49 percent, 40 percent) than do the
Michigan women (85 percent, 42 percent) with regard to perceptions of their
husbands' empathy.

Companionship is a form of expressive gratification which is sought in a
marriage. In order to test this, the following question was asked the respon-
dents:

> Companionship has to do with shared leisure or non-work time activities,
> e.g., movies, picnics, parties and dancing. Are you generally satisfied ____'
> ____ or dissatisfied _____ with this aspect of your marriage or former
> marriage?

Table 4 shows that a greater proportion of married women were satisfied
with the companionship in their lives than women who were separated or
divorced for both the Michigan and Mississippi samples. Conversely,
divorced or separated women were more dissatisfied with their companion-
ship than married women. Here, we observe that the difference between
married and single women is greater in the Michigan sample (90 percent and
56 percent, respectively) than the Mississippi sample (67 percent and 49
percent, respectively). A 52-year-old divorcee from Michigan said that her
former husband was never home long enough to do anything with her and
their six children, even when not working. This confirms a common expec-

tation—if separated or divorced women were satisfied with their marriages, they would still be married, especially since companionship is the essence of marriage.

Interacting individuals in any situation must constantly interpret the gestures of others and, in so doing, arrest, recognize, and adjust their own intentions, wishes, feelings, and attitudes. Similarly, they have to judge the fitness of norms, values, and group prescriptions from the situation indicated by the acts of others. This process of interpretation and redefinition relates to all kinds of interpersonal situations, whether they involve cooperation, love, conflict, hostility, or anger. This notion is examined by using the following questions:

How often would you say that you and your husband/former husband had a big "blow up" and really got angry with each other?

 _____ never
 _____ seldom
 _____ sometimes
 _____ often
 _____ very often

Table 5 shows that married women in the Michigan sample are more likely than the separated or divorced women to never have marital conflicts. On the other hand, separated or divorced women were more likely to have had conflicts with their former husbands. This conforms to a common-sense expectation. Conflict is negatively related to marital disruption, although some conflict is positively related to a marriage.

TABLE 5 Frequency of Conflict During Marital Relations

MICHIGAN	Never		Seldom or Sometimes		Often or Very Often		Total	
	N	%	N	%	N	%	N	%
Married	12	15	63	77	7	8	82	100
Separated or divorced	2	2	31	40	45	58	78	100
MISSISSIPPI Married	0	0	59	74	21	26	80	100
Separated, divorced, or widowed	0	0	20	48	22	52	42	100

In the Mississippi sample, we find that neither married nor single women (separated or divorced) had no marital conflicts. The married women experienced conflicts less often than did the single women (26 percent and 52 percent, respectively).

The notion of conflict in a marital relationship brings to mind an article

entitled "Problems Remain the Same" which appeared in a well-known magazine some time ago, noting a request for advice from a marriage counselor:

> After ten years of marriage, our problems today are the same as at the beginning. It seems that there can be no compromise. Briefly, our problems are:
>
> (1) He thinks I talk too much detail. He tunes me out, and does not remember things I have told him.
> (2) He says I depend on him too much for little decisions.
> (3) I don't like to argue. I used to cry over misunderstandings, which disgusted him. Now I sulk.
> (4) I have always been more affectionate than he—sometimes too aggressive, which annoys him. I have restrained myself, but this has not made him more affectionate. Signed, Lonely [Home Life, 1972]

Conflict is often viewed negatively. However, some theorists suggest that conflict has some positive aspects (Simmel, 1955). It can serve as a force which integrates people on opposing sides, bonding them firmly into a group. Granted, this also applies to at least two people interacting. Thus, conflict may be advantageous to some Black married couples in that they may refrain from personal abuse and confine a quarrel to issues, thus eliminating points of tension. In addition, it may serve to bring husbands and wives into communication with one another, forcing them to face up to their problems.

In examining reasons for conflict among the women and their husbands or former husbands, the following questions were asked:

> What is/was this usually about?
>
>> occupational and financial matters or
>> other matters
>
> Thinking back over your married life, what was or is the *one* thing that you and your husband or former husband have disagreed about most?[2]

Table 6 shows the issues over which the women had marital conflicts. For the Michigan married women, "suspicion of husband playing on wife," followed by occupational or financial issues were those over which they had the greatest conflicts. The issues over which they had the least conflicts were discipline of children and infrequent sexual activity on the part of the husband (11 percent each). For the single women, the reverse was true. The greatest conflict occurred over occupational or financial issues, followed by "suspicion of husband playing on wife." The issues which caused least conflict for single women were "infrequent sexual activity on the part of the husband" followed by discipline of children.

TABLE 6 Major Reasons for Conflict During Marital Relations

MICHIGAN	Occupational or Financial		Suspicion of Husband "Playing" on Wife		Disciplining Children		Infrequent Sexual Activity —Husband		Total	
	N	%	N	%	N	%	N	%	N	%
Married	24	35	30	43	8	11	8	11	70	100
Separated or divorced	47	61	22	29	5	7	2	3	76	100
MISSISSIPPI										
Married	17	28	20	34	23	38	0	0	60	100
Separated or divorced	15	35	23	55	2	5	2	5	42	100

In the Mississippi samples, we find some variations from the Michigan sample. Mississippi married women's greatest marital conflicts appeared to be over child discipline, followed by suspected infidelity by the husband. The issue of child discipline caused less marital conflict in the Michigan sample. The issue over which the least conflict occurred was "infrequent sexual activity on the part of the husband." For the single women, the conflict occurred most frequently over "suspicion of husband playing on wife," followed by occupational or financial issues. The issues over which they had the least conflict were discipline of children and husband's infrequent sexual activity.

SUMMARY AND CONCLUSION

This study is by no means exhaustive—it is merely an effort to describe the social and symbolic interaction among 400 Black women who were either married, separated, or divorced. Specifically, we were concerned with the interpersonal behaviors that affect the maintenance of marital relationships. From the empirical findings, one may conclude that alternatives utilized by Black married couples in retaining their marital status include perceptions of cathectic affection, perceptions of the opportunity to relate to their husbands (thus having them favorably respond), perceived degree of satisfaction with companionship, and the ability of both partners to use conflict to their advantage in the relationship.

In conclusion, Black married and unmarried women may see one function of social and symbolic relationships in marriages as an outlet of emotional support (support system) and concern of someone to confide in. Spouses (mates) seem to fulfill that need which cannot be found in the larger society due to its structure. Let us also realize that being divorced or separated does, in many instances, eliminate social and symbolic interaction between Black women and Black men in a living arrangement. Although sometimes misunderstood by outsiders, memories of this relationship can remain a part of a former Black mate's entire life. This was suggested by the 400 Black women from Michigan and Mississippi.

Black women and Black men, as reasoning creatures, can relate to each other verbally and through self-disclosure, can learn something about each other and about our own identities as well. In addition, as sexual creatures, we have the ability to express ourselves, our feelings, thoughts, and even our fantasies through physical (nonverbal) communication. It simply becomes an ongoing process of relating, sharing, and communicating.

NOTES

1. Pseudonyms are used to identify the women and their husbands or former husbands for

each example, since names of the respondents were not secured to assure confidentiality.

2. It is important to note that open-ended responses to this question were also used in pursuing data on "communication" between the women and their husbands/former husbands, where responses regarding "communicating" occurred.

REFERENCES

Blumer, H. (1966) "Sociological implications of the thoughts of George Herbert Mead." American Journal of Sociology 71 (March.)

Callum, M. (1972) Body Talk. New York: Bantam.

Fullerton, G. P. (1977) Survival in Marriage: Introduction to Family Interaction, Conflict, and Alternatives. Hinsdale, IL: Dryden.

Green, E. J. (1978) Personal Relationships: An Approach to Marriage and Family. New York: McGraw-Hill.

Henley, N. M. (1970) "The politics of touch." Presented at the American Psychological Association Meetings, Miami Beach, Florida, September.

_____(1974) "Power, sex, and nonverbal communication." Berkeley Journal of Sociology 18.

Kogan, B. A. (1973) Human Sexual Expression. New York: Harcourt Brace Jovanovich.

Ladner, J. A. (1972) Tomorrow's Tomorrow: The Black Woman. New York: Doubleday.

Lauer, R. H. and W.H. Handel (1977) Social Psychology: The Theory and Application of Symbolic Interactionism. Boston: Houghton Mifflin.

Masters, W.H. and V.E. Johnson (1974) "The role of religion in sexual dysfunction," in M.S. Calderone (ed.) Sexuality and Human Values. New York: SIECUS/Association Press.

Mead, G. H. (1934) Mind, Self, and Society (C.W. Morris, ed.). Chicago: University of Chicago Press.

Myers, L.W. (1973) "A study of the self-esteem maintenance process among Black women." Dissertation, Michigan State University. (unpublished)

_____ (1975) "Black women and self-esteem," in M. Millman and R. M. Kanter (eds.) Another Voice: Feminist Perspectives on Social Life and Social Science. Garden City, NY: Anchor/Doubleday.

Simmel, G. (1955) Conflict and the Web Affiliations (K. H. Wolff and R. Bendix, trans.). New York: Free Press.

Walster, E. and G.W. Walster (1978) A New Look at Love. Reading, MA: Addison-Wesley.

PART III

POLITICAL, EDUCATIONAL, AND ECONOMIC INSTITUTIONS AND THE BLACK WOMAN

In the opening chapter of Part III, Eleanor Engram examines the orientation of preadult women toward future roles. The data come from 361 Black women and 821 white women between the ages of 17 and 24 who were in school and never married in 1968 and out of school in 1971. Engram found that at the point of their entry into adulthood, the young Black women did not differ significantly from white women in their plans for the future. Young white women were somewhat more likely to enact a labor market role, while Black women were more likely to enact marital roles. Engram concludes that Black women in this sample did not have stronger career orientations or weaker homemaking orientations at their point of entry into adulthood than white women. Both groups continue to give priority to marital roles, although a majority will work at some point in their adult lives.

Cheryl Leggon studies the problems associated with the "elite" Black professional woman, primarily that they represent status discrepancy. In the case of Black professional women, the discrepancy is both in terms of race and sex. The author studied medical doctors, attorneys and holders of M.B.A. degrees. Most of the respondents said they experienced more discrimination on the basis of race than on the basis of sex. The author also studied the ease with which Black professional women cope with the conflicting role demands of career and home. Leggon concludes that the Black elite professional woman does not gain benefits from her double-negative status.

Rhetaugh Dumas discusses the increase in Black women in professional positions. She views the increase in status with mixed feelings, as Black women are pressed into symbolic roles that conflict with the tasks they are hired to perform. The Black woman, she asserts, is constantly torn between the expectations and demands born of her mythical image and those that are inherent in her official status. The author maintains that the preference is to have the Black woman assume a variety of functions that resemble those described for the Black mammy during the plantation era. The author concludes that the Black female executive must strive to balance the symbolic functions and those that are task-directed. The success of Black women execu-

tives lies in their ability to move back and forth between these two roles.

Cheryl Gilkes, in "Holding Back the Ocean with a Broom," is concerned with the work of Black women in the community of Hamptonville—a fictitious name. The author studied 25 Black women who were recognized as community leaders. Gilkes says that the problems they faced in helping to support and educate their families were transformed from private troubles to public issues. What started as isolated actions to change specific conditions in their lives soon became routine activities. Because of their work in the community, these women are highly respected. The work of these women in the community is a full-time occupation; they struggle on a day-to-day basis to solve the problems created by nearly 400 years of oppression. The women, indeed, seem to be able to hold back the ocean with a broom.

Jewel Prestage closes this section with an article on the political behavior of black women in America. She tells us that Black women have been left a legacy of feminine leadership in political and military affairs: such as Hatshepsut, Cleopatra, and Ann Zingha. Black women continued their role in political and military affairs during slavery. Prestage discusses the political and military activities of Harriett Tubman, Sojourner Truth, and Nanny Prosser. Their activity was characterized by exertion of leadership within the slave community, agitating for the abolition of slavery by both violent and nonviolent means. The author tells us that after slavery, Black women continued their political activities even though they could not vote. Even with the 19th Amendment, Black women were still not permitted to participate in politics, since their participation was more a function of race than sex. Prestage maintains that as the nation changed its laws to protect the rights of Blacks, more Black women began to take part in politics. In 1977, there were 782 Black women holding elective office. From all indications, Prestage concludes, the Black woman will continue to participate in the political affairs of this country.

10

ROLE TRANSITION IN EARLY ADULTHOOD
Orientations of Young Black Women

Eleanor Engram

INTRODUCTION

Prevalent social science theory posits the labor market activity of Black women to be an enculturated aspect of their sex-role identity and of Black community life. That is to say, widely read and disseminated studies have argued that participation in the labor market is a goal desired by most Black women and that it is this labor market activity which creates an imbalance of power between Black spouses and, ultimately, leads to family disruption (see, for example, Moynihan, 1965; Blood and Wolfe, 1960). Implicit in this thesis is the position that the success rate of white marriages is attributable to white women's greater valuation of traditional homemaking roles and the extra bargaining power this gives their husbands' labor force earnings.

The enculturation thesis has found support in studies which find a higher probability of labor market activity among daughters of working mothers than among daughters of nonworking mothers (Almquist and Angrist, 1970; Geysberg et al., 1968; Baruch, 1972). We contend, however, that intergenerational patterns may also derive from intergenerational continuity in other impetuses to labor force activity—for example, economic need. In fact, while the labor force participation rates of white women have catapulted during the past quarter-century, Black women's rates have been fairly constant during this period. This study examines the orientation of preadult females toward future marital and labor roles and, as such, attempts to test this enculturation hypothesis.

THEORETICAL BACKGROUND

The structure of sex roles in American society and the expectations surrounding these roles shape the occupational orientations of young men and women about to move into the post-educational phases of their life cycles. Fundamental to modern thought on men, women, and work is the assumption that there exists in society a division of labor between the sexes. Women have an absolute advantage in having children and a comparative advantage in rearing them. Such duties thus become women's primary social function. Indeed, whether they do or do not participate in the labor market and when they do—be it out of necessity or choice—home and children remain their primary responsibilities.

Historically and traditionally, males have overwhelmingly reported labor market aspirations, whereas women often have favored other alternatives (Thorpe, 1969; Antonovsky, 1959). Although some categories of women, such as the poor, the Black, the widowed, the orphaned, and the spinster, traditionally have *had* to work, the normatively prescribed arena for the labors of women traditionally has been the home. Thus, at least until the past quarter of a century, women not of the needy genre would be more likely to opt for homemaking than to plan a labor market role or combined role (Smuts, 1974).

The structure of race relations in America made the structure of sex roles ill-shaped to fit the Black experience. The subordination of Black males in the labor market made participation of Black women in the labor market essential for economic survival of Black families. Black women, being in the category of women who work out of necessity, have long combined family and labor market roles. Economic conditions in the Black community and correlated desires for better living standards have always conflicted with the notions of women belonging in the home and being spared from productive paid labor.

Consistent with such orientations toward the labor market, young Black women have high occupational aspirations (Sain, 1966; Thorpe, 1969; Antonovsky, 1959). These aspirations, however, historically have not been translated into high occupations and incomes (Lerner, 1972), since Black women traditionally have had the lowest median level of occupation and income of any other race-sex group (U.S. Dept. of Labor, 1974; Gurin and Epps, 1966). Whether the reasons for these low attainments lie in the counterplay between home and labor market roles or in factors endemic to the social structure is one of the major questions raised by this study.

The notion that marital and parental roles compete with work roles in the lives of American women is suggested by the prevailing public sentiment regarding the roles of women (Howe, 1972) and by the patterns of their labor market behavior (Waldman, 1970). In comparison to white rates, the labor

force participation rates of Black women have been high and less sensitive to the effects of assuming parental roles (see Table 1). Differences in the work patterns of Black and white women have been attributed by some to differences in valued feminine roles (Blood and Wolfe, 1960; Moynihan, 1965; Scanzoni, 1975). Scanzoni, for example, theorized that Black women value nontraditional roles more and that this elevates their labor force participation relative to that of white women. Such a position became popular with the Moynihan (1965) thesis, which maintained that labor market participation was a goal of most Black women and that such activity created an imbalance of power between Black spouses, ultimately leading to marital disruption.

Careful scrutiny of Black women's labor force participation rates is suggestive of other possibilities, however. That is, the relative constancy of their actual participation rates suggests that homemaking roles have also appealed to Black women. We are suggesting, consistent with a model of the work experiences of women which incorporates this possibility, that the labor force participation rates of Black women have reflected the need for their incomes and many Black women may therefore actually desire homemaking roles.

TABLE 1 Nonwhite and White Mothers in the American Labor Force, by Age of Children (March 1967)

Age of Children	Non white %	White %
Under 6 years	44.0	27.0
6–17 years	58.0	48.0

SOURCE: Adapted from Feagin (1972).

BRIEF LITERATURE REVIEW

The dramatic increase in the labor force participation rates of young women between the ages of 20 and 34 (Table 2) would suggest that "work" has become an increasingly desirable posteducational activity for all women, both Black and white. As yet, these women's work activities have not generated theoretical models of occupational attainment which incorporate the procreative considerations which often shape their career decisions. Although Black women long have reflected this work pattern and thus have produced significant increments to Black family income, traditional status attainment studies have left this work force activity unanalyzed except where Black women have been family heads. This may be attributed to the fact that status is traditionally viewed as having its locus in males (Parsons, 1959).

Some consequences of using an attainment model that is derived from the work experience of males are that (1) such a model assumes orientation toward labor market occupational roles and (2) it ignores sex-related barriers

to attainment. Women may perceive other roles to be either more important or just as important as labor market roles,[1] and when they have the same occupational values as males, their sex may operate as a factor in their attainments.

TABLE 2 Black Women and All American Women in the Labor Force, Selected Years, 1900–1974

Year	Black Women %	All Women %
1900	41.2	20.4
1910	54.2	25.2
1920	43.7	23.3
1930	38.9	24.3
1940	37.3	25.4
1950	46.9	29.0
1960	48.2	34.5
1970	49.5	42.6
1973	49.0	44.0
1974	49.1	45.2

SOURCE: Adapted from United States Bureau of the Census, *Current Population Reports,* March 1974, and *Census of the Population,* 1900–1970.

In spite of their early labor market experience, some Black women continue to reach higher educational and occupational levels through the child-bearing years and into the preretirement stage of the life cycle. This is evidenced in 1970 census figures which show a positive relationship between the age of Black women and occupational status and income (U.S. Bureau of the Census, 1970). Also, without regard to age, a comparison of 1966 to 1969 census figures reveals a 3.5 percent increase in the number of Black women professionals between those years, an 8.7 percent increase in clerical and sales workers, and a 13.5 percent decrease in household and service workers, although the latter remains the modal employment category. These data suggest that labor market concerns are salient features in the lives of adult Black females.

Borow (1956), in studying occupational socialization, concludes that this is as much a feature of adulthood as of adolescence, and, as such, occupational aspirations and attainments are properly viewed as developmental processes. Brim (1968) posits occupational socialization to be *greater* in adulthood than in childhood, since he argues that what is learned in childhood is inadequate for technological and other changes occurring in a non-static society. Occupational goals, then, should reflect upward and downward revision through the life span consistent with ideal and practical later-life considerations. For women, marriage and parenthood are proposed to be among these considerations.

THE ROLE ORIENTATIONS OF WOMEN

The central thesis of the sociological approach to the study of status attainment can be stated as follows: The individual is socialized through the life span into societal roles, "work" being among the most important required roles in America. Occupational roles thus are a feature of the everyday life of adults, they become incorporated into the individual's "self," and they are reinforced by participation in social or community life.

Because the normatively prescribed role of the male is that of "breadwinner," it is generally assumed that American men orient themselves toward occupational roles early in life and that their roles as "workers" dominate others in their role complex. As a result, the occupational attainments of men are attributed primarily to their personal qualities, such as "intelligence," "personality," and "aspirations," and secondarily to the socioeconomic environment of their preadolescent years, the latter being an important determinant of the preparation young men receive to pursue their careers. Other life events, such as marriage, parenthood, and illness, have not been considered as having major importance in the study of male occupational placement.

The same type of orientation toward labor market occupational roles, however, cannot be assumed to exist for women. Women may or may not be oriented toward labor market roles, consistent with idealized models of womanhood which incorporate other roles. Such other roles may have primacy over or compete with labor market roles. Thus, the occupational aspirations and attainments of women will be influenced by the particular model of femininity to which they subscribe.

Whether upon completion of her education a woman chooses to marry, go into the labor market, or a combination of the two will be greatly influenced by the images of women she learns to value before adolescence. Thus, early role choices are proposed to vary directly with role valuation and indirectly with family structure and socioeconomic status—factors which affect role valuation.

Since labor market roles are just one set that vie for the commitment of women, initial career plans will be subject to both voluntary and chance revision, thus precluding one-to-one correspondence between early plans, later plans, and the actual positions women fill after they finish school. Women who plan to marry often end up working, and vice versa.

To the extent that occupational roles become incorporated into the identity, women will revise their occupational aspirations in accord with shifts in the actual positions they fill. For example, women who plan labor market careers may revise their occupational aspirations as they embark upon other adult careers such as marriage and/or parenthood.

THE ROLE ORIENTATIONS OF
YOUNG BLACK WOMEN

Billingsley (1968) posits a model to be used in the study of Afro-American families which this study uses to advance our understanding of Afro-American sex-roles and the labor force participation of Black women. Black Americans, he maintains, are a subsystem of the larger society; consequently, at the same time they are subject to the social prescriptions of the larger society they face societal impediments to conformity to those prescriptions. This approach points out the contradictions in American society which, while expecting families to maintain themselves economically and expecting males to be dominant in these activities, impedes the abilities of categories óf males to do this. However, being a subsystem of American society, Black Americans have been able to devise responses to these contradictions in the form of women's work. When viewed within the context of such a theoretical paradigm, Black women's work force participation becomes a dynamic role which is constantly affected by both social prescriptions and economic conditions. Therefore, competing hypotheses are suggested regarding the high degree of intergenerational continuity in American sex-roles.

A key flaw in most studies which have been directed to these questions is that they have observed the orientation of women toward the labor force *after* they have entered marital and parental roles (Almquist and Angrist, 1970). In contrast, this study compares the planned and actual early adult roles of a sample of young Black and white women who were still in school and yet unmarried at first observation, and who were out of school upon a later observation. We consider this an estimate of their orientation to adult roles at a critical period—that is, when they are making the transition to adulthood by leaving educational roles for entry into roles associated with adulthood (work and/or marriage).

DATA SOURCE

The data on which this analysis is based come from secondary analysis of the "Parnes" sample survey data of the "Work Experience of Young Women." The survey respondents were 361 Black women and 821 white women between the ages of 17 and 24 in 1971. Their responses to two questions ("What are your plans after school?" asked in 1968; and Marital and Labor Force Status, asked in 1971) were recoded into the following categories and comprise the data of this study: (1) work; (2) joint roles; (3) marriage; and (4) other. Responses falling into the category "other" were negligible and this category was dropped from our analysis with a loss of eight women from the original sample.

The women in the subsample included in this analysis were selected on

the basis of their being in school and never having married in 1968, and being out of school in 1971. These criteria create a very select sample, since different socioeconomic and racial groups have different probabilities of remaining in school, of having interruptions due to pregnancy, and so on. By adopting these criteria, however, we were able to observe the women both before and after they had enacted adult roles. We have excluded those women in the age range 14 to 24 who had left school by 1968, who had married by 1968, and/or who were still in school in 1971.

Table 3 presents the means and standard deviations of selected socioeconomic characteristics of all women in the larger data set and of women in the subsample drawn from it.

Comparing the socioeconomic characteristics of the Black and white subsamples of women reveals that, on the average, they are about the same ages and have similar educational levels, but they have relatively different socioeconomic origins. The fathers of the white women have, on the average, two more years of education than the Black women's fathers, and the white fathers have occupations on the average 2.82 points higher on the Duncan Scale. It would appear that while the Black women are generally of lower socioeconomic status than the white women in the subsample, they are of much higher status than the larger sample of Black women from which they were drawn (Table 1). Black women in the larger sample have parents whose occupations are only one-half the Duncan Scale value of the occupations of parents in the larger white sample. Having a relatively middle-class subsample of Black women will make them more comparable to the white women in the study but, of course, this limits our ability to generalize to other Black women in the population. These restrictions on generalizations were a necessary outcome of our sampling criteria. However, we do have a sample of middle-class Black women and feel that they represent a valid category to consider—one which is often neglected in sociological research.

PROCEDURES

Our first strategy was to look at the planned adult roles of the young women to determine the typical patterns within each group. That is, what did women of each racial group plan to do when they finished school? Then, we compared the plans of Black and white women to see if the distributions of planned roles were similar or different. Research on Black families suggests that, on the average, Black women should be expected to plan less traditional activities than white women. We expected, however, that since Black women are members of an American subsystem they share the ideals of the larger society; thus, our expectations were that their plans would be similar to those of white women, although they may be subject to different constraints in pursuing those plans.

TABLE 3 Descriptive Summary of Selected Characteristics of all Women and Subsamples of Women in the Study (1968 means and standard deviations)

| | Black Women | | | | White Women | | | |
| | All Women | | Subsample | | All Women | | Subsample | |
Characteristic	Mean	S.D.	Mean	S.D.	Mean	S.D.	Mean	S.D.
Age	18.39	2.95	17.08	1.99	18.85	3.04	17.00	1.97
Father education	7.55	3.73	8.93	4.11	10.75	3.53	10.61	3.69
Father occupation	19.08	14.33	31.61	23.80	38.92	24.74	34.43	23.83
Mother education	8.81	3.19	9.62	3.42	10.91	2.89	10.80	2.87
Mother occupation	18.30	17.56	26.03	22.41	36.48	21.22	30.89	20.71
Siblings	2.81	2.59	2.93	2.43	2.59	1.99	2.79	2.21

Our next step was to examine the actual roles which the young women were enacting when they were reinterviewed in 1971. Irrespective of their original plans, how were the actual roles of the young women distributed by 1971 when they had finished school? We expected different patterns in actual roles to prevail for Black and white women, since Black women historically have been more likely to work than have white women. We present these analyses in Tables 4 and 5.

THE PLANNED ROLES OF YOUNG WOMEN

Looking at the distribution of plans in Table 4, we observe that nearly four-fifths of all women of each race planned to work for their earliest adult activity (77.8 percent of Black women and 78.9 percent of white women). About half of the remaining women in each racial group planned a joint role, and one-half planned a marital role. An overwhelming majority of almost 90 percent of the women planned an immediate posteducational role which incorporated work. And, contrary to prevalent theory (Feagin, 1972), white women were as likely as Black women in the sample to have planned such labor market activity. These data suggest that at this preadult stage, while still in school, females in both racial groups have very similar orientations toward adult roles and, for the most part, desire to enter the labor market. Table 5 records their actual early adult roles.

**THE ACTUAL EARLY ADULT ROLES
OF YOUNG WOMEN**

Examining the patterns of actual adult role enactment, (Table 5), we see

TABLE 4 The Planned Early Adult Roles of Young Women Interviewed in 1968 by Race

Plans	Blacks	Percentage	Whites	Percentage
Work	281	77.8	648	78.9
Joint Role	46	12.8	90	11.0
Marriage	34	9.4	83	10.1
Total	361	100.0	821	100.0

Note: N = 1182.

TABLE 5 The Actual Roles of Young Women Entering Adulthood by Race (1971)

Actual Role	Blacks	Percentage	Whites	Percentage
Work	196	54.3	511	62.3
Joint	24	6.6	71	8.6
Marriage	141	39.1	239	29.1
Total	361	100.0	821	100.0

that by 1971 54.3 percent of young Black women were in the labor market; a mere 6.6 percent were in joint roles, and 39.1 percent were in marriage roles. Although, as we expected, a majority of young Black women (90.5 percent) had planned early adult roles which incorporated work, by 1971 only 60.9 percent were working. Contrary to prevalent theory, marital roles do present competition for work roles in the early adult years of Black women. More than three times as many as planned an exclusive marital role were in that role in 1971. Such competition is also highlighted by the small percentage of Black women who were enacting combined roles in 1971.

In 1971, of the young white women in the sample, 62.3 percent of the total were working. Like the Black women, most of the white women had planned a role which incorporated work (89.9 percent); but, likewise, many (29.1 percent) of the white women were married and not working in 1971. And similar to the case of Black women, very few (8.6 percent) of these women were in joint roles in 1971 (Table 5).

In contrasting the actual role enactment of young Black and white women, we note, almost counterintuitively, that young white women were somewhat more likely to enact a labor market role (62.3 percent versus 54.3 percent), while Black women were more likely to enact marital roles (39.1 percent versus 29.1 percent). However, because three years is only a short time, the magnitude of any correlation between planned and actual roles must be considered in light of the fact that many young women only plan a labor market role until they will marry a few years after leaving school—that is, they may desire a marital role but not expect to marry immediately. If they happen to marry early, then their actual role, though inconsistent with the plans reported in 1968, would be consistent with the actual goal of most young women.

DISCUSSION

While prevalent theory on Black women suggests that they have more positive labor market orientations and less positive marital orientations than white women, our data do not indicate it. Black and white women in the sample were of generally similar socioeconomic origins and were equally likely to plan labor market, joint, and marital roles, suggesting that these orientations may be a function of socioeconomic status. These findings suggest that Black and white women conform to the same cultural ideals, and, unlike many sociological theories suggest, that Black women do not have stronger career orientation or weaker homemaking orientations at their point of entry into adulthood. Also suggested by these findings is that differences in the patterning of female labor market behaviors throughout their adult life cycles are due to structural and not characterological factors. This is also suggested by the relatively constant labor force participation

rates which Black women have exhibited for the past half-century. Although many studies have noted the salience of the female work role in the lives of Black Americans, the concurrent "myth of the matriarchy" (Tenhouten, 1970) has precluded the notion that it may be associated with role conflict. These data suggest that this possibility should be explored. A major implication of the entire study is that the adult careers of women come under the influences of forces outside their socialization arena which affect both their planned and their enacted early adult roles. The rate at which young Black and white women enacted marital roles within the three-year period 1968 to 1971 suggests that these forces may be related to their conjugal partners. These data and the overall patterns of the young women's enacted roles suggest that, contrary to popular expectations created by images of women associated with the feminist movement, women are still very traditional and will continue to give primacy to marital roles, although a majority will work at some point in their adult lives. This is also suggested by the dichotomy in the actual roles the women enacted, although we know that many of these women will very likely enact joint roles at some time in their lives. It is suggested, however, that women of this generation will not be radically less traditional than were the women of their parents' generation.

CONCLUSION

This study, which had as its central interest the differences in the early adult experiences of Black and white women, has found that the plans and ideals of Black and white women of similar socioeconomic origins are also very similar. Yet, the images of Black women in American society arising from their historical salience in the labor market would suggest that they reject traditional ideals. This study has comprised a test of that thesis. Black women vary as much as others in the traditionality of their response to adult roles. However, while social forces have designated the white woman's place as the home, they have designated the Black woman's place as in the labor market (although in low-status occupations). It is no wonder, then, that the efforts of feminists to gain mass support from Black women have failed. I am reminded of the motto of the International Women's Year, 1975: *"Power to Change/Freedom to Choose."* It seems that freedom to choose a labor market role has been denied some women, and freedom to choose homemaking roles has been denied others.

NOTE

1. Kreps (1972), for example, argues that women make decisions to work based on their evaluation of two sets of advantages: the home set, consisting of more leisure time, community activity, freedom of schedule, etc.; and the market set, consisting of earnings, fringe benefits, job status, associations in the work place, and interest in the work itself.

REFERENCES

Almquist, E. and S. Angrist (1970) "Career salience and atypicality of occupational choice among college women." Journal of Marriage and the Family 32: 242–249.

Antonovsky, A. (1967) "Aspirations, class and racial-ethnic membership." Journal of Negro Education 36: 385–393.

_____(1959) "Occupational aspirations of lower class Negro and white youth." Social Problems 7: 132–138.

Baruchi, G. K. (1972) "Maternal influences upon college women's attitudes toward women and work." Developmental Psychology 6: 32–37.

Billingsley, A. (1968) Black Families in White America. Englewood Cliffs, NJ: Prentice-Hall.

Blau, P. M. and O. D. Duncan (1967) The American Occupational Structure. New York: John Wiley.

Blood, R. O. and D. M. Wolfe (1960) Husbands and Wives: The Dynamics of Married Living. New York: Free Press.

Borow, H. (1956) "Development of occupational motives and roles," in L. V. Hoffman and M. L. Hoffman (eds.) Review of Child Development Research, Vol. 2. New York: Russel Sage.

Brim, O. G. (1968) "Adult socialization," in J. A. Clausen (ed.) Socialization and Society. Boston: Little, Brown.

Cohen, J. and P. Cohen (1975) Applied Multiple Regression/Correlation Analysis for the Behavioral Sciences. New York: John Wiley.

Duncan, O. D. (1961) "A socio-economic index for all occupations," in A. J. Reiss, Jr. (ed.) Occupations and Social Status. New York: Free Press.

_____D. L. Featherman and B. Duncan (1972) Socioeconomic Background and Achievement. New York: Seminar Press.

Durkheim, E. (1933) Division of Labor in Society. New York: Free Press.

Engels, F. (1884) The Origin of the Family, Private Property, and the State. Moscow: Foreign Language Publishing House.

Feagin, J. R. (1972) "Black women in the American work force," in C. V. Willie (ed.) Family Life of Black People. Columbus, OH: Charles E. Merrill.

Geysberg, N. C., J. C. Johnston, and T. Geist (1968) "Characteristics of career and homemaker oriented women." Journal of Counselling Psychology 15: 541–548.

Gurin, P. (1966) "Social class constraints on the occupational aspirations of students attending some predominantly Negro colleges." Social Forces 45: 27–40.

_____ and E. Epps (1978) Black Consciousness, Identity and Achievement. New York: John Wiley.

Haller, A. O. and A. Portes (1973) "Status attainment processes." Sociology of Education 46: 51–91.

Hamilton, C. V. (1971) "Racial, ethnic and social class politics and administration." Public Administration Review 32: 638–648.

Hill, R. B. (1972) The Strengths of Black Families. New York: Emerson Hall.

Howe, L. K. [ed.] (1972) The Future of the Family. New York: Touchstone Books.

Kandel, D. B. (1971) "Race, maternal authority, and adolescent aspiration." American Journal of Sociology 76: 999–1020.

Kerckhoff, A. C. (1971) Educational, Familial, and Peer Group Influences on Occupational Achievement. Washington, DC: U.S. Dept. of Health, Education and Welfare.

Kreps, J. (1972) "Do all women want to work? the economics of their choice," in L. K. Howe (ed.) The Future of the Family. New York: Touchstone.

Kriesberg, L. (1970) Mothers in Poverty: A Study of Fatherless Families. Chicago: AVC.

Kuvlevsky, W. P. (1967) "The relevance of adolescents' occupational aspirations for subsequent job attainments." Rural Sociology 32: 290–301.

Ladner, J. A. (1972) Tomorrow's Tomorrow: The Black Woman. New York: Doubleday.

Lerner, G. (1972) Black Women in White America. New York: Vintage.

Miller, S. M. and S. J. Reissman (1971) Social Class and Social Policy. New York: Basic Books.

Mirande, A. M. (1968) "On occupational aspirations and job attainments." Rural Sociology 33: 349–353.

Moynihan, D. P. (1965) The Negro Family: Case for National Action. Washington, DC: U.S. Government Printing Office.

Nie, N. H. et al. (1975) Statistical Package for the Social Sciences. New York: McGraw-Hill.

Ohio State University (1973) National Longitudinal Surveys Handbook.

Parsons, T. (1936) "Age and sex in the social structure of the United States." American Journal of Sociology 42: 81–94.

——— (1959) "The school class as a social system: some of its functions in American society." Harvard Educational Review 29: 297–318.

Proctor, S. D. (1969) The Young Negro in America: 1960–1980. New York: Association Press.

Sain, L. F. (1966) "Occupational preferences and expectations of Negro students attending a high school located in a lower socio-economic area." Dissertation Abstracts 27 (4) 966.

Scanzoni, J. H. (1975) "Sex roles, economic factors, and marital solidarity in Black and white marriages." Journal of Marriage and the Family 31: 130–145.

Sewell, W. H. and R. M. Hauser (1972) "Causes and consequences of higher education: models of the attainment process." American Journal of Agricultural Economics (December): 851–861.

——— A. O. Haller, and M. A. Portes (1969) "The educational and early occupational attainment process." American Sociological Review 34: 82–92.

——— A. O. Haller and M. A. Strauss (1957) "Social class and educational and occupational attainment." American Sociological Review 22: 67–73.

Solomon, D., R. J. Parelius, and T. V. Busse (1969) "Dimensions of achievement-related behavior among lower-class Negro parents." Genetic Psychology Monograph 79: 163–190.

Smuts, R. W. (1974) Women and Work in America. New York: Schocken Books.

Stack, C. B. (1974) All Our Kin. New York: Harper & Row.

——— (1974) "Sex roles and survival strategies in an urban Black community," in M. Z. Rosaldo and L. Lamphere (eds.) Woman, Culture and Society. Stanford, CA: Stanford University Press.

Tenhouten, W. D. (1970) "The Black family: myth and reality." Psychiatry 145–155.

Thorpe, C. B. (1969) "Status, race, and aspiration: a study of the desire of high school students to enter a professional or technical occupation." Dissertation Abstracts 29 (10-A) 3672.

Tseng, M. S. (1971) "Social class, occupational aspiration and other variables." Journal of Experimental Education 39: 88–92.

U.S. Bureau of the Census (1970) Characteristics of the Population. Washington, DC: U.S. Government Printing Office.

U.S. Department of Labor (1974) Years for Decision. Manpower Research Monograph. Washington DC: U.S. Government Printing Office.

U.S. Department of Labor, Women's Bureau (1972) Negro Woman in the Population and the Labor Force. Washington, DC: U.S. Government.

U.S. Department of Labor (1975) Manpower Report of the President: 1975. Washington, DC: U.S. Government Printing Office.

Waldman, E. (1970) "Changes in the labor force activity of women." Monthly Labor Review 93: 10–18.

11

BLACK FEMALE PROFESSIONALS
Dilemmas and Contradictions of Status

Cheryl Bernadette Leggon

Everett Hughes, the author of one of the seminal essays on dilemmas and contradictions of status, argues that when

> new kinds of people in established professional positions are assessed by others, that that assessment of their statuses and the role activity associated with them is likely to be made on the basis of both universally accented technical criteria and in terms of "auxiliary" characteristics carried over from such other social contexts as race and sex [Hughes, 1945: 353].

This, coupled with the fact that in contemporary American society, Blacks and women qualify as "new kinds of people in established professional positions,"[1] suggests that the case of elite Black professional women should certainly pose an interesting problem for investigation.

The expectations concerning the "auxiliary" characteristics are both created in and reinforced by what Blumer (1958) refers to as the "public arena," which includes public forums, "everyday talk," and the mass media—newspapers, magazines, radio, movies, and especially television.[2] People tend to hold a dual image of professionals: On the one hand, they associate with being a professional, a certain amount of technical skill (for example, specialized training or licensing); on the other hand, they associate certain auxiliary characteristics. For example, when one thinks of a physician, the image of a "Marcus Welby" type comes to mind: mature, competent, white, Anglo-Saxon, Protestant, and male. What happens when a

potential client encounters a professional who does not fit the image? Hughes' study focused upon the dilemmas occasioned for an individual encountering a status-discrepant professional such as a Black physician or a female attorney. My study focuses upon the status-discrepant professional herself rather than on the client.

Hughes argues that when an individual encounters a status-discrepant professional, the outcome of that encounter depends upon the situation: whether or not it is defined as an emergency and/or whether or not another professional (presumably a non-status-discrepant professional) is available. If the situation is defined as an emergency or if the individual decides that "there is no other way," then she/he may feel forced to relate to the status-discrepant professional on a purely professional basis. Should the potential client not be forced to relate to the status-discrepant professional on a purely professional basis, what emerges is the fact (pointed out by Hughes) that there are "master status traits"; namely, that certain statuses tend to over-power any other characteristics which might run counter to them. For many, race and sex are master status traits; that is, when encountering a status-discrepant professional, the potential client encounters a Black or a woman first and a doctor or lawyer second. What emerges, then, is a status hierarchy with ascribed status (race, sex) on the top and achieved status (for example, professional) below.

According to my findings (and consonant with those of Hughes), not only is there a status hierarchy in which ascribed status is placed above achieved status, but within that top stratum of ascribed status the Black female professionals whom I interviewed perceive a hierarchy in which race usually ranks above sex. It is my contention that their double-ascribed minority statuses— Black and female—place Black professional women in what Epstein (1973a) has called "a double bind," in that they share in the economic discrimination patterns based on sex which prevail in American society in addition to those economic discrimination patterns imposed on all Blacks; the latter are enforced more strictly than the former. Further, this double bind and its effects are greater than the sum of its parts, the two minority-ascribed statuses of race and sex (Dumont and Wilson, 1957). The Black female professional is the product of the confluence of unique sociohistorical, economic, and psychological factors. Although statistics can yield an abundance of useful information, they cannot measure or even delineate the psychological and social psychological problems peculiar to the Black female professional. These problems are the focal point of my inquiry.

This study of elite Black professional women is more of an ethnographic field study than a verification study of explicit theoretical propositions. The theoretical framework resembles what Dumont and Wilson (1957) have called a theory sketch,

a more or less vague indication of the propositions and initial conditions considered as relevant, but needs 'filling out' to develop into a full-fledged theory. The theory sketch suggests the direction for further research required in the filling out process.

Specifically, my pilot study[3] of elite Black professional women sought to determine

(1) whether elite Black professional women perceived race discrimination as more salient than sex discrimination in their professional experiences, and to what extent, if any, there is a cumulative effect from both racial and sexual discrimination in the professions; and

(2) the extent to which the status-discrepant individual (i.e., the elite Black female professional) recognizes her status-discrepant position and the way(s) in which she attempts to cope with it.

Since there is a great deal of dissension as to which occupations should be included under the category "professions," I chose to examine three of those occupations that are consistently highly ranked on prestige-ranking scales such as that of Hodge and Rossi (see Blau, 1967)[4]: medical doctors, attorneys (who have graduated from law school and passed at least one bar examination), and women with Masters degrees in Business Administration (M.B.A.s).

The pilot study was conducted in the Chicago metropolitan area during the academic year 1974–1975. The Chicago metropolitan area is statistically interesting in terms of Black professionals: Although Chicago has the largest number of Black attorneys of any American city (approximately 330 in 1975), the number of Black physicians has decreased 13.5 percent since 1961 (Blan and Duncan, 1967). This decrease is partially attributable to the increase in opportunities for Black physicians in the United States, particularly in the South and West. In 1974, Chicago had 212 Black doctors, of which 52.7 percent were over 50 years of age (McClory, 1975: 1). The membership roll of the Cook County Bar Association, the nation's oldest and largest local Black bar association, greatly facilitated the task of estimating and locating the universe of approximately 31 Black female attorneys; this task was somewhat more difficult for physicians because most lists contained only last names and first initials—perhaps because many people are wary of female doctors except in "traditionally female" specialties of obstetrics and pediatrics. At the same time my study was being conducted, another study of Black physicians in Chicago was being conducted by Comprehensive Research and Development, Inc., which independently estimated the number of Black female physicians in Chicago to be between 15 and 25; using the snowball technique, I obtained the names of 18. Of these, four were eliminated from my sample because they were foreign-born and raised,[5] and one was eliminated because she suffered a stroke and was unable to be interviewed. It was most difficult to assess the number of Black

females with M. B. A.s in the Chicago area. Although I am confident that I located all of those who received M. B. A.s from the University of Chicago and who remained in the Chicago area, the Dean's office of the Graduate School of Business of the University of Chicago informed me that the school did not keep records by sex until 1971. The Dean's office of the Graduate School of Business of Northwestern University did not have records of its graduates broken down by race and sex. Therefore, from those names I did receive, I asked each for the name of any other Black female M. B. A. they knew. Excepting three who were impossible to locate and one who refused to be interviewed, the sample consisted of six M. B. A.s and one Certified Public Accountant (one of two in the Chicago area, and one of six Black female C. P. A.s in the country at that time). Names of doctors, attorneys, and M. B. A.s were obtained from the membership roll of the League of Black Women, an organization founded in 1972, whose membership includes women from all areas of life and a representative cross-section of professionals. Each woman contacted was asked to name three or four other women (either in her profession and/or others included in the study) whom she recommended the interviewer contact. This snowballing technique proved useful in locating those women not members of organizations and thereby enlarged the population from which the sample was drawn.

The final sample consisted of 12 Black female attorneys, six Black female medical doctors, and seven Black female M. B. A.s (including one C. P. A.). A matched sample was utilized: Respondents in each occupational category were divided into two groups on the basis of whether they entered their profession before or after 1965 (the year in which Title VII of the Civil Rights Act of 1964 went into effect); this sampling procedure allowed for the detection of age-specific trends across occupations. Due to the complex and sensitive areas probed and in order to reduce interviewer bias, I personally interviewed all of the subjects; this is consonant with basic interviewing techniques based upon the experience of survey research organizations such as the National Opinion Research Center, which finds that the best results are obtained when Blacks interview Blacks, whites interview whites, and females as opposed to males are the interviewers. My sole instrument of data collection was an interview schedule designed to elicit information that relates the research questions on the professions, women, and Blacks implicit in my review of the literature and theoretical sketch of relevant propositions. Over three-fourths of the respondents grew up in the central city of a metropolitan area in the continental United States with a population of more than two million; further, most of the respondents came from families of three or fewer children.

The professionals in my study in both law and medicine tended to be concentrated in specialties traditionally labeled "women's specialties": For

law, these specialties are domestic relations (divorce, adoption); for medicine, obstetrics and pediatrics. In business, the traditionally "female preserve" is personnel; the evidence in my study was insufficient to indicate any discernible trend toward concentration because, as a result of being in training for their companies, many of the M. B. A.s were assigned to different departments on a rotating basis. Further, at the time of my study, it was not clear as to which area/division of the company they would ultimately be assigned.

Black female professionals share certain problems with professionals in general—obtaining degrees, meeting licensing requirements, meeting professional standards, and the like. In addition, they share concerns specific to Blacks—that is, the problems of racial discrimination in hiring and professional advancement.

Although Black female professionals share certain problems/issues specific to Blacks, this does not mean that Black women can be subsumed under the category "Black professionals." To do so would obscure crucial differences between Black male and Black female professionals:

(1) From 1940 through 1960, Black male professionals were shown to be more widely distributed than Black female professionals among the professions; female professionals were highly concentrated in a few occupations such as teaching, and Black female professionals appeared to be the most highly concentrated of all sex-race categories [Glenn, 1963: 443–448].

(2) Black females have a greater chance of entering professions designated as open to women than Black males have of entering professions designated as open to men [Glenn, 1963: 443–448].

Some sociologists attribute this phenomenon to the "farmer's daughter effect" (Bock, 1969: 17–26). That is, like farm families, Black families choose to spend their limited resources to educate daughters rather than sons because, since girls tend to do better than boys in school,[6] they have a better chance of going on for further training, which improves their chances of getting good jobs and/or marrying well when they migrate to urban areas. In addition, given the limited financial resources of the family, the male children are often pressured to contribute to the family resources, which usually leads to their dropping out of school. Another explanation offered by Jackson (1973) seems more plausible: This theoretical tendency among Black families to educate their daughters at the expense of their sons[7] may be interpreted as an effort to keep Black women away from domestic work[8] which is and has been, in addition to being an position in which Black women could "learn the ropes" of white society, a position of sexual vulnerability (Epstein, 1973b: 917).

Although Black professional women share certain problems specific to women, such as the problems of maternity leave and its ramifications for

professional advancement, this does not mean that Black women can be subsumed under the category "female professionals," because by so doing crucial differences between Black and white professional women would be obscured. Epstein (1973b) argues that one of these differences is that "because these women are Black they are perhaps not perceived as women; . . . they may not be viewed as sexual objects." Sociohistorical evidence indicates that this argument is invalid; indeed, Black women have been viewed legally as well as socially in the United States as *sex objects par excellence* (Hernton, 1965)! Rather than one negatively valued ascribed status (race) canceling out the effect(s) of the other (sex), my evidence indicates that the two operate to the disadvantage of Black professional women. The very fact that most of the respondents were unable to distinguish between race and sex as the basis on which they were being discriminated against indicates that these status-discrepant professionals felt that *both* are operant. Therefore, it seems to me that the crucial differences between Black and white professional women are those of expectations and orientations:

(1) A greater percentage of Black women than white women work after marriage and childbirth; Black women work more years of their lives than do their white counterparts, yet their earnings are lower and their unemployment rate greater (Lerner, 1978).[9]

(2) Whereas for the majority of white middle- and upper-class women the decision to pursue a career is optional, Black women are raised with the expectation that whether or not they marry, whether or not they have children, they will work most of their adult lives; "work to them, unlike to white women, is not a liberating goal, but rather an *imposed* lifelong necessity (Lerner, 1978).

These expectations are consonant with Epstein's (1973b: 923) generalization that "black women are more concerned with the economic rewards of work than are white women." Further, these orientations help to account for the fact that, as a group, Black career women feel less guilt than do their white counterparts about spending less time with their family due to the demands their careers place on their time.

During preliminary conversations with Black professional women, the older women tended more frequently than did the younger women to attribute any lack of advancement in their career to racial discrimination. Therefore, I expected that the older women as a group—those entering professions before 1965 (the year in which Title VII of the Civil Rights Act of 1964 went into effect) —would tend to attribute their perceived lack of professional advancement to racial discrimination; if they mentioned sexual discrimination, I expected that it would be subordinate to racial discrimination. As a whole, I expected the younger women to attribute problems of advancement to sexual discrimination;[10] if mentioned, racial discrimination would be secondary.

My findings indicate that the ability to distinguish discrimination based on race from discrimination based on sex is profession-specific; that is, women in business and law are in a better position than their counterparts in medicine to encounter prospective clients and learn why they do not become actual clients. As one older physician put it, "I know why those who come to me come, but I don't know why those who don't, don't." A young attorney related an anecdote revealing reasons for one potential client seeking counsel elsewhere:

> A woman obtained my name from the American Bar Association and sent her husband to me. He knew that I was a woman, but when he arrived and I introduced myself, and he saw that I am Black, he said, "I knew you were a woman, but this is too much," and he turned and left.

This anecdote supports Hughes' finding that there is a status hierarchy in which ascribed status supercedes achieved status; further, it supports my finding that within the ascribed status hierarchy, the status of race supercedes that of sex. Finally, this anecdote does not lend support to Epstein's (1973b: 914) hypothesis that perhaps "two statuses in combination create a new status (for example, the hyphenated status of Black-woman-lawyer) which may have no established 'price' because it is unique." Quite the contrary, it indicates that the "new" status combination does indeed have a price and a very high one: loss of a potential client. Thus, contrary to my initial expectation, most respondents—including more than half of the younger respondents—experienced more discrimination on the basis of race than on the basis of sex, although many respondents added that it is often difficult to distinguish between the two, as one young woman in business describes:

> Although it's difficult to distinguish betweeen the two, most days I think it's sexual because I see white women experiencing the same things I am . . . In the matter of salaries, you can't tell whether it is racist or sexist.

This quote seems more applicable to business than to medicine and law because (1) discrimination on the basis of sex is probably still more widespread in business than in medicine and law, and (2) women in business see more potential clients than do their counterparts in medicine and, perhaps, law. This is due to the tendency for prospective consumers to "shop around" less for medical and legal expertise than for business expertise because, generally, by the time they recognize the need for the former, the problem situation already exists and time presses them for a solution. In other words, those using medical and legal services tend to use them in a remedial way (that is, to remedy an already existing situation), whereas consumers of business services tend to use them in a preventive way. That most of the younger respondents—including all of those in business—report that they

have personally experienced discrimination more on the basis of race than of sex may be attributed to the fact that civil rights gains made in the 1960s are being checked or even reversed; attempts to retard this process are evident in the attribution of greater importance on the part of the respondents to civil rights for Black rather than for women.[11] On the other hand, many respondents may believe that civil rights for Blacks include civil rights for Black women.

My second hypothesis was that whichever form of discrimination they perceived to have most frequently experienced should dictate which of the two liberation movements, the Black or the women's, is most important to them in terms of a coping mechanism for their status-discrepant position. Therefore, if a respondent replied that she has experienced more discrimination on the basis of race than of sex, then the Black Liberation Movement should be more important to her. Further, since the Black Liberation Movement was followed by the Women's Liberation Movement, I hypothesized that younger women would be more likely than older women to feel tension between the Black Liberation Movement and the Women's Liberation Movement, because for older women professional success was viewed as "a credit to the race" and hence consonant with the struggle for racial equality. One unintended consequence of Title VII of the Civil Rights Act of 1964 (which prohibits discrimination in employment based on race, color, religion, sex, and national origin; and which covers discrimination by employee unions and employment agencies) was that many people believed it gave a competitive advantage to Black females in that prospective employers could get "two minorities for the price of one." Hernton (1965) points out that while this may be true in the most liberal parts of the North (New York City, Washington, D.C., and Chicago—from which the respondents in my study are drawn), this does not occur as frequently in the South. For the younger women, then, professional success could be viewed as dissonant with the struggle for racial equality, especially if these women are seen as being (and see themselves as being) in direct competition with Black males.

Contrary to expectation, for the younger respondents the Black Liberation Movement is more important than the Women's Liberation Movement: This is not to say that Black professional women are less concerned about the problems they encounter because of their sex than those they encounter because of their race (even assuming that the two can be distinguished, which they often cannot), but that the Black Liberation Movement does a better job of addressing the latter than does the Women's Liberation Movement the former. As it is presently constituted for the most part, the Women's Liberation Movement addresses more problems of non-Black than Black women; in response to this, the National Black Feminist Organization (NBFO) was formed in New York City in 1972 and presently has chapters in

many major metropolitan areas. Because it was relatively new at the time of my pilot study, many respondents were unaware of but expressed interest in the NBFO. Indeed, comparative research on the two feminist organizations—Black and white—would increase knowledge of the points of consensus and dissension between the ways in which Black and white professional women deal with the problems engendered by status inconsistency.

My third hypothesis concerns the ease with which Black women cope with the conflicting role demands of the professional and the "traditional female" roles. My findings support Epstein's claim that Black women experience less guilt than white women over the effects on their children of working. This claim is based on two considerations:

(1) Since a greater percentage of Black women work after marriage and childbirth, having adult female members of the household working has been historically and continues to be a more usual experience for Blacks than for whites.

(2) In contrast to the situation of her white counterpart, work for the Black woman is not an option, but a necessity if her family is to maintain its precarious middle-class status.

Therefore, rather than viewing her work as taking something away from her family, the Black professional women views her career as enabling her to make an even greater contribution to her family's stability and hence to its welfare. This is precisely because for Black women in general, work is obligatory rather than optional (as it is for their white counterparts). There is no social role toward which there is no ambivalence. Roles vary in the extent to which it is culturally and psychologically permissible to express ambivalence, to discuss or admit negative feelings toward them. Black women feel less ambivalence about working, precisely because they view their careers as consonant rather than dissonant with the maternal role: Their work contributes rather than detracts from the stability of their family. Consequently, I hypothesized that not only is it easier for Black women than for white women to cope with the demands of the role of professional and those of the "traditional female role," but that among Black women viewpoints of the "female" role along a "traditional-feminist" continuum would be divided along age lines: As a group, the older women would fall more toward the traditional end, while the younger women as a group would fall more toward the feminist end. While this held so far as agreement with the idea that women always have the "option" of being housewives (whether or not they work), most of the women—regardless of age—expressed at least a moderately feminist viewpoint.[12] This deviation from expectation was caused by older women in business and law expressing strongly feminist viewpoints.[13] This, in turn, is probably due to the fact that Black women in business and law would be expected to be more sensitive to discrimination against women

and would be more likely to espouse less traditional viewpoints than would their counterparts in medicine. Thus, viewpoint of the female role (traditional or feminist) is a function of the age of the respondent and her profession.

Location of respondents according to viewpoint of the female role along the traditional-feminist continuum is necessary, but not sufficient to ascertain how individuals coped with the strain(s) engendered by their status-inconsistency. It was necessary to inquire (1) whether a respondent anticipated problems before marriage in combining marriage, and perhaps motherhood, with career; and (2) the extent to which their expectations affected the amount of strain perceived and the coping mechanisms adopted to deal with the strain. The responses vary with the respondent's age and profession, as discussed in the following sections.

(1) Age. The older Black professional women increased the compatibility or decreased the incompatibility of the role demands of professional and "traditional" female (wife and mother) by deciding a priori that marriage and family would take precedence over their career. Perhaps this type of adjustment was necessitated for this group as a whole by the strength of the societal expectations (prevalent during their youth) that a woman should marry and that the home is her primary responsibility whether or not she is working. However, the lag between the societal definition of women's role ("woman's place is in the home") and certain economic realities (for example, that realization of the American Dream—a house in the suburbs with a two-car garage—requires both husband and wife to work) affects Black women less than white women because societal standards concerning women (including standards of beauty) have been and continue to be based on white women. In addition, unlike whites, most Black women are raised with the expectation that whether they marry or not, they will be working most of their adult lives. I found evidence for the older women of the self-fulfilling prophecy: Those who decided before marriage that marriage would take precedence over career found that that expectation materialized. Further, many of these women attributed to this decision their perceived lack of professional progress (for example, "If I hadn't decided that my family would come first, I would be farther along in my career than I am now."). It is difficult to test the accuracy of this perception, although support of it is indicated by the following observations:

 (a) Most of the older women in medicine were in private practice so that they could set their hours to coincide with family needs; they gave this as one of their most important reasons for going into private practice;

 (b) Older physicians tended to be in general practice or obstetrics and gynecology rather than in areas characterized by longer training and less flexible hours (for example, surgery);

(c) Older attorneys stated the desirability of shorter and more flexible work hours and achieved this end by limiting themselves to cases that require the attorney to spend relatively little time in court (such as in adoption or divorce cases) as opposed to the more lucrative but time-consuming cases (such as criminal or anti-trust).

Because they are able to avail themselves of certain options easier than their older counterparts (for example, living with a mate without benefit of clergy, choosing not to have children), the younger respondents on the whole tend to feel the traditional expectations of marriage and motherhood to be less binding upon them. Nevertheless, that traditional expectations are still felt by today's young women is indicated by a young attorney who is married to an attorney:

> Many women know that what they are doing is intellectually as important as what their husbands do, but they still feel guilty about not doing everything and keeping up the house. In the final analysis, it falls on the women's head if the house is messy.

(2) Profession. Regardless of age, many respondents maintain that marriage can be combined easier with business and law than with medicine. Most physicians in my study—married and single—concur, and posit marriage to another physician as the best way for them to combine medicine with marriage: This enables their mate to understand, sympathize, and empathize with the demands medicine makes.

Whether or not they share the same profession, most respondents agree that the greater the personal and professional or occupational security of one's mate, the more able and willing he is to accept and encourage a professional wife, which in turn reduces the tension generated by the demands of profession, marriage, and family.

Taking as the dependent variable the strain(s) engendered by the confluence of the demands of the roles of professional and female, the strength of this strain is a function of the relative degree of commitment to each role: The more the commitment to each role, the greater the resulting strain. Commitment to the role of professional is determined by the amount of sunk costs involved (length of time in training, cost of training, and the like) and is profession-specific; commitment to the role of female—at least, as it has been traditionally defined—is more age-specific, in that current societal consensus on the definition of the female role is weakening and more options (for example, scientific and legal advances making birth control a more viable option) are open to the present generation. The independent variable, social support, can come from many sources: the family of procreation in terms of encouragement to continue (as well as to enter) a profession; spouse (which is a function of his own personal and professional security); relatives; outside help hired for household and/or child care tasks; and others with

common experiences who will at least discuss common problems (so that these women know their problems result from larger structural constraints rather than from personal idiosyncrasies) and who will articulate and seek solutions to common problems in the long run and try to relieve the tensions generated by these problems in the short run.

The study of elite Black professional women affords an unusual opportunity to examine a variety of dilemmas and contradictions of status.

NOTES

1. The first Black female admitted to the bar in the United States was not admitted until 1897 (Lutie Lyttle in Topeka, Kansas); the first Black female to become a physician did so in 1864 (Rebecca Lee, Boston, Massachusetts). See Lerner (1973).

2. M. L. Ramsdell's study of 600 hours of eight soap operas in 1971–1972 found that 90 percent of the primary white male characters in one program were either doctors or lawyers (Schrank, 1977).

3. Presently, I am in the process of conducting this study on a nationwide basis to ascertain the generalizability of these findings.

4. This is contrary to Epstein's argument (1973b) that two statuses in combination create a new status. For a detailed critique of this argument, see Leggon (1979).

5. The fact that my sample consisted solely of Black women born and raised in the United States, whereas Epstein's (1973b) sample included Black women born and raised in the West Indies, accounts for the differences between her findings and mine. These differences are explored in detail in Leggon (1979).

6. Much of the sociological and social psychological literature on women documents this. For example, see Komarovsky (1945, 1950).

7. Jackson (1973) maintains that there appears to be no evidence supporting the systematic preference of Black parents to educate their daughters at the expense of their sons' education or their sons at the expense of their daughters'.

8. Of all the sex-race categories, Black women are most highly concentrated in the category of domestic service.

9. According to Axel (1977), the percentage of total population 16 years of age and over in the labor force is as follows:

Labor Force Participation Rates by Age, Sex, and Race

FEMALE	1950	1960	1965	1970	1975
White	n.a.[a]	36.0	37.7	42.0	45.4
Black, other	n.a.	47.2	48.1	48.9	48.7

a. Means not available.
SOURCE: Axel (1977)

10. One reason for this expectation was the fact that since sexual discrimination had recently become at that time a "fashionable" topic of discussion in the public arenas (the mass media; the legislature, both state and national), public attention began to focus on, or at least to recognize, the phenomenon of sex discrimination, whereas heretofore, discrimination in the United States usually referred to racial discrimination.

11. Respondents were asked: "Which do you feel is more important, civil rights for Blacks or for women?" Forty-four percent of the older women in law and medicine said civil rights for Blacks; 44 percent of the older women in law and medicine said that civil rights for Blacks is as important as civil rights for women; and 11 percent of the older women in law and medicine and 50 percent of the older women in business said that civil rights for women is more important than civil rights for Blacks. In contrast, 88 percent of the younger women in law and medicine and 40 percent of the younger women in business said that civil rights for Blacks is more important, while only 11 percent of the younger women in law and medicine said that civil rights for women was more important.

12. Respondents were asked: "What is your reaction to the following statement: 'Even if she has a career, a woman always has the option of being a housewife'?" Response categories were strongly agree, agree somewhat, somewhat disagree, disagree strongly, and neutral.

13. Respondents were asked to indicate the extent to which their own views approximate the "feminist" or "traditional" viewpoint. The "feminist viewpoint" stresses greater equality and similarity in the roles of men and women than now exist, with greater participation of women in leadership positions in politics, the professions, and business. The "traditional viewpoint" stresses the differences between the roles of men and women, in which women's lives center on home and family and their job participation is in such fields as teaching, social work, nursing, and secretarial service.

REFERENCES

Axel, H. [ed.] (1977) A Guide to Consumer Markets 1977/1978. New York: The Conference Board, Inc.

Blau, P. and O. D. Duncan (1967) The American Occupational Structure. New York: John Wiley.

Blumer, H. (1958) "Race prejudice as a sense of group position." Pacific Sociological Review (Spring): 3–7.

Bock, W. E. (1969) "Farmer's daughter effect: the case of the Negro female professional." Phylon 30: 17–26.

Degler, C. N. (1964) "Revolution without ideology: the changing place of women in America." Daedalus 93: 658–670.

Dumont, R. G. and W. J. Wilson (1957) "Aspects of concept formation, explication and theory construction in sociology." American Sociological Review 32: 985–995.

Edwards, G. F. (1959) The Negro Professional. New York: Free Press.

Epstein, C. F. (1973a) "Black and female: the double whammy." Psychology Today (August): 57–61, 89.

————(1973b) "Positive effects of the multiple negative: explaining the success of Black professional women." American Journal of Sociology (January): 913–935.

Ginzberg, E. (1966) Life Styles of Educated Women. New York: Columbia University Press.

Glenn, N. D. (1963) "Some changes in the relative status of American non-whites: 1940–1960." Phylon 24: 443–448.

Goffman, E. (1959) The Presentation of Self in Everyday Life. Garden City, NY: Doubleday.

Gurin, P. and E. Epps (1966) "Some characteristics of students from poverty backgrounds attending predominantly Negro colleges in the Deep South." Journal of Negro Education 35: 336-350.

Hernton, C. C. (1965) Sex and Racism in America. New York: Grove Press.

Hughes, E. C. (1945) "Dilemmas and contradictions of status." American Journal of Sociology 50: 353–357.

Jackson, J.J. (1973) "Black women in racist society," in C. Willie (ed.) Racism and Mental Health. Pittsburgh: University of Pittsburgh Press.

Komarovsky, M. (1945) "Cultural contradictions and sex roles." American Journal of Sociology 52: 184–189.

————(1950) "The functional analysis of sex roles." American Sociological Review 15: 508–516.

Leggon, C.B. (1979) "Some negative effects of the multiple negative." Chicago Circle: University of Illinois. (unpublished)

Lerner, G. [ed.] (1973) Black Women in White America: A Documentary History. New York: Random House.

McClory, R.J. (1975) "Fewer Black doctors in Chicago: foreign physicians practice in inner city with some bad side effects." The Chicago Reporter 4: 1.

Rossi, A. S. (n.d.) "The roots of ambivalence in American women." Chicago: National Opinion Research Center Study #483, 34 pp.

Schrank, J. (1977) Snap, Crackle and Popular Taste: The Illusion of Free Choice in America. New York: Delta Publishing.

Staples, R.E. (1973) The Black Woman in America: Sex, Marriage and the Family. Chicago: Nelson-Hall.

12

DILEMMAS OF BLACK FEMALES IN LEADERSHIP

Rhetaugh Graves Dumas

From the time that they first set foot in the New World, black females have struggled courageously to contribute toward a better quality of life in black communities and in the society at large. From 1619 to the present, their struggles have been waged from the lowest position among black and white Americans, and they have labored under the hardest conditions. While their contributions have been significant in the development of this Nation and in the continuing fight against the oppression of its black citizenry, black females have yet to enjoy the full benefits of their suffering and arduous labors. Obstructed by the dynamics of racism and sexism in the groups in which they live and work, the full leadership potential of black females throughout their history in this country has remained a relatively untapped—or at best, underutilized—resource, not only in predominantly white institutions and organizations, but also in black communities as well.

During slavery, organizations were not often permitted among the slaves. Among the free, black women had limited, if any, opportunities to head any of the significant organizations that existed in the north during slavery or those that developed around the country after the Civil War. Organizations that included black and white males and females were headed by white males. Women's groups that were racially mixed were headed by white women. Outside the family—which was headed by males—the black church was the first major social institution fully controlled by blacks. It was the critical training ground for black leadership. The vast majority of black

AUTHOR'S NOTE: This chapter appeared as an article in *Journal of Personality and Social Systems,* Volume 2, Number 1, April 1979.

leaders, including the post-war politicians, got their start in the church. Despite the fact that women comprised 62.5% of the membership[1] and their dues provided the bulk of the financial support, their roles were facilitative and supportive. Men held the top leadership posts and the power. Just a few weeks ago, for the first time in history, two black women were appointed to high posts in a black church organization. Whatever access the black community had to the powerful leaders in the larger community was achieved through the church. Black preachers were able to exercise more influence than any others in the black community. Prior to emancipation and for some four decades to follow, black men had greater access to education. The first college degrees in the black community were earned by males. In higher education, the first black woman earned a Ph.D. degree forty-five years after the first such degree was awarded to a black male in the United States. That woman was Sadie T. Mossell (Alexander) who earned the degree in Economics at the University of Pennsylvania in 1921. Edward A. Bouchet was awarded the doctorate from Yale in 1876.

Historically, their executive positions and training in the church and their access to formal educational institutions have made men the most powerful and the most celebrated leaders in black communities. During the Reconstruction in the South, there was a great emergence of black men who provided political leadership. Men held the franchise for their communities; twenty served in the U.S. House of Representatives and two in the Senate. Others served as lieutenant governor, sheriff, prosecuting attorney, recorder of deeds in their localities. One woman served as postmistress in Indianola, Mississippi. The vast majority of black women leaders were limited to projects for the social uplift of the community, and their main followers were other black women and youth. It was only during periods of extreme stress that the value of the black woman's leadership outside of her women's groups could be realized. Even then the women had to struggle not only on the boundary between blacks and whites, but they also had to find ways to endure the frustration and hardships posed by the lack of support from black males whose existing circumstances and prior experiences made it difficult—if not impossible—to transcend what I call the hydraulic systems principle of male-female relationships. That principle stipulates that black males can rise only to the degree that black women are held down. Finding themselves unable to submit to their dissatisfactions when survival in a hostile and increasingly violent environment held primacy and when a sense of community and togetherness seemed so essential, ambitious black females with leadership abilities concentrated their efforts on relieving the suffering imposed by illiteracy, poverty, and disease. This situation was still very apparent as late as the sixties. Earlier black female leaders realized the need for the strength and mutual support that would come from group effort

and they began in 1892 to organize local black women's clubs and thus planted the seeds that ultimately grew into a national movement (still existing today). Under the motto, "Lifting as we climb," the National Association of Colored Women provided the model for what became the most significant resource available to black women, not only for mutual support and social uplift, but also as a training ground for black female leadership. During the sixties, many young females rejected as too middle class many of the traditional organizations for ambitious black women. I might also point out here that although black women found a lot of meaning in the black protest and civil rights movements and seemed to have fewer social conformists among their ranks, they did not occupy prominent leadership positions. They were often caught up with black men in that hydraulic principle which forced them to take only those roles that would enable their men to go forward. Many black women with outstanding leadership abilities held their skills in abeyance lest they might undermine the security and threaten the masculinity of the black men. Bound by the fear of the strong, uppity, castrating black woman, the full range of the black female's leadership was never fully exploited. There were, of course, exceptions like Daisy Bates, Erika Huggins, Angela Davis, and others, who did not permit themselves to be bound by these dynamics, at least not all of the time.

It is significant to repeat that while males were being trained for leadership of both sexes, and when some few black males were sometimes provided opportunities for leadership in racially mixed groups, black females were limited to the leadership of other black females. Furthermore, when they dared to turn their attention from service-oriented programs to the political arena, they have had to struggle against strong opposition in both the white and black communities. Despite these obstacles, many black women have cleverly combined political, civic, and social goals and strategies, and some gains have been visible in each generation. But there is still a long way to go. For despite the outstanding achievements of some black women in many fields of endeavor, the mass of black women in America are still at the bottom of the heap—among this country's underdogs. And although increasing numbers of black women are beginning to occupy important positions of authority and prestige in organizations within and outside black communities, there are forces at work today as in the past that tax the physical and emotional stamina of these women, undermine their authority, compromise their competence, limit the power that they might conceivably exercise, and thus limit their opportunities for rewards and mobility in the organization—not to mention the impact of these on job satisfaction. I contend that this problem has its roots in myths about the privileged position and role of black women in slavery. The mythical image of the strong, powerful, castrating black matriarch pervades contemporary organizations

and poses a critical dilemma for black females which makes competition for, and competent performance in, leadership positions at best a costly endeavor. There are increasing efforts to resurrect the Black Mammy in today's ambitious black women who aspire to move up the socioeconomic ladder or into political arenas. And there are negative consequences for those who succumb as well as for those who dare to resist. The remainder of this paper is devoted to an elaboration of this thesis. In preparing the following section, I have utilized data compiled for a more extensive study of this topic. Many historical sources were utilized, most of which are the works of secondary authorities, but narratives of slaves and witnesses and black autobiographies were among the materials examined. Very little of the literature is addressed to the problems of black women leaders—or to those of women in general. Therefore, I have utilized my own experiences as an appointed city official, an associate professor and department head of a professional training program in a prestigious Ivy League university, a Federal executive and a member of the consultant staff for group relations training in the Tavistock tradition. I have relied more heavily upon the experiences of numerous other black women leaders around the country. Some of them described their dilemmas during informal discussions at social gatherings or during professional meetings; others (totaling over 500 during the period of data gathering) while participating in institutes, workshops, or group relations training conferences. I have supplemented these sources with descriptions in the literature—particularly, biographies and autobiographies of black women. These were valuable although sparse resources. The most telling autobiographies were those of Ida B. Wells Barnett (Elfreda Duster, Ed. *Crusade for Freedom: Autiobiography of Ida B. Wells,* Chicago: University of Chicago Press, 1970) and Mary Church Terrell (*A Colored Woman in a White World,* Washington, D.C.: Ransdell Publishers, 1940). I commend these to your reading list.

The data derived from these experiences are naturally less structured and more casual than those that come from a more rigorously designed approach. Nevertheless, there are advantages in the intimacy of detail and the breadth of exposure that this approach permits, especially at such a rudimentary stage of inquiry. Keeping in mind then that the data is soft, I hope that this analysis will at least stimulate the commitment toward a more intensive approach to this very critical area of study.

The presence of black women in leadership positions takes on highly significant meanings in organizational life. Myths of the superiority of black women over white women and black men, their tremendous power and strength, and their unique capacity for warm, soothing interpersonal relationships prompt others to press them into symbolic roles that circumscribe the nature and scope of their functions and limit their options and power in

the organizations in which they live and work.

The black woman leader is often torn between the expectations and demands born of her mythical image and those that are inherent in her official status and tasks in the formal organization. The pressures to conform to the roles of her earlier predecessors are often irresistible. Whether she likes it or not, the black woman has come to represent a kind of person, a style of life, a set of attitudes and behaviors through which individuals and groups seek to fulfill their own socio-emotional needs in organizations. It is not surprising, therefore, that there is a great deal more interest in the *personal* qualities of black women administrators than in their skill and competence for formal leadership roles.

There is general resistance to having black women perform competently in formal, high-status positions. Rather, the preference is to have the black woman assume a variety of functions that resemble those described for the black mammy during the plantation era. In performing these functions, however, the power of the black woman leader is as illusory as Mammy's was. It is derived from her relationships in the *informal* system—her willingness to put her *person* at the disposal of those around her. And it can be maintained only as long as she is willing or able to provide what is demanded of her.

The demands very often go beyond the responsibilities of her formal position. For example, the black woman in leadership is expected to comfort the weary and oppressed, intercede on behalf of those who feel abused, champion the cause for equality and justice—often as a lone crusader. She is expected to compensate for the deficits of other members of her group—speaking up for those who are unable or unwilling to speak for themselves, making demands on behalf of the weak or frightened, doing more than her share of the work to make up for people who dawdle or fail to complete their assigned tasks. Expected to be mother confessor, she counsels and advises her superiors and peers as well as her subordinates, often on matters unrelated to the tasks at hand. She is called upon to fill in for her boss in dealing with problems of sex and race, to mediate in situations of conflict—quiet the "natives," curb the aggression of black males, dampen the impact of other aggressive black women—and to maintain stability or restore order in the organization or one of its sectors.

Black women who are pressed into such positions are faced with problems that challenge their own identity and threaten their inner security. For example, they are often caught in the struggles between the boss and subordinates, blacks and whites, men and women, between units in the organization, and between the organization and the community in which it is located. Sometimes they are unclear who or what they are representing and find themselves trying to manage certain organizational boundaries without ade-

quate authority and hence without appropriate backing and support. They are subject to high levels of tension as they become the repository of the problems, conflicts, and secrets of individuals and groups on both sides of the boundary.

Because of the myths about the strength and courage of their predecessors, black women today are also expected to have unlimited internal resources to cope with any problem that might conceivably confront them. Consequently, people around them are likely to be insensitive to their needs for socio-psychological support, reassurance, or some relief from the heavy demands on their time and energy.

Many of them work long hours in activities related to these symbolic roles, leaving less time and energy available for task performance. Consequently, doubts may be raised as to their competence for the positions they hold. Some black women in this predicament come to doubt their own ability and are disillusioned with their newly acquired status and prestige. Unfortunately, efforts to alter these situations are met with strong resistance from people who value their performance in the informal network of relationships. Such people are likely to subvert the leader's attempts to effect a more realistic distribution of time and effort between the informal and formal roles. If they persist, such situations not only undermine the upward mobility of the black woman, but they also have important implications for her physical and emotional health as well. For she takes the risk of being "used up" or "burnt out" rapidly. The trouble with symbolic leaders is that they often cannot tell where their personal lives end and where their organizational roles begin. They are treated as if they belong to the people around them and they feel as though they do. Black women who succumb to these symbolic roles do not actually lead—they offer themselves to be used. Hence the danger of overcommitment to activities of this nature.

CASE 1

Dr. A. holds an executive position in a large and prestigious organization in the Mid-West. Her academic and professional credentials are impressive. In her present position she has come to be the person on whom everybody depends. She is overworked because the people in her department believe they can't do without her and she behaves as if they really can't. She is the one who sees that visitors and clients are properly entertained. Most of the luncheon or dinner parties are held at her apartment and it is she who makes the necessary preparations. At her office she has an open-door policy and people drop in at all hours during the day to seek her counsel and guidance or just to sit and talk. She is called upon to support the causes of the low-status groups in the organization and works with them sometimes after office hours to plan strategies and aid them in presenting their grievances to top management. She is called by local and national groups to recommend blacks to serve on special committees and boards of directors. In discussion of these requests, she is

often talked into serving on the boards or committees. In addition, she is assigned to several inter-organizational committees and task forces to represent her department. She is given the tiresome travel assignments that others do not wish to take. She is frequently called at the last minute to cover commitments that another member of the staff is unable to keep—including those of her boss. Her boss continues to redefine her job to take up slack created by staff attrition. In all of this the responsibilities that comprise the job for which she was hired are compromised and she is beginning to receive criticism. Her clients are complaining that she does not return their telephone calls or follow through on commitments. Her colleagues are complaining that she does not provide feedback from the meetings she attends. The fact is that she frequently arrives at those meetings late and leaves early, so she herself does not get very much information from them, and she doesn't seem to contribute very much either. However, the people don't seem to mind that. They comment on what a warm and pleasant person she is and how much they enjoy having her there for however long she is able to stay. Her friends and colleagues outside of her organization have observed a downward trend in her communications and performance at professional meetings. She appears to be tired; her presentations are superficial and often confused. She touches on a variety of topics but never seems to get into any one in depth. Her family complains that she does not spend enough time at home. When she is not traveling, she works late at her office. Her friends in the community where she lives complain that she makes no social overtures, and they have begun to limit their contacts. Dr. A. complains bitterly that she never seems to get to those tasks that she is supposed to do because of all the interruptions and the extra responsibilities that are forced on her. Her boss doesn't seem to understand the pressures that she is working under. He is not satisfied with her performance of the job she was hired to do and has refused to recommend her for promotion. She is growing more disillusioned with her job and plans to retire earlier than she anticipated. The popularity she once enjoyed is diminishing; she is not able to deliver all that people expect of her and she still is unable to say no. She has much less influence than she had during the first year' or so on the job. She has been in her current position for a little over three years and is looking forward to getting out within a couple of years.

Realizing this vulnerability, some black women refuse to assume symbolic roles. They try hard to focus exclusively on formal tasks and become rigid in their avoidance of personal involvement with their colleagues. They are likely to interpret invitations to participate in informal relationships as bids to behave according to stereotypes of earlier black women. Intent on avoiding that image, they isolate themselves, which makes them unavailable for those informal contacts that might well enhance their executive effectiveness. The more impersonal they are, the more curious people are to know them better, and the more they will challenge the boundary that the leader endeavors to maintain between her person and her role. Of course, the more

this boundary is challenged the more rigid it becomes, which unfortunately leads to the image of a cold, inflexible authority. Thus, in the effort to avoid becoming the symbol of the good and willing resource for the satisfaction of the needs of people in the organization, these leaders develop an image that can be equally destructive. By their aloofness they are distinguished from the symbolic benevolent black mammy, but they become instead the wicked malevolent mammy. The negative consequences of this image are no less injurious than those endured by the executives who assume the caring, nurturing, protective roles.

In his analysis of the archetype of the Great Mother, Erich Neumann[2] calls attention to the fantastic and chimerical images elicited by the symbolism of the Terrible Mother:

> In the myths and tales of all peoples, ages, and countries—and even in the nightmares of our own nights—witches and vampires, ghouls and specters assail us, all terrifyingly alike. The dark half of the black-and-white cosmic egg representing the Archetypal Feminine engenders terrible figures that manifest the black, abysmal side of life and the human psyche. Just as world, life, nature, and soul have been experienced as a generative and nourishing, protecting and warming Femininity, so their opposites are also perceived in the image of the Feminine; death and destruction, danger and distress, hunger and nakedness, appear as helplessness in the presence of the Dark and Terrible Mother.

Although males in authority may be symbolized as good or bad mothers, the implications are more severe for females. Feminine authority cast against a black background thus becomes the most haunting of all symbolic mothers. Bad mothers who are white seem to be more easily tolerated than bad mothers who are black; bad mothers who are black and female border on the intolerable. Indeed the rich imagery evoked by black women comes as close to the Great Mother as one might imagine. When the black woman leader fails to give people what they believe they need, she is perceived to be deliberately depriving and rejecting, and therefore, hostile and potentially destructive. Just as she is believed to be capable of providing generative, nourishing, protective Femininity of the most powerful order, she is also imagined to have the capacity to withhold or destroy resources necessary to life and safety in the organization's symbolic world. The forceful exercise of her authority thus arouses intense irrationality and creates one crisis after another with which she must deal.

The black woman leader who is perceived as a bad mother—bad black mammy—must deal with the dependency, fear, and rage that often find expression covertly and undermine the effectiveness of all involved. Stubborn resistance to work is a frequent manifestation of anger in such situations.

The leader finds herself deluged by requests for clarification of procedures or special instructions for the most simple tasks. Indeed, those who feel deprived by her will frequently relinquish their authority and behave as if only she has the knowledge and skill required for a particular task. This type of dependency leads many executives to take on themselves the responsibilities that should be delegated, or at least shared by others.

Sometimes the anger and hostility find as targets people who are close to or supportive of the black woman in question. In these and other ways, the black woman in such situations is kept busy mediating staff conflicts, dealing with hostile confrontations, having to rush to meet deadlines for work that should have been completed long before, having to persist against covert resistance to get information she needs to do her job well. The following case illustrates this point.

CASE 2

Dr. B. has recently resigned from her position as dean of a professional school in a large private university. She held the position for three years. When she took the position her faculty—all white women—seemed very happy to have her, and wanted to get to know her better. She spent a great deal of time with them in social gatherings and orientation meetings. However, when the time came to turn her attention to her work, she began to have problems. The faculty that seemed so eager to work with her and who appeared from their academic and professional credentials to be well qualified for their jobs, began to appear more and more insecure and immature. The dean found herself having to give more direction than she believed was warranted by the nature of their tasks, and had to be careful lest she arouse their anxiety. Her time was often spent in individual conferences to discuss plans or to check completed work. In general, most of the faculty seemed reluctant to work independent of her guidance and approval.

Dr. B. described the behavior of her faculty as a desire to be spoon fed by her, which she finally decided would not be in her best interest or theirs. So she challenged them to take more responsibility for their own assignments and to exercise the authority that had been delegated to them in their respective roles. She suggested that they might use each other to check out ideas and work through problems; she would continue to meet with them periodically but was unable to continue to give them the time they demanded. Later she found herself having to deal with a number of conflicts among the faculty and between faculty and students. It seemed that simple problems escalated rapidly into crises. It was difficult for her to get away from her school to attend to issues critical to its survival and its relationship with other parts of the university. The faculty complained when she was away and invariably some mishap would occur in her absence. With one exception, the faculty were becoming more and more dissatisfied with their jobs and were generally uncooperative. At a time when it was doubtful that she could recruit replacements, several of

them gave notice of their intention to resign at the end of that academic year.

The one faculty member who seemed to work independently and on whom the dean had to rely very heavily became the target for hostility from her colleagues. The crowning blow to her and to the dean was a cruel joke: a C.O.D. package that contained an Afro wig.

These are but a few examples of the difficulties that Dean B. reported which no doubt figure significantly in her decision to resign the deanship.

The black woman executive, perceived to be either good or bad, becomes a kind of superstar among some individuals or groups in the organization. People love her when she gives what is desired and hate her when she fails to perform as expected. In either case people are moved by an image they have constructed of the black person in the leadership role—how they imagine her to be by her life style, attitudes, values, and what they symbolize for the beholder. When she is good, she becomes their heroine. When she is not good, she becomes their villain—but always an object for them to identify with, positively or negatively.

The leader who objects to being Mammy may not be subject to all the honors bestowed on her benevolent counterpart. Nevertheless, she does not suffer from want of attention from the people around her who seem to enjoy the experience of hating her. They want their friends and family to witness the bad person, especially in situations where she will be embarrassed, made into a fool, symbolically "killed off." So she is given invitations that set the stage for the kill. If she is not careful she may even do the job for them. Other blacks are often recruited for the dirty work in predominantly white organizations, or other women in predominantly male-oriented situations.

The first black woman superintendent of public schools in a middle-sized urban community had held the position less than three years when she became involved in a series of angry disagreements with the Board of Education. From the reports of their conflicts in the public news, I am impressed by the fact that the one board member who consistently led the confrontation was also a black woman. No other voices on the board seemed to equal hers in opposition to the superintendent's handling of the business of public education or in support of her leadership.

I suspect that the board member who levied the harsh criticisms was doing so on behalf of at least the majority of the board. She was delegated to set the stage for the embarrassment of the superintendent, and for even more drastic action in the future. I am proposing that it was not by accident that the leadership for the opposition was assumed by a black female.

This situation reminds me of an incident that occurred after I refused to recommend reappointment of a member of the faculty in a program I administered. It was not my decision alone that determined the action; the committee voted unanimously to deny reappointment, although people be-

haved as if I had forced the committee to that action. I was challenged by the woman in question and several individuals and groups advocated that I change my recommendation, which they felt would lead the committee to reverse the decision. I refused to change my recommendation. However, the committee was persuaded to review the decision and a second vote was taken because a couple of the members felt that I had exerted an overwhelming influence on their votes and they wanted an opportunity to reopen the case. This was done and the decision of the committee again was to deny reappointment, although the vote was not unanimous. The aggrieved applicant elicited the support of blacks in the community who led several angry protest marches into the school and the clinical agency where she and I held joint appointments. I found myself on the boundary between the school and the angry black leaders who yelled obscenities at me for allowing myself to be taken in by "the system" that was "kicking out" the only member of the faculty who cared anything about the black community. The one other black faculty member was on leave of absence, therefore I was the only black faculty around at that time, and I felt totally alone. I became the target for a great deal of hostility over a period of several months. I must admit that I discovered in retrospect how much I had participated in my election to the post of "flack-catcher." People had treated me as if I were so powerful that I single-handedly forced the committee to deny reappointment; as if even those who might have protected the unfortunate woman's job were helpless against my wishes. I felt confident in my reasons for refusing to recommend her appointment. However, I came to believe that in exercising my responsibility to maintain the level of quality in the program that the faculty and I had agreed upon, I had pushed the school into a terrible crisis. While I was not willing to change my vote, I did feel unusually responsible for the disturbance. Unwittingly, I was behaving as if I really did have all that power. And no one in the school objected to my taking the front line between them and the malcontents from outside. The dean was relieved to have me perform that role for her and for the school. The director of the clinical agency refused to have me assume that position in his organization. One might speculate about his reasons: being a white male and a good administrator, he was not about to relinquish his authority to me. Being a colleague and a friend, he wanted to protect me. Being a male chauvinist pig, he had to protect me. Regardless of the real motivations at the time, I have come to appreciate the soundness of the organizational principles that he later espoused as the major determinants for his position during that series of tense and stressful episodes.

Indeed these types of incidents are not limited to black women leaders. Nevertheless, blacks are particularly vulnerable, and black males are spared more often than black females.

The die seems to have been cast by the group of historians and other writers who chose from among all the black women in history the roles of Mammy, Sojourner Truth, and Harriet Tubman as exemplary models. Descriptions of Harriet Tubman are particularly pertinent to this discussion. Note the following:

> There were many who in the years prior to 1860 undertook the Mosaic mission and appealed to the plantation owners to abandon the system of chattel slavery. There were those too who, tiring of the apparent fruitlessness of these diplomatic missions, took up the mantle of the deliverer. Some of these were notably unsuccessful (Nat Turner and John Brown, for example). While others, relying upon more devious means, were notably successful. Among these latter none was more daring or individually successful than was Harriet Tubman. . . . Harriet Tubman was not only an illiterate, highly visible runaway slave but . . . she was engaged in an illegal activity. . . . And though the results of her unexampled heroism were not to free a whole nation of bondmen and bond-women, yet this object was as much the desire of her heart as it was of the great leader of Israel. Her cry to the slave-holders was ever like his to Pharaoh, "Let my people go," and not even he imperiled life and limb more willingly than did our courageous and self-sacrificing friend. . . . Her name deserves to be handed down to posterity, side-by-side with the names of Jeanne d'Arc, Grace Darling, and Florence Nightingale, for not one of these women, noble and brave as they were, has shown more courage and more power of endurance, in facing danger and death to relieve human suffering, than this poor black woman. . . . After her almost superhuman efforts in making her own escape from slavery, and then returning . . . nine times, and bringing . . . away . . . over three hundred fugitives. Her shrewdness . . . her courage in every emergency, and her willingness to endure hardship and face any danger for the sake of her poor followers was phenomenal. . . . She had often risked her own life for her people, and she thought nothing of that.[3]

I know firsthand the tremendous hardships and anguish inherent in attempts to live up to this model in the symbolism of contemporary organizations—which represent in microcosm the society at large. I have felt the pangs of guilt evoked by those who would lead me to believe that to protect myself and promote my general welfare is to let my people down. I am now beginning to see how it is possible to let my people down by *failing* to protect myself and my interests and to seek fulfillment of my own needs. Indeed in modern organizations, racism and sexism dictate that I AM MY PEOPLE. I AM BLACK. I AM WOMAN.

Numerous other black women executives know the pain and anguish to which I refer. Some of them are discovering, as I am, when and how *not* to be Mammy, Miss Truth, Miss Tubman, and still survive. This does not mean that they will be able to avoid becoming symbols in the organizations. It does mean that they are trying to have some part in the development of their

symbolic images. It means that they are finding ways to balance the symbolic functions and those that are task-directed. There is at least one writer who argues that it is not possible for the same person to fulfill the socio-emotional and task needs in organizations simultaneously. Perhaps the success of black women executives lies in their ability to move back and forth between symbolic and task-directed functions. The pendulum rarely stays in the center, and when it moves too far to either extreme there is trouble. But even the most successful black woman executive finds her life hectic at best, and pays a high price for competent performance. Yet, her struggles yield greater and more lasting achievements and satisfaction than those of her black sisters who are locked into symbolic roles most of the time.

It is often difficult to separate the influence of race from that of sex; there is no doubt in my mind that the *combination* levies a heavy toll on the black woman who tries to exercise her authority and responsibility in groups. Herein lies the most significant challenge to black women executives, to those who claim an interest in promoting the upward social mobility of minority groups and women in America, and to all who are concerned with the development of social and psychological theories of organizational leadership.

NOTES

1. Woodson, Carter. History of the Negro Church. (Washington, D.C. 1921), pp. 278–79.

2. Neumann, Erich. The Great Mother (Princeton, 1972), pp. 148–49.

3. Bradford, Sarah. Harriet Tubman (Secaucus, New Jersey, 1974). Quote is composite statement from introduction by Butler A. Jones, preface containing several testimonial letters, and author's text.

13

"HOLDING BACK THE OCEAN WITH A BROOM"
Black Women and Community Work

Cheryl Townsend Gilkes

INTRODUCTION

Black women in American society have provoked peculiar sociological interest because they have failed to conform to the mythical feminine stereotype of the dominant society. Within the normative framework of the dominant society, they represent a deviant group, and the complaint of some white sociologists has boiled down to a declaration of Black women as the source of the problems of Black people (Ryan, 1971). The myth of the Black matriarchy (Staples, 1970) is crumbling, and a sociology which accounts for the integral and unique role of the Black woman within Black society is being developed.

This chapter is concerned with the work of Black women in the Black community of Hamptonville.[1] The data used in this study come from a subsample of 25 interviews I conducted. The seven women discussed here are located in different agencies or voluntary associations in Hamptonville—mostly within its Black community. They are known to the Black residents of Hamptonville as women "who have worked for a long time for change in the Black community."[2] The entire sample was gathered because of their reputation within the Hamptonville community using informants. Black community newspapers were used as a check on the informants. All respondents were interviewed in an open-ended manner, the aim of the

AUTHORS NOTE: This chapter is a revised version of a paper prepared for presentation at the annual meeting of the Association of Black Sociologists and Sociologists for Women in Society, Chicago, September 5, 1977.

research being to explore the lifestyles and biographies of a group of women of similar status—hard workers for the good of the community.

Using Hughes' analysis of occupations (1971), I hope to demonstrate that Black women, through their work in the community, aid the community in its response to the problems of surviving in a racist society while attempting to change that same society. They provide an interlocking network that binds together groups of competing interests and ideologies. I hope to show that an occupational analysis more than a social movement analysis of Black women's work provides a key to understanding the potential stress and strain which exists within Black communities as they deal with the routine problems of oppression.

THE WOMEN

Each of the seven women in the subsample is of interest in terms of her own special set of community activites and her perspectives on community work.

Mrs. Baldwin, 55, is executive director of the Skills Uplift Project of an affiliate of the National Association of Colored Women's Clubs.

Mrs. Davis, 29, is director of the Hamptonville-South branch of the YWCA.

Mrs. Coven, 44, is director of a municipal education project which she has converted into an agency which also deals with Black female juvenile delinquents.

Mrs. Brown, 43, is a welfare mother who volunteers her time as an aide in a newly integrated and troublesome high school in a hostile white area of Hamptonville.

Dr. Dunn, 45, is executive director of the African Religious Caucus.

Mrs. Fuller, 40, is one of the state representatives from Hamptonville's Black community.

Mrs. White, 85, is Honorary Vice-President-for-Life of the Hamptonville branch of the NAACP.

The women are located in strategic institutional offices which allow them to carry out the tasks they find necessary for their work in the community.

These seven women are typical of the women in the sample: They are married or have been married. Their focal concerns regarding the work to be done in the community represent extensions of their concerns and problems they face or have faced as wives and mothers within the community.The problems they faced in helping to support and educate their families were transformed from private troubles to public issues; for most, their involvements were logical extensions of the personal survival problems they shared with other members of the community:

There were a lot of summer programs springing up for kids, but they were exclusive and only certain kids got into them, and I found that most of our kids were excluded.

I guess it was really through my children and through the schools [that I got involved]. Well, even when my children were going to nursery shcool I just always felt it was important for me to be involved and would do whatever I could do with mothers' groups. I lived in the projects with the mothers' group down there and when we moved up here, I joined a couple of neighborhood associations and got fairly involved.

I had four children who are still in and some have passed through the Hamptonville Public School System and have always been interested in education and working with young people within and outside of the schools to help them solve some of their problems.

[After telling of an incident at her college involving the football team] The president [of the college] slapped the football player, and things really began to happen. The next day the students went on strike. . . . We got the dorm rules changed and . . . protested the slapping incident. [After organizing for the student strike, the students] went down to Selma in 1965 for the second Selma march. They sent out the call for people to come down and here we went! College students! Rah! Rah! —we thought we were so great running down to demonstrate.

It began several years ago—just in a local community organization. . . . I organized the Williams Avenue Neighborhood Association . . . in 1953. And simply because we wanted to get together and do things for the community and get the streets cleaned up and the garbage picked up and wanted a mailbox installed on the corner, and things like that—and we did that. And then we branched out into other things.

What started as isolated actions to change specific conditions in their lives soon became routine activities. As one woman stated, "It's a lifestyle!" According to Mrs. Coven, "Once you get started, it's like a disease, it's frustrating and it's just an endless task but you never run away, no matter how hard you try, you always come back." Mrs. Davis said, "You get caught up on a bandwagon that you never get off!" Once they get "out there" in the community, the women realize how much work really needs to be done. "It's a trap, you know the whole thing is really a trap! And when you look at the total picture, it depresses you enough so that you feel like going home and never coming back out your door again!" But by coming back again and again, these women find themselves occupied with the routine problems of a poor, oppressed, and Black community.

OCCUPATION: COMMUNITY PERSON

Once they are "out there" in the community, the women become part of an

ongoing system of activities which is the community's response to the rou-
tine problems it faces. The reactions to oppression and to the social conse-
quences of racism are an important part of Black culture and social organiza-
tion (Blauner, 1972). Although diverse, the Black community is united "by
both the external threats and impositions of white racism and its inner
resources" (Blackwell, 1975: 281). As one explores the situation of Black
women known for their hard work, one discovers a division of labor within
the community and a system of routine activities organized around coping
with and eliminating the problems of oppression. One discovers that the
problems existing within Hamptonville are so complex and differentiated
that it takes a group of specialists working full-time to meet community
needs.

The work of meeting the needs of the community is an occupation.
According to Hughes:

> An occupation . . . is not some particular set of activities; it is the part of an
> individual in any ongoing system of activities. The system may be large or
> small, simple or complex. The ties between the persons in different positions
> may be close or so distant as not to be social; they may be formal or informal,
> frequent or rare. . . . The occupation is the place ordinarily filled by one
> person in an organization or complex of efforts and activities. . . . The divi-
> sion of labor. . . consists, not of ultimate components of skill or of mechanical
> or mental operations, but of the actual allocation of functions to persons. . . .
> The logic of the division and combination of activities and functions into
> occupations and of their allocation to various kinds of people in any system is
> not to be assumed as given but is in any case comething to be discovered
> [1971: 286].

The places occupied by these women are varied and reflect the range of
ideologies and interests in the community. Blackwell emphasizes

> that there is no single Black community and that communities over time have
> come to be differentiated in terms of social class variables, color, size (for
> example, small rural, large urban and intermediate types), as well as a sense of
> identity and ideological perspectives [1975: 283].

Although the places are varied, the functions attached to their offices are
quite similar.

This occupation is tied to the history of Black people in America. Drake
and Cayton (1970), in their study of Bronzeville in the 1940s, found a set of
community perspectives on people who worked hard for the community. In
those days, they were called Race Men and Race Women. Feeling in the
community also judged the men differently from the women:

> Bronzeville is somewhat more suspicious . . . of its Race Men, but tends to be
> more trustful of the Race Woman. "A Race Woman is sincere," commented a

prominent businessman; "she can't capitalize on her activities like a Race Man." The Race Woman is sometimes described as "forceful, outspoken and fearless, a great advocate of race pride" . . . "devoted to the race" "studies the conditions of the people" . . . "the Race is uppermost in her activities" . . . "you know her by the speeches she makes" . . . "she champions the rights of Negroes" . . . "active in civic affairs." The Race Woman is idealized as a "fighter," but her associated role of "uplifter" seems to be accepted with less antagonism than in the case of the Race Man. She is sometimes described as "continually showing the Negro people why they should better their condition economically and educationally."

Cynics are apt to add "intelligent and forceful but has little influence with whites." Certain women were repeatedly named as "good Race Women"—one or two local Bronzeville women who were active in civic organizations, and such nationally-known figures as Mrs. Mary McLeod Bethune [Drake and Cayton, 1970: 394].

The Race Woman is also described distinctly from the class elite of Bronzeville:

Civic virtue often demands a turning away from "Society." Unlike society women, she comes in close contact with middle class women in "uplift" organizations and has wide contacts with white liberals, trade unionists, and politicians. She derives prestige as well as personal satisfactions from "advancing the Race," and she is the keeper of the upper class conscience [1970: 543].

History and events such as the civil rights movement, the War on Poverty, the Black Power movement, and the busing controversy have acted to change the language of the Black community's reponses. However, the demands of the occupation have changed little and the amount of work involved has increased as the complexity of racism in American society and the frontiers where it must be met have increased.

THE LICENSE

The women of Hamptonville have all made the step from the arena of "private troubles" to the arena of "public issues" (Mills, 1959: 8). Once they are "out there" and have shown some skill in solving problems shared by other members of the community, people seek them out. They find their telephones ringing:

I began to take little kids in and I just found that I liked working with kids. . . . Kids would call me in the middle of the night. . . . I go home [from the high school at three o'clock] and I'm on the phone until about six. [She then takes the phone off the hook in order to work with a group of teenagers who come at six o' clock.]

> The phone starts ringing early in the morning . . . as early as five o' clock and as late as three o'clock in the morning depending on what the problem is.

> I often have phone calls starting about six-thirty [in the morning] . . . they have to do with any problems which people have who can't reach me at any other times . . . and that time is about the only time you can get me for sure.

The telephone becomes a physical symbol of the license they have received from the local community whose demands for their skills exceed the abilities of the women to handle the demands. It is the variety and the number of these problems as well as the complex politics surrrounding their solutions that produce these women's feeling that they are "holding back the ocean with a broom."

"An occupation consists in part in the implied or explicit license that some people claim and are given to carry out certain activities rather different from those of other people" (Hughes, 1971: 287). The women do less claiming than the community does giving. They are called upon by other members of the community with problems. Success at one endeavor invites more calls. The talent that they display in solving problems leads to their obtaining institutional offices that are strategic sites for doing the work. Mrs. Fuller, in recounting her movement through a series of community positions, cited a typical incident:

> I began working as a neighborhood worker at the settlement house—from there, the girl that was leaving encouraged me to apply for her job [an administrative position]—I said, "I can't do that" but she encouraged me to try. And when she got ready to leave, she recommended me for the job and I got hired and became much more involved in the situation, working with other parents.

Once in a position, community members may prevail upon the women to remain, even if they feel they should retire:

> This is my fiftieth year with them [the NAACP] and I still wish that I could do more than I have done but I am trying to resign from the board because I do feel that there are so many brilliant young men and women around and there's only a limited number who can work on the board that I feel that I'm taking the place of some of those who can—and I'm trying now to get them to see it that way, I'm going to insist that they do!

I had attended the meeting at which she attempted to resign from the board, and she was ruled out of order by the branch president. Even elective office may have community license attached to it. Mrs. Fuller's colleague in the next district was reelected, in spite of opposition from two candidates (one of whom was backed by the mayor), polling 91 percent of the vote in her district. Mrs. Fuller received two-thirds of the vote in her own district through a low-key campaign against very energetic opposition from a young male known for his hard work in the community.

While in these positions, the women may perceive a problem and initiate an attempt to solve it. If the community approves, they may act to encourage more of the same. At Imani House, Mrs. Davis pointed out the window of her office and said:

> You look out the window, there are two bus stops. [There are little wooden shelters at the bus stops on each side of the street.] We did that one over there first and we got so many calls in and people said so many nice things about it and then there was a bazaar where some of the folks out here raised some money to put up the second one . . .That's the second one [pointing to the one right below the window]. People came by and said, "It's a great idea and it helps me because the bus doesn't roll by here, anymore." They now actually stop here where before they didn't . . . plus the fact that no one has been raped or mugged . . . since that bus stop has gone up.

Mrs. Baldwin's extensive program for the elderly grew in the same way. She decided to have her secretary pick up hot meals for six elderly neighbors of the organization's building on State Avenue. "They began to bring one more and one more and after a while she couldn't bring all of that and they [Meals on Wheels] decided they would deliver for us." Mrs. Baldwin is now running a full-scale social program for the elderly in addition to the Skills Uplift project.

THE MANDATE

The sense of identity and solidarity that comes from being in an occupation and, therefore, responding to the demands of others carries with it a reciprocal feeling of what is proper conduct for the occupant of the position and the others with whom she interacts. Hughes asserts that "they will seek to define . . . not merely proper conduct but even modes of thinking and belief . . . for the body social and politic with respect to some broad area of life which they believe to be in their occupational domain" (Hughes, 1971: 287). Doctors treat illness, but may also write pamphlets telling people how to avoid illness. The community women of Hamptonville provide specific needed services and occupy strategic positions considered important by the community. They also organize Blacks in the community to work for specific changes while making demands against the white community in order to effect change. In fact, the respect they acquire through working for the community confers upon them the privilege of publicly criticizing the Black community and raising the community's consciousness. The privilege and responsibility of their defining proper action is evident to the community and results in the women's being called upon by others in the community who need advice in doing work similar to their own—not just Blacks, but other ethnic groups as well. The reaction of others to their work gives the women perception of their mandate:

I believed that I had something to contribute, I believed that I could see the truth for what it was and I was not afraid to tell it regardless of what the penalties were going to be because when I looked into someone's eyes and saw that love coming back at me—That is power! People don't respect you—don't give you that love unless you're doing the kind of thing that they themselves would like to do and frequently cannot do, and I found that out and will never let it go.

[Concerning her awards] I feel very grateful for them, very. I am very grateful to the people who *thought* I did something. . . . I just feel that a person should just do whatever they *can* do in this world regardless. Whatever comes their way and they find that they *can* do some good in any way, I feel that's their duty!—Their real duty to do it! Now that's my expectation of them that comes afterwards.

THE BLACK COMMUNITY AND
THE MORAL DIVISION OF LABOR

Just as "the largest part of everyday conduct takes place within what may be called *routine* situations" (Hewitt, 1976: 110), so is the bulk of the activity directed toward change and survival in Hamptonville. The residents of the community are aware of the pervasiveness and complexity of their problems. The residents are limited in their ability to act for many reasons: economic constraints, fear, lack of skills, despair, and lack of time. The women know this, and this knowledge can be a source of encouragement to them to continue:

Lots of people call me up at midnight. A school teacher will call me up now and tell me about the hassles that she's going through on a given day—because I was chairman of the court's Committee on Education in the desegregation order and there's no one else to turn to and of course I certainly know the law a little bit and I've managed a quasi-traditional agency for three years. I know a little bit about sociology and social dynamics of the community—the systematic discrimination and so on, so I'm able to help in different ways. I also know a lot of people so I'm able to pick up the phone and make contacts. Sometimes I find it easy to do for other people who don't have the same resources. . . .

I heard people talking about how Black parents were apathetic. There were a number of circumstances that kept them from participating in the process: First of all, most of them were working and couldn't; the second thing was that parents had always had the feeling, and I was under the same impression until I became involved with the teachers, that teachers were always right because we [Black people] always have this great respect for education—and there was not always just the confrontation level—but going in and *talking* to teachers. Parents were afraid that since they were less educated that they should not go and talk to the teacher. I think that it was much more fear than apathy. Another

thing, if the parents were working, it was very difficult to get off the job to go. It's difficult. . . . to even get [the time] off but even if you could get off, making that choice of losing a day's pay or going to the school when you are living from week to week—the paycheck is hard!—and coupled with really being afraid to go talk to teachers you would tend to go to work . . . I felt even though I worked with a parent's group that because I wasn't a teacher no one took my words very seriously and I decided that I was going to become a teacher, not to work in the classroom, but to work with parents . . . I went to school in 1970 and graduated in 1974 [major: elementary education].

So we try to think of a person as a whole human being with all their various needs. . . . Hamptonville has every kind of service . . . but you've got to know where. You get tired of being sent from here, here, there, there. . . . So you go . . . and they say you're in the wrong district and you go to the next one and they say I think that's your district and you go there and that isn't the right one either. Then a person gives up! So that's why we try to see it through. We have a worker that will go out with you and see if that's the place you belong. If it isn't then she'll go to the next place with you. Wherever that is. So we try to make our services very personal so that we can't say that we do this, that or the other. We can say that we do what the person needs.

They [whites] know that a Black man has a family to support, and he must make compromises in order to earn a salary in order to support his family. . . . I know a lot of Black men who want to do some things to make changes but ultimately they're threatened and so that leaves it [community work] to the Black woman.

However, in spite of their understanding of the constraints upon more participation by the wider community, the women can still be irritated by what they see as crisis-oriented and divisive behavior:

I have a short fuse when it comes to Black folks' attitudes . . . Black parents just don't get involved unless it's crisis-oriented . . . We're through the crisis part of the desegregation—upset or whatever you want to call it and Black folks are on their laurels!

But even when we're in the thick of things—we do a lot of routing and yelling . . . and we do a lot of preaching . . . and then when it comes time to stand your butt on the line, they're not there!

Progress is based on participation and not in terms of how many inroads we have made into the system to activate some kind of reform. . . . Until Black people can get together, we have to do it together! But there's always the white folks around the corner who throw a few crumbs that divide us.

I think that [Black] people who come here from other countries do have a sense of self, . . . often translated into arrogance . . . and it's unfortunate but I also recognize how it was developed . . . One of the things about the Muslim

Temple which I think was so crystal-clear in the teachings . . . of course was the fact that we were all slaves and that the people in the Caribbean were taken off the boat to start earlier.

I think the people are wiser but weaker . . . we're easily co-opted. And we're wise enough to know better . . . Today we have more educated Blacks than we have ever had in the history of the country, so you have to say we're wiser.

Because they know the power of mass movements in gaining changes and concessions, the women sometimes express frustration when the work is left to them and people outside the community begin to notice:

But if the people who are being deprived aren't the ones to go to the legislature—they're sick of seeing agency people come down!

When I'm screaming and hollering at this man upstairs and I'm telling him, "This isn't the way you treat Black kids!" and he says, "Who says?"and I look around and there's nobody but me!

There is a paradox at work: The women do their work so well that the rest of the community perceives their work as professional and their competence and potential success as a foregone conclusion.

Because of the functions performed by the women and the importance of these functions to the Black community, the women's success at their endeavors earns them a highly valued status in the community's moral division of labor. The licences and mandates possessed by the women "are the prime manifestations of the *moral* division of labor—that is of the processes by which differing moral functions are distributed among members of society, as individuals and categories of individuals" (Hughes, 1971: 288). What the women see as apathy on the part of the Black community when it is not facing a crisis quite possibly can be viewed as an unconscious cultural complement: The community has conferred that status of "professional" upon them.

Although social scientists have attempted to define the term "profession," "people conventionally apply the term profession, in the morally evaluative sense, to certain occupations. . . . They implicitly affirm that (these occupations) have in fact achieved this morally desirable kind of organization" (Becker, 1970: 90). When the term "profession" is viewed as a folk concept rather than as an absolute category, it is easier to understand how the community evaluates the women. The women would resent the word professional because it implies working for rewards—"I don't think of it as a profession, I consider it simply a part of my life." But the respect that they receive from the community confirms this folk definition of them as professionals. "Profession' is an honorific title. . . . a collective symbol and one that is highly valued" (Becker, 1970: 92). One informant argued that I

should interview another woman because she was an "important professional woman and highly educated." When I later interviewed her, I discovered that she had finished high school with her daughter but "I have a Ph.D. in survival."

Community events confirm the moral evaluation of the women by the community. They receive awards at these events. At banquets, they are acknowledged when in the audience if they have not been asked to sit at the head table. The women are called upon to introduce celebrated Blacks from national organizations and government. They are constantly invited to give speeches at community conferences and at local colleges. They are sometimes invited to speak and give papers at the national and regional meetings of professional and learned societies. They also receive honorary doctorates.[3]

The fact that they are honored, that their work is routine, and that the work has the characteristic of an occupation provides insight into the nature and pervasiveness of racism and its consequences in Hamptonville's Black community. The women stand out as a group separate from the men engaged in community work. This separation indicates the special constraints in American society on outspoken Black men *and* the special effects of racism on survival issues concerning women.[4] Racism affects Black people early in the life cycle—which explains why many of the women got involved "through my kids." Mrs. White, whose involvement in the community began with the problems of settling herself and other people after migration from the South, provides a vivid example:

> We were comfortably fixed in Little Rock: we owned our own home; we built to suit ourselves; and we were comfortably fixed. But the racial situation was pretty bad at that time and something happened that just drove us away immediately— . . . they lynched this boy. . . . they had to pass by our door and my children saw them—the gang, the mob passing my house with this boy in the car just screaming and yelling and having a big picnic on the way to a big bonfire that had been built right in the center of the Black district. . . . They built this fire right at the intersection of two streets and burned him alive— while the women, the white women clapped their hands. And I told my husband, "This is it! We must leave immediately!" I could not think of rearing my children in a town like that anymore!

Housing, violence, employment, education, health, and legal problems are critical issues in Hamptonville's Black community. They have, as far as the women can see, their greatest impact on the youth of the community. Their roles as wives, mothers, aunts, and neighbors give them a special day-to-day insight into the community situation. The community generally agrees with with them and defers to the women's expertise, treating them like the professionals they claim they are *not*.

"WORKING FOR YOUR PEOPLE
IS A FULL TIME JOB!"

Working "out there" from the area of their private troubles to the public issues that are at the root of their troubles is very much like Ezekiel's entry into the Valley of Dry Bones. They discover through hard work that one problem is attached to another problem and that these problems have emerged through some basic faults in the system. Working with household domestics leads into the area of the problems of women with low skills:

> Now here we have changed from the strict focus on household workers to all low-skilled women. . . . It was fine to take household workers because there was no advocacy for them—but when things began to deteriorate in this inflation that they refuse to call a depression then all low-income women were in the same boat. And we'd like to have them all feel the same about it—that we've all got to get together and say we're not going to let you shaft us any longer. We do the work, we want the money, and we also want the jobs opened up!

Working with teenagers having problems with the educational system forces one to take a broader view. Mrs. Coven expanded her agency's focus even though it is still working primarily with students:

> I find out that working with the students is an intensely necessary sort of task. But there's something that comes before education. If you have a young person—be they male or female—who has encountered the system, and most of our young people do, if it's the courts or not, it's very hard for them to think in terms of academics when there are so many other problems involved in their life—social, financial, environmental.

The women also discover that no one organization can solve all of the community's problems:

> I don't think any organization is more important than the other and I'm not just saying this because I'm a politician. . . . But I think there's a place for everything and that there are certain things that one can do that another one cannot and if one is thrust in a more important role than the other, then we begin to downgrade their importance.

> There is so much competition . . . I don't see why it should be so competitive—I think that organizations should make up their mind that whoever does his stick the best should be allowed to do it, because there is a lot of work to be done around here and not nearly enough folks to do it.

These women are uncomfortable with the organizational and ideological divisions that prevent a united front in the face of the system, a system which appears to need basic and radical change. As Mrs. Davis said, "This system needs to be 'jacked up'."

This ideology comes from their experience at attempting to solve problems. They discover their ideology through their work and not through the organizations whose boards recruit them to membership and elect them to office. In fact, their organizational networks and their board memberships act as a counter balance to the divisiveness of competing ideologies in the community. Dr. Dunn works with the African Religious Caucus and is a member of the Republican Party and an admirer of Mao Tse-tung. Mrs. Davis, a former Black Panther, works through the YWCA. Mrs. Brown, an admirer of Malcolm X and affiliated with a local cultural nationalist organization, is constantly forming coalitions with white liberal and white parent groups in order to make changes and acquire resources for her students.

Besides the hours which they invest in the places which are their principal work settings (strategic sites)—an average of 8–12 hours per day—they must attend meetings at night and on weekends. Some women, because of the number of meetings they must attend, will not make appointments before nine or ten o'clock in the morning. That privilege, however, is rare. The bulk of the women spend a minimum of ten hours a day away from home. Even if they are holding a salaried position, they are not paid to go to meetings. As one woman in the larger sample stated, "There are easier ways to make a living!"

As an occupational group, these women move in and out of all of Hamptonville's Black community organizations. This sometimes causes friction with allies from the white community who are antagonists to a particular social group but arrive at a community meeting expecting to work with Mrs. Davis and find representatives of nationalist and anti-Zionist groups present. This is expecially frustrating for Jews, since groups such as the Black Muslims and the Ethiopian Center are militantly anti-Zionist. It is often the physical and moral presence of these women that keeps these antagonisms from breaking into open conflicts so that the work at hand can get done.

Studying these women as an occupational group gives us some insight into the concrete details of the processes which hold the Black community together in spite of its diversity. In addition to the collective effects of racism, which binds the community together to a certain extent, the women's work and the networks they establish while doing this work forces intra-group cooperation in situations of potential ideological conflict.[5]

Sociologists generally view social movements as unusual special events that are the result of precipitating events and faults in the social structure. They are not treated as routine happenings in the life of a society. Occupations, on the other hand, are considered to be stable normal elements of the social structure of complex societies—a concrete manifestation of the normative division of labor. Viewing the activities of these women through an

occupational rather than a social movement perspective will give us insight into racism in American society as a stable and normal element of the social structure. Racism in American society is a stable and pervasive element and economic struggles are becoming increasingly important. Inequality—the result of racism in our society—is being fought on an ever-widening front. Inequality has created needs within many communities besides the Black community. Because of the particularr history of Black people in America, the tradition of the Race Woman is now an occupation. Groups outside the Black community have discovered these women and are recruiting them to community. Because of the particular history of Black people in America, sociologists will also be able to shift their conceptual gears in order to explore this important facet of our culture and social organization. Now that sociologists have discovered racism (Gilkes, 1976), they should discover the work that racism has created. As Mrs. Coven so bluntly put it, "I think that whites are beginning to realize that the four hundred years' job they did on us is wearing thin."

NOTES

1. Hamptonville is a pseudonym. The names of the women and the local organizations in the community have been changed. I have a research bargain with the women that is designed to guarantee them as much anonymity as possible. Where possible, certain biographical characteristics may be removed or compositely presented.

2. The phrase "Women who have worked hard for a long time for change in the Black community" is the phrase I used consistently when speaking with informants who were used to generate the list from which the respondents in the study were drawn. A list of over 60 women was used and checked against the Black newspapers in the community where the study was conducted.

3. Dr. Dunn holds an earned doctorate. Several of the women in the larger sample belong to traditionally organized professions—nursing, social work, education, and law. Their careers, professionally, are a special case and will be dealt with in a separate paper. All of the women under age 60 (23) have received higher education. In 19 cases, that education was acquired as needed to do community work. Their educations have been focused in human services and administration, and many cannot receive degrees because they lack distribution credits even though the number of credits they possess exceeds the number required for graduation.

4. Space does not permit a long discussion of the very complex and unique effects that racism has had on the organization of sex roles in the Black community. The historical position of Black women in Black communities, however, was commented on by one woman as "a demeaning sort of freedom." All of the women provided long discussions of their attitudes toward women's liberation. Their statements were both volunteered and directed.

5. Certain events have highlighted the problems of leftist groups in the Black community. Those antiracist leftist groups with very small Black student memberships have met rejection and conflict when attempting to act within the Black community. Those leftist groups which have formed coalitions through interlocking directorships and steering committees have little conflict when they focus on tasks rather than ideological technicalities. The problem between Hamptonville's Black community and the white left is not unlike the problem discussed by

Cabral concerning the problems that Third World socialist groups have with their relations between themselves and European Marxists—paternalism (Cabral, 1969: 68).

REFERENCES

Becker, H. S. (1970) "The nature of a profession," in H. S. Becker (ed.) Sociological Work: Method and Substance. Chicago: AVC.

Blackwell, J. E. (1975) The Black Community: Diversity and Unity. New York: Dodd, Mead.

Blauner, R. (1972) Racial Oppression in America. New York: Harper & Row.

Cabral, A. (1969) "Brief analysis of the social structure of Guinea," in A. Cabral (ed.) Revolution in Guinea: Selected Texts. New York: Monthly Review Press.

Drake, S. C. and H. Cayton (1970) Black Metropolis: A Study of Negro Life in a Northern City. Chicago: University of Chicago Press.

Gilkes, C. T. (1976) "The respondents who cried 'I am': sources of conceptual revolutions in the field of race relations." Presented to the annual meeting of the Eastern Sociological Society.

Hewitt, J. P. (1976) Self and Society: A Symbolic Interactionist Social Psychology. Boston: Allyn & Bacon.

Hughes, E. C. (1971) "The study of occupations," in E. C. Hughes (ed.) The Sociological Eye: Selected Papers on Work, Self, and the Study of Society. Chicago: AVC.

Mills, C. W. (1959) The Sociological Imagination. London: Oxford University Press.

Ryan, W. (1971) Blaming the Victim. New York: Random House.

Staples, R. (1970) "The myth of the Black matriarchy." The Black Scholar 1: 8–16.

14

POLITICAL BEHAVIOR OF
AMERICAN BLACK WOMEN
An Overview

Jewel L. Prestage

Leaving a legacy of feminine leadership in political and military affairs that encompassed such greats as Hatshepsut, Makeda, Cleopatra, and Ann Zingha (Rogers, 1972), Black women, along with their kin, arrived on the American shores to commence an experience of oppression which has included indentured servitude, chattel slavery, segregation, discrimination, and a variety of forms of differential treatment and status. Among the very first group of 20 Blacks to arrive at Jamestown, Virginia, in 1619 were several women. The first detailed census in Virginia, conducted in 1624–1625, indicated that in the state's total population of 1227 there were 23 Blacks: 11 males, 10 females, and two children.

With a focus extending from arrival in the early seventeenth century to the contemporary era, this chapter will attempt to provide an overview of the political behavior of Black women in America. Essentially, five contentions serve as the basis for the discussion. These are:

(1) Black women have been the victims of dual oppression in the American political system—one type of oppression issuing from race and another issuing from sex.

(2) In each historical epoch in the development of the American political system, Black women have been centrally involved in the major political struggles confronted by both Black people and women.

(3) The political activity of Black women has varied in accordance with the historical conditions under which that activity has taken place, and has in-

cluded abolitionist activity, politicization of normally nonpolitical positions, protest demonstrations, electoral participation, and officeholding. Any effort to understand the political behavior of Black women must take cognizance of changing patterns over time.

(4) Black women have expanded their political involvement progressively, escalating at unprecedented levels since 1965, especially in voting and officeholding.

(5) Political advancements for Black women have paralleled more closely the advancements of Black men than they have the advancements of white women.

Early Black residents in the colonies did not enter as chattel slaves, but as indentured servants, assigned basically the same status as white indentured servants and permitted to work out their freedom. As a result, free Blacks were among the population of all of the colonies by the middle 1600s. Beginning around 1660, however, the colonial economic and political power structure abolished the practice of white and Black indentured servitude in favor of a system of perpetual slavery of Blacks. In a companion move, initiated by Virginia in 1662, all children were assigned "slave" or "free" status at birth, according to the status of the mother. Hence, children born as a result of interracial cohabitation between white men and Black slave women were assigned the slave status of the mother. In addition, subsequent legislation in Virginia created sharp legal differences in the status of white women and that of "free" Black women. Similar laws emerged throughout the colonies, and by the opening of the eighteenth century the new slave system was pervasive (Franklin, 1974). However, free Blacks, living in the colonies, were not assigned slave status by these laws and the population of free Blacks continued to grow—as did the slave population.

The record shows that for most of the seventeenth century, women were a small minority among the Black population. As a corrective measure for this imbalance, some colonies imported special shipments of women. Expansion of the Black population was more rapid in the latter part of the century; by 1800, it was estimated that there were about one-half million Black women in America. (Franklin, 1974: 56–67).

The plight of the slave woman was especially trying. Slaves were, by definition, nonparticipating members of the body politic. Prime motivation for the slave system was economic gain. All policies and practices related to the slave system were assessed in terms of their contribution to increased productivity and decreased costs. Overwork, forced sexual cohabitation for breeding purposes, physical beatings, and torture were not excluded as measures for dealing with male and female slaves. Those laws which were on the books to protect slaves went mostly unenforced.

Slave families experienced great difficulty in efforts to achieve stability. In the main, slave owners refused to recognize the slave family as an institution worthy of respect. Only among those owners interested in "moral and religious development of their slaves" was there any real thrust toward stable family units. Even in these cases, slaves were encouraged to marry someone on their own plantations. In the master's view, interplantation unions tended to reduce the work efficiency of both parties. Black slave men preferred marriage with women from other plantations so that they would not have to witness the abuse of their wives. One fugitive slave wrote: "I did not want to marry a girl belonging to my own place because I knew I could not bear to see her ill-treated" (Blassingame,1972: 86).

Childbearing and child rearing were tedious experiences for slave women. Among the more trying aspects were the conditions under which conception took place, little time off for delivery, and the absence of any acknowledged role for the slave mother in bringing up her own children. In fact, children were frequently sold away from the mother.

In the face of these seemingly insurmountable odds, Black slave men and women struggled to create some semblance of stability in family life wherever and whenever possible.

The establishment of community life among slaves, a condition now documented by various scholars, entailed the development of a leadership cadre. Women were a part of that cadre and some even became key persons in some of the larger communities (Franklin, 1974: 155). Midwives, for example, were especially significant contributors to community security and well-being.

Frederick Douglass wrote of Black slave women:

> More than a million of women in the Southern states of the Union are, by laws of the land . . . consigned to a life of revolting prostitution . . . by those laws. . . . If a woman, in defense of her own innocence, shall lift her hand against the brutal aggression she may be lawfully put to death. . . . By the laws of slave states . . . three million of the people of those States were utterly incapacitated to form marriage contracts . . . Slave breeding is relied upon by Virginia as one of her chief resources of wealth. . . . I leave you to picture to yourselves what must be the state of society where marriage is not allowed by the land and where the woman is reduced to a mere chattel. . . . You have already conceived a state of things equalling in horror and abominations, your worst conceptions of Sodom itself [quoted in Aptheker, 1969: 313].

Political implications of the subordinate status of slave women for slave men has been the subject of commentary by a number of social science scholars. Rape of slave women, they assert, was a political act as well as an act of physical violence. Davis (1971), for example, contends that such rapes represented an indirect attack upon the slave community as a whole.

Through assertion of sovereignty over this critically important figure, the master also struck a blow at the Black man. In fact, it was hoped that the Black man, sensing his inability to defend his women, would begin to develop deep-seated doubts about his ability to resist in any way. While this prognosis proved unreliable, some of the trauma which the Black man experienced is reflected in the words of a young male slave reporting his feelings when he saw a white man flogging his sister:

> God knows that my will was good enough to have wrung his neck; or to have drained from his heartless system its last drop of blood! And yet I was obliged to turn a deaf ear. . . . Strong and athletic as I was no hand of mine could be raised in her defense, but at the peril of both our lives [Blassingame, 1972: 99].

Not all Black men were equally restrained. There are numerous historical accounts of Black men lashing out against slavery in incidents involving their families, even when their lives were put in extreme jeopardy (Ladner, 1972: 31).

➤ Some indication of the political sensitivity of free Black women can be discerned from the variety of activities in which they were involved. Records of antislavery societies, letters to editors of newspapers and periodicals, and public speeches reveal names of Black women whose energies and talents were devoted to the abolitionist cause. One women's group, the all-Negro Ladies Anti-Slavery Society of Delaware, Ohio, addressed a militant resolution to the Ohio Convention of Negro Men in 1856 urging their steadfast continuation of the fight for improvement of the plight of Black people. This contributed toward the men's decision to send a resolution to the Ohio legislature (Apel theker, 1969: 380–387). Black women were also active in the formation of the New England Freedom Association in 1845 to assist fugitive slaves (1969: 253) and the New England Colored Citizens' Convention of 1859 to deal with problems in that region (1969: 433). The Colored Women of Brooklyn (1969: 441–442) through their organization, responded collectively to John Brown's martyrdom. Individual Black women like Aletha Turner and Jane Minor were known to have purchased slaves and granted them freedom (1969: 126). Others went North and worked to purchase freedom of sons, husbands, and other relatives. Frances Ellen Watkins Harper lent her eloquence as an orator, writer, and poet to the cause of justice for her race (Lerner, 1977: 354–357).

The legendary Harriett Tubman was among those who conducted the Underground Railroad. Of her, historian Bennett (1969) writes: "The short Black woman was without nerves and she had no peer, male or female, in her chosen trade: organizing and managing slave escapes." She made 19 round-trips leading slaves through Maryland, Delaware, Pennsylvania, and New York into Canada. Her title, "the Moses of her people," was well deserved.

Between trips she worked as a cook, maid, or laborer to accumulate money. Because she could neither read nor write, it was necessary for her to get others to write coded letters to designated persons in the target area. Arrival in the area, preparations for the trip, and a strict discipline system during the trip were standard procedures in her operation. A great commando leader, she never lost a single slave by capture or return. During the Civil War she served as a scout for the Union Army, on one occasion leading Colonel James Montgomery and his 300 Black soldiers into South Carolina to destroy southern property and bring out 800 slaves. After the war, despite her outstanding service, she was plagued by problems relative to the pension she was due for such service.

Another giantess of the abolitionist movement was Sojourner Truth. Formerly Isabella Van Wagener, in 1843 she adopted a new name, gave up a job as a domestic in New York City, and decided to go East to travel up and down the land showing the people their sins and "being a sign to them" (Bennett, 1969). A moving and forceful speaker, Sojourner's fame grew. She became the first Black woman antislavery speaker. In addition to agitating oratory, her contributions to the Civil War included immersing herself in the service of the Union by nursing Union soldiers and improving sanitary conditions in the "contraband" camps. At one point she went to Washington to see President Lincoln. Irritated by the Jim Crow policy of the transit system in the seat of government, she staged "sit-ins" on the white horse-drawn street cars. After being roughed up by one conductor, she sued and won.

Sojourner Truth was not only an advocate for Black liberation but for women's liberation as well. The ambivalence of white women toward her involvement is reflected in their unwillingness to accord her a central role at the Second Annual Women's Suffrage Movement Convention in Akron, Ohio, in 1852. The women felt that their cause would be hurt if it were associated with the cause of Black liberation. However, at a critical juncture in the proceedings when the women were taking a shellacking from the opposition, Sojourner gained recognition from the chair and delivered one of the most eloquent orations of all time. In it she challenged the allegations, made by male speakers, that women were weak, could not carry their share of manual labor, and generally had to be assisted in most physical chores. Contrasting this alleged pattern with her own record of physical prowess and biological reproduction, she asked, "And aren't I a woman?" In a moving chronicling of these contrasts, punctuated by the refrain "And aren't I a woman?," she managed to bring the apprehensive (mostly white) women to their feet with cheers and applause. (Bennett, 1969: 125). After the Civil War, she spent the rest of her life (she lived past 90) working to achieve a just and equitable Reconstruction. One of her goals was governmental support

for the resettlement of former slaves in northern and western states. "America owes my people some of the dividends. She can afford to pay and she must pay. I shall make them understand that there is a debt to the Negro people which they can never repay. At least then, they must make amends (Bennett, 1969: 127).

Thousands of Black women left the Confederate states to serve as washwomen, cooks, nurses, and general laborers in the northern army.

Another form of resistance by slaves was revolt, and women were centrally involved in some of the uprisings. Notable in the ranks of revolters was Nanny Prosser, wife of Gabriel Prosser, the man who led the unsuccessful uprising in Virginia in 1800. Many acts of violence were committed by slave women against their masters and mistresses—poisonings, burning of houses and barns, beatings, and slayings. These women, bent on curtailing some of the inhumanity inflicted upon them, joined with Black men of similar persuasion to move against the slave system in a nonpassive fashion. According to Franklin (1974), many Black women offered violent resistance to the sexual attacks upon them by white masters and overseers. Rather than endure slavery, some slave mothers chose death for themselves and their offspring. Runaway slave records contain information on "Sarah," who was described as

> the biggest devil that ever lived, having poisoned a stud horse and set a stable on fire, also burnt General R. Williams' stable and stockyard with seven horses and other property. . . . She was handcuffed and got away at Ruddles Mills on her way down the river, which was the fifth time she escaped when about to be sent out of the country [Blassingame, 1972: 116].

One Virginia planter wrote "The Negro women are all harder to manage than the men" (1972: 153).

The slave and Civil War periods, then, were marked by Black female political activity which encompassed exertion of leadership within the slave community, agitation for abolition by both violent and nonviolent means, and service with military units in a variety of roles.

For most Black men and women, Reconstruction represented their initial opportunity to legally and officially create a family, and many took full advantage of it. Particularly noteworthy is the large number of Blacks who utilized newspaper announcements and handbills in the intense struggle to locate relatives separated by sale during slavery. Women as well as men seemed acutely aware of the political significance of close-knit family structures and the bonds of kinship in the face of a hostile majority community as they attempted to move from slavery into freedom.

Politically, Reconstruction was a period of widespread voting and office-holding by Black men. The women, because of state laws barring their

exercise of the suffrage, were excluded from engaging in these activities. However, it is reported that they found ways and means of bringing pressure of a political nature upon their fathers, husbands, brothers, sons, and other male relatives and acquaintances. John H. Burch, speaking in the late nineteenth century, alleged that Black women exerted unwarranted influence upon their male (voting) relatives in Louisiana. Burch had served in the Louisiana State House and Senate and was connected with two newspapers in the early 1870s. Among the political activities he attributed to Black women were following their men from morning to night around the parishes (counties) demanding that they vote Republican, forming a large segment of those present at political assemblages, evidencing a deep interest in all that pertained to politics, advocating that voting Republican was the only means by which they could secure homes and education for their children, and finally pushing Republicanism so hard that they swept the Republican government away from the state. They then turned their attention to an emigration drive or exodus designed to get Blacks out of the state. Similar exodus experiences occurred in other states as well, and Black women were given credit for "masterminding" (or mistressminding) them. In New Orleans, a committee of 500 Black women organized with Mary J. Garrett as president. The committee, in 1878, published a document demanding that Black women be accorded every right and privilege guaranteed to their race by the Constitution, and declaring that they would use every power in their hands to get these rights and privileges. (Aptheker, 1969: 721–722). Thus, Reconstruction Black women, still deprived of the right to vote and hold political office, resorted to alternative strategies of influencing public policy during the first period in which Black men were legally involved on a large scale in the decision-making process in America.

Termination of Reconstruction and restoration of white control in the South brought an end to Black political involvement. Through devices such as other purges, grandfather clauses, poll taxes, literacy tests, and general humiliation of Blacks, southern whites destroyed the Black voter bases in the various states. In addition, maltreatment of Black women as a means of demoralizing the Black community was a general practice. When all else failed to bring about the desired results, whites used violence and murder to accomplish the suppression of Black aspirations. Lynchings numbered over 2500 between 1884 and 1900. Another 1000 occurred between 1900 and the beginning of World War I. (Franklin, 1974: 323). While most lynching victims were Black males, some white males and Black women were also hanged. In one instance, a pregnant Black woman was lynched, her stomach slit, and the unborn child stomped to death by the mob after it fell from the mother's abdomen onto the ground. Efforts to combat this form of murder were organized across the United States and in other countries.

One Black woman prominent in the antilynch movement was Ida Wells Barnett, frequently cited as its initiator. She began her career as a Jim Crow-fighting editor of the Memphis *Free Press,* but was forcibly ousted from that city in 1892. After joining the Chicago *Conservator,* she lectured on lynching throughout the northern half of the United States and in Europe. She pioneered in the exposure of the falsity of rape charges as an explanation for lynching. In 1898 she carried the fight to the White House where she met with President William McKinley. As a result of her tours, the British founded the British Anti-Lynch Society. While on one such tour, she confronted Frances Willard, national president of the Women's Christian Temperance Union, also on tour from the United States, for the latter's "apologist" attitude and comments regarding lynching and maltreatment of Blacks in the South. Possibly as a result of that encounter, Ms. Willard became a subscriber to the British Anti-Lynching Society. Ms. Barnett married in the midst of her career as a journalist and political activist, gave birth to four children, and continued her work in both areas, frequently bringing her baby along. She was active in the founding of the Ida B. Wells Woman's Club, the National Association of Colored Women, the Negro Fellowship League, the National Association for the Advancement of Colored People, and the Alpha Suffrage Club of Chicago (Lerner, 1977: 196–205).

Another Black woman active in the antilynch struggle and other moves by Blacks to counteract the hostile laws and practices of the post-Reconstruction era was Mary Church Terrell. Raised in Tennessee and educated at Oberlin College, she taught at Wilberforce University and at the High School for Colored Youth in Washington, D.C. She was an active woman suffragist, first president of the National Association of Colored Women, personal friend of and collaborator with Susan B. Anthony and Jane Addams, and a charter member of the National Association for the Advancement of Colored People. Over most of the 91 years of her life, she spoke out vigorously against lynching and discrimination, even contesting the racial restrictive policies of the American Association of University Women when she was 83 years old. In the same year, she led a campaign to end discrimination in Washington, D.C., restaurants. She died in 1954 (Lerner, 1977: 205–211).

Many Black women were members and supporters of the antilynch activities and other efforts spearheaded by Barnett, Terrell, and other Black leaders at the national, state, and local levels.

The organization of the NAACP in 1909 was a major turning point in the Black struggle for equality as major emphasis shifted largely to the courts and litigation. Black women were involved in the establishment of the organization and in its work.

In the period between the 1920s and the mid-1950s, when litigation and

lobbying were prime strategies for achievement of equality for Blacks, Black women were found in principal roles in almost all dimensions of the struggle.

During the latter half of the 1950s and extending through the 1960s, Blacks launched an outside-of-the-courtroom dimension to their struggle for equality—the civil rights movement. Research on the movement reveals, almost without exception, a critical role played by Black females. Chafe, in *Women and Equality* (1977), writes that Black women have played a pivotal, initiating role in defining the issues of sex and race liberation for white women. Quoting a young white woman, Chafe states that young black women "shattered cultural images of appropriate female behavior." Of older Black women, an SNCC leader reports that "Mammas" in southern towns provided the organizational base for action against the white power structure, coordinating food, shelter, transportation, jail visits, and other life-support activities. All of this prompted one southern white woman to observe, "for the first time I had role models I could respect" (1977: 108–110).

Grass roots organizers like Fannie Lou Hamer in Mississippi and Victoria Dee Lee in South Carolina, along with Rosa Parks, who served as the catalyst for the Montgomery bus boycott, are among the outstanding Black women political activists to emerge from the era when political participation for Blacks was mainly "protest" participation.

Studies of civil rights demonstrations by Black college students reveal broad participation by females. Matthews and Prothro state that 48 percent of the students who personally took part in the sit-ins and freedom rides were female.

A study of traditional and protest political participation by Black men and women in New Orleans (Pierce, 1973: 442–430) revealed the following:

(1) only minimal overall differences in the amount of protest and traditional participation by Black men and women;
(2) a higher association between the two forms of participation among the women;
(3) in both types of political behavior, lower-class women participate more than lower-class men when income is the gauge of class, but when education and occupation are controlled for status, findings are mixed;
(4) black women have less positive feelings about the political system than Black men; and
(5) beliefs about the political system are more important predictors of levels of participation for the women than for the men.

Overall, the New Orleans study runs counter to basic canons of political behavior as based on research utilizing non-Black populations.

In the era of protest, Black women students and adults had unexpected

levels of active involvement, levels which are at odds with reportings on non-Black women's involvement in either protest or traditional politics.

Lansing (1973) has studied the voting pattern of American Black women utilizing comparative sex and race data for the 1956, 1964, 1968, and 1972 presidential elections. Some striking results have been reported. Among the youngest cohorts (18–24 years of age), Black women voted at rates higher than Black men, while among the middle age groups (25–54 years), the two sexes voted at about equal levels. For those 55 and older, Black men out-voted Black women. Further, in the 1960s, Black women increased their rate of voting at higher rates than Black men, and more than either white sex—for whom turnout declined after 1960. Lansing also found that Black women in white-collar and manual occupations voted at somewhat higher levels than Black males in these occupations, while this was reversed for service and farm workers. Black men in professions and technical fields trailed Black women in those fields in voting. However, no differences were found between women heads of households and wives of heads of households. White men and white women of elementary education were further apart in their voter participation than were Black men and women of similar educational attainment.

Overall, it would seem reasonable to generalize that once legal and cultural barriers to Black voting were removed, Black women registered and began to vote in a rather energetic manner, with Black women trailing Black men to a lesser degree than is the case for white women.

Officeholding in political parties and government for Black women followed increased registration and voting by Blacks, mainly in the South and mainly in the aftermath of the Voting Rights Act of 1965. Clayton, in 1964, observed that the majority of Black political workers were women. They outnumbered men in performing grass roots tasks. However, rewards to Black women were not commensurate with their contributions to party work, as only "a score or so" had achieved success in politics. Less than a dozen Black women across the nation had gained elective office at that time. Those women who had gained political office had done so within the context of the political parties. An examination of the careers of a diverse sample of these women failed to yield any single pattern for success (Clayton, 1964: 122–148).

The first Black woman to be elected to a seat in a state legislature was Crystal Bird Fauset, who took a position in the Pennsylvania lower house in 1938. It was not until 1952 that a Black woman became a state senator, Cora Brown of Michigan.

In 1973, there were 337 Black women holding elective office, among a total of approximately 520,000 officeholders in the United States. This figure represented an increase of 160 percent over the 131 Black women

holding office in 1969. In 1969, Black women were 10 percent of the total number of Black officeholders, while they accounted for 12 percent in 1973. Regionally, 39 percent of the women officials were from the South in 1969 and 34 percent were Southerners in 1973 (Bryce and Warrick, 1973). New York led the nation with 37, followed by Michigan with 30 and Mississippi with 22. These states with the largest number of Black women officeholders were also the ones with the largest number of Black males in office and those which ranked high among the top ten in percentage of Blacks of voting age (Prestage, 1977).

By 1977 the Joint Center for Political Studies reported that the number of Black women holding political office increased to 782, or roughly 18 percent of all Blacks in elective office: 4311. Again, the major portion of these, 51.5 percent, were in the South. The state of Michigan led the nation with 65; Illinois and New York followed with 55 and 49, respectively. Education-related offices continued to dominate, as 263 offices fell into that category. Municipal governing bodies accounted for 197 and other municipal positions accounted for 183. There were 39 state representatives and seven state senators along with four members of Congress.

Most recent figures are those released by the Joint Center for Political Studies in October 1978. Of a total of 4504 Blacks in elective office, 843— or about 12 percent—were women. The proportion of Black women in the southern region was 53 percent. Thus, while the South continues to lead, the West continues to produce the smallest percentage, 7 percent. The state of Michigan leads in women officials with 70, trailed by California with 53, Illinois with 51, New York with 50, and Mississippi with 46. Like Black officials generally, the women were clustered in municipal and education-related positions: 47 percent and 34 percent, respectively. There were also eight state senators and 38 state representatives.

Studies of Black women officeholders have been rather limited given the recency of their entry into the political arena and the small percentage of officeholders which they comprise (less than 1 percent of all officeholders in the United States). Women generally hold between 5 and 7 percent of the nation's elective offices, and Black women hold 12 percent of the offices held by Blacks. Obviously, Black women have been more successful within their racial subgroup than have white women in their subgroup. However, among all adult women in the United States, Blacks make up about 11 percent; and among women office-holders, Black women constitute from less than 1 percent to about 6 percent of the offices as reported by the Center for the American Woman and Politics in 1976.

Most prominent among Black elected officials are the four women who have served in the United States House of Representatives. Shirley Chisholm was the pioneer, elected to office in 1968, and still continues that

service through reelections in 1970, 1972, 1974, 1976, and 1978. Barbara Jordan, Yvonne Braithwaite Burke, and Cardiss Collins were elected in 1972, 1972, and 1973, respectively. Ms. Jordan chose not to seek reelection in 1978 after three terms, and Ms. Burke chose not to make a 1978 reelection bid after equal tenure, reducing the cadre to two. The former has become a university professor and the latter ran unsuccessfully for the post of attorney-general in California and is now on the governing board of the state university system. Ms. Collins gained office after the death of her husband while he was serving in the House. Only Shirley Chisholm and Barbara Jordan have chosen to write accounts of their political careers. The absence of a significant body of literature by and/or about Black women politicians has prevented any synthesis of findings regarding their success patterns, role perceptions, ambitions, and similar aspects of their experiences.

In a 1974 study of Black women state legislators (Prestage, 1977), an effort was made to develop a profile of one group of these women office-holders. This effort included an exploration of their socioeconomic backgrounds, family situations, prelegislative political experiences, perceptions of their offices, the nature of their legislative work, and their attitudes on some policy issues. The sample included 32 of the 35 Black women who served in state legislative bodies between 1970 and 1974. Some very interesting findings emerged from that study.

The profile of Black women legislators which evolved from the study was a woman entering the legislature at age 40 or above with roots mostly in the urban South but elected mostly in urban areas of midwestern states where Black men have also been successful in their bids for legislative seats. She is comparatively well-educated, with work experience outside the home in a multiplicity of occupations, presently or once married, from families in which no member had held elective office, and without significant prior political experience in the traditional sense. Despite limited or no prior experience, the Black woman legislator is confident in her ability to bring to legislative bodies special expertise and experiences that will be significant in her work there. Generally, the legislators were optimistic about the future of both Blacks and women in the political arena. They were supportive of women's liberation but at a very low-priority level. In the main, these are women who regard supportive attitudes of husbands and children as necessary to their political involvement.

Over the past decade, all women have increased their interest in and bidding for elective office. Black women have been no different. If the current trend continues, Black women officeholders are likely to increase and to come from a more diversified geographic base. It is hoped that an expanded participation pattern will lead to expanded study and research, especially research with a comparative orientation along race and sex lines.

SUMMARY AND CONCLUSIONS

The political experiences of Black women in America have been reflective of their status of dual oppression. Responses of Black women to this double burden have varied between violence and nonviolence, traditional and nontraditional political activity, apathy and activism. While both racism and sexism have conditioned Black women's political experiences, racism seems to have been the prime determiner of their political status in the American system.

Essentially, on the basis of available data, the five major contentions on which this study was based would seem to be confirmed.

Studies focusing on the political behavior of the Black woman have been very limited. Especially lamentable is the absence of works authored by Black women who have been active in the political arena at the elite level. Special attention to efforts to increase this body of literature might be an appropriate challenge to these women and to social science scholars generally.

REFERENCES

Aptheker, H. [ed.] (1969) A Documentary History of the Negro People in the United States. New York: Citadel Press.

Bennett, L., Jr. (1960) Pioneers in Protest. New York: Penguin.

Blassingame, J. (1972) The Slave Community: Plantation Life in the Antebellum South. New York: Oxford University Press.

Bryce, H. and A. Warrick (1973) "Black women in electoral politics." Focus 1.

Chafe, W. (1977) Women and Equality. New York: Oxford University Press.

Clayton, E. T. (1964) The Negro Politician: His Success and Failure. Chicago: Johnson.

Davis, A. (1971) "Reflections on the Black woman's role in the community of slaves." The Black Scholar (December).

Franklin, J. H. (1974) From Slavery to Freedom. New York: Alfred A. Knopf.

Ladner, J. (1972) Tomorrow's Tomorrow: The Black Woman. New York: Doubleday.

Lansing, M. (1973) "The voting patterns of American Black women." Presented at the 1973 meeting of the American Political Science Association, New Orleans.

Lerner, G. [ed.] (1977) The Female Experience: An American Documentary. Indianapolis: Bobbs-Merrill.

Matthews, D. A. and J. W. Prothro (1966) Negroes and the New Southern Politics. New York: Harcourt Brace Jovanovich.

Pierce, J. et al. (1973) "Sex differences in Black political beliefs and behaviors." American Journal of Political Science 17: 422–430.

Prestage, J. L. (1977) "Black women state legislators: a profile," in M. Githens and J. L. Prestage, A Portrait of Marginality: The Political Behavior of the American Woman. New York: David McKay.

Rogers, J. A. (1972) World's Great Men of Color, Vol. 1. New York: Macmillan.

PART IV
SOCIAL PSYCHOLOGY OF THE BLACK WOMAN

Rodgers-Rose studies the relationship between Black men and women. She maintains that it is this relationship between Black men and women which determines how Blacks will survive in this society. Rose discusses myths of the roles and relationships between Black men and women, and properties in male-female relationships—conversation, monetary exchanges, sex, and quality. The latter property is analyzed in detail. Based on interviews with 49 Black women and 39 Black men, the study found that there were distinct differences between age and sex groups in the qualities wanted in an intimate relationship. The author points out the importance of being able to know what qualities are wanted in intimate relationships.

Christine Carrington looks at depression in Black women from a theoretical perspective. She tells us that women are placed in more vulnerable situations for becoming depressed than men: They are socialized to live for and through others. Thus, in studies of depressed women, we find that they are highly conscious of their roles as mothers and homemakers; reluctant to express hostility, they conform in order to gain approval. Carrington tells us that depressed women also suffer from loss of self-esteem. Further, in her clinical work with depressed Black women, she found that they expressed strong needs to nurture and "take care of" others in their lives. They also felt guilt when engaging in self-enhancing activities. The author points out the great need for further research in the area of depression in Black women. There is a need to know what the factors are that account for depression in Black women in order to help them remain mentally healthy.

Delores Aldridge writes that suicide among Black women has drawn attention because it is increasing. However, she reveals that less than 500 of the 23,000 suicides committed in 1970 were carried out by Black women. The increase in Black female suicide may be due to the increase in the overall number of Black females in the population. Suicide is not, Aldridge claims, by far one of the major health problems facing Black women; she maintains that while all problems

facing Black women need to be dealt with, there is a danger in focusing on dramatic, comparatively infrequent problems like suicide and paying little attention to less dramatic, but more frequent and chronic problems. Black women still have the lowest suicide rate—lower than white men, white women, and Black men. The author suggests that the data do not justify the excitement over suicide among Black women.

Willa Hemmons contends that the Black woman's propensity to embrace or reject the women's liberation movement is a function of what her society has made of her and she of it. Hemmons raises the question: "How do Black females react to a call for unification with a group which heretofore has been a source of subjugation and humiliation for them?" Her study consists of 82 women, 45 Black and 37 white. The findings reveal that, contrary to expectations, Black women embraced the precepts of the women's movement more often than white women. Although the differences are not significant, one would have expected Black women to have negative attitudes toward the women's movement. Also, she found that Black women more often than white women embraced the concept of the traditional "feminine" role. However, this did not decrease the percentage of Black women who held positive attitudes toward the women's movement. The author concludes that Black women have not joined the women's movement because of differences in priorities; rather, they are concerned about concrete conditions of life—racial oppression, massive unemployment, poor housing, and poor education. They will join the women's movement to the extent that these issues are addressed.

Geraldine Wilson brings us full circle in the final chapter. She sums up all that has been said by putting the Black contemporary woman back into the historical perspective of her African heritage. Wilson maintains that Black women have been and continue to be a part of the community process of consideration, reflection, and evaluation. In addition, Black women have been moved in each generation and currently to respond in various ways to the debilitating, constricting, distorted images of them created by American society. The struggle continues between who we are and what "they" say we are. The question becomes, "How can self/group be actualized under a system of colonialism?" Wilson avers that the various portraits of African women give us a broad perspective of characteristics from which to draw our womanhood. These portraits show women who were not only mothers and wives, but also intellectual companions, traders, power brokers, poetesses, rulers, women in love, resisters, culture keepers, and soldiers. The author concludes that the process of con-

sideration, reflection, and evaluation suggests that we do not need all the characteristics of our African and African-American foremothers. Each of us can choose a few to complement the ones we have. Our self/group actualization must include some of these characteristics.

15

DIALECTICS OF BLACK MALE-FEMALE RELATIONSHIPS

La Frances Rodgers-Rose

One of the most complex and pressing issues in the struggle for Black survival is centered in and grows out of the relationship between Black men and women. This relationship, in the final analysis, determines how they support each other as men and women and how they will raise their children.

The relationship between Black men and women does not take place in a vacuum. They act out their behavior in a society which has clearly defined role behavior. Men are supposed to be aggressive, women passive. With such a definition of role behavior, based on inequality rather than equality, the relationship between men and women cannot help but be tenuous. Moreover, in any male-female relationship, there are the dialectics of creation and criticism which must take place in an environment of open discussion and sociability (Foote, 1953). This chapter will attempt to look at some of the issues that confront Black men and women as they interact in a process of criticism and creation. Specifically, I will discuss some myths about Black men and women and properties of male-female relationships.

MYTHS OF THE ROLES AND RELATIONSHIPS BETWEEN BLACK MEN AND WOMEN

If a situation is defined as real, then it is real in its consequences.

W. I. Thomas

Most of what we know about Black male-female relationships is a result of the biased research conducted by white social scientists. For example, we

hear that in order for Black people to succeed, Black women must stand behind Black men—Black women must step back and let the Black man lead. The assumption, based on biased work of white researchers, is that Black women have led their men. But any objective look at Black history will show this has never been the case. Equality between Black men and women has been misrepresented as female dominance. What has happened is that some Black men and women have internalized the myths of white social scientists, and these definitions of situations have become real in their consequences.

Another myth that some Blacks have internalized is that the Black male is shiftless, that he does not want to work, that he would rather hang on the corner than look for a job. Objective reading of Black history shows the efforts that Black men have made to find jobs—jobs that paid very little and were demeaning in nature. Yet another myth in this country is that Black women earn more money than Black men, that Black women can get jobs when Black men cannot. U.S. Census Bureau data show that this is not true, nor has it ever been true. In fact, Black women are the lowest paid group in the country: They make less money than white men and women and Black men (Ferris, 1971: 141). Black women are, in general, the most unemployed and underemployed group. (1971: 302–320) A related myth is that Black women are generally more educated than Black men, and historically this has been the case. However, today this is no longer as true (1971: 23).

I am suggesting that a great deal of what is happening to Black men and women as they relate to one another is a consequence of definitions based on stereotypes of Blacks or biased research, and not from the reality systems of Black men and women. Before we can move toward defining Black male and female relationships, we must expose false definitions that grow out of thought systems which serve to divide and conquer Black people. To the extent that we are unaware of these false reality systems, we will believe them, define them as real, and, as W.I. Thomas suggested, they will become real in their consequences. For example, the Black woman is seen as having certain qualities and the Black man is seen as lacking these qualities. The Black woman is seen as needing little protection either physically or mentally, while the Black man is seen as needing both physical and mental protection—he lacks the ability to survive in the outside world. The Black woman must protect him. Further, the Black woman is seen as a dominating matriarch: She emasculates the Black man and his character becomes "feminine" in nature. He does not know what to do unless he is told by the woman.

Growing out of this myth is the further notion that most Black households are headed by women, that the male is absent from the home, and that Black children do not have male models. The reality of the situation is that two-thirds of all Black households do have both male and female present. In

some households, the male is not present to be counted by the census taker. He may be absent for strategic purposes—for example, a needy mother cannot get welfare if there is a man in the home; aid is given only to dependent children, not to struggling intact families. Moreover, white social scientists ignore the fact that Black women have boyfriends, fathers, brothers, and uncles who can and do serve as role models.

Finally, the Black man and woman are defined as being sexually aggressive. White mythology has asserted that both the Black male and female are anxious to have sexual relationships with whites. The female is defined as loose in her morals and out to sell her body to the highest bidder; she wants to establish meaningless relationships with white men at the expense of the Black man. Black men seek sexual relationships with white women. Again, when we unmask the myth, we find that less than two percent of all marriages in this country are between Black and white people. When Blacks are asked to rank the priority of things they want in this country, interracial marriage is ranked last, with economic and political equality ranked first.

As can be seen from the foregoing discussion, it is easy for Black people to internalize and use such false definitions of themselves. To the extent that an individual has internalized these definitions, his/her mode of interaction with the opposite sex will be affected. Therefore, when a relationship is not going well, the individual will resort to such negative definitions and interpretations as "Black women are too independent," "Black men are too possessive," "Black men's feelings are too easily hurt," "Black women are evil," "Black women argue too much," "Black men are weak," "Black men are castrated," and "Black women don't appreciate good treatment." Moreover, these negative definitions have already been supplied and are readily available to the actor. These ready-made definitions keep Black men and women from looking inward to what they contribute to the outcome of a particular relationship. One can easily blame the other. Such myths, then, have functioned to divide Black men and women, and they have served as rationalizations for the status quo. Myths keep the individuals focused on criticism rather than on the interplay between the critical and the creative aspects of any male-female relationship.

PROPERTIES OF
DIALECTIC RELATIONSHIPS
BETWEEN BLACK MEN AND WOMEN

Sociologists have in many cases failed to study the depth of interpersonal relationships between the groups of people they analyze. They have, instead, tended to study the surface areas—those aspects which can be easily defined, codified, and discussed. We know a great deal about financial and sexual aspects of marriage, but we know much less about what attracts one

individual to another, what people are looking for in intimate relationships, and what qualities make for viable dialectic relationships. Likewise, we find that men and women are not socialized to look for nor can they articulate their needs in terms of qualities wanted. We are taught to pay more attention to the outward characteristics of a person: education, occupation, and income. Recently, sexual compatibility has been included in these characteristics. Thus, we find people in relationships not realizing what they want from that relationship.

QUALITIES IN
MALE-FEMALE RELATIONSHIPS

This chapter is based on interviews of 49 Black women and 39 Black men. The data were collected in April and May 1975.[1] Each person was asked five questions: (1) What qualities do you want in a man/woman with whom you are having an intimate relationship? (2) What behavior/action would show the above qualities? (3) What qualities do you dislike/hate in a man/woman that would make you dissolve that relationship? (4) What behavior/action would show these negative qualities? (5) If you were dating steadily, how often would you like to see that person?[2] The responses to each of these questions were recorded verbatim. Each response was then content analyzed. Background data on age, education, occupation, and marital status were also gathered. Table 1 shows the distribution of males and females by age groups on specific characteristics. As one can see from Table 1, there is a wide range and a similar age span for males and females. The educational level is above the national norm. Most are single or separated/

TABLE 1 Distribution of Males and Females by Age Group on Specific Status Characteristics

| | Females | | Males | |
Characteristics	Under 30 Years (N=24)	Over 30 Years (N=25)	Under 30 Years (N=22)	Over 30 Years (N=17)
Mean Age	22.8	42.0	22.0	39.0
Mean Education	13.6	14.4	14.8	15.3
Dates/Week	4.0	2.2	3.4	3.4
Marital Status				
Single	16	1	16	5
Married	3	9	6	8
Separated	3	4	0	2
Divorced	1	7	0	2
Widowed	1	3	0	0
Occupation				
Professional	8	13	8	11
Clerical/Skilled	5	6	5	3
Unskilled	0	5	1	2
Student	7	0	5	1
Housewife	2	0	0	0

divorced. Only 30 percent of the sample is presently married, and the professional category is overrepresented in the sample.

The following results were indicated for males and females. In the area of positive qualities, one may note from Table 2 that females under 30 years of age say that the qualities they most want in a man are understanding, honesty, and a person who is warm and gentle. These are the *global* qualities; that is, qualities showing the greatest frequencies. Only qualities mentioned by at least five persons are listed in the tables which follow; however, many other qualities were given. The aim of this study was to show those qualities that have some kind of consensus among age and sex groups. Other qualities mentioned by women under 30 years of age were intelligence, sense of humor, stability, and awareness of self. Table 2 for women over 30 indicates that the most outstanding desirable quality was honesty. This was the only global quality listed, while for women under 30, honesty and understanding had the same frequency. There is a greater consensus among females than males on the positive qualities desired in a person with whom they are having an intimate relationship. For men under 30, the quality having the greatest frequency was independence—a characteristic which men traditionally do not like to see in women. Men over 30 show a global quality of good manners: for example, they mention "acts like a lady," "has good manner of speech," and "the way she carries herself in public." This quality, proper manners, indicates the more traditional way of viewing women. Also, in viewing Table 3, one may note that males over 30 list "character" traits of the individual rather than the "affective" qualities of the person.

When we turn to how these positive qualities are viewed in behavior, the picture changes. Here we find that women under 30 do not ask for a behavioral quality paralleling the qualities of understanding and honesty; rather, they say the person should be respectful and well-groomed. One must raise the following question: Is there an incongruency between stating that the most desired quality is understanding and stating that, behaviorally, one wants respect and a person who is well-groomed? One refers to effect— understanding—and the other talks about character traits—respectful. In general, males and females in this sample found it more difficult to give behavioral/actions indicators than general qualities. And in several cases there were people who listed general qualities as behavior/action. It would seem that this is the area in which one needs to be able to identify the action that shows love. As Foote (1953) suggested, love is known by its works. It is an activity, a process. It is one thing to articulate qualities, but an entirely different thing to know that a certain behavior/action is love.

To summarize, for women over 30 years we find a consistency in the qualities wanted, "honesty," and the behavior indicated is "open communication." Women over 30 indicate affective behavioral qualities, while

TABLE 2 Positive Qualities Wanted in a Male by Black Females

I. Black Females Under 30 (N=24)

A. Global Qualities	B. Behavioral Global Qualities
1. Ideas	1. Ideas
Aware of Self (6)	Specific goals (7)
Black identity (6)	
Independent (6)	
	2. Character
2. Affectivity/Character	Respectful (11)
Understanding (14)	Well-groomed (11)
Honesty (14)	
Warm/gentle (10)	3. Affective
	Good lover (7)
3. Character I	Responds to my needs (7)
Intelligent (8)	Encourages me (6)
Sense of humor (8)	
Positive self-concept (8)	
Stable (8)	
4. Character II	
Nice looking (7)	
Generous (7)	

II. Black Females Over 30 (N=25)

A. Global Qualities	B. Behavioral Global Qualities
1. Affectivity	1. Affectivity
Understanding (9)	Sharing (6)
Aware of my needs (9)	Kind to others (6)
Affectionate (8)	
Aware of others (7)	2. Affectivity
	Sexually compatible (6)
2. Character I	
Honesty (16)	3. Affectivity
	Open communication (15)
3. Character II	
Dependable (6)	4. Affectivity
Down-to-earth (7)	Takes me where he goes (10)
Handsome (5)	Gives self according to
	my needs (11)
4. Character III	
Intelligent (10)	
Ambitious (11)	

women under 30 indicate character traits. For men in both age groups there is also a consistency of qualities and behavior. The males under 30 say they want a woman who is "calm"—cool in her behavior, one who is doing something to better herself, such as going to school or being employed. These are behavioral indicators of independence. Males over 30 say they want a woman who has "proper manners"; behaviorally, the global quality is "knowing when to listen," an indicator of proper manners.

In general, there seems to be a distinct difference among the four age groups on the qualities wanted in an intimate relationship. This is true

TABLE 3 Positive Qualities Wanted in a Female by Black Males

═══

I. Black Males Under 30 (N=22)

A. Global Qualities B. Behavioral Global Qualities
 1. Affectivity
 Loving/tender (13) Takes care of my needs (6)
 Understanding (10) Sexually compatible (6)
 Considerate (6)
 Faithful (6) 2. Character I
 Manners (9)
 2. Character I Calm (10)
 Independent (17) Going to school/employed (9)

 3. Character II 3. Character II
 Honest (13) Independent action (7)
 Clean and neat (11)
 Beautiful (7)

 4. Character III
 Strong self-concept (10)
 Aware of self (8)
 Intelligent (11)

 5. Character IV
 Open-minded (9)
 Respectful of others (5)

───

II. Black Males over 30 (N=17)

A. Global Qualities B. Behavioral Global Qualities
 1. Affectivity/Character 1. Affectivity
 Understanding (8) Sexually compatible (4)
 Honest (8) Kissing, holding,
 Sensitive (7) responding to me (4)
 Tender and kind (7)
 2. Character I
 2. Character I Knowing when to listen (9)
 Proper manners (17)
 3. Character II
 3. Character II Active in sports (4)
 Clean and neat (8)
 Independent (8)
 Intelligent (5)

 4. Character III
 Loyal (7)
 Dependable (6)
 Open and truthful (6)

───

particularly for the global qualities. However, in looking at the various qualities wanted, there is indeed overlap. But the significant point is the priority given the different qualities. It would seem that Black males and females differ among themselves and also within groups. In fact, a review of Tables 2 and 3 seems to suggest that females over 30 have more in common with males under 30, and that females under 30 have more in common with

TABLE 4 Negative Qualities Disliked in Males by Black Females

I. Black Females Under 30 (N=24)	
A. Global Qualities	B. Behavioral Global Qualities
1. Character I	1. Affectivity
Dominant (14)	Sexually incompatible (5)
Selfish (14)	
Dependent (12)	2. Character I
2. Character II	Lying (13)
Unfaithful (8)	
Possessive (8)	3. Character II
Dishonest (6)	Physical violence (9)
	Stay-at-home (8)
3. Character III	Disrespectful (8)
Ignorant (7)	Never show/late (8)
Immature (7)	Lazy (7)
	Loudmouth (5)
4. Character IV	Drunken (5)
No patience (7)	
No self-respect (5)	
II. Black Females Over 30 (N=25)	
A. Global Qualities	B. Behavioral Global Qualities
1. Character I	1. Character I
Immature (11)	Physically violent (13)
Dishonest (10)	
	2. Character II
2. Character II	Drunken (9)
No self-respect (6)	
Dependent (5)	3. Character III
	Other women (7)
3. Character III	
Ignorant (5)	4. Character IV
Selfish (5)	Verbal abuse (5)
	Never show/late (5)
	Gossipy (5)
	Jealous (5)

males over 30. A larger sample is needed before we can be sure of this possible relationship.

When we turn to the negative qualities and behaviors disliked in a man/woman, we find that women were able to list more negative qualities disliked in males than vice versa. Whereas females have at least seven negative qualities, males only have four areas of negative qualities. Females under 30 say they dislike a male who dominates or who is selfish and dependent, while females over 30 say they dislike a male who is immature and dishonest. Here again we see a consistency in females over 30 in the things they like in a male ("honesty") and the things they dislike in a male ("dishonesty"). This consistency across positive and negative qualities is only true for this age and sex group. For males under 30, the qualities disliked—again, similar to females over 30—were dishonesty and a person who is unaffectionate. Males over 30 showed less of a consensus than any other age or sex group.

TABLE 5 Negative Qualities Disliked in Females by Black Males

I. Black Males Under 30 (N = 22)	
A. Global Qualities	B. Behavioral Global Qualities
1. Affectivity/Character	1. Character I
Unaffectionate (11)	Unclean (8)
Dishonest (11)	Cheats (8)
2. Character	2. Character II
Selfish (8)	Lying (6)
Irresponsible (8)	Disrespectful (5)
Poor outlook on life (8)	Nags (5)
II. Black Males Over 30 (N = 17)	
A. Global Qualities	B. Behavioral Global Qualities
1. Character	1. Character I
Disrespectful (5)	Lying (9)
Rigid (5)	
Irresponsible (5)	2. Character II
Dishonest (5)	Curses (6)
	Drunken (5)
	Unclean (5)

The highest frequency for any quality disliked was listed by only five people. Here they list disrespectfulness, rigidity, irresponsibility, and dishonesty. Although listed as global qualities, these are not global in the same sense as other tables showing global qualities. Looking at the behavioral qualities disliked, we find that males over 30 and females under 30 both mention lying as the behavior most disliked. For women over 30, physical violence is most disliked, and for males under 30 it is a person who is unclean and one who cheats (runs around with other men).

It is interesting to note that in listing the qualities liked or the qualities disliked in intimate relationships the traditional variables that sociologists use in studying marriage and the family are not shown. That is, in the global qualities shown no one mentioned occupation, income, education, or sexual compatibility. But rather, qualities dealt more with the inner person—his/her character or the affective aspects of the person.

This preliminary study indicates that if we are to begin to understand the relationship between Black men and women, or for that matter women and men in general, we must move beyond the outer status of the person to the inner qualities of the person. When given an open-ended, unstructured question on the qualities liked and the qualities disliked in intimate relationships, this sample of Black men and women showed that they are concerned with qualities such as understanding, honesty, warmth, dress, respectability, open communication, sharing, independence, listening capability, dominance, selfishness, lying, unfaithfulness, immaturity, physical violence, lack of affection, and uncleanliness.

Research along this line will add to our knowledge of the relationship

between Black men and women. Further, I feel that what is true for Black men and women will also be true for men and women in general. That is, people are concerned with intangible, hard-to-analyze qualities in a relationship rather than outward status variables. It remains to be seen whether Blacks and other racial groups will show the same diversity as this sample, or whether a larger, more random sample will produce the same results between Black males and females. I am presently pursuing the latter question of a larger, more random sample of Black men and women.

I have attempted to show in this brief research study that sociologists who have studied relationships between males and females have failed to study the qualities wanted in persons with whom intimate relations are established. Instead, they have studied the outward status characteristics of income, education, occupation, and sexual compatibility. They have studied the first three properties of intimate relationships—conversation, monetary exchange, and sex—but they have paid little attention to the fourth property of the qualities wanted in a relationship. Further, we know very little about what men and women expect behaviorally from each other. A content analysis of 88 interviews with Black males and females show that they are concerned with inner qualities of the individual rather than outward qualities. Even the quality of sexual compatibility does not rank as high as the qualities of honesty, understanding, independence, and proper manners. Additional research along these lines would add to our limited knowledge of Black male-female relationships, and perhaps to male-female relationships in general. Further research in this area will begin to lead the way toward the kinds of variables that must be included in any study which seeks to understand the dialectics of male-female relationships. It is imperative that we begin to study the criticism and creativity in male-female relationships.

NOTES

1. A search and referral method was used to obtain the sample. The research initially made contact with a small number of Black men and women. They in turn were asked to refer the interviewer to another person.

2. Interviews ranged from 45 minutes to two hours.

REFERENCES

Alexander, T. and S. Sillen (1972) Racism and Psychiatry. New York: Brunner-Mazel.
Anderson, C. S. and J. Himes (1969) "Dating values and norms on a Negro college campus." Marriage and Family Living 21: 227–229.
Bambara, T. C. (1972) "How Black women educate each other." Sexual Behavior 2: 12–13.
Beal, F. (1969) "Double jeopardy: to be Black and female." New Generations 5: 23–28.

Bernard, J. (1966a) "Marital stability and patterns of status variables." Journal of Marriage and the Family 28: 421–439.

————(1966b) Marriage and Family Among Negroes. Englewood Cliffs, NJ: Prentice-Hall.

Billingsley, A. (1966) Black Families in White America. Englewood Cliffs, NJ: Prentice-Hall.

————(1969) "Family functioning in the low-income Black community." Social Casework 50: 563–572.

Blood, R. and D. Wolfe (1960) Husbands and Wives: The Dynamics of Married Living. New York: Free Press.

Blumer, H. (1940) "The problem of the concept in social psychology." American Journal of Sociology 45: 707–719.

————(1969) Symbolic Interactionism: Perspective and Method. Englewood Cliffs, NJ: Prentice-Hall.

Bond, J. and P. Perry (1974) "Is the Black male castrated?" in T. Cade (ed.) The Black Woman: An Anthology. New York: Signet.

Bradburn, N. (1969) "Working wives and marriage happiness." American Journal of Sociology 74: 392–407.

Burchinal, L. (1964) "The premarital dyad and love involvement," in H. T. Christensen (ed.) Handbook of Marriage and the Family. Chicago: Rand McNally.

Burgess, E. and P. Wallin (1953) Engagement and Marriage. Chicago: J. B. Lippincott.

Byrne, D. (1961) "Interpersonal attraction and attitude similarity." Journal of Abnormal and Social Psychology 62: 712–715.

Cooley, C. H. (1902) Human Nature and the Social Order. New York: Scribners.

Coser, R. L. [ed.] (1964) The Family: Its Structure and Functions. New York: St. Martin's Press.

Deutscher, I. (1973) What We Say/What We Do: Sentiments and Acts. Glenview, IL: Scott, Foresman.

Donnelly, M. (1963) "Towards a theory of courtship." Marriage and Family Living 25: 290–293.

Drake, S. C. and H. Cayton (1945) Black Metropolis. New York: Harcourt Brace Jovanovich.

DuBois, W. E. B. (1903) The Souls of Black Folk. Chicago: A. C. McClury.

Edwards, G. (1963) "Marriage and family life among Negroes." Journal of Negro Education 32: 451–465.

Farley, R. (1971) "Family stability: a comparison of trends between Blacks and whites." American Sociological Review 36: 1–17.

Foote, N. (1953) "Love." Psychiatry 16: 245–251.

Frazier, E. (1939) The Negro Family in the United States. Chicago: University of Chicago Press.

Ferris, A. L. (1971) Indicators of Trends in the Status of American Women. New York: Russell Sage.

Geismar, L. (1962) "Measuring family disorganization." Marriage and Family Living 24: 51–56.

Glaser, B. and A. Strauss (1967) The Discovery of Grounded Theory. Chicago: AVC.

Glick, P. and A. Norton (1971) "Frequency, duration and probability of marriage and divorce." Journal of Marriage and the Family 33.

Goode, W. (1956) After Divorce. New York: Free Press.

————(1959) "The theoretical importance of love." American Sociological Review 24: 38–47.

Gorer, G. (1948) The American People: A Study in National Character. New York: W. W. Norton.

Gouldner, A. (1962) "Anti-minotaur: the myth of value free sociology." Social Problems 9: 199–213.

Habenstein, R. [ed.] (1970) Pathways to Data: Field Methods for Studying Ongoing Social Organizations. Chicago: AVC.

Hannerz, U. (1969) "The roots of Black manhood." Transaction: 6: 12–21.

Hare, N. (1964) "The frustrated masculinity of the Negro male." Negro Digest 14: 5–9.

Harper, R. (1958) "Honesty in courtship." The Humanist 18: 103–107.

Harris, A. O. (1974) "Dilemma of growing up Black and female." Journal of Social and Behavioral Sciences 20: 28–40.

Hernton, C. (1965) Sex and Racism. New York: Grove Press.

_____(1974) Coming Together. New York: Random House.

Herr, D. (1958) "Dominance and the working wife." Social Forces 36: 341–347.

_____(1963) "The measurement and bases of family power." Marriage and Family Living 25: 133–139.

Herskovitz, M. (1941) The Myth of the Negro Past. New York: Harper & Row.

Herzog, E. (1966) "Is there a 'breakdown' of the Negro family?" Social Work 11: 3–10.

Hewitt, L. (1958) "Student perceptions of traits desired in themselves as dating and marriage partners." Marriage and Family Living 20: 349–360.

Hill, R. (1945) "Campus norms in mate selection." Journal of Home Economics 37: 554–558.

Hill, R. (1972) The Strengths of Black Families. New York: National Urban League.

Hyman, H. and J. Reid (1969) "Black matriarch reconsidered: evidence from secondary analysis of sample survey." Public Opinion Quarterly 33: 346–354.

Jackson, J. (1971) "But where are the men?" The Black Scholar 2: 30–41.

_____(1973) "Black women created equal to Black men." Essence (November): 56–72.

_____(1974) "Ordinary Black husbands: the truly hidden men." Journal of Social and Behavioral Sciences 20: 19–27.

Johnson, C. S. (1934) Shadow of the Plantation. Chicago: University of Chicago Press.

Ladner, J. (1972) Tomorrow's Tomorrow: The Black Woman. New York: Doubleday.

Kamii, C. and N. Radin (1967) "Class differences in the socialization practices of Negro mothers." Journal of Marriage and the Family 29: 302–310.

King, C. (1954) "The sex factor in marital adjustment." Marriage and Family Living 16: 237–240.

King, K. (1967) "A comparison of the Negro and white family power structure in low-income families." Child and Family 6: 65–74.

Lerner, G. (1972) Black Women in White America. New York: Pantheon.

Lewis, H. (1955) Blackways of Kent. Chapel Hill: University of North Carolina Press.

_____(1965) "Child rearing among low-income families," L. Ferman et al. (eds.) Poverty in America. Ann Arbor: University of Michigan Press.

_____(1967) "Culture, class, and family life among low-income urban Negroes," in A. Ross and H. Hill (eds.) Employment, Race and Poverty. New York: Harcourt Brace Jovanovich.

Liebow, E. (1967) Talley's Corner. Boston: Little, Brown.

Mack, D. (1971) "Where the Black matriarchy theorists went wrong." Psychology Today 4: 86–88.

Mannheim, K. (1936) Ideology and Utopia. New York: Harcourt Brace Jovanovich.

Maxwell, J. W. (1968) "Rural Negro father participation in family activities." Rural Sociology 33: 80–93.

Mead, G. H. (1934) Mind, Self and Society. Chicago: University of Chicago Press.

Miller, S. M. et al. (1965) "A critique of the non-deferred gratification pattern," in L. Ferman et al. (eds.) Poverty in America. Ann Arbor: University of Michigan Press.

Mills, C. W. (1940) "Methodological consequences of the sociology of knowledge." American Journal of Sociology 46: 316–330.

———(1959) The Sociological Imagination. New York: Oxford University Press.

Morgan, R. [ed.] (1970) Sisterhood is Powerful. New York: Vintage Books.

Moynihan, D. (1965) The Negro Family: The Call for National Action. Washington, DC: Department of Labor.

Myers, L. (1975) "Black women: selectivity among roles and reference groups in maintenance of self-esteem." Journal of Social and Behavioral Sciences 21: 39–47.

Nye, F. I. (1957) "Child adjustment in broken and in unhappy homes." Marriage and Family Living 19: 356–361.

Prescott, D. (1952) "The role of love in human development." Journal of Home Economics 44: 73–176.

Parker, S. and R. Kleiner (1966) "Characteristics of Negro mothers in single-headed households." Journal of Marriage and the Family 28: 507–513.

———(1969) "Social and psychological dimensions of the family role performance of the Negro male." Journal of Marriage and the Family 31: 500–506.

Prescott, D. (1952) "The role of love in human development." Journal of Home Economics 44: 73–176.

Rainwater, L. (1966) "Crucible of identity," in T. Parsons and K. Clark (eds.) The Negro American. Boston: Beacon.

Reid, I. (1972) Together Black Women. New York: Emerson Hall.

Reiss, I. (1960) Premarital Sexual Standards in America. New York: Free Press.

Scanzoni, J. (1971) The Black Family in Modern Society. Boston: Allyn & Bacon.

Schulz, D. (1969) Coming Up Black: Patterns of Ghetto Socialization. Englewood Cliffs, NJ: Prentice-Hall.

Staples, R. (1970a) "The myth of the Black matriarchy." The Black Scholar 1: 2–9.

———(1970b) "Educating the Black male at various class levels for marital roles." The Family Coordinator 30: 164–167.

———(1971) The Black Family: Essays and Studies. Belmont, CA: Wadsworth.

———(1972) "The sexuality of Black women." Sexual Behavior 2: 4–15.

———(1973) The Black Woman in America. Chicago: Nelson-Hall.

Stokes, G. (1968) "Black woman to Black man." Liberator 8: 17–19.

Sullivan, H. S. (1953) The Interpersonal Theory of Psychiatry. New York: W. W. Norton.

16

DEPRESSION IN BLACK WOMEN:

A Theoretical Appraisal

Christine H. Carrington

In studying emotional disorders, particularly depression, there is a need to understand the impact of societal values on the minds and emotions of all members of that society. Members of minority groups who, by definition, are peripheral to mainstream societal activities tend to be affected by the dynamics of that society differently than are majority group members. Black women in America are in a state of "double jeopardy" (Beal, 1969). In a society predicated on economic, racial, and political hierarchies, Black women are still at the lowest rung of the ladder both economically and politically, resulting in negligible status as a class. Depression seems to have a higher incidence among persons who are in powerless roles in a society and who live under restrictive and constrictive conditions. The link between environmental circumstances and depression seems to be strongly established in psychosocial literature (Fabrega, 1973, 1974).

The literature on depression in women strongly supports the notion that women are more depression-prone than men because of their peculiar status in society. Women are powerless and oppressed as a group, a result of both sexism and traditional role socialization. Primary role designations for women in this society include marriage and family as a primary focus; reliance on a male for sustenance; emphasis on nurturance and life-preserving activities; a ban on the direct expression of aggression, assertion and power; and living for and through others (Altman, 1972: Weissman, 1972; Paykel, 1973; Bart, 1970). Traditional theories of depression have

postulated that women are biologically inferior to men and have depression-prone personalities because of their biological complexities (Freud, 1950). Results of factor analytic and item analytic studies of "attitudes toward self" fail to confirm that depression-proneness is unique to women. However, role designations for women place them in more vulnerable conditions for becoming depressed. Depressed women are highly conscious of their roles as mothers and homemakers and reluctant to express hostility. They verbally endorse high achievement values; they have stereotyped, conventional social values; and they conform in order to gain approval. Significant characteristics of Black women and white women with depressive symptoms are poor self-esteem, preoccupation with failure, dependence on others' good opinions; sensitivity to criticism or rejection by others; and decreased drive in pursuing sources of gratification (Paykel, 1973; Carrington, 1979).

Critical to an examination of depression in Black women is the element of loss of self-esteem (Howze, 1976). In reviewing the family background and personal histories of Black women who were severely depressed and subsequently suicided, Howze found a common thread of "severe blow to self-esteem and security" in these women as small children which placed a heavy toll on the child's psyche through the developing years. Each of the women studied complained about the continuous frustrations they experienced during their developing years in trying to meet their needs for nurturance.

Depressed Black women express strong needs to nurture and "take care of" significant others in their lives—spouses and children. They also feel guilt when engaging in self-enhancing activities, either professionally or personally, that do not directly or indirectly include their families. This sense of guilt is particularly observed in depressed Black women who are upwardly mobile. In striving for fulfillment and self-enhancement, Black women are acutely conscious of labels that have been projected onto them by majority group members and have been reinforced by other Blacks, such as "super woman" and "matriarch." These traditional labels have created and perpetuated exaggerated tensions between Black men and women and have triggered many conflicts within their intimate interpersonal relationships (Bracey, 1971). Depressed women generally are most impaired in intimate interpersonal relations.

Mental health professionals have focused attention on the insidious and debilitating effects of racism on Black women in America. Huth (1971), in reporting the proceedings of a group of 20 leading Black and white psychiatrists and other social scientists in pursuit of some "truths" about racism in mental health, concluded that racism and discrimination have mixed effects on the way children view themselves; they have warped the educational system; they have degraded Black women and have proven emotionally debilitating to whites. Butts (1971), in his treatment of the power motive as

it relates to racism, finds that those possessed of power "need" to subjugate those who are powerless. Chesler (1972) studies the relationship among sex, race, and admission to outpatient psychiatric facilities, and found that adult white men have lower admission rates at all ages than do white women, nonwhite women, and nonwhite men. Nonwhite women had higher admission rates than did any other group. We do not know the extent to which admission rates may be the consequence of socioeconomic status. That is, people with power and money may not need to use the outpatient facilities of public clinics, while the poor are confined to use of these facilities. Black women are lowest in the socioeconomic scale, and this might account for their high admission rates.

The socialization of the Black woman has reinforced in her a sense of having to transcend ordinary reality in order to survive. She faces many hurdles daily in an effort to meet her needs for personal fulfillment. Black women are facing issues for survival in a society that has cast her as a loser. She must continue to fight against the negative image that society projects on her. She must remain strong and continue to show a love of self and a love of her people. For some Black women, there is the task of generating all of the forces within them to repair their damaged self-esteem—the task of "healing their own wounds." Self-hate has to be replaced with self-love, indignity with dignity, depriving love objects with nurturing love objects, feelings of victimization with feelings of power and self-mastery. Black women who suffer from a loss of self-esteem need help in regaining their love of self. Family and friends can serve this function. In addition, there is a genuine need for people who are in the helping professions to become sensitive to the mental health needs of Black women. Psychologists and psychiatrists must become aware of Black lifestyles and Black culture in order to aid Black women specifically and Black people in general in solving their mental health problems.

Black women are socialized, as are their white counterparts, to place primary emphasis on nurturing the significant people in their lives. These nurturing activities are considered priority activities. Along with her nurturing functions, the Black woman is expected to work to help support the family. These role designations are considered necessary for high rewards. Yet, the Black woman is still the lowest-paid worker, held in least esteem, and holds the least power on the economic-social hierarchical ladder. She performs her role well, but she is constantly searching for "the rewards." This imbalance contributes to the sense of hopelessness and despair found in some Black women (Carrington, 1979).

Contemporary theories of depression, especially cognitive theories (Beck, 1976) and social learning theories (Moss and Boren, 1972), seem to capture the depressive Black woman's dilemma more cogently than the

traditional theories of depression. Cognitive theories of depression view "incorrect thinking" as the aggravate in depression. Thoughts are unreasonable and serve no useful purpose at the time, yet the severity of the depression is determined by the individual's allowing herself to sink into the grip of these thoughts, feeling that they can no longer be controlled. As control is relinquished, there is an overwhelming feeling that everything is hopeless. Thoughts of depressed women are typically self-defeating: "I'm a loser; nobody cares about me; no matter what I do, nobody appreciates me."

In a clinical study of depression in middle-class Black women, Carrington (1979) found a thread of early psychological losses in these women resulting from physical and/or psychological separations from one or both parents during the developing years. Most of these women experienced intense psychic pain in attempting to restore these losses. In seeking to identify the source of distress, these women made self-discoveries through therapy that they were still grieving internally over losses they experienced in childhood and had failed, through the years, to restore their sense of wholeness. These results are true for this simple sample of middle-class Black women. We cannot say that depression in working-class Black women would be due to the loss of one or both parents. It may indeed be the case that there are variations in the causes of depression among Black women by social class. There is a need for more clinical research in this area.

Issues surrounding loss and feelings of helplessness and hopelessness in overcoming losses are recurring themes in theoretical and empirical literature on depression (Abraham, 1927; Klein, 1948; Radloff, 1975). Furthermore, the sense of helplessness has been preconditioned by historical experiences of deprivation (Wolfenstein, 1969). Black women are uniquely conscious of their roles in trying to build healthy and stable homes for their families. With their mates, many of them succeed against unbelievable odds. The history of Black people in America continually gives us stories of Black mothers and fathers who have built stable and healthy families. Hill (1972) documents the strengths in Black family life. In studies of depression in Black women, one finds that these women consistently experience intense conflict with their mates. In their efforts to contribute toward the survival of their families, they experience disagreement with their mates. These women are led to a sense of hopelessness and despair. Their greatest problems center on interpersonal relations in the family rather than on the job. The relationship between marital status and depression has been consistently substantiated in psychosocial literature. Within the context of marriage and the family, conflict and tension are high. Depressed married women have self-perceptions of being submissive and weak. Married women working outside the home are generally less impaired than married women who are not employed outside the home (Bullock et al., 1975; Mostow, 1975).

In working with depressed women in therapy, I have found cognitive therapeutic interventions more successful than traditional approaches in helping these women restore their sense of esteem and worthiness. Clinical data of depressed Black women reveal deep feelings of inadequacy and despair. These feelings tend to contradict the actual life experiences of these women, however. Most of the women I have treated clinically are, by external observations, successful. They are in lucrative professions, regarded highly by colleagues and peers, physically attractive, and have positive relationships with peers and colleagues. Yet, they carry deep within themselves seeds of unworthiness and despair. The similarity of findings among depressed Black women and depressed white women highlights the societal contribution to depression in women regardless of race. They are expected to place the needs of others before their own. In order to counteract this socialization process which has fostered a "negative identity" in some women, contemporary therapeutic approaches such as cognitive therapy have proven highly effective.

In treating the depression symptomatology in depressed women using a cognitive model, the clinical practitioner is actively (1) identifying faulty thinking leading to a depressive mood state; (2) examining and evaluating the client's system of logic; and (3) modifying unrealistic and self-defeating cognitions resulting in destructive behaviors (Beck, 1976). Implicit in this model is the assumption that the depressed person has self-perceptions of being a "loser." Consequently, a loss of something of value is viewed as a loss resulting from personal inadequacy. The primary goal of the therapeutic cognitive model is to interrupt the downward spiral of depressive thoughts and to reverse the pattern to include thinking winning thoughts of being strong and masterful, rather than losing thoughts of being weak and powerless. This aim is accomplished through structured mental exercises and, in instances where a behavioral model accompanies the cognitive model, through structured behavioral exercises. It is theorized that the cognitive structure incubates images and that flashbacks of these images trigger emotional counterparts of the images (Moore, 1977). Since loss is associated with most depressions, (that is, actual losses or perceived losses), it can be speculated that the losses experienced by depressed women are typically interpersonal.

A secondary goal of the clinical practitioner is to help the client revivify cognitions of self-mastery and self-control. The role of cognition as a major component of self-control has been clearly supported by studies exploring the relationship between cognition and self-regulation (Moore, 1977; Mischel and Ebbesen, 1970; Epstein and Smith, 1967). A focus on mastery and control along with cognitions affecting the process of mastery and control influence the overall restoration to premorbid levels of functioning.

A study of depression in women—generally and more specifically, Black women—necessitates a study of sociocultural variables affecting women. An exhaustive study of the dynamics and manifestations of depression in Black women would have to include, at all levels, knowledge about the internal and external pressures on the psychophysiological system. The most pervasive external factor operating on Black women is racism. We must understand not only the contemporary functioning of racism on Black women but also the historical functioning of racism. Specifically, we would need to know how racism interferes with the ability of Black women to earn a living, get an education, and help raise their children. Further, we would need to be able to separate those conditions which affect the psychological well-being of Black women; conditions which, on the surface, may not appear to be a consequence of racism but whose root causes are indeed racism. Likewise, we must begin to identify those factors that impinge on Black women which are the consequences of sexism. We need to know what the similarities are in the depressive states of Black and white women. Are there variations in the causes of depression between middle- and working-class Black women? Are some social classes more prone to depression than others?

Finally, we need to systematically analyze the types of interpersonal relations that Black women have among themselves and with Black men. These relationships are crucial to the survival of Black people. We must know the extent to which depression in Black women is a consequence of competition between women rather than cooperation. Are there variations in depression among Black women by the absence or presence of meaningful friendship relations? We also need to know what types of interpersonal relations between Black women and men account for increases in depression among Black women. Are there differences in the depressive states of Black women who have mates and those who do not? What kinds of conflict make for healthy interpersonal relations?

We need to identify the kind of personality characteristics that minimize depression in Black women. Can we find ways to instill these characteristics in those Black women who do not have them? What external and internal factors account for positive self-esteem in Black women? Through the continued research efforts of social scientists, we will begin to answer some of these crucial questions that will help explain depression in Black women. Black women need these questions answered. If they are to remain mentally healthy, they must be aware of the factors that impinge on their psychophysiological well-being. Black women are awakening! They are becoming aware of their needs. They need our help, our support, and our trust.

REFERENCES

Abraham, K. (1927) "The first pregenital stage of the libido" in M. D. Jones (ed.) Selected Paper of Karl Abraham (D. Bryan and A. Strachey, trans.). London: Hogarth Press.

Altman, J. H. (1972) "Identification of personality traits distinguishing depression-prone from non-depression-prone individuals." Doctoral dissertation, Michigan State University.

Beal, F. (1969) "Double jeopardy: to be Black and female." New Generation 5l: 23–28.

Bart, P. (1970) "Depression in middle aged women," in V. Gornick and B. K. Moran (eds.) Women in Sexist Society: Studies of Power and Powerlessness. New York: New American Library.

Beck, A. T. (1976) Cognitive Therapy and the Emotional Disorders. New York: International Universities Press.

Braceu, J. (1971) Black Matriarchy: Myth or Reality? Belmont, CA: Wadsworth.

Bullock, R., C. Siegal, P. Rise, M. Weissman, and E. Paykel (1975) "The weeping wife: marital relations of depressed women." Journal of Marriage and the Family 34: 488–495.

Butts, H. F. (1971) "Psychoanalysis and unconscious racism." Journal of Contemporary Psychotherapy 3: 67–81.

Carrington, C. H. (1979) "A comparison of cognitive and analytically oriented brief treatment approaches to depression in Black women." Doctoral dissertation, University of Maryland.

Chesler, P. (1972) Women and Madness. New York: Doubleday.

Epstein, S. and B. Smith (1967) "Modes and adequacy of resolution of three basic types of cognitive-motor conflict." Journal of Experimental Psychology 74: 264–271.

————(1974) Disease and Social Behavior: An Interdisciplinary Perspective. Cambridge, MA: MIT Press.

Fabrega, H. (1973) "The study of disease in relation to culture." Behavior Science 17: 183.

————(1974) Disease and Social Behavior: An Interdisciplinary Perspective. Cambridge, MA: MIT Press.

Freud, S. (1950) "Mourning and melancholia," in Collected Papers, Vol. 4. London: Hogarth Press and the Institute of Psychoanalysis.

Hill, R. B. (1972) The Strengths of Black Families. New York: Emerson Hall.

Howze, B. (1976) "Black suicide: with some special references to Black women." Presented at the annual convention of the National Association of Black Psychologists, Detroit.

Huth, T. (1971) "Racism and mental health: pursuing truths." Washington Post, May 20: H,1,6.

Klein, M. (1948) "A contribution to the psychogenesis of manic-depressive states," in Contributions to Psychoanalysis. London: Hogarth Press.

Mischel, W. and E. B. Ebbesen (1970) "Attention in delay of gratification." Journal of Personality and Social Psychology 16: 329–337.

Mostow, E. and P. Newberry (1975) "Work role and depression in women: a comparison of workers and housewives in treatment." American Journal of Orthopsychiatry 45: 538–548.

Moore, B. S. (1977) "Cognitive representation of rewards in delay of gratification." Cognitive Therapy and Research 1: 73–83.

Moss, G. R. and J. J. Boren (1972) "Depression as a model for behavioral analysis." Comprehensive Psychiatry 13: 581–590.

Paykel, E. S. (1973) "Life events and acute depressions," in J. P. Scott and E. C. Senay (eds.) Separation and Depression. Washington, DC: American Association for the Advancement of Science.

Radloff, L. S. (1975) "Sex differences in depression: the effects of occupation and marital status." Sex Roles 1: 249–265.

Weissman, M. (1972) "The depressed woman and her rebellious adolescent." Social Casework 53: 563–570.

Wolfenstein, M. (1969) "Loss, range, and repetition." Psychoanalytic Study of the Child 24: 432–460.

17

BLACK FEMALE SUICIDES:

Is the Excitement Justified?

Delores P. Aldridge

Suicide among Black women has drawn considerable attention because it is increasing. But a fact which must not be overlooked is that less than 500 of the 23,000 suicides committed in 1970 were carried out by Black women (U.S. Bureau of the Census, 1974). The numerical count appears to be increasing by about 85 for every five-year time span from 1960 through 1970. But the number of Black women has also increased. Why, then, all the furor? Why all the excitement? Why all the focus on discussion and theory espousal among both lay people and professionals? The print and broadcast media are beginning to give considerable coverage to suicide among Black women. Why at this juncture in time? Suicide is by far not one of the major health problems facing Black women; more suffer from chronic depression and physical ailments than from suicide (U.S. Department of HEW, 1970). There is no question but that there is a need for monitoring and research by Black scholars. Suicide must be dealt with, but within a proper perspective. There is real danger in focusing on dramatic, comparatively infrequent problems before the hard data are assembled and carefully examined. And presently there does not appear that very much of this has been done.

This chapter raises certain questions based on some preliminary findings of existing data regarding Black women and suicide. The presentation should point out factors which suggest that suicide among Black women demands more investigation before the current "craze" is justified.

SUICIDE DEFINED

Theoretically, the act of suicide is a "socially meaningful" act made by a person to communicate something to himself and to others (Douglas, 1968: 383). As a social indicator, suicide characterizes the state of social relationships, the cultural and psychosocial conditions of society. The particular significance attached to a change in the rate of suicide rests upon the theoretical position to which one adheres. If, guided by sociologist Emile Durkheim, one posits that the critical relationship is the degree of integration of the individual in the group, then the state of anomie (normlessness), or egoism, or altruism, or fatalism—whichever is the basic condition— may be considered to be increasing if the rate of suicide increases. If so, the evidence in Table 1 does imply change in these factors where there is an increase in suicidal rates among Black females. Guided by theory, however, the status of Black women in American society suffers less from the dysfunctional consequences of the basic causes of suicides than those of Black males, white males, or white females. Even so, the trend for Black women is moving slowly in an undesirable direction.

PREVALENCE OF SUICIDE

An estimated 23,000 persons in the United States committed suicide in 1970. The number of such deaths has not been below 20,000 since 1961, and the actual toll from suicide is probably higher (U.S. Department of HEW, 1970). Among Black women, less than 500 individuals took their lives in 1970. As an indicator, the suicide rate has the defect of apparently being underreported. The circumstances of death may be interpreted as accidental when actually they were intentional, such as erroneously ingesting poison— a means frequently (30 percent) used by females—or the accidental discharge of firearms, or a motor vehicle accident. Further, the numbers do not include what Karl Menninger (1938) calls chronic or partial suicide, such as the progressive self-destruction seen in continuous psychological depression such as is found among many Black women. Families succeed in hiding a number of genuine suicides. It is estimated that self-destructive impulses and accident-proneness are factors in about half of all nonfatal accidents. Many suicide attempts are never recorded in vital statistics. In many of the cases in which death occurs, weeks or months after the attempt, the death is not recorded as suicide.

Recent suicide rates in the United States have generally been lower than those prevailing in the 1920s and 1930s. In 1921, the rate stood at 12.4 per 100,000; it began increasing in the late 1920s, reaching a peak of 22.1 in 1930, and generally declined thereafter to a low point of 14.5 in 1955. Since 1955 there has been an increase upward with the exception of 1968, when there was a drop from 1965 (U.S. Bureau of the Census, 1974).

The suicide rate in the United States was relatively constant during the 1960s for the overall population, having risen slightly since 1955, when it reached the lowest level in over half a century. The slight increase in the rate in the latter 1950s, particularly in 1958, may be partly attributed to a change in the clerical practice of assigning "self-inflicted" injuries not designated either as suicide or accident to the category "suicide" (National Center for Health Statistics, 1967: 10).

Indeed, there is an increase. However, this might simply be a reflection of clerical changes, as has been the case in dealing with other social problems such as juvenile delinquency. It has been noted time and again that improved means of reporting a phenomenon lead to an apparent increase in rates for years to come (Fleisher, 1966). Might not this be the case with Black women? Have the suicides been occurring all the time and are only now being discovered?

VARIATIONS IN SUICIDE RATES
BY RACE AND SEX

Variations in the trend of suicide rates in the United States by race and sex are shown in Table 1. Suicide rates among white males increased gradually during the 1920s and early 1930s to a high of 36.4 per 100,000 in 1930 and declined regularly thereafter. Suicide rates among white females have ranged between a high of 10.4 in 1930 and 6.9 in 1955: since then the trend of white female suicide rates has been increasing. Black male suicide rates also peaked in 1930 11.3 per 100,000, declined to a low of 8.5 in 1945, and have been generally increasing ever since. For Black females, current suicide rates are at the highest levels recorded during the past fifty years (U.S. Bureau of the Census, 1974). But what is this reflective of? Is it just a matter of better recording? Or, better yet, is the number of Black women committing suicides obscured by the fact that they are lumped in a category of "Negro and all others"?

Since 1952, the increase in Black female suicide has climbed far above the increase in rates among white men, white women, and Black men. Between 1955 and 1965, the rate reported for Black females almost doubled, but even so, it is still less than 500 in absolute numbers; for white females the rise was about two-fifths, for Black males about one-eighth; with little change for white males (Metropolitan Life Insurance Co., 1970). These figures are interesting but they have told us very little about Black women and suicide. Another question centering on the increase begs to be asked. Has there been a numerical increase in the number of Black women in the suicide-prone age group within the last two decades? If so, is the increase a proportionate increase of the total number of Black women?

In 1940, there were 6,596,480 Black females; in 1950, the number had

TABLE 1 Suicide Numbers and Rates by Sex and Race: 1930–1970

| | | SUICIDES | | | |
| | | White | | Negro and Other | |
YEAR	Total	Male	Female	Male	Female
NUMBERS					
1930	18,323	13,877	3,863	442	141
1935	18,214	13,465	4,094	477	178
1940	18,907	13,990	4,294	476	147
1945	14,782	10,374	3,920	380	108
1950	17,145	12,755	3,713	542	135
1955	16,760	12,430	3,662	531	137
1960	19,041	13,825	4,296	714	206
1965	21,507	14,624	5,718	866	299
1968	21,372	14,520	5,692	859	301
1969	22,364	14,886	6,152	971	355
1970[1]	23,480	15,591	6,468	1,038	383
1971	24,092	15,802	6,775	1,058	457
1972 (prel.)	24,280	15,990	6,670	1,300	310
RATE[2]					
1930	22.1	36.4	10.4	11.3	3.6
1935	19.6	31.8	9.8	10.8	3.9
1940	19.2	31.3	9.6	10.4	3.1
1945	15.1	25.6	8.2	8.5	2.1
1950	15.6	26.0	7.4	10.4	2.4
1955	14.5	24.5	6.9	9.6	2.3
1960	15.4	25.7	7.6	11.7	3.1
1965	16.1	25.3	9.2	12.9	4.0
1968	15.2	24.2	8.8	12.1	3.8
1969	15.7	24.4	9.3	13.3	4.3
1970[1]	16.2	25.3	9.6	13.4	4.3
1971	16.3	25.0	9.9	13.6	5.2
1972	16.0	24.8	9.6	16.3	3.4

[1]Excludes non-resident deaths.
[2]Per 100,000 resident population 15 years old and over; enumerated as of April 1 for 1930, 1940, 1950, 1960, and 1970; estimated as of July 1 for all other years.

SOURCE: U.S. Bureau of the Census, *Statistical Abstract of the United States: 1974*. Washington, D.C., 1974: 150.

risen to 7,743,564; by 1960, there were 9,758,423 Black females; and by 1970, there were 11,832,000 Black females in the population of the United States. It appears, then, that the number of Black females has been increasing at the same time that the rate of suicide among them has increased (U.S. Bureau of the Census, 1960: 9; 1962: 31; 1973: 26). Even with the increase in population, the absolute number of suicides among Black women has been increasing by only about 85 per year, taking every five years beginning with 1960.

VARIATIONS IN SUICIDE RATES
BY SEX, RACE, AND AGE

Figure 1 shows rates by race, sex, and age among the general population of the United States in 1972, the latest year for which figures are available. White male suicide rates increased with age to a high of 56.0 per 100,000 at ages 85 and over; for white females, however, the peak occurred in the 45-64 age group (12.7). Both Black males and females experienced their highest suicide rates in the age range of 25-45—16.2 and 5.0, respectively. The occurrence of Black female suicide is most frequent between the ages of 15 and 24. In general, Black suicides on the national level reflect the highest proportions among Blacks ranging in age from 20 to 30 (Statistical Bulletin, 1970; U.S. Department of HEW, 1970).

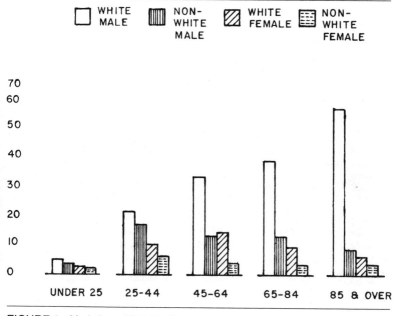

FIGURE 1 Variation of Suicide Rates per 100,000 by Age, Color, and Sex— United States, 1972

Clearly, there are differences in suicide rates with respect to race and age. But of what significance are the differences? At present there are no correlations with other variables. Data show that Black women between 15 and 24 are more prone to suicide than in any other age group. Even though these statistical data exist, they tell nothing of the employment status, marital status, or educational levels of these women. A study of data demonstrating further correlations is necessary. Without such correlations, a blanket state-

ment of statistics tells nothing about suicide among Black women, except that it is on the increase. This assertion, in view of the limited correlative data, merits question and analysis.

MOTIVES FOR SUICIDE

The motives for suicide are often difficult to isolate. In addition to poor health, dread of disease, and mental imbalance, severe reverses in personal finances have frequently triggered suicide. For Black females additional motives have been set forth which include the double-negative status of being Black and female, relative deprivation, and decline of the Black church (Slater, 1973). However, there appear to be no tests of the motives about which serious questions can be raised.

DOUBLE-NEGATIVE STATUS

In the exchange system of American society, women's sex status and Blacks' racial status have typically cost them prestigious and remunerative benefits because society did not evaluate them as being high in either capacity or potential. Those who did succeed had to be brighter, more talented, and more specialized than other race-sex groups, which the society ranked higher. Thus, they paid more for the same benefits (Epstein, 1973: 912). Though Epstein was not addressing suicide, her point serves as a departure for discussion, particularly since status is so closely linked to one's sense of self and consequently one's emotional stability.

Where categories of persons have several negative statuses, there often tends to be a cumulative negative effect. The costs of having several negatively evaluated statuses are particularly high and lead to social bankruptcy when people simply cannot muster the resources to pay them. This effect has great significance for Black women who historically have been at the bottom of the occupational pyramid (Epstein, 1973: 912–913; Jackson, 1971).

The predicament of the poor Black female is especially singled out with respect to double-negative status and suicide.

> The most disastrous impact of racial institutions seems to be felt so early in life and so overwhelmingly that the plight of the female seems as bad as that of the male. Frustration, rage, and violence already characterize the lives of both sexes when they are teenagers, and there is little difference between men and women in the degree of despair that is so often present by the time they are young adults. While the male is the harder hit by socio-economic pressure, it is often the female who bears the brunt of his anger [Slater, 1973: 154].

The status which includes being Black and being a woman has been one of the most cumulatively limiting and frustrating for both poor and middle-income Black women (Epstein, 1973). Granted double-negative status ex-

ists, it is not clear that sociologists understand the dialectical relationship of double-negative status and Black women's everyday lives. While perhaps not extolled in the larger society, many Black women are possessors of high status in Black communities. How is the independence-dependence relationships viewed with respect to white folk but also vis-à-vis Black people? Does the double-negative status in terms of the white world weigh so heavily as to cause the increase in suicides? Is is not imperative to take a systematic look at the cushion that the Black community has provided Black women through close family relationships and the satisfactions of being able to contribute in some meaningful way to the family? Can the double-negative be offered as a motive for increased suicide rates among Black women? Where are the data that demonstrate that the relational system and strong roles of Black women in the Black community have declined? Until such data are presented, can such a motive be accepted as indicative of increased rates of suicide among Black women?

RELATIVE DEPRIVATION

The increased educational opportunities are bringing Black women to a position where they are better able to realize how deprived they still are (Slater, 1973). Thus, relative deprivation exists. Blacks tend to experience more frustration than do whites, particularly in their efforts to realize vocational aspirations. As opportunities allow them in the door, they experience frustration as they see others promoted while they produce the same or better work—a continuous system of having to outdistance everyone else to get minimal crumbs. But if relative deprivation is the motive, why is it only now being focused upon? Has there been a gradual deprivation awareness over the past 20 years with a concomitant rate of increase? If so, what does this mean? Has the increase been accelerated by factors other than relative deprivation? Although the rates are dramatic, this is far from being the case with respect to absolute numbers.

WOMEN'S LIBERATION MOVEMENT

It has been suggested that the women's liberation movement has had a paradoxical effect on the suicide rates of Black women who have always been liberated to some extent (Slater, 1973). With greater liberation, the expectations are greater and the frustration level has become greater. Further, the women's liberation movement serves as a catalyst for Black female identity crisis.

Women in the growing Black middle class just coming into a modicum of affluence and its household gadgetry such as blenders, washing machines and dryers want now to enjoy these things for a while. The lower-class Black woman lacks the educational background to move into male positions and

therefore does not see that as an immediate possibility. In any case, it is hard for a Black woman to imagine liberating herself from the household when she already has been forced out to work. In the past, she has long tried against great odds to adhere to society's concept of the woman's role and so now stands perplexed when she is suddenly told that the old ideals of marital and family life are no longer desirable. The things white women are demanding liberation from are what we've never even experienced yet [Hare and Hare, 1972: 180–181].

While Black women stand to gain from some of the present and projected accomplishments of that movement, the major opinion seems to be that Black women must identify with the total Black liberation struggle rather than with women's liberation. However, this is a dilemma for some Black women which must be resolved.

The women's liberation movement has acted as a catalyst to give Black women an understanding of the chauvinistic society and has served to identify it even within our own ranks. But white America deals with all Blacks on the basis of race as racism continues to permeate the society. This can never be forgotten. A critical query regarding the women's movement as a crucial factor in Black female suicides needs to be answered. Are there measures to determine the extent of the effect, if any, of women's lib on the suicide rates of Black women? Opinions are even divided as to the stance of Black women toward the women's movement. Several writers have attempted to grapple with Black women's views on women's liberation (Conely, 1970; King, 1970; LaRue, 1970; Morrison, 1970). But, in any event, are there data to support the notion that the women's liberation movement has contributed to the increase in suicide among Black women?

DECLINE OF THE BLACK CHURCH

The Black church has historically been a strong force in the lives of Black people, both men and women. However, in recent years the church has been viewed as a deteriorating institution in the Black community, affecting the psychological well-being of Black women and consequently contributing to a higher rate of suicide among them.

Comer particularly suggests that the decline of the Black church has had a disastrous psychic effect on Black women who once found "a sense of belonging and importance" within that system. The church had a built-in defense mechanism for Black people. When you don't relate any longer to a protecting system like that, you are thrown out into the larger system which is a rejecting system. You're thrown into a competitive game whose rules say that you must "make it" to be an adequate person. But in the Black church you didn't have to "make it," because you had an intrinsic worth and value in that system [Slater, 1973: 160–161].

Earlier researchers have demonstrated that the suicide rate varies inversely with the strength of the relational system (Henry and Short, 1954). When the individual is thoroughly enmeshed in a social group, the chances of suicide are low. Accordingly, if the church in which Black women had strongly been integrated no longer provides a strong relational system, their suicide rates increase.

Dodson and White (1972) concluded that there was no way of numerically or empirically identifying any reduced participation in Black churches. Though they found a difference in orientation by theology, within those differences there was an active participation by members in the activities of the church. They continue in their presentation by stating that complete participation or strong church participation continues to characterize the Black church. Such findings should be assessed against data to the contrary. Even the Yearbook of American and Canadian Churches (Jacquet, 1973: 4), a work in which the Council of Churches compiles numerical statements of churches and their congregational compositions, prefaces its itemization with a statement to the effect that its data vary greatly in quality and reliability. Further, the Bureau of the Census terminated its compilation of data on churches around 1930.

Thus, two of perhaps the most likely sources to provide evidence of a decline or increase of church participation cannot be looked to for hard, reliable data. But data must be found to support avowals that the church is on the decline, particularly if its decline is to be used to explain suicide increase among Black women. Are the women committing suicide even a part of the church? Beyond the simple acquisition of data arises the question of the source of the data and the motive behind its collection. Provide the data and qualify its sources. *Then* talk about the nexus between increasing suicide rates among Black women and the decline of the Black church.

EMPIRICAL DATA ON
SUICIDE AMONG BLACK WOMEN

It is easy enough to seize upon the dramatic rates of increases in suicide among Black women over the last several years and to thus lose sight of the small absolute number that is occurring. There is the need to keep level heads and not overplay the statistics such that there is created a self-fulfilling prophecy. Who is setting forth the statistics? For what reasons? And why *now?* Black women committed a total of less than 500 suicides in 1970. It is still the lowest, and by a considerable margin, of all other race-sex groups.

Hill (1972) made a timely analysis regarding suicides and Black families.

In most discussions of the pathology of Black families, a significant indicator of alienation, suicide rates, is rarely mentioned. Why is this so? Is it that the

rates are in the "wrong" direction? Since suicide rates are much higher among whites than Blacks, they fail to fit conveniently the theories of self-hatred and pathology that social scientists have generated about Blacks.

The lower susceptibility to suicide among Blacks—a possible indicator of stability—is an intriguing area for further analysis (Hill, 1972: 26).

The new focus on the increasing rate of suicides of Black women might serve to open up still another area for pathologists to study the Black family which Black people do not need. A preliminary examination of the literature suggests that studies of suicide among Black women are virtually nonexistent. Hendon (1969) concluded from his study of 25 Blacks (13 females and 12 males who attempted suicide) that somewhat different motivations operate in Black suicides than in other groups studied by him. These differences are related particularly to the role of hostility and anger in the psychodynamics of the patients studied.

Like Hendon, Breed (1966) studied a mixed-sex group of Blacks. However, the subjects of his study were not attempted suicide patients, but individuals who were already dead. Breed based his findings on data collected in interviews with their friends and relatives. He found that central to the conflict of Black suicidal victims were their feelings of impotence in dealing with arbitrary authority.

An earlier psychiatric study of Black suicide was done by Prudhomme (1973), who concluded that race is not a factor in suicide among Blacks because the subjects he studied did not attribute their suicide attempts to racial problems. But such a conclusion borders on naivéte of what it has meant to be Black in American culture and the effect of that culture on the lives of Black people.

Maris (1969) observed three patterns among Black female suicides in a study conducted in Chicago: a low suicide rate among Blacks, a concentration of Black suicides in the 15–45 age category, and a relatively high suicide rate among young Black females in the 15–24 age bracket. However, this was a study focusing on urban suicides; only in a limited way did it deal with Black females. Several other studies focused on suicide and alluded to Black females (Henry and Short, 1954; Schmid and Van Arsdol, 1955; Schniedman and Farberow, 1957).

It appears that empirical studies of Black suicide are limited and those focusing on Black females are virtually nonexistent. When studies have concentrated on Blacks, they have selected subjects in a single city (such as Chicago, New York, New Orleans, and Seattle) which have not been broad-based studies of the United States as a whole. This, again, points to the need for research before conclusive statements can really be made with respect to motives of suicide among Black females.

CONCLUSION

Suicide commands attention because it is on the rise among Black women, but less than 500 per year kill themselves. Thus, it is far from being the major health problem and must be viewed in proper perspective. While all problems facing Black women need to be dealt with, there is a danger in focusing on dramatic, comparatively infrequent problems like suicide and paying little attention to less dramatic, but more frequent and chronic problems.

This presentation suggests that, while the longer-term trend in suicides bears observation, the suicide rates of Black women disaggregated into meaningful socioeconomic categories such as age, marital status, religion, and occupational and educational status would provide much more interpretable clues of changes in the sociocultural situation.

Future research should be designed to provide insight into the psychological processes and social dynamics that operate in the lives of Black women which have given rise to the increases in suicide rates among them. The area of suicide among Black women should receive scholarly attention and stem the current wave that is pointing up further "pathological defects" in the Black family which may lead to even greater rates following the "self-fulfilling" prophecy logic. Throughout this chapter it has been suggested, implied, and emphatically stated that the data do not justify the excitement over suicide among Black women. Monitor, research, concern—all are vital so long as excitement ceases to be the order of the day.

REFERENCES

Breed, W. (1966) "Suicide, migration, and race: a study of cases in New Orleans." Journal of Social Issues 22: 30–43.

Conely, M. (1970) "Do Black women need the women's lib?" Essence (August): 29–34.

Dodson, J. and C. White (1972) "Pulpit theology: a study of Black Methodism in Oakland, California." Berkeley: University of California. (unpublished)

Douglas, J. D. (1968) "Suicide, I-social aspect," in D. L. Sills (ed.) International Encyclopedia of the Social Sciences, Vol. 15. New York: Macmillan/Free Press.

Durkheim, E. (1951) Suicide (J. A. Spaulding and G. Simpson, trans.). New York: Free Press.

Epstein, C. (1973) "Positive effects of the multiple negative: explaining the success of Black professional women." American Journal of Sociology 78: 912–935.

Fleisher, B. (1966) The Economics of Delinquency. Chicago: Quadrangle.

Hare, N. and J. Hare (1972) "Black Women 1970," in J. M. Bardwick (ed.) Readings on the Psychology of Women. New York: Harper & Row.

Hendon, H. (1969) Black Suicide. New York: Basic Books.

Henry, A. F. and J. F. Short (1954) Suicide and Homicide. New York: Free Press.

Hill, R.B. (1972) The Strengths of Black Families. New York: Emerson Hall.

Jackson, J. (1971) "But where are the Black men?" Black Scholar (December): 30–41.

Jacquet, C. [ed.] (1973) Yearbook of American and Canadian Churches. Nashville: Abington Press.

King, H. (1970) "The Black woman and women's lib." Ebony (July): 68–76.

Larue, L. (1970) "Black liberation and women's lib." Transaction (December): 59–64.

Maris, R. (1969) Social Forces in Urban Suicide. Chicago: Dorsey.

Menninger, K. (1938) Man Against Himself. New York: Harcourt Brace Jovanovich.

Metropolitan Life Insurance Company (1970) Statistical Bulletin 51 (May): 10–11.

Morrison, T. (1971) "What the Black woman thinks about women's lib." New York Times Magazine (August): 14–15, 62–64, 66.

National Center for Health Statistics (1967) Reports of the Division of Vital Statistics. Washington, DC: U.S. Government Printing Office.

Prudhomme, C. (1973) "The problem of suicide in the American Negro." Psychoanalytic Review 25: 187–204, 372–391.

Schmid, C. F. and M. D. Van Arsdol (1955) "Completed and attempted suicides." American Sociological Review 20: 273–283.

Schneidman, E. S. and N. L. Farberow (1957) Clues to Suicide. New York: McGraw-Hill.

Slater, J. (1973) "Suicide, a growing menace to Black women." Ebony 25 (September): 152–160.

U.S. Bureau of the Census (1960) Historical Statistics for the United States, Colonial Times to 1957. Washington, DC: U.S. Government Printing Office.

————(1962) Statistical Abstract of the U.S., 1962. Washington, DC: U.S. Government Printing Office.

————(1973) Statistical Abstract of the U.S., 1973. Washington, DC: U.S. Government Printing Office.

————(1974) Statistical Abstract of the U.S., 1974. Washington, DC: U.S. Government Printing Office.

U.S. Department of Health, Education and Welfare (1970) Facts of Life and Death. Public Health Service Publication No. 600. Washington, DC: U.S. Department of Health, Education and Welfare.

18

THE WOMEN'S LIBERATION MOVEMENT
Understanding Black Women's Attitudes

Willa Mae Hemmons

In order to effectively understand the dynamics of a society, one must not only consider the affects of individual processes, but the affects of cultural processes as well. This is particularly true when studying a social movement, which is an ongoing social process, such as the women's liberation movement and the attitudes of Black women toward that movement. The Black woman is in part a product of her society. Her propensity to embrace or reject a social movement such as the women's liberation movement is thus partially a function of what her society has made of her and she of it.

The illumination of attitudes held by Black women toward a movement which scorns a traditional feminine status which has been promoted as the ideal not only in white society but in Black society as well is the chief factor of this study. How do Black females react to a call for unification with a group which heretofore has been a source of subjugation and humiliation for them? Will they let bygones be bygones, see a greater purpose, and join forces? Will only a certain portion of them unite? If so, which part? Where will Black women put their priorities: or, in other words, do they see their future more with the Black male or the white female? Or, is there any conflict at all for them in embracing the precepts of the women's liberation movement? These are questions which this chapter seeks to answer.

DESIGN OF THE STUDY

The study consists of 82 women, 45 of whom are Black, 37 of whom are white. Although we were mainly interested in the attitudes of Black women toward the women's movement, we included white women as a comparison

group. A random sample is often forwarded by scientists as the ideal method to employ in a research design to obtain optimal use of the data (Edwards, 1958). Since our study is exploratory in nature—investigating a social phenomenon whose formal dimensions have yet to be specifically delineated—an alternative sampling procedure which meets our demands is the purposive quote sample (Zelditch, 1970). For instance, the Black woman who is a consciously ardent follower of the women's liberation movement is a very rare person and would almost undoubtedly be overlooked in a simple random sample. The sampling technique which was chosen permits the observation of other rather elusive groups, such as white female movement members and Black and white females who might embrace many of the movement's tenets without expressing membership. In addition, Black and white middle- and working-class women were able to be included in the sample.

The women in this sample were contacted through clubs, schools, and various work agencies. Black and white women who were part of WIN (Work Incentive Program) in 1972 filled out the questionnaire during a regular classroom session. Members of the Black women's liberation group and white women of the women's liberation movement completed the questionnaires. Women in a Black social club were included in the sample, as well as teachers at a junior high school. When viewed as a total group, these women represent various occupations—hairstylists, teachers and teachers' aides, nurses and nurses' aides, clerks, salesclerks, waitresses, secretaries, switchboard operators, housewives, social workers, and musicians.

ATTITUDINAL VARIABLES

Several variables were thought to be related to Black women's attitudes toward the women's movement. According to Durkheim, anomie is a result of conditions existing within a society in which an individual resides and reflects the nonincorporation of a person within the fabric of her society. This quality was relevant to our study because we felt that those persons measuring high on anomie would be less inclined to participate in any social activity, let alone a social movement which requires a high degree of group cooperation versus single autonomy and emphasizing altruism rather than individualism as far as the attainment of its goals is concerned. Cronbach's Alpha, or the degree to which the component items reflected a unidimensional scale, for anomie \propto was .52. The items included are shown below:

Item	Correlation of Item Total Score
1. One reason I would not have any (more) children is to keep from bringing them up in such an uncertain, unpleasant world. (pessimism)	.72

2. As soon as I get used to one thing, it changes and I have to start all over.
> (time orientation) .64

3. The lot of the average person is really getting worse, not better.
> (pessimism) .54

4. People nowadays, as a whole, are mostly out for themselves.
> (individualism) .52

5. A person who can't get along without other people is weak.
> (individualism) .51

These elements seem to relate to the values of the women's liberation movement in that their presence in a given woman may have the effect of inhibiting her from its acceptance, inasmuch as the information concerning that movement suggests the opposite characteristics as those found in anomie.

The second variable that we felt might help to explain the attitudes of Black women toward the women's movement was femininity. Much of the writing on women reflects a feminine view which sees the female as weaker, less intelligent, more emotional, less stable, and more domesticated than the male. Alpha \propto for the femininity scale was relatively high, .74.

	Correlation of Item
Item	Total Score
1. When a man marries, he should be more experienced in making love than his bride.	.79
2. A wife should do everything she can to help her husband further his career, even if it means sacrificing her own.	.75
3. One of the most important duties of a woman is to act like a lady at all times.	.72
4. Most women, Black or white, should be content to be wives and mothers.	.62
5. Feminine reading material (e.g., *Glamour, True Story, Mademoiselle, Good Housekeeping,* etc.).	

Femininity represents a subordinate-superordinate relationship between a man and a woman. The women's liberation movement seeks to eliminate this type of structured, relatively inflexible relationship between what they feel are two otherwise equal human beings (Bart, 1970; Morgan, 1970; Bird, 1968; Weisstein, 1967; Rossi, 1964; Battle-Sister, 1971; de Beauvoir, 1968; Miller, 1970). To be feminine is, almost by definition, to be antiethical to true female liberation. Accordingly, there should be an inverse relationship between the two variables. In other words, the expression of feminine values will be negatively associated with the expression of female liberalism.

Racial liberalism, our third explanatory variable, may serve as an indice

for propensity toward the women's liberation movement. The underlining assumption is that there are some general characteristics which are typical of people who join "radical" social movements (Killian, 1964; Morrison, 1971; Olsen, 1970). The scale of racial liberalism resulted in an alpha of .52, and the correlations of the items are shown below.

Agreement with the above items (especially the first four) gives some indication, then, of a person's general predilection toward racial liberalism. For whites, however, agreement with the last item may not be an accurate indicator of change propensity, in that it may be interpreted in one of two ways. First, those agreeing with it are advocates of pride in one's cultural heritage to which Blacks have just as much right as whites and which would indicate a liberal orientation. Second, those in agreement with the fifth statement are conservatives, reacting against recent progress made by Blacks and desiring to reemphasize white supremacy. This second interpretation would mean that there would not be too much success in trying to recruit these persons to radical social movements.

Item	Correlation of Item Total Score
1. The Black Power Movement is the best thing to happen to Blacks as a group in the past 20 years.	.78
2. I personally, as a Black (or if I were Black) would like to be a member of the Black Power Movement.	.74
3. For Black women, the Black Power Movement is more important than the Women's Liberation Movement.	.59
4. I am a member of the Black Power Movement.	.54
5. Much of my happiness comes from being an Afro-American or Caucasian (as the case may be).	.37

OUTCOME VARIABLE

It is with the outcome variable that we are most concerned. The items under this heading concern the ideology advocating the achievement of equality for women. The previous three variables were hypothesized to influence the dependent variable female liberalism. The alpha for female liberalism is the highest of the variables scaled at .77, and its component appear below.

Item	Correlation of Item Total Score
1. I, personally, would like to be a member of the Women's Liberation Movement.	.88

2. The Women's Liberation Movement is the best thing to happen to
 women as a group in the past 20 years. .76

3. Most of my friends like the Women's Liberation Movement. .75

4. I am a member of the Women's Liberation Movement. .71

5. Everybody, married or single, should be able to get birth control. .49

DATA ANALYSIS

Our three major hypotheses are:

H_1 A female who scores high on femininity will manifest a low score on female
 liberalism.

H_2 A female who scores high on racial liberalism will also manifest a high score
 on female liberalism.

H_3 A female who scores high on anomie will manifest a low score on female
 liberalism.

Table 1 shows that there were no differences between Black and white
women's affinity for or rejection of female liberalism. Slightly more than
half of each group rejected it, and slightly less than half endorsed it. Black
women in this selective sample appear just as ready to accept a change for
women's status as white women. This finding is contrary to the general idea
forwarded by the mass media, which suggests that Black women have
negative attitudes toward the women's movement.

TABLE 1 Percentage of Women by Race Manifesting a High or Low Degree of Female
Liberalism

Female Liberalism		Black %	White %
High		47	46
Low		53	54
	Total	100	100
		(N=45)	(N=37)

TABLE 2 Percentage of Women by Social Class Manifesting a High or Low Degree of
Female Liberalism

Female Liberalism		Middle Class %	Working Class %
High		50	45
Low		50	55
	Total	100	100
		(N=45)	(N=37)

There was a slight difference between middle- and working-class women
on female liberalism: The middle class was slightly more receptive to the
movement. When the data were divided by race, we found that little differ-
ence exists among Black women. However, the Black working-class woman

was slightly more receptive to the precepts of the women's movement than the Black middle-class woman. The white class distribution was more along the lines expected: 73 percent of the white working class scored low on female liberalism, while 46 percent of the white middle class scored low on female liberalism. The findings for white women conform more to the general perception of who joins the women's movement, whereas Black women did not differ by class on acceptance or rejection of female liberalism (see Tables 3–6).

TABLE 3 Percentage of Black Women by Social Class Manifesting a High or Low Degree of Female Liberalism

(Blacks only—total=45)

Female Liberalism	Middle Class %	Working Class %
High	44	48
Low	56	52
Total	100	100
	(N=18)	(N=27)

TABLE 4 Percentage of White Women by Social Class Manifesting a High or Low Degree of Female Liberalism

(Whites only—total=37)

High	54	27
Low	46	73
Total	100	100
	(N=22)	(N=15)

TABLE 5 Relationship Between the Variables Race and Class and Independent Variables

Independent Variables	Group Variables	
	Black (N=45) %	White (N=37) %
Anomie		
High	51	46
Low	49	54
Total	100	100
Femininity		
High	62	41
Low	38	59
Total	100	100
Racial Liberalism		
High	60	62
Low	40	38
Total	100	100

TABLE 5 Continued

	Middle Class (N=40) %	Working Class (N=42) %
Anomie		
High	47	50
Low	53	50
Total	100	100
Femininity		
High	33	74
Low	67	26
Total	100	100
Racial Liberalism		
High	74	48
Low	26	52
Total	100	100

COMPARISON ON THE INDEPENDENT VARIABLES: ANOMIE, FEMININITY, AND RACIAL LIBERALISM

Table 7 shows the distributions on the independent variables by race and class. Black women manifested a slightly higher degree of anomie than white women. However, both groups were nearly evenly divided, with 51 percent of the Blacks and 46 percent of the whites scoring high on anomie. What this table shows is that Black and white women in this sample are not as integrated into the society's norms as one might expect. It is commonly thought that white women are more integrated into society than Black

TABLE 6 Percentage of Black Women by Social Class Manifesting a High or Low Degree of the Independent Variables

(Blacks only—total 45)

Independent Variable	Middle Class (N=18) %	Working Class (N=27) %
Anomie		
High	39	59
Low	61	41
Total	100	100
Femininity		
High	44	74
Low	56	26
Total	100	100
Racial Liberalism		
High	83	44
Low	17	56
Total	100	100

TABLE 7 Percentage of White Women by Social Class Manifesting a High or Low
Degree of the Independent Variables

(Whites only—total=37)

Independent Variable	Middle Class	Working Class
	(N=22)	(N=15)
	%	%
Anomie		
High	50	33
Low	50	67
Total	100	100
Femininity		
High	23	73
Low	77	27
Total	100	100
Racial Liberalism		
High	68	47
Low	32	53
Total	100	100

women, but these data do not show this. Women in general seem to manifest the same degree of anomie.

Femininity is endorsed by almost two-thirds of the Black women, whereas only two-fifths of the white women endorsed this concept. Black women show a greater acceptance of the traditional definition of female roles. However, they are just as likely as white women to embrace the precepts of racial liberalism. Sixty percent of the Black women and 62 percent of the white women scored high on racial liberalism.

When the group was divided by class, almost three-fourths of the working class as opposed to only one-third of the middle class endorsed norms of femininity. The opposite relationship can be seen for racial liberalism: Three-fourths of the middle class but less than half of the working class scored high on this variable. We can see from Table 9 that there are differences between Black and white women on femininity but not on racial liberalism, and there are differences on both of these variables by class. Middle-class women are low on femininity and high on racial liberalism.

Looking at differences between Black and white women on the independent variables in greater detail by controlling for class, we see that most of the class trends remain the same regardless of race (see Tables 6 and 7). Both Black and white middle-class women scored lower on femininity than Black and white working-class women. Likewise, both Black and white middle-class women manifested a higher degree of racial liberalism than working-class women. The only trend in which the classes differ according to race is on the variable of anomie. More white middle-class women are high on anomie than working-class white women. However, for Blacks, more work-

ing-class women are high on anomie than middle-class women. Since our sample is not large enough to continue this analysis by race and class, we will restrict the remainder of this study to the racial differences between women and their attitudes toward the women's movement. However, the findings from this sample suggest that this is indeed a fruitful area for research. One is left with the question, To what extent does class outweigh race in explaining women's attitudes toward the women's movement?

RELATIONSHIPS BETWEEN THE INDEPENDENT AND DEPENDENT VARIABLES BY RACE

In order to understand the interrelationships between the independent and dependent variables correlations, (r) and t-distributions were analyzed. The correlation-coefficient (r) ranges from a possible -1.00 to $+1.00$, with correlations closely approximating .00 representing little or no relationship. In order for the t-distribution, given the sample size, to be significant at the .05 level, it had to be equal to or greater than 1.68. The correlation corresponding to this value of t was .26 for significance. Correlations are based on the entire score range (5 through 25) for each variable rather than the dichotomized scores of high and low as previously discussed.

Tables 8 and 9, showing Black and white correlations, respectively, present data which bear out the first hypothesis concerning the relationship between femininity and female liberalism. The t-distribution on both tables is also significant beyond the .05 level. Thus, for both Black and white women, traditional endorsement of femininity is incompatible with the values of the women's movement. The correlation for Blacks was -.46; for whites it was -.46. These are rather high correlations, which suggests that a woman who embraces the precepts of the women's movement does not take traditional positions on women's roles. They do not believe that a woman should put her husband's career before her own; nor do they feel that it is necessary for a woman to act like a "lady" at all times. According to the percentage distribution, Black women were more able than white women to sustain these two dissonant values. Thirty-eight percent of those who scored high on femininity also scored high on female liberalism, while this was true for only 20 percent of the white women in this category. Perhaps it is in this category that we can begin to see the differences between Black and white women. For, behaviorally, Black women have had to perform roles defined as non-traditional feminine roles, and at the same time they have had to "act feminine." Generally, we must say that femininity and female liberalism for both Black and white women are two dissonant values. Women who are high on femininity are low on female liberalism, and vice versa.

TABLE 8 Correlation Between Femininity and Female Liberalism for the Black
 Woman

(Blacks only—total=45)

| | | Female Liberalism | | |
Femininity		High	Low	
High	(%)	38	62	Total=100 N= 28
Low	(%)	53	47	Total=100 N= 17

(r)=−.4605
(t)=3.20 p<.05

TABLE 9 Correlation Between Femininity and Female Liberalism for the White
 Women

(Whites only—total=37)

| | | Female Liberalism | | |
Femininity		High	Low	
High	(%)	20	80	Total=100 N= 15
Low	(%)	64	36	Total=100 N= 22

(r)=−.4654
(t)=3.24 p<.05

Evidence for Hypothesis 2 dealing with the relationship between racial
liberalism and female liberalism is given in Tables 10 and 11 for Black and
white women, respectively. This hypothesis is accepted. The t-distribution
exceeded the .05 level of significance. Nearly 60 percent of both groups who
scored high on racial liberalism also scored high on female liberalism, and
only a small proportion of each group, 28 percent of the Blacks and 14
percent of the whites, who responded negatively to racial liberalism were
proponents of female liberation values. Seen another way, 72 percent of the
Black women who scored low on racial liberalism also scored low on female

TABLE 10 Correlation Between Racial Liberalism and Female Liberalism for the
 Black Women

(Blacks only—total=45)

| | | Female Liberalism | | |
Racial Liberalism		High	Low	
High	(%)	59	41	Total=100 N= 27
Low	(%)	28	72	Total=100 N= 18

(r)=.4609
(t)=3.20 p<.05

TABLE 11 Correlation Between Racial Liberalism and Female Liberalism for the
White Women

(Whites only—total=37)

Racial Liberalism		Female Liberalism		
		High	Low	
High	(%)	65	35	Total=100 N= 23
Low	(%)	14	86	Total=100 N= 14

(r) = .5575
(t) = 4.14 p<.05

liberalism. The same was true for 86 percent of the white women. The (r) for
Black women was high at .46 and for white women it was even higher, .56.
These results suggest that women who embrace a radical social movement
will also embrace the ideas of the women's movement.

With both Blacks (Table 12) and whites (Table 13), the expected negative
relationship between anomie and female liberalism according to our third
hypothesis was not true. Correlations for both groups were near zero: For
Black women it was -.06; for white women it was .02. The t-distribution is
also not significant. Percentage-wise, the distribution for the two groups
was almost identical, as shown by the tables. Women could indeed believe
that the world is unfit for children and still believe that women need to

TABLE 12 Correlation Between Anomie and Female Liberalism for the Black Women

(Blacks only—total=45)

Anomie		Female Liberalism		
		High	Low	
High	(%)	35	65	Total=100 N= 23
Low	(%)	59	41	Total=100 N= 22

(r) = -.0634
(t) = .3914 not significant

TABLE 13 Correlation Between Anomie and Female Liberalism for the White Women

(Whites only—total=37)

Anomie		Female Liberalism		
		High	Low	
High	(%)	35	65	Total=100 N= 17
Low	(%)	55	45	Total=100 N= 20

(r) = .0293
(t) = .1806 not significant

change their relative position in society. Or, they might say that nowadays most people are out for themselves, and at the same time say the best thing that has happened to women in the past 20 years is the women's movement. The reader may recall that Black women and middle-class white women scored rather high on the anomie scale. They seem to be most alienated from the present structure of society. Thus, we reject the third hypothesis.

DISCUSSION

This study gives data concerning Black women's attitudes toward the women's liberation movement and the factors which influence the formation of that attitude set. It has often been suggested that Black women are anti-women's movement. The data for this study do not show this. In fact, more Black women in this study embraced the precepts of the women's movement than white women, 47 versus 46 percent. It is true that the difference is not nearly significant, but it is indeed surprising to find that just as many Black women believe in the ideas and values of the women's movement as white women. We must also recognize that the sample in this study is small, and we would need to see whether these findings hold true in a larger sample. The salient findings suggest that the attitudes Black women have about the women's movement can be specified by other variables. One cannot say that Black women will have positive attitudes or negative attitudes toward the movement without specifying the characteristics of the woman. We found that Black women who were committed to the Black liberation movement were also committed to the women's liberation movement. Further, Black women who took traditional attitudes toward the roles of women were less likely to embrace the ideas and values of the women's movement. Surprisingly, Black women were more "feminine" in their values than white women, but this did not decrease the percentage of women who showed a positive attitude toward the women's liberation movement. We have suggested that this inconsistency may result from the various non-traditional roles that Black women have played. In short, it is a result of Black women having a different history than white women. This writer has heard many Black women say they are unconcerned with giving up feminine behavior—they still want men to open doors for them and take them to dinner. At the same time, these women do not mind washing dishes, cooking, and taking care of children. What they want is the same economic benefits enjoyed by the white man. Black women do not want to invade all-male clubs because they do not want men to invade their clubs. Black women enjoy the sister-hood of other women—it is a part of their culture. Black women say they want the same education and job opportunities of white males.

To this extent, the writer would maintain that the main reason Black

women have not joined the women's movement centers on the priorities of the movement. When white women were into consciousness-raising sessions trying to come to grips with who they were apart from their husbands and children, Black women were seeking groups that would address the issue of massive unemployment and underemployment among Black people in general and Black women specifically. When white women were trying to find time to write or do research, Black women were trying to find groups that would address the poor education their children were receiving. When white women were devising strategies for getting out of the house and into the labor force, vast numbers of Black women were suggesting that they would gladly return home and take care of the home and children if the economic system were not so oppressive on Black men. At the same time, they were saying to Black men that a return to the home did not change their independent nature.

The data in this study show that Black women are indeed aware of their status as women. They are in agreement with the ideas and precepts of the women's movement as often as white women. To the extent that white women in the movement begin to address the issues of economic and racial oppression, they will see more and more Black women openly joining the struggle of women and all oppressed peoples. However, the Black woman cannot negate her Blackness; to do so would be to deny her man and children. For she is indeed both Black and woman.

REFERENCES

Adams, R. L. (1964) Great Negroes Past and Present. Chicago: Afro-Am Publishing.

Axelson, L. (1970) "The working wife." Journal of Marriage and the Family 32.

Bart, P. (1970) "Mother Portnoy's complaints." Transaction 8 (November-December).

Battle-Sister, A. (1971) "Conjectures of the female culture question." Journal of Marriage and the Family 33 (August).

Beal, F. M. (1970) "Double jeopardy," in R. Morgan (ed.) Sisterhood is Powerful. New York: Random House.

Bennett, L., Jr. (1963) "Negro woman." Ebony 18.

Bernard, J. (1966) Marriage and Family Among Negroes. Englewood Cliffs, NJ: Prentice-Hall.

Billingsley, A. (1968) Black Families in White America. Englewood Cliffs, NJ: Prentice-Hall.

Bird, C. (1968) Born Female. New York: Pocket Books.

Blood, R. O. and R. L. Hamblin (1958) "The effects of the wife's employment on the family power structure." Social Forces 36.

Butts, H. F. (1969) "Black rage." Freedomways 29.

Cade, T. (1970) The Black Woman. New York: New American Library.

Cleaver, E. (1968) Soul on Ice. New York: McGraw-Hill.

Comer, J. P. (1968) "The social power of the Negro." Rhetoric of Black Power.

Current Population Reports, Special Studies (1970) The Social and Economic Status of the Negro, 1970. Series P-23, No. 38. Washington, DC: U.S. Government Printing Office.

Curtis, R., Jr. and L. A. Zurcher, Jr. (1971) "Voluntary associations and the social integration of the poor." Social Problems 28.

De Beauvoir, S. (1968) Second Sex. New York: Bantam.

Edwards, A. L. (1958) Statistical Analysis. New York: Holt, Rinehart & Winston.

Ellis, J. (1970) Revolt of the Second Sex. New York: Lancer.

Feagin, J. R. (1970) "A note on the friendship ties of Black urbanites." Social Forces 49.

Frazier, F. (1952) "The failure of the Negro intellectual." Negro Digest 30.

Freud, S. (1922) Beyond the Pleasure Principle. London: Hogarth.

Grier, W. H. and P. M. Cobbs (1968) Black Rage. New York: Basic Books.

Halsell, G. (1969) Soul Sister. Cleveland, OH: World Publishing.

Hare, N. and J. Hare (1970) "Black women 1970." Transaction 8.

Hunter, C. (1970) "Many Blacks wary of 'women's liberation' movement in U.S." New York Times November 17.

Jackson, J. (1972) "Where are the Black men?" Ebony, (March).

Killian, L. (1964) "Social movements," in R. E. L. Faris (ed.) Handbook of Modern Society. Chicago: Rand McNally.

Ladner, J. (1972) Tomorrow's Tomorrow: The Black Woman. New York: Doubleday.

La Rue, L. (1970) "Black liberation and women's lib." Transaction 8.

——— (1972) "Black sex." Transaction 3.

Mack, D. (1969) "The husband-wife power relationship in Black families and white families." Ph.D. dissertation, Stanford University.

Massaquoi, H. J. (1969) "Interview with Muhammad Ali." Ebony (April).

Miller, S. M. (1970) "Creaming the poor." Transaction (June).

Morgan, R. (1970) Sisterhood is Powerful. New York: Random House.

Morrison, D. E. (1971) "Some notes toward theory on relative deprivation, social movements and social change." American Behavioral Scientist 14 (May).

Norton, E. (1970) "For Sadie and Maude," in R. Morgan (ed.) Sisterhood is Powerful. New York: Random House.

O'Connor, L. (1970) "Male dominance," It Ain't Me Babe 1.

Olsen, M. (1970) "Social and political participation of Blacks." American Sociological Review 35.

Palmore, E. and F. J. Whittington (1970) "Differential trends toward equality between whites and nonwhites." Social Forces 49.

Patton, G. (1970) "Black people and the Victorian ethos," in T. Cade (ed.) The Black Woman. New York: New American Library.

Robinson, P. et al. (1970) "A historical and critical essay for Black women in the cities, June 1969," in T. Cade (ed.) The Black Woman. New York: New American Library.

Rossi, A. (1964) "Equality between the sexes." Daedalus 93 (Spring).

Ryan, W. (1965) "Savage discovery: the Moynihan Report." The Nation 201.

Staples, R. (1969) "Research on the Negro family." The Family Coordinator 18.

——— (1971) "Towards a sociology of the Black family." Journal of Marriage and the Family 33.

Stokes, O. P. (1970) "Today's Black woman." Colloquy 3.

Tallman, I. (1969) "Working class wives in suburbia." Journal of Marriage and the Family 31.

U.S. Department of Commerce (1943) 1940 Census of Population, Education. Washington, DC: U.S. Government Printing Office.

Weisstein, N. (1967) Kinde, Kuche, Kirche as Scientific Law: Psychology Constructs the Female. New York: Free Press.

Wilson, R. A. (1971) "Anomie in the ghetto." American Journal of Sociology 77.

Wirth, L. (1938) "Urbanism as a way of life." American Journal of Sociology 44.

Zelditch, M., Jr. (1970) "Some methodological problems of field studies," in W. J. Filstead (ed.) Qualitative Methodology. Chicago: Markham.

19

THE SELF/GROUP ACTUALIZATION
OF BLACK WOMEN

Geraldine L. Wilson

> It is the life thing in us
> that will not let us die.
> Even in death's hand
> we fold the fingers up
> and call them greens and
> grow on them.
>
> Lucille Clifton: *An Ordinary Woman*

Throughout the history of this nation, the political, social, and cultural forces in the society—that is, the forces of colonialism set in a framework of capitalism—have stimulated/forced many individuals and different cultural groups to involve themselves in the processes of consideration, reflection, and evaluation. At stake was/is the state of their individual and group membership, the extent to which that group is in jeopardy or not in jeopardy in this society, and whether or not that group has progressed ("become amalgamated or assimilated"). History will inform us that the Black community has not been exempt from these processes and has periodically and rather regularly used these processes to determine who we are and what kinds of solutions we ought to develop in response to our continual oppression in this land. An example of this kind of total community examination becomes crystal clear if we look carefully at the kind of controversy that erupts among

us each time we change our group name or They label us. Those controversies have always brought anger to some, anxiety and/or fear to some, great conflict to others. Many look to the processes of consideration, reflection and evaluation, hoping against hope that the issues of who we are as a group, who we want to be, who we ought to be, where our roots are and—crucially, to whom we owe our psychological, emotional, and spiritual allegiance (this nation or *our nation*)—will be finally settled.

Obviously, Black women have been a part of this community process. We have been moved in each generation and currently to respond in various ways to the debilitating, constricting, distorted images of us created by American society and projected and disseminated in their popular print and broadcast media. The negative images of Black women have in the past— and some still do—appeared in magazines, on food products, in children's picture books, on billboards. (Lord, deliver us from the recent billboard whiskey ads that are presently flourishing in Black communities portraying us as hopeless, dependent, and blank-looking carbon copies of the white *Vogue* magazine model.) In the past, we have been a boon to the tourist industry. We were "captured" and our important African expressions of womanhood were brutally caricatured and portrayed on postcards, as dolls, on or as cups, on plates, as cookie jars, tea cozies, pin cushions, on and on, *ad infinitum* and *ad nauseum*. These items are now expensive memorabilia. (Lord, we still bein' sold!)

These popular negative images—rooted strongly in the minds of whites as a result of their elaborate rationale for slavery—preceded the development of the disciplines of psychology, sociology, and anthropology. Whites carried these negative perceptions and misinterpretations of us and our behavior into universities and systemized them through the mechanism of "scientific research" in the behavioral and social sciences. In the esoteric and private research circles, uninformed and racist research was spawned. Pseudoscience developed "theory" about our roles, responsibilities, and behaviors as Black sisters, wives, mothers, grandmothers, and female personalities. Sometimes the Black community has reverberated with intense shock and great rumbling of the earth in response to the release, dissemination, and public discussion of these research reports because they contained certain negative images and behavioral distortions of Black women and their family members. Indeed, it seems that sometimes Black men and women appear to be reaching out to each other across the crevices and chasms created in the "ground on which we stand" by those reports on our collective behavior that have been compiled by those Dr. Asa Hillard calls "strangers to our community." As a result, there has been inter- and intrapersonal conflict, inter- and intragender conflict, pain, incriminations, and recriminations. And, of course, *as usual,* there has been resistance and organized commu-

nity protest and response to these reports. There has been unrecorded and untold struggle and demonstrated courage by some Black students, faculty, and professionals in universities and in public and private agencies who have responded in resistive fashion to the initiation, and/or discussion, and/or promotion and to the use of these studies. They have often—when they have known and/or when it was possible and sometimes when it wasn't possible—challenged the basic assumptions of the research, the methodologies, the interpretations, and the wholesale dissemination thereof.

There are a number of rather obvious and elementary responses regarding Black women and this society's negative responses and descriptions of them. The printable ones are:

(a) How do *we* see ourselves as girls and women?

(b) What is important *to us* and *for us?*

(c) What is *our response* to all those negative reports? ("Well, who *is* Moynihan anyway?" asked one confident young sister who heard a raucous argument in the Black community about whether or not Black women were matriarchs. She had no idea she was supposed to be one. She said she never met any and besides she didn't know any women who had any time to be "sitting round on no throne orderin' no men around." Anyway, she didn't know no men who'd "listen to nobody who sounded like what they was all arguin' about!")

(d) What do we Black women feel are *our proper roles, duties, responsibilities and obligations?* (Some of us are tired enough of the era of integration and its new forms of oppression that the glowing idea of "roles," an outgrowth of that era, will dim shortly enough.)

(e) What is a near-accurate picture of *our collective* selves as women who are a part of a worldwide community of African women?

(f) What and who fulfills Black women? What brings us the traditional "satisfaction"? (We miss you, Otis!) What gives us purpose? Our sense of spirituality? What makes us fearful? What triggers fight?

Serious consideration, reflection, and evaluation of such questions as a way of looking at Black women (Good Lord!) In the next life we'll just *be* and not be looked at, will reveal that, no matter how varied the results of that reflection are, one of the continuing problems for us has been this society's different criteria for womanhood. Through the invidious, colonial mechanism of institutional and individual comparison, the differing requirements for what is considered appropriate feminine behavior (white women as the standard) have been imposed. Force has then been exerted to result in changing the African cultural orientation to womanhood of African-American girls and women.

Responsible history and research make it clear that African societies (that is, their philosophies, spiritual world-views, and the value systems that shaped their attitudes and behaviors) could be conceptualized as the African Experiential Tradition (AET). That experiential tradition has resulted in some significantly different behaviors among Black women in this country. And well it should have! In addition, the requirements of colonialism—

specifically, those interlocking subsystems of racism, cultural repression, political disenfranchisement, economic exploitation, and force—have resulted in the need for behaviors among Black women that would of necessity be different from women who live in the colonial sector of this society. It is most often those women against whom the behavior of women of African descent have been compared. That set of Euro-American/Judeo-Christian societal norms regarding women and women's behavior are a result of a male-dominated, polarized, exclusionary, classist, exploitative framework for the definition of Male (Superior, Owner, Controller, Definer, and Dominator) and Female (inferior, owned, submissive, accepting definition, and passive). Thus, the definitions of male and female behaviors and relationships are based on the Euro-American religious and secular mythology of the inferiority of women and the children They "produce."

Into that kind of cultural climate we African women came with our different selves; in chains as captives but with a particular way of seeing ourselves. The mirror that society gave us had "her" in it, not us. (Wasn't no mirror. What a trick!) As colonialism spread, more and more "her" image was (and continues to be) beamed around the world. It is becoming pervasive. And for those of us who don't feel personally threatened by "her," there is grave concern among us on a political and cultural level as we watch late-1970s sisters seductively push their long straightened hair out of their eyes, using the same gestures as "her." Of course the questions we raise are valid. Of course we must engage them as a way of beginning to make decisions about the nature of the struggle. That struggle involves who we as women want to be, what we want our community to be. The goal of colonialism is to change us without our permission. How can that be fulfilling? How can self/group be actualized under a system of colonialism? Maybe we'll find out we don't need or want their mirrors. We'll see.

The continent of Africa seems to be the Beginning and the End, the Alpha and Omega, the place where the chickens come home in the end to rest or to roost. Africa is the undisputed home of life itself as documented by the monumental work of the Leakey family in Tanzania and the Africans who worked with them. Many major social/societal ideas—philosophical, aesthetic, spiritual, religious, agricultural, military, ideological, spiritual, and familial systems—began in Africa. These ideas grew into philosophical, aesthetic, spiritual, religious, agricultural, military, ideological, spiritual, and familial systems in Africa. History has shown and is continuing to show that many of these ideas and systems have been carried or were taken to all parts of the world. Ideas about one god, many spirits, science, mathematics, healing, family, clan, village, city, education, and a rich reservoir of aesthetic responses to life in the form of art, dance, music, masquerade, and poetry that it seems will never be exhausted—all come out of Africa.

DuBois made clear in a 1915 *Atlantic Monthly* article the continued importance of the impact of Africa on the world. With inimitable candor, his discussion makes it clear that one of the major reasons for World War I was the European tribal conflicts over who was going to control Africa. He wrote:

> Nearly every human empire that has
> arisen in the world, material and
> spiritual, has found some of its
> greatest crises on this continent
> of Africa, from Greece to Great
> Britain.

Perhaps we can now, finally, conceptualize that important ideas about African womanhood and femininity and the systems through which womanhood and femininity are expressed in African life had influence in the world community. Perhaps it is the very vitality and strength of these ideas and systems of femininity and womanhood that are responsible for their continued suppression by European colonial administrators, missionaries, and educational administrators in Africa, the Caribbean, and in the United States. For, having suppressed their own women, what white men don't need is another group around with a womanhood system that has some different, workable criteria in it.

The very concept of Mother Africa has been a value in the socialization of women (and our men, too) and has had a qualitative effect on the relationship between Black men and women. It has determined in some measure the kind of traditionally expressed caring, nurturing, loving of, and fighting for (and in great love—sometimes conflicted love—fighting with) Black men and children; for which Black women have sometimes been castigated in this country. But there is evidence that women of Africa had the care, love, protection, and institutional *and* societal support of men as they—the women—carried out major military, governmental, and family responsibilities. (The clan system in Africa traditionally made the discrete, western separation of military and governmental concerns from family concerns very difficult.)

It seems appropriate to continue the discussion of Black women and their processes for arriving at self/group actualization with some thoughts about W. E. B. DuBois and some words about Black women written by him. As a Black woman, I chose him for this particular discussion for a number of reasons.

One. He is our Black Scholar-Man of gigantic proportions who set a number of models for theory-building and doing research about us that we would do well to use. We could do no worse than to emulate his serious, disciplined work and commitment to us.

Two. He left a reservoir of valid research that embodied issues and questions about Black families, Black instititions, and the Black community's relationship to this capitalistic, exploitative system that we need to locate and continue to work on answering.

Three. DuBois set up a model by which we could/should have been looking at the Black family. His book *The Negro American Family* was published in 1908. In it, he cautioned "the careful scholar" not to neglect the "distinct nexus between Africa and America" in any study of Black families. Hence, any discussion of Black womanhood must take the nexus or relationship with Africa under consideration.

Four. Throughout his works, DuBois makes masterful use of an African-based imagery inherent in our oral literary addition to describe Black women, whom he loved. His descriptions of us are powerful, respectful, inspiring. He revered his mother and makes several references to his grandmother whom he tells us crooned African tunes to him "in words whose meanings she had forgotten." Throughout his work, he speaks clearly and repeatedly to the subjugation of women as a major world problem in ways that few scholars have, either before or since his time.

Five. Through the use of DuBois as a reference about Black women, I want to demonstrate the importance, the political and spiritual necessity of a collective definition of who we are as Black women. Our men, after all, have perceptions of us based on experiences with us, and at least some of them must be true whether we like what they see in or say about us.

Six. DuBois was an activist. We respect him for his ability to theorize, rhapsodize, intellectualize, and rhetoricize. He tested his theories and constructed *The Philadelphia Negro,* thus leaving us a documented history and leaving sociology its first major sociology study. He built the *Crisis* because he knew we needed a voice and a publication. He was a teacher, he was an organization builder. We—after all is considered, reflected on, and evaluated—must, like him *do* something about it/us.

In the chapter "The Freedom of Womanhood" in *Gift of Black Folk* (1924), DuBois, tripping duly only slightly, makes absolutely clear our impact on the life of this nation. He portrays us as we have been: domestics, workers, mothers, concubines, and what he calls "Negro women in revolt." He helps us to understand that we were not just to "guide their own folk but to influence the nation," and "emancipate all women." His analysis—at that point in time—underscores the varied characteristics of the Black woman's conceptual and real self. Her qualitative relationships to her nation, her community, her family are multidimensional and in characteristic African fashion those varied relationships and characteristics are often not fragmented. Traditionally, for her, there is little (or at least less) discontinuity among the institutions of family, community, and nation. African

women and we, their stateside sisters, have in more or less flexible and simultaneous fashion fulfilled our responsibilities as

> mothers, rulers, daughters,
> negotiators, aunts, political
> representatives, lovers,
> captives, intellectual
> companions, wives, grandmothers,
> military personnel, entrepreneurs,
> sisters, liberation fighters.

In addition, we have had to resist the requirement of this society to make us, as women, choose among work outside the home, men, marriage, family, children. Therein is one of the contradictions and a part of the definition. We had to work, and in some instances chose to work because it was within our tradition. So, according to "them," we weren't women. Lots of us knew better and still do.

What might be some of the questions of definition, description, feeling, attitude, action, and what are some of the categories into which they would fall?

Family: How do we define ourselves in relation to mother, grandmother, father, sisters, aunts, uncles, cousins, our children? What are the mutual obligations and duties of Black women and family members? How do they perceive her and she them? What are the stresses, strains, and supports for her in her relations with family? How does she perceive and use the survival spirit of the family? What are her responses to her symbolic family role in the Black community?

Children: How do Black women see children, what do they mean to her, and not just those born to her? How does she see herself in relation to those nieces, nephews, neighbor's children, and, later in life, her grands and great-grands? How do Black women feel—collectively—about how they should relate to the rambunctious array of children? How do they express their maternal life-giving energy—those who've not borne their own—with nieces, nephews, and "adopteds"? How have Black women felt about "second" children? What have been the dynamics that supported Black women's decisions to enlarge their families with "other" children? How have we fared in roles as child welfare workers, teachers? How have we done as those who've raised the children brought to us to care for and who often suffered agonies when "parents" came for them? How do we feel about the children who've been born to us? What have been our dishonesties and angers—if any—about our children? Our disappointments? What are the conflicts we have about our children? Which aspects of our children don't we understand?

Black women: How do we feel about the women in our families? Our sisters, aunts, mother, grandmothers, second mothers, stepmothers? How

do we feel about each other in our community—the sister on the block, the sister with Dee-grees, the domestics, the hairdresser, the factory workers, the businesswomen, the sister on welfare and the recently arrived corporate executive? What misperceptions might they/we have about what kinds of dues they/we have each paid and what kinds of opportunities have and have not been available to each? Really? What myths about the nature and range of Black womanhood separate them from us and us from them? What forces, situations, circumstances, what philosophies and/or values unite us?

Men: How does she see and what does she feel about her father, brothers, uncles, cousins, the men in the neighborhood and community? How do they see her and feel about her? How does she see and what does she feel about her loved one and/or her husband, her male children? What are the stresses and points of strain in those relationships? What are the points of solid and deep agreement between them? What angers her, hurts her, and brings her fulfillment, maintenance, sustenance, and joy in her relations with her men? Will she fight for him? To keep him? Under what circumstances?

Work: How do Black women perceive and define work? Hasn't it been almost anything they felt they had to do in order to provide for their children, their family members, and their men when work was unavailable to them? Is her job her only work? Does she see them as different (the job and work)? Is there work she has not done that she would prefer to do? How have we dealt with the "role changes" forced on us by the system of colonialism? (As an example: After all, in many parts of Africa, planting was—and in some places continues to be—woman's work.) What has it cost Black women to be forced out of that work by a system that degrades the spiritual and familial reasons that the African Experiential Tradition assigned that work to women? What other role assignments have been forced on us? What is fulfilling work? Who among us still continues to see the rearing of children as fulfilling work?

Political Structure (Colonialism): The political structure in this case is an alien one. How do Black women define themselves in the face of competing, politically valued, and powerful images of females and feminine values that are not Black? How does she defend the nature of her being? What aspects or expressions of her African heritage is she aware of? willing to identify? willing to fight to keep? Does she see the system as alien? How and under what circumstances has she fought against the political system? What things frighten her about it? How does she maintain her wholeness? What happens to her when she doesn't or can't?

Where can Black women go in order to begin the process of consideration, reflection, evaluation and definition? The European male with a preference for locking his lady up in his stone tower reported his story, not our story, nor even her story about whether or not she liked being locked up,

so that most history as we come to know it in this society was not written by us. With all of that, African women nudge their way boldly through the white curtain that has been hung over the rich Blackness of our history. They stand shoulder to shoulder with the "extraordinary" African men—though sometimes standing alone—as figures of our story (i.e., The History of African Peoples). Even in history written by Europeans it happens often enough, this nudging through *their* history of "extraordinary African women," that one begins to think again (and we must think again and again) of the kinds of ideas and systems and people that come out of Africa. We must reflect on the nature of African family life, since so many "extraordinary" men and women appeared throughout African (including Afro-Caribbean and African-American) history and life. Is it "extraordinary" only by invidious comparison to the European perception of us, or is the behavior we see the fact that we just keep doin' our "ordinary" African, African-Caribbean, and African-American thing? And so it is to that history that we can go for some portraits of Black women, portraits that when compiled reveal what have been our duties, obligations, responsibilities, experiences. We can see then if we've followed in the footsteps of our women ancestors, forbears, predecessors; we can determine through the processes of evaluation, consideration, and reflection if we can "actualize" our individual/collective selves based on our heritage, our legacy of characteristics and the tasks we have to do. We do have to do them, don't we?

The various portraits of African women give us a broad panoply of characteristics, roles, responsibilities, and personality characteristics from which we can define our womanhood. It's back in time we go to continue that process. As we begin to identify our collective characteristics as they have emerged in this country, we can use the characteristics of African women as a check to be sure we've included all the characteristics, qualities, talents, and gifts given to us as weapons for our struggle against colonialism. Obviously we are not all queens—that's a political designation. But Sonia Sanchez, the poet, reminds us that we are queenly (or ought to work on it if we ain't). The queens of Africa are very different from most we've ever known about (like Elizabeth and those) or those we see in movies, TV, or children's picture books.

Our relationship to African women is not as far away and as much a part of our "memories" as white historians (and some of ours) have tried to make it. It's been close enough to reach out and touch. It's had impact on our upbringing as children. Let's catch it before it's too late and let's have one of our own take us back in time.

Lucille Clifton wrote a marvelous, poetic history of her family called *Generations* (1974). In it she writes that her father used to tell her over and over again as a small child, "You named for Dahomey women, Lue." He had

specific reference to his own great-grandmother, Mammy Caroline, who when she was eight walked from New Orleans to Virginia. She used to tell Lucille Clifton's daddy, "Get what you want, you from Dahomey Women." In terribly brief summary, it meant that history has revealed that Dahomean women were in and controlled the army. They could make and inherit money. They controlled the marketplace. They could get a divorce and could create and head a family. (Ooo-ops. We're in trouble in this land.) Lucille Clifton's daddy was raised on the idea and *practice* of African womanhood. Lucille Clifton's daddy raised her on the idea of African womanhood. So, because of her heritage meet Lucille Clifton—

African-American sister
African-American wife
African-American mother of six
African-American poet and writer for grown folks and children
African-American literary preserver of our cultural symbols
African-American great great granddaughter of a Dahomean/Benin woman who was captured in Africa as an eight-year-old girl child and sold into American slavery.

Meet Queen Nefertiti—

One of the more renowned African queens—shrewdly appropriated by Europe as was all of Egypt—but she remains African nonetheless, as does Egypt. She was known to have had great influence on her famous husband, Akhenaton. In her own right, she was a wise and creative woman. She had political influence. One of the most profoundly inspiring portraits of Nefertiti which is rarely projected by the media is a portrayal of her as queen, sitting at equal height (showing equal status) opposite Akhenaton. Each one of them holds one of their two daughters. Nefertiti was

African wife
African intellectual companion
to her husband
African mother
African queen
African woman

Meet Queen Hatshepsut of Egypt—

She was described by some historians as formidable and agreed by all to be powerful. Skillful in the art of trading, she was responsible for the revival of trade with the Kingdom of Punt on the Somalia Coast. Considered a wise, observant and tough bargainer, she brought riches into Egypt through the exchange of weapons, beads, rings, and other products considered valuable

by the folk of that era. Hatshepsut was an accomplished poetess and built a beautiful temple in honor of her father. She was

> African queen
> African daughter
> African trader and bargainer
> African power broker
> African poetess
> African builder of her empire
> African woman

Meet Queen of Sheba—

The virtuous, smart, lovely woman who has become the subject of western romance and is known by many through this media. However, when one reads the Ethiopian *Kebra Negast* (meaning the Glory of the King), one wishes one had been raised on that version of the Bible rather than the King James one. That source tells us that Sheba heard of the wisdom and greatness of Solomon in the Palestinian empire. She took gifts. She went to learn from him and her own knowledge was respected and received. It is bandied about that they fell in love, but in contrast to the Anglo-Saxon, Judeo Christian version of the fabled romance portrayed in movies and TV, she came home to her family/ nation with all her stuff—and lots of Solomon's stuff, too—it's reported!! Shortly thereafter, she gave birth to the boy child who would become Menelik I, founder of the dynastic lion of the Lions of Judah who still have power in Ethiopia. Solomon received his son in court, as is the African way. Sheba was—and in our tradition—continued to be

> African queen
> African ruler
> African woman in love
> African responsible to her people
> African woman

Meet Nzinga—

Nzinga of the JaJa People (or the Luando people of the Congo-Angola area), was sent by her brother, Ndongo, to negotiate with the man appointed by the Portuguese to be the governor of Luando. The task of this governor was to convert and control the Luando people and those related to them.After traveling to negotiate with him, in true colonial fashion the appointee of the Portuguese government refused Nzinga a chair in which to sit. That would have been the diplomatically correct thing to do. She was African, she was a woman, and he conveyed quite clearly that he did not consider her equal in rank to him. In true African style, using an improvisational response, Nzinga commanded one of her attendants to kneel on all fours. Clear about her inherent status, not to be outdone or shamed, imperiously and with great cheek

(I'm sure she rolled her eyes and handed her hip), she sat squarely on the back of her attendant and completed that sensitive, strategic, political mission. When she succeeded her brother, she renounced Christianity and fought valiantly against the Europeans, riding fiercely into battle with the troops. She ruled until she was 75. She was

African sister
African daughter
African resister
African ruler
African culture keeper
African soldier
African woman

Meet Yaa Asantewaa The Great—

The British Colonial administration who tried—unsuccessfully until the early twentieth century—to break the back of the cultural and military strength of the Asanti people (in the Gold Coast, now Ghana) had a name for her. Yes, indeed! They called her "The Old Terror." Her people know her as "The Great" and describe her in their praise forms as "The woman who carried a gun and the sword of state into battle." She needled the chiefs she thought would succumb to the seduction and/or force of the British. She resisted and fought against the ideas and practices of Christianity. Her analysis of Christianity's impact on some of her people led her to the shrewd political prediction that Christianity would be a disorienting, disruptive force in Asanti life. Everyone—British and Asanti—knew she would die rather than surrender. And so her exile, along with Prempeh I, Chief of the Asanti, was a painful, courageous act. It is symbolized—paradoxically—as defeat and resistance; for she chose, instead of death, to accompany Prempeh I into exile. She was a live symbol of hope for the Akan nation who felt shame in what was to be a temporary bow to colonialism. Yaa Asantewaa was

African aunt
African queen mother
African preserver of culture
African warrior
African exile
African woman

Toni Cade Bambara, author and teacher, holds the mirror up for us to look at ourselves and insists that we look at what is beautiful about us, as well as what is ugly. It is she who can provide additional direction for those of use who got dragged away from Africa and got mired down in questions of who we are. She discusses what she calls the culture of resistance in which our families in the Caribbean, North, Central, and South America have struggled, survived, and prevailed. And women have played a strong, sure,

dominant (often predominant) sustaining role in our families that have had to function under colonialism. Toni tells us that the family is *not* the enemy, but a shrewd, psychologically supportive and unifying organism and structure. The family has traditionally overseen the education of its members and stood behind folk as they left the family to get additional education in the school setting. What resulted were families and family members who were flexible and strong. The families supported the emergence of fighting spirit, independence, courage, skill, perception, interdependence, and excellence as goals for all family members, male and female.

Slave narratives are a rich source of our womanly relations to our men, children, other women, and to the system of colonialism here in this land. One narrative reveals that a captive mother on a plantation told her daughter in the South:

> "I'll kill you, gal, if you don't stand up for yourself. Fight and if you can't fight, kick and if you can't kick, then bite."

This mother showed her daughter that she meant business, for she almost killed her mistress when she tried whip the slave woman's daughter. Then she violently and successfully avoided being punished by two armed professional "nigger beaters." She was

African captive in the U.S.A.
African-American mother
African-American teacher of resistance
African-American protector of children
African-American defender of her person
African-American woman

It is out of our African heritage and out of this culture of resistance that the girls of the Caribbean and North America, trained, nurtured, loved, comforted, and disciplined by men and women, grew to sharpen their share of inherited and taught-to-us collective characteristics of African women. (We don't need to have them all, you know. We'd just be too terrible if we did. Each of us can choose a few to complement the ones we have. There's enough to go around.) You know some of the women who went before. We must learn about more of them. Queen Mary of the Virgin Islands, Georgia Johnson, Mary McLeod Bethune, Bottom Belly, Angela Davis, Nannie Helen Burroughs, Georgia Jackson (mother of George), Harriet Tubman, Winnie Mandela, Rose Morgan, Ida Wells Barnett, Assata Shakur, Billie Holliday, Louise Bennett, Dr. June Wright, Lucy Lannie, Maggie Lena Walter, Fannie Lou Hamer, Cardiss Collins, Mammy Pleasant, Eloise Greenfield, Abbie Lincoln, Miriam Makeba, my mother.

Your mother?
Your aunt?
Your neighbor?

You?

Yes. Great struggle is *still* the path that lies before us. Yes! In the words of our women who came before, we must walk it, not by ourselves, but we must walk it. Not to do so is to die forever. We must not be convinced that our struggle is over.

Oh yes! We must walk the path together and our definition of us exists. It *BE*. It includes who we were, who we are, wherever we are. That includes those of us who have remained tillers of the soil and those who are shouldering rifles as guerillas in the liberation struggle. We've been characterized and actualized by our contradictions, our sometimes paternalism with our men and children, our evilness (sometimes situations require it!) and by our independence, our response to oppression, our beauty, our anger, our strength, our resistance, our humor, our spirit, our songs, our tears, our toughness, our ability to do the job, our deep pain, our love, and our laughter.

ABOUT THE AUTHORS

DELORES P. ALDRIDGE received her Ph.D. in sociology from Purdue University. She is professor of the Graduate Institute of Liberal Arts and Coordinator of Black Studies, Emory University. She has published in a variety of education and social science journals and is a member of many professional organizations. Her research interests are the Black family and the mental health of Black families.

CHRISTINE H. CARRINGTON, Ph.D. is a licensed, certified psychologist who is currently employed by the University Counseling Service, Howard University, Washington, D.C. She also has a private practice. Her research interests include cognitive treatment of depression in Black Women and relaxation therapy in the treatment of psychophysiological disorders. She is currently engaged in research at Howard University Medical School.

CHRISTINA BRINKLEY-CARTER is a demographer and professor in the Population Studies Center of Columbia University. She completed her Ph.D. at Princeton University. Her research interests are in the areas of Black fertility and population growth and development in Third World countries.

BONNIE THORNTON DILL earned her Ph.D. from New York University. She is professor of Sociology at Memphis State University. Her interests include Black women and work, social inequality, and marriage and the family. She is currently doing research on the ways in which class structure and labor market organization affect Black women's labor force participation and income.

RHETAUGH GRAVES DUMAS is one of a few Ph.D. nurse scientists in the country. She is also a social psychologist. She received her Ph.D. from Union Graduate School, and is currently Deputy Director, Division of Manpower and Training Programs, National Institute of Mental Health. Her research interests are in the areas of Black women and power and stresses on professional Black women.

ELEANOR ENGRAM received her Ph.D. in sociology from Duke University. She is formerly a member of the faculties of the University of California at Berkeley and Morgan State University. She is presently Vice-President and Director of Research of the Resource Center for Community Institutions, Oakland, California. Her professional interests include complex organizations and human development. Her research and publication activities have been in the areas of women, families, organizational development, youth, and aging.

GLORIA WADE-GAYLES received her undergraduate degree from LeMoyne College and will receive her Ph.D. degree from Emory University in May 1980. She has received numerous grants. Her poetry and essays have appeared in *The Atlantic Monthly, Liberator, Black World, Essence,* and *The Black Scholar.* She wrote the introduction to *Sturdy Black Bridges* (Doubleday, 1979). Her research interest is in the area of the impact of race and sex on Black women as seeen in literature and sociology.

CHERYL TOWNSEND GILKES is a Professor of Sociology at Boston University. She received her Ph.D. from Northeastern University. Her research interests are in the historical and contemporary role of Black women in responding to problems of individual survival and racial oppressions through community work, and the role of the "sanctified church" as an African-American cultural phenomenon in Black life.

JANICE HALE received her B. A. from Spelman College and her Ph.D. from Georgia State University. She is presently on a leave of absence from Clark College in Atlanta, Georgia, where she is Assistant Professor of Early Childhood Education. For the 1979–1980 school year, she is a research associate in the Department of Psychology at Yale University. Dr. Hale has published numerous articles in the area of Black child development. She is presently working on a manuscript entitled, *Black Children: Their Roots, Culture and Learning Styles*.

WILLA MAE HEMMONS received her law degree from the University of Illinois and her Ph.D. in sociology from Case Western Reserve University. Presently she is a professor in the Criminal Justice Department at Cleveland State University. Her research interest is in the area of Black women's attitudes toward the women's movement and the sociology of law.

CHERYL BERNADETTE LEGGON received her Ph.D. in sociology from Harvard University. She is Professor of Sociology at the University of Illinois, Chicago Circle. Her research interest is in the area of the professional Black woman and organizational dynamics.

HARRIETTE PIPES McADOO received her Ph.D. in psychology from the University of Michigan. She is a professor of social work at Howard University. Her research interests include changes in role behavior of middle-class Black families, the socialization of Black children, and racism and mental health.

CARRIE ALLEN McCRAY is Professor of Sociology and Social Work at Talladega College. She has been interested in the study of various aspects of the Black family and in developing materials that reflect a more positive perspective. She is currently developing videotapes on the "strengths of Black families," to be used for inservice training programs in the southern region of the United States.

LENA WRIGHT MYERS is a Professor of Sociology at Jackson State University. She received her undergraduate degree from Tougaloo College and the Ph.D. from Michigan State University. She has published her research work in various journals, and served as director of a research study on self-esteem maintenance among Black women in Mississippi. Her academic areas of specialization are social psychology, social deviancy, and the sociology of women.

JEWEL L. PRESTAGE has a Ph.D. in political science. She is Professor and Chairperson of the Department of Political Science, Southern University. She is currently completing a research project on Black female elected officials. Her most recent publication is a volume co-authored with Mary Ann Gittens, *A Portrait of Marginality: The Political Behavior of the American Woman*.

LAFRANCES RODGERS-ROSE received her Ph.D. from the University of Iowa in social psychology. She is Visiting Professor of Afro-American Studies at Princeton University. She has been a research sociologist at Educational Testing Service, and is a past president of the Association of Black Sociologists. Her research interests are in the areas of Black culture, Black women, and Black personality development.

ESSIE MANUEL RUTLEDGE received her Ph.D. in sociology from Michigan State University. She is currently Professor and Chairperson of the Department of Afro-American Studies at Western Illinois University. Her area of specialty is the Black family. She is currently doing research on the Black woman in higher educational institutions.

GERALDINE L. WILSON was formerly Project Director for the New York City Head Start Regional Training Office at New York University. She is now a free-lance consultant with early childhood programs, school systems, and corporations while she completes her dissertation on children and plantation life during slavery. Born and raised in Philadelphia, Pennsylvania, Gerry has worked in the South extensively and has a keen interest in Black child rearing, Black language forms, children's literature, and a recent interest in writing.